DRESSING THE PART:
TEXTILES AS PROPAGANDA IN THE MIDDLE AGES

DRESSING THE PART:
TEXTILES AS PROPAGANDA
IN THE MIDDLE AGES

KATE DIMITROVA, MARGARET GOEHRING (EDS.)

BREPOLS

D/2014/0095/236

ISBN 978-2-503-53676-7

Printed in the EU on acid-free paper

TABLE OF CONTENTS

CHAPTER 1

Introduction

Kate DIMITROVA and Margaret GOEHRING

During the Middle Ages, textiles played a particularly prominent role in the communication of wealth and authority by defining both bodies and spaces as sites of political, religious, and social power. From the ornamented sphere of ecclesiastical dress and the celebrations of feast days to an aristocrat's various rites of passage (such as birth, marriage, coronation, and death), textiles often functioned as propaganda in the Middle Ages. Sacred and secular rulers alike during the Middle Ages expressed their dynastic claims, military prowess, political aspirations and accomplishments by commissioning, displaying, wearing, and offering textiles as gifts.

The papers in this volume aim to illustrate the scope, richness, and complexity of the language of medieval textiles. The geographic and chronological scope of this book encompasses the Latin West, Byzantium and Islam of the eleventh century to the late fifteenth century. The essays in Part I, *Textiles in Context*, focus on the capacity of textiles to perform, generate, and even to regenerate meaning. While several papers draw heavily upon material culture studies, others, particularly those in Part II – *Textiles as Sign* – reconstruct the world of medieval textiles through their representation in other media. The project was shaped by the following questions: How do textiles function in memorializing identity, status, and authority? What role did textiles play in the enactment of power in the secular and ecclesiastical realms of medieval society? To what extent did textiles mediate the interplay and interconnection of these two realms? How do the meanings of textiles change when placed in new or different contexts than originally intended? How does the inherent materiality of a textile convey meaning and what are its potential messages? Although these questions may not be readily answered, the essays in this volume offer ways in which we might begin to understand this largely under-explored realm of visual rhetoric.

While much of textile studies continues to focus on necessary foundational questions concerning dating, workshop processes, stylistic development, vocabulary, and other technical details, the scholarship offered in this volume also questions how medieval textiles were used and invoked in the construction and display of power by addressing their semiotic functions. In this vein, the title of this collection – *Dressing the Part* – moves beyond a literal reference to fashion, clothing and costume (although these are certainly considered here) to invoke the broader ways in which textiles not only mediated both the body and space, but also how they mediated experience, identity, politics, and ritual.

Barthes hinted at this expanded notion of 'dress' when he argued that dress was both a system and a process.[1] For him, clothing could be analyzed as a language that operated within the larger semantic sphere of society and culture:

> When its signified is explicit, the vestimentary code divides the world into semantic units which rhetoric apprehends in order to 'dress them up', order them, and from them construct a genuine vision of the world.[2]

While Barthes focused on deconstructing the 'semantic units' of fashion, we have broadened his approach in order to explore an expanded matrix in which medieval textiles operated. Instead of looking only at how clothing mediated the body, we also explore how textiles – from hangings and liturgical furnishings to gifts and the painted and carved reproductions of textiles – mediated both the body and space.[3] Barthes argued that dressing was a form of performance; we propose that the display of textiles on and around the body is also part of that performance.[4] The essays gathered here clearly illustrate that medieval textiles had a performative function that activated both body and space through a synthesis of the individual units of sensory information – silk, gold, cloth, vestment, church, ritual, audience – into a comprehensive matrix of signs.[5]

This matrix of signs is the crux of several of the studies presented here. For instance, Evelin Wetter (*Material Evidence, Theological Requirements and Medial Transformation: 'Textile Strategies' in the Court Art of Charles IV*) offers a new allegorical reading of the materials and iconography of liturgical vestments found in two Bohemian panel paintings made at the court of Emperor Charles IV. For her interpretation of the so-called Glatz Virgin, Wetter moves beyond the heraldic emphasis, which has traditionally characterized earlier analyses, to combine close readings of William Durandus's *Rationale divinorum officiorum*; the hagiography associated with the donor; the inventories of St Vitus's Cathedral; and the evidence offered by extant textile donations from late medieval Prague. After outlining the theological symbolism and hierarchy associated with each liturgical vestment illustrated in the painting and suggesting how the panel would have been understood in light of contemporary politics and theological debates, she concludes that the represented garments reinforced the donor's episcopal position and allegorical role as the bridegroom of the church.

In his essay, Warren Woodfin (*Orthodox Liturgical Textiles and Clerical Self-Referentiality*) explores the performative aspects of a group of Byzantine liturgical textiles with the motif of Christ as high priest that were produced in Turkish workshops during the early Ottoman period. He focuses on the repetition of roundels with the figure of Christ that were typically embroidered onto, and subsequently woven into, vestments, demonstrating how this iconography was used to reinforce the notion that the priest-wearer was both a representative and a representation of Christ. He situates the earlier textiles within Byzantine liturgical practices and visual culture of the thirteenth through fifteenth centuries to argue that a triangulation occurred between the woven vestments the clergy wore, the imagery found in the church setting (notably wall paintings and hung embroideries), and the highly orchestrated and dramatic ritual of the mass, which created a mimetic association that identified the priest as being a living icon of Christ. Over time, the vestments became progressively self-sufficient, activating this mimetic association solely by being worn.

David Ganz (*Pictorial Textiles and their Performance: The Star Mantle of Henry II*) also investigates the performative role of textiles in his essay. He further offers a solution to a vexing problem that often faces historians: how to propose a reading of a textile that is in a ruinous state; in this case, the so-called Star Mantle of Henry II. At the core of the history of this eleventh-century textile are the impact of its restoration in the fifteenth century and the subsequent changing of its meaning, function, and appearance into something new. Borrowing a structuralist approach, Ganz identifies the warp and the woof of the textile as a built-in grid system of coordinates – what he describes as a 'topological syntax' – upon which the imagery of the mantle was arranged. By analyzing this syntax, he is able to verify the extent of the visual and structural changes that were made to the garment, and subsequently understand what had not been altered. Moreover, by viewing the historical accumulation of meaning to be significant in and of itself, he is able to reconstruct the role of 'silk diplomacy' involved in the commissioning, weaving, offering, changing, and re-presentation of the Star Mantle.

Because textiles are portable, wearable, and displayable, their performative qualities function at multiple levels of signification, resulting in multivalent meanings, which medieval patrons exploited. The essay by Yuka Kadoi (*Textiles in the Great Mongol Shahnama: A New Approach to Ilkhanid Dress*) investigates the coded language of dress, pattern, and ornament in the now dispersed Great Mongol *Shahnama* ('Book of Kings') produced during the Ilkhanid period in Iran. Comparing the illustrations to extant textiles from Iran, China, and Mongol Eurasia, she shows how the universalist agenda of the Mongol Empire appears to have informed the representation of clothing in this manuscript. While many of the textiles represented in the miniatures offer a window into the contemporary Mongolian and Iranian fashions of the Ilkhanid court, they also served as a means to express Mongol political hegemony.

The very portability of textiles ensures that their meaning can never truly be fixed. Perhaps more than any other art form, textiles reveal the medieval appreciation for the inherent flexibility of signs. Textiles fundamentally represent a confluence of messages because they operate within multiple systems of signs, such as fashion, liturgical presentation, ceremonies of state, funerary ritual, memorial display, and personal or corporate identity, to name a few. The essay by Henry Schilb (*The Epitaphioi of Stephen the Great*) analyses how Stephen the Great, Voivode of Moldavia, who commissioned a cluster of Byzantine liturgical textiles, exploited their inherent capacity for multivalency in order to express several messages. Much of Schilb's argument focuses on the changes in, and maintenance of, prescribed and often formulaic iconography and dedicatory inscriptions of the *epitaphioi* that were hung during the liturgies on Good Friday and Holy Saturday. He interprets the hangings in light of contemporary political events and liturgical usage, which was undergoing change during this period, to show the dynastic ambitions of this ruler and his desire to secure his line of succession, his piety and munificence, as well as his wish to form an alliance with the Ottoman Empire.

Several essays investigate the operation of textiles within medieval memorial culture and the construction of corporate identity. For example, Kristin Böse (*Cultures Re-shaped: Textiles from the Castilian Royal Tombs in Santa María de las Huelgas in Burgos*) describes how the cultural dialogue of the Christian re-conquest of Muslim Spain was played out in the burial fabrics found in the royal tombs of Santa María de las Hueglas in Burgos, and how this dialogue promoted the political ambitions of the royal family. Her essay demonstrates that the hybridity of royal funerary textiles, which display a Christian appropriation of Muslim techniques, materials and motifs, buttressed and reinforced the identity of the Castilian royalty. The burial textiles were unambiguous, yet simultaneously multivalent signs, denoting not only pious wishes for salvation and honored *memoria*, but also promoting Castillian political hegemony.

Jennifer Courts (*Weaving Legitimacy: The Jouvenel des Ursins Family and the Construction of Nobility in Fifteenth-Century France*) uncovers a literal fabrication of identity through the representation of cloth. She explores the intersection of space, identity, and textiles in a fifteenth-century panel painting that originally hung in the Jouvenel des Ursins family's private chapel in Notre-Dame Cathedral in Paris. Her analysis of Jean II Jouvenel des Ursins's construction of the family's genealogy in various writings – coupled with the imagery found in the panel painting and also in a fragmentary set of tapestries housed in the Musée du Louvre – illustrates how the family used textiles to reinforce their legitimacy as members of the *noblesse ancienne*.

Catherine Walden (*'So lyvely in cullers and gilting': Vestments on Episcopal Tomb Effigies in England*) addresses episcopal identity in her investigation of the effigies found on thirteenth-century tombs in England. These tombs were often carved and painted to represent the rich, sumptuous fabrics of liturgical clothes, some of which were occasionally far more luxurious than those the

deceased could have actually owned. She compares the textiles depicted on the tombs of various English archbishops and bishops with extant textile vestments (sometimes found within those very tombs). Walden proposes that vestments – both real and depicted in stone – established one's worldly status within the church, but they also expressed spiritual aspirations, particularly salvation.

During the Middle Ages, the intrinsic material value of textiles – especially those imported from great distances, or which were woven from silk, enriched with silver and gold threads, or garnished with precious stones – employed a complex visual language that could convey ideological and symbolic messages. Christiane Elster (*Liturgical Textiles as Papal Donations in Late Medieval Italy*), for instance, examines the layered cultural meanings associated with the donation of liturgical textiles by late medieval popes. By connecting surviving textiles – donated by Popes Nicholas IV, Boniface VIII, and Pius II to their hometowns – with archival records, Elster is able to shed light on the nuances involved with the papal gifting. While many of these liturgical textiles were often originally part of the papal treasury, some were pieces of cloth that were specifically purchased to be donated, allowing the recipients to make different types of vestments and furnishings. Situated within the anthropological and sociological frameworks of gift-giving, particularly rooted in the theories of Marcel Mauss, Elster finds that such papal textile gifts were infused with a potent symbolic 'capital of honor that fuelled papal memorial culture in the towns of Ascoli Piceno, Anagni, and Pienza.

On the other hand, as Stefanie Seeberg (*Monument in Linen: A Thirteenth-Century Embroidered Catafalque Cover for the Members of the Beata Stirps of St Elizabeth of Hungary*) argues, deliberately humble materials could also be invoked to offer equally potent statements, especially useful in the display of piety or humility. Seeberg demonstrates the inherent value of medial analysis in reconstructing the original function and meaning of a textile long removed from its original context. Her essay re-examines the function of a thirteenth-century embroidered linen cloth currently housed at the Museum für Angewandte Kunst (Frankfurt am Main), which had previously been described as an altar cloth. Through a comprehensive analysis of its materials, colors, compositional arrangement, and iconography she proposes that the textile was probably the cover for a catafalque, making it the earliest known extant example. It had likely been used for memorial celebrations at the convent of Altenberg, which is linked to St Elisabeth of Thuringia through her daughter, Gertrud, who was the *magistra* and possible patron of the funerary cloth.

Ultimately, this collection of essays demonstrates the multiple ways in which textiles expressed and communicated propagandistic motives during the Middle Ages. Multivalent functions and meanings intersect with multiple media comprising a complex matrix of visual signifiers that would neither have been overlooked nor likely misinterpreted by medieval patrons and audiences alike. Bodies and spaces were dressed to play a part, and textiles – as a medium that was integral to communicating a specific and often coded message – served a fundamental role within that performance. This performative characteristic is particularly interesting because textiles are portable and therefore can often easily be relocated, repositioned, reused; the regenerative aspects of their use and function offer a spectrum in which these objects continue to resonate new, interesting meanings, then, now, and into the future.

PART I
TEXTILES IN CONTEXT

CHAPTER 2

Pictorial Textiles and their Performance: The Star Mantle of Henry II

David Ganz

Modern viewers tend to view textiles as an especially fragile medium.[1] Thus, clothing and power are categories more easily perceived in terms of opposition and contrast than those of alliance and analogy, particularly if the original fabric of the object in question has only survived fragmentarily. This paper is concerned with one such example, namely the Star Mantle, or *Sternenmantel*, a fabric dating to the Ottonian period that owes its name to the embroidered pictures of the constellations of the celestial spheres adorning its surface. It is hardly an exaggeration to call this vestment a ruin (Fig. 1).[2] The same fifteenth-century restoration that preserved the mantle for posterity brought about the destruction of considerable parts of its embroidered silk fabric.[3] At that point in time, the cloak evidently was in an advanced state of deterioration. Hence, its status as a precious heritage of Bamberg Cathedral prompted the decision to save it by drastic means. The images and captions – originally embroidered in appliqué and gold thread – were detached from the old foundation fabric and subsequently applied to the electric blue pomegranate-patterned silk damask, all of which greatly contribute to the mantle's current visual impact.[4] Technological analyses of the mantle also revealed that most of the *tituli* – distributed loosely across the spaces in between the images – were

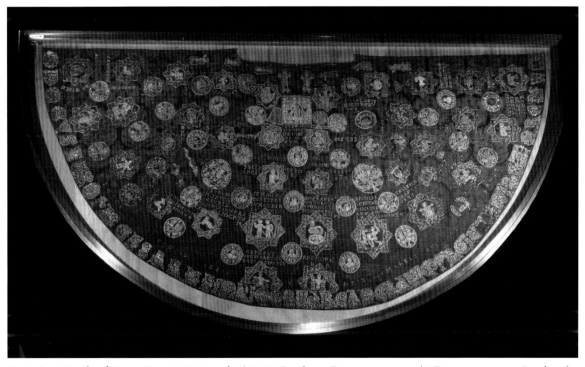

Fig. 1 Star Mantle of Henry II, *c.* 1019-20 and 1453-55. Bamberg, Diözesanmuseum (© Diözesanmuseum Bamberg)

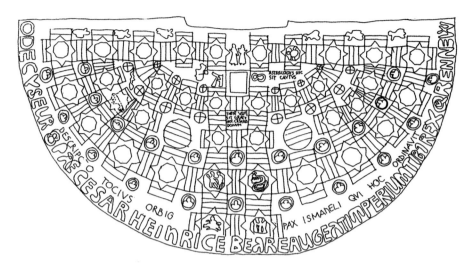

Fig. 2 Star Mantle of Henry II, original composition according to R. Baumgärtel-Fleischmann (1990)

removed piece by piece in the course of the fifteenth-century restoration and rearranged so as to form new words and sentences.[5] This evidence in particular, published in a 1990 article by Renate Baumgärtel-Fleischmann, seemed to suggest that an interpretative analysis of the *Sternenmantel* had become all but impossible.[6]

In attempting nevertheless to analyze the mantle, I shall not pretend that the loss of the *tituli* can simply be neglected. Instead, I propose to draw attention to a significant dimension of the mantle far less affected by the late medieval restoration, namely the spatial distribution of the pictorial elements on the mantle's surface, that is, their topological syntax.[7] The technological analyses – partly carried out beneath the operation of a microscope – corroborated not only numerous losses but also disclosed significant positive evidence concerning the cloak's state of preservation. Specifically, they revealed that the fifteenth-century restorers retained the compositional arrangement of the embroidered pictures with considerable fidelity to the original (Fig. 2). This could be proven due to several fortunate circumstances. For instance, all of the embroideries show remnants of the original foundation fabric – a deep purple silk. Hence, the silk's consistent pattern of warp and woof may be understood as something like a system of coordinates for placing the images. Furthermore, the mantle's design is not based upon an orthogonal scheme of equal-sized elements, but rather on a radial distribution with various sizes and angles.[8] Finally, the placement of three of the more extensive donor's inscriptions has also been preserved. These are not only of interest with regard to their positioning, but also in terms of their contents. To summarize briefly, the inscriptions recount that the cloak was produced as a gift for the Ottonian Emperor Henry II (r. 1002–24) and that its donor was a certain Ismahel, who is well documented in several written records.[9] Furthermore, passages of the inscriptions suggest that subsequently the luxurious gift for the emperor was transformed into a precious present to God. Henry did not keep the mantle in the imperial treasury, but rather passed it on as a pious donation to the treasury of Bamberg Cathedral that he himself had founded in 1007.

In spite of the significant gaps caused by the change of the *tituli*, there is considerable evidence regarding the early eleventh-century spatial distribution of the golden embroideries, as well as the social rituals at which such a mantle would have been used. Whether or not the emperor himself wore the embroidered garment is less consequential than the powerful impact of its making and its

role in the two-fold act of gift-giving. The history of changes in the mantle's functions begins immediately after its presentation to Henry II. First, the mantle became a treasury item, then it was used as a liturgical vestment, and finally, since the nineteenth century, it has been displayed as a museum exhibit. For a long time the commemoration of its original donor was more potent than the commemoration of its imperial recipient. Even after the canonization of Henry in 1146, the mantle was not venerated as a 'contact relic' of the new saint, but instead was perceived as a precious gift by a prince from abroad, with the name of 'Ismahel'.[10]

Methodological questions

What can the ruined state of a pictorial textile reveal about the display of power? Previous research on the object has focused far too exclusively on its iconography, as scholars have searched for the models and the iconological meaning of the star patterns. From the outset, however, the success of this approach has been fundamentally called into question because of the later changes to the captions. A far more promising approach may be to deploy a methodology that combines the analysis of the mantle's topological structure with the consideration of its mediality as a pictorial vestment. In this perspective, it is fundamental to state that the layers of meaning conveyed by a cycle of astronomical motifs differ significantly depending on whether it is painted on the folios of a codex or woven in embroidered images across a silk cloak that measures approximately three meters in width and one-and-a-half meters in height.[11]

In the early twentieth century, a young Austrian historian of religion, Robert Eisler, coined the term 'Sternenmantel'. In his monograph, Weltenmantel und Himmelszelt (Mantle of the World and Firmament), Eisler interpreted the Bamberg mantle as a crucial visual testimony of an alliance between textile usage and cosmology that had its roots in ancient layers of religion. In accordance with a scholarly opinion widely accepted then (and disproven since), Eisler was firmly convinced that the robe preserved in the Bamberg Cathedral treasury was identical to the cloak worn by Henry at his coronation as Holy Roman Emperor in 1014. For Eisler, the star decoration of the cloak symbolized the emperor's investiture with a cosmic order that in itself was conceived as a textile structure.[12]

For the modern reader, Eisler's two-volume treatise is primarily a document of historiographical value and exemplifies the contemporary fascination with the tracing of occult ideas meandering in manifold ways from culture to culture and era to era.[13] Nevertheless, his basic idea — postulating an affinity between the cloak's pictorial contents and the textile medium that carries the imagery — still deserves attention. This paper advances an analysis that takes the approach of medial history. Apart from investigating the concrete context of usage, this approach considers the entire range of activities contributing toward the making of the cloak: the weaving of the foundation fabric from purple-colored silk, the embroidery of images, and the insertion of the embroidered inscriptions and ornaments with gold thread.

Descripcio tocius orbis

The short inscription on the border of the cloak's left half provides the viewer with a summary of the embroidered images: DESCRIPCIO TOCIUS ORBIS ('description of the entire world'). As becomes rapidly obvious from the selection of motifs, orbis — instead of referring to the earthly world with its continents — in this setting exclusively denotes the circle of heaven. Thus, let us briefly survey the components that form this heaven. As Ernst Maass had already observed in the late nineteenth century, 'the pictorial decoration is divided into two parts, a Christian one and a secular one'.[14]

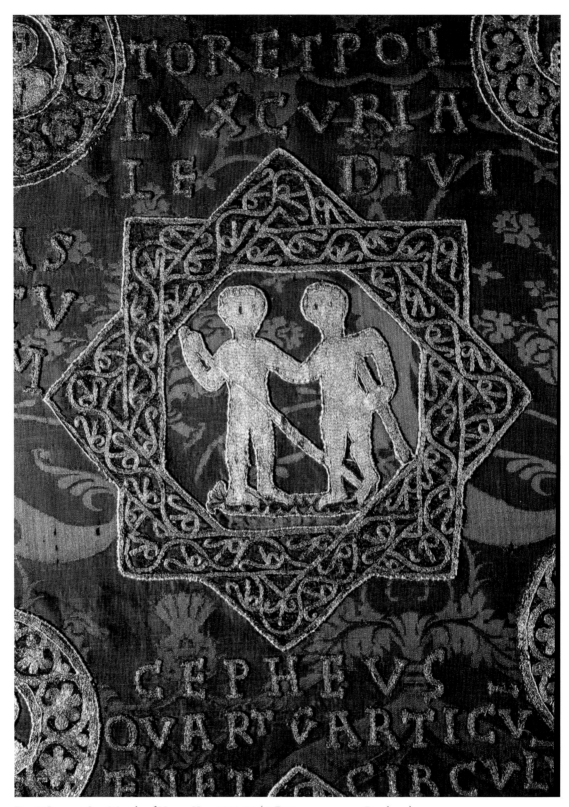

Fig. 3 Gemini. Star Mantle of Henry II, *c.* 1019-20 (© Diözesanmuseum Bamberg)

Fig. 4 Gemini. Leiden Aratea, *c.* 804. Leiden, Universiteitsbibliotheek, Ms. VLQ 79, fol. 16v (© Universiteitsbibliotheek Leiden)

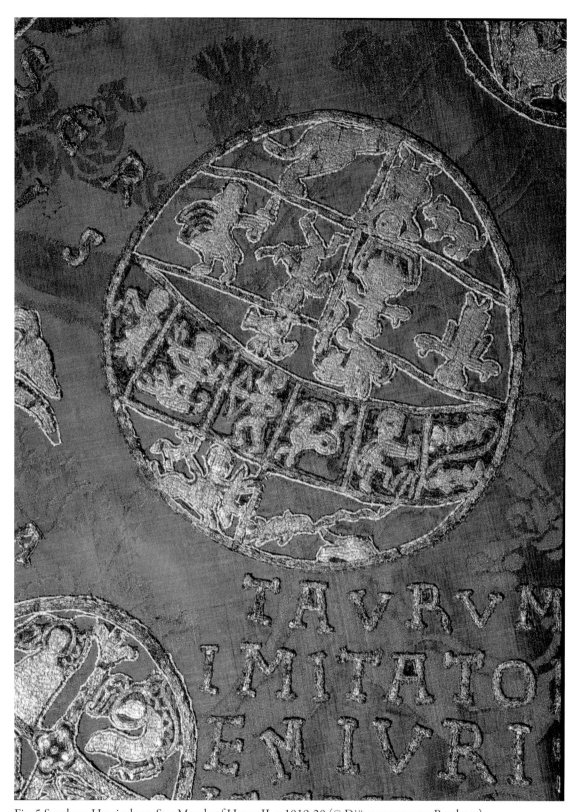

Fig. 5 Southern Hemisphere. Star Mantle of Henry II, *c.* 1019-20 (© Diözesanmuseum Bamberg)

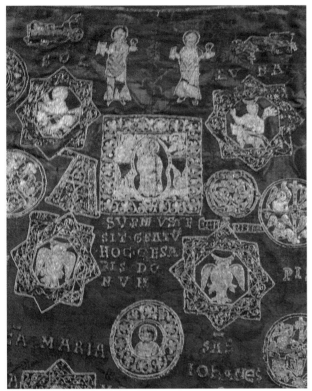

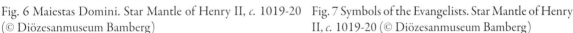

Fig. 6 Maiestas Domini. Star Mantle of Henry II, *c*. 1019-20 (© Diözesanmuseum Bamberg)

Fig. 7 Symbols of the Evangelists. Star Mantle of Henry II, *c*. 1019-20 (© Diözesanmuseum Bamberg)

The visually most dominant group of images refers to the heaven of astronomy, consisting mainly of thirty-two constellations 'depicted in mythologized, figural form'.[15] Among these, all twelve signs of the Zodiac are present, albeit distributed without any discernable order (Fig. 3). Only a minor role is assigned to the planets: within the medieval group of the seven moving stars, only the sun and moon are represented. Thus, the mantle's iconographic program would certainly not have contained an astrological layer of meaning in the present-day sense, even though this has occasionally been assumed.[16] The astronomical elements are accompanied by schematic depictions of the northern and southern hemispheres (Fig. 5). This type of image, in particular, decisively indicates that illustrated Latin compilations of the late antique *Aratea* poem served as models for the embroideries (Fig. 4). These manuscripts were an important source of astronomical knowledge in the early Middle Ages.[17]

The second pictorial register relates to the Christian heaven of the Blessed. It comprises saints, shown both as full-length figures and as busts, along with cherubim and seraphim. At the very center of the entire composition, the *Maiestas Domini* is represented as the formative principle of the universe (Fig. 6). Combinations of these motifs were stock features of Christian images of heaven since Carolingian times.[18] Within this series, however, special mention must be made of the particular emphasis placed on symbols of Holy Scripture. The four symbols of the evangelists are to be found not only at the center, filling the corners of the *Maiestas* image, but also distributed across the entire upper zone of the mantle in fourteen small roundels (Fig. 7).

Examined separately, each of the two pictorial registers appears rather like a standardized compilation; however, when combined, they become an original and meaningful pictorial ensemble encom-

passing two traditionally separate notions of heaven.[19] In what follows, attention will thus be drawn to the formal means by which this fusion is accomplished. The systematic use of various frames on the cloak is especially notable. Apart from a few saints along the neckline and the front border, all of the pictorial elements are framed. The saints' busts and the evangelists' symbols are enclosed within circles, whereas eight-pointed frames forming stylized stars surround the constellations (Fig. 8).

If both pictorial registers are therefore clearly differentiated by their frames, there are three focal points at which they are intertwined with one another. The first two are the representations of the hemispheres, which have circular frames linking them to the sacred realm (Fig. 5). As will be demonstrated further below, each half of the mantle centers upon one hemisphere image. Finally, a third frame type, which is a rectangle with an almost square format, appears exactly at the center of the entire pictorial system and surrounds the standing figure of Christ, the *Maiestas Domini* (Fig. 6). This frame, which incorporates the evangelists' symbols in its corners, can be interpreted as the 'archetype' of the star-shaped frames made up of two interlaced squares.

A principle-defining feature of medieval textile art is the use of geometric patterns that are lined up serially (Fig. 9).[20] Outstanding examples with this characteristic include the other garments on display in the Bamberg Diocesan Museum. Both the so-called *Kunigundenmantel* − dating to around the same time − and the slightly later *Reitermantel* are defined by designs comprising the uniform sequence of identical frames according to a strict grid scheme (Fig. 10).[21] Although the grid scheme has been embroidered in these garments, the uniformity of this design feature is probably to be understood with regard to design principles of weaving where seriality could easily be achieved by 'programming' the loom with endless repeatable patterns. It is well known that the eleventh-century West was not equipped with the expertise to create ornamental silk fabrics.[22] If serial patterns were indeed formally adapted from woven textiles, their utilization here was probably motivated by the wish to realize a design of comparable regularity by using the technique of gold embroidery. Be that as it may, these regular patterns evidently constitute a design principle that is germane to textile imagery. A characteristic by-product of this design scheme is the cutting in two of the image medallions at the borders; thus, even pictorial compositions that are significant in terms of content can occasionally be reduced to hardly legible residual areas, as is shown on Kunigunde's mantle. It is precisely such a cutting that also occurs on the *Sternenmantel* in a prominent position, namely the star patterns of Cepheus and Andromeda, located at the bottom of the cloak on its central axis (Fig. 1).

In devising the large visualization of heaven, the *Sternenmantel* designers hence adhered to a scheme that was specific to textile arts. In assessing their achievement, however, the degree to which they were prepared to deviate from the 'eastern' design principles of embroidered vestments must be noted. In contrast to the *Kunigundenmantel*, as well as the *Reitermantel*, the Star Mantle conveys a markedly less rigid and uniform character. The designers transformed the pictorial pattern in order to generate a radial and concentric scheme. This 'western' feature of the mantle − irritating in its current museum display, which exposes the radial scheme by flattening it out − was in fact conceived with regard to its three-dimensional appearance when worn on the human body. It is only when worn that the regulating effect of the concentric scheme becomes apparent, allowing for an almost perpendicular alignment of the depictions of heaven.

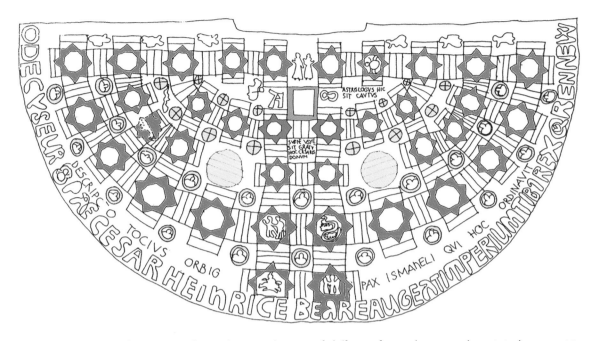

Fig. 8 Star Mantle of Henry II, figure showing the use of different frame shapes in the original composition (R. Baumgärtel-Fleischmann / author)

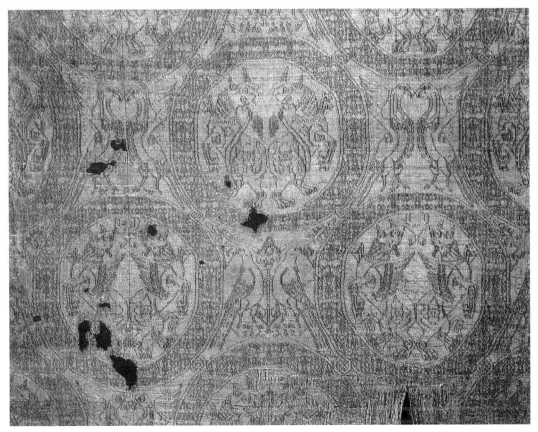

Fig. 9 Pluviale of Pope Clement II, early eleventh century. Bamberg, Diözesanmuseum (© Diözesanmuseum Bamberg)

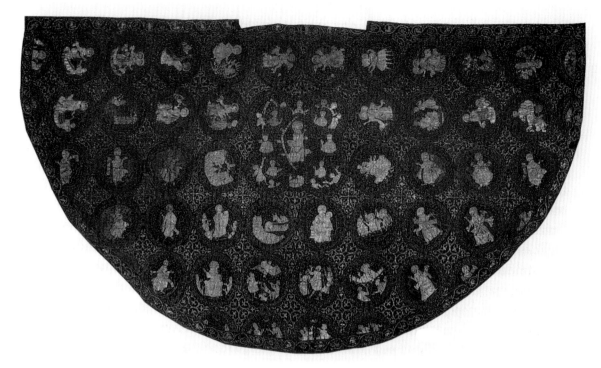

Fig. 10 Kunigundenmantel, early eleventh century. Bamberg, Diözesanmuseum (© Diözesanmuseum Bamberg)

The making of a Christian garment of heaven

The two circular diagrams representing the northern and southern hemispheres of the nocturnal sky are among the most distinguishing features of the astronomical cycle on the Star Mantle (Fig. 5).[23] To be precise, they have little in common with the modern notion of 'northern' and 'southern' night skies – the southern one, in particular was little known at the time. Rather, they follow an antique astronomical convention of dividing the northern night sky alongside the equinoctial points of the ecliptic. Accordingly, each depiction comprises one half of the Zodiac and the neighboring extra-zodiacal constellations. The significant placement of the two circular diagrams supports the idea that the mantle itself would have been understood as meaningful in its spatial scope. By dividing the cloak into northern and southern halves, the two diagrams do not merely represent cosmic order, but in fact manifest its presence.

That being said, it would indeed be a gross misinterpretation of the mantle if one were to read it as a map depicting the spatial relationship of the constellations on the firmament. As Elizabeth O'Connor stated, 'There is no question of the Mantle serving as a skymap or planisphere; the placement of the images corresponds neither to a map nor to a celestial globe. The distribution of figures seems to be entirely arbitrary; constellations are placed next to other constellations which should be in distant parts of the sky, and those which should be juxtaposed are not.'[24] For instance, when looking for the constellations of the southern hemisphere, the viewer will find on the left, 'northern' half

of the cloak the constellations of Aries, Taurus, and Gemini, whereas Cancer, Leo, and Ursa Major are located on the right, 'southern' hemisphere.[25] The topological relationship between the figures on the mantle's surface bears no significance whatsoever with regard to an astronomical order.[26] The 'description of the entire world' (*descripcio tocius orbis*) as announced by the border inscription aims at something completely different.

Instead of resorting to disinterest or deficiency of knowledge when attempting to explain the irregular placement of the celestial constellations, it may be more fruitful to assume intentionality behind this feature. If the blending of astronomical and Christian imagery is deliberate and meaningful, the dissolution of concrete spatial relationships between the constellations – such as recorded by celestial globes or star catalogues – does make sense: a new Christian order of the stellar sky has been visualized.

In this context, a celebrated model may be recalled, namely Gregory of Tours, who also undertook efforts to Christianize the celestial constellations that had been coined by the pagans.[27] In his tract *De cursu stellarum*, Gregory went as far as banning the figures of pagan myth altogether from the sky and replacing their ancient names with Christian ones, for example, renaming the classical constellation from Cygnus to the Large Cross (*Crux maior*). The illustrations for Gregory's tract substitute schematic depictions of the single stars for figural entities (Fig. 11).[28] This is not to say that the Bamberg *Sternenmantel* takes Gregory's point of view, regardless of what the lost inscriptions might have had to say on this matter. The large-scale depictions of the constellations would be inconceivable if there had not been at least some belief in their animated nature. Yet, at the level of the different frames on the cloak, there is a meeting of minds between the late antique bishop and the *concepteurs* of the Star Mantle: the figures of pagan myth that denote the constellations merge into a new *constellatio* formed by the geometric pattern of their star-shaped frames.

Script is the second dimension ensuring the dense intertwining of the mantle's features. On the one hand, script, in the sense of Holy Scripture, is a crucial element of the imagery, namely its second, Christian register. Fourteen medallions were placed on the upper part of the cloak, each showing a central cross and the evangelists' symbols in the four quadrants. This may be read as a validation of the *christianitas* of this heaven and especially of the celestial order's base in the four Gospels. This concept – elementary as it was in the cosmology of early medieval Christianity – is further endorsed at the actual center of the entire garment with the image of the *Maiestas Domini* and thereby provides heaven with a foundation in Holy Scripture.

On the other hand, script is a dominant element of the mantle in the guise of inscriptions that complement the pictorial program. According to Baumgärtel-Fleischmann's reconstruction, the wide spaces in between the images were filled much more densely by captions referring to the constellations.[29] As has been set out above, it is now impossible to determine the overall contents of the original texts, since the fifteenth-century 'restorers' reassembled entirely new texts from single letters. Nevertheless, the visual impact of the robe, caused in part by the prominence of written texts across its surface, is equally suggestive. The combination of script of gold threads and a purple-colored silk ground was suited to evoke contemporary instances of chrysography as a common practice in the making of manuscripts for Ottonian rulers.[30] The only preserved caption – that of the star sign Cancer – suggests that the *tituli* were laid out in a revolving distribution of letters that were directly linked to the frame.[31] Hence, if the simple, capital letter inscriptions closely circumscribed the eight-pointed frames, the *tituli* became part of the ornamental features that mediated between image and text.[32] On various layers, then, script appears to have been a leitmotif within the overall layout of the cloak. It would therefore seem as if it was not by chance that the border *titulus* talks

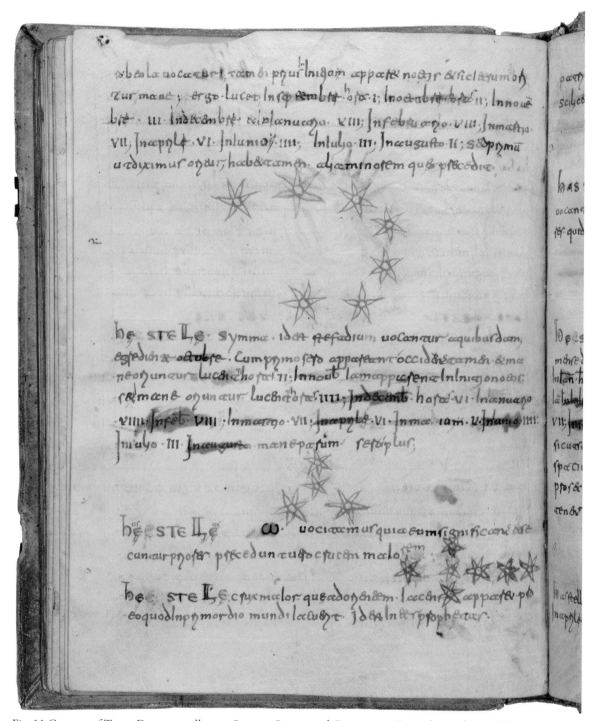

Fig. 11 Gregory of Tours, De cursu stellarum: Symma, Omega and Crux maior. Compilation, late eighth century. Bamberg, Staatsbibliothek, Ms. Patr. 61, fol. 79v (© Bayerische Staatsbibliothek Bamberg, photo: Stefan Raab)

about *descriptio*, rather than *figura* or *imago*, of the entire world.

The proximity between what has been written and what has been woven – *textus* and *textum* – must have been elaborated much more meaningfully in the mantle's original state.[33] For the creators of the cloak, a natural convergence may have existed between the Christian belief in a foundation of the world by scripture and the pagan conviction of the cosmos having been created through weaving. The textile medium could therefore be perceived as particularly appropriate for the visualization of a celestial order that would have been invisible to the human eye. As I shall demonstrate in the last section of this paper, it was precisely this principle of a textile-textual composite – or, to adopt Macrobius's term, *contextio* – that functioned as a prerequisite for the performative efficacy of another group of written texts, namely the dedications and vows that were inscribed into the robe.[34] Their script, too, was executed in an ornamental manner: the letters of the large inscription on the mantle's border – as well as Alpha and Omega on either side of the *Maiestas Domini* – are devised as richly decorated characters. With their tendril fillings, they contributed toward the interweaving of this text with the entire garment.[35]

The mantle on the ruler's body

The above analysis can be used to reconstruct the performative context of the *Sternenmantel*. Early scholarship was full of speculation about the issue of performance. For a long time, scholars assumed that Henry II wore the mantle during his imperial coronation ceremony, which took place in 1014.[36] However, the information provided by the inscriptions on the mantle itself strongly suggests that the cloak was not made until around 1019/20.[37] Whether or not the mantle was intended to be worn by Henry at any particular occasion remains open. Nevertheless, the images and texts on its surface resonate with the expectations and wishes aimed at what *should* happen once the emperor wears such a cosmic pictorial textile around his body.

In view of the dearth of records, it remains questionable if the use of the *Sternenmantel* was informed by the ancient tradition of cosmic vestments beginning with Alexander the Great – a concept that formed the focal point of Eisler's book. An extremely precise reference to the mantle's role model, however, is provided by the formula DESCRIPCIO TOCIUS ORBIS.[38] These words lead to those found in the Book of Wisdom 18:24, where the Jewish high priest's robe is described as follows: 'For in the long garment was the whole world [*totus orbis terrarum*], and in the four rows of the stones was the glory of the fathers graven, and thy Majesty upon the diadem of his head.'[39] Hence, the Star Mantle's wording *totus orbis* (*terrarum*) is a clear evocation of the high priest's robe and emphasizes the well-known view of the emperor as *rex et sacerdos*.[40]

Jewish exegetes like Josephus and Philo of Alexandria interpreted the ornaments on the high priest's *tunica superhumeralis* as symbols of the twelve signs of the Zodiac.[41] In Philo's treatise *De somniis*, this interpretation is even linked with the idea of weaving as a 'manner of making the world', suggesting that the priest's robes are an appropriate medium to represent the cosmos:

> For the art of variegation has been looked upon by some as so obscure and paltry a matter that they have relegated it to weavers. I on the contrary regard with awe not only the art itself but its very name, and most of all, when I fix my eyes upon the sections of the earth, upon the spheres of heaven, the many different kinds of animals and plants, and that vast variegated piece of embroidery, this world of ours. For I am straightway compelled to think of the artificer of all this texture as the inventor of the variegator's science, and I do homage to the inventor, I prize the invention.[42]

Following this strand of exegesis, medieval sources normally mention the zodiac's twelve-fold structure when called upon to relate the imperial cloak to the priest's robe in the Old Testament.[43] The Bamberg cloak, however, adhered to a far more comprehensive program that highlighted the imperial claim to rule over the entire world by representing the complete stellar order. Starting from this observation, a close reading of the dedication inscription alongside the cloak's border may inform us, at least partly, as to how the *Sternenmantel* was perceived by its contemporaries: O DECUS EUROPAE, CESAR HEINRICE, BEARE // AUGEAT IMPERIUM TIBI REX QUI REGNAT IN AEVUM ('O ornament of Europe, Emperor Henry, you are blessed. May the king who rules forever increase your realm').[44]

The dedication addresses the relationship between two rulers: the Emperor Henry and Christ as king. The former governs the terrestrial realm, the latter the entire universe. The mantle in some sense mediates between the emperor and Christ. By wearing this garment, Henry would place himself under the protection of Christ, the all-powerful ruler. Hence, the power evoked by the pictorial robe is not the power of Henry alone. As emperor, it was his exclusive privilege to wear such a virtuous fabric.

As mentioned above, the embroidered images focus on depicting two notions of heaven – astronomical and Christian. This two-fold cosmological order of the mantle brings about an interconnection between the visible realm of the ritual performed by the emperor and an invisible realm of supernatural power. The distant celestial spheres of constellations, angels, and saints would have acted as forces protecting the terrestrial ruler. One particular aspect, underscored in the last part of the inscription, concerns the dimension of eternity that characterizes the celestial realm. Wearing the mantle would have enabled the ruler to participate in this timeless, eternal dimension.

When addressing performativity of the mantle, it is highly relevant to consider the cloak's visual impact as it was worn on the emperor's body. Spread across the ruler's shoulders, the garment could only be seen in sections from a single point of view. As Wendy R. Larson states in regards to the similar case of the *Pienza Cope* (*c*. 1310–30), 'the wearer's movements would cause different scenes to be highlighted or covered at different moments, providing an endless range of possibilities that would also vary depending on the location of the viewer'.[45] Usually, designers of pictorial robes coped with these restrictions by a strategy of focalization: central elements of the imagery were positioned on those parts of the garment that guaranteed the highest degree of visibility. The back, for example, was the area where fewer folds would have formed. On the *Sternenmantel*, the back accordingly offered an especially meaningful view, displaying Christ in Majesty on the central axis of the pictorial system, arguably the climactic focal point. Right beneath the figure of Christ, the zodiacal sign of Gemini was also placed in a distinguished position, perhaps on account of Henry's birthday on 6 May 973.[46] The position of the sign is contiguous with the central part of the dedicatory inscription where the emperor is addressed (CAESAR HEINRICE BEARE). Nevertheless, the cloak's three-dimensional configuration ensured that neither the iconographic program nor the inscriptions on the hem could be visible in their entirety from any single position.[47] To make sense of the hidden elements, it is useful to turn to Alfred Gell's terminology: the 'agency' of both the inscriptions and the entire pictorial ensemble would not have been activated through reading but through the 'index' of weaving, embroidering, gift-giving, robing, and wearing.[48]

A two-fold donation

This observation leads to my final point that addresses the relationship between the textile's topological structure and its dedicatory inscriptions. Research on the *Sternenmantel* has long established that the inscriptions, which date to the Ottonian period, refer to a two-fold donation act. The southern Italian patron of the mantle, Ismahel, records his gift and conveys blessings to the emperor in large and heavily decorated ornamental letters forming two hexameters. Above them, a much smaller caption indicates the overall meaning of the program and names the donor: DESCRIPCIO TOCIUS ORBIC PAX ISMAHELI QUI HOC ORDINAVIT ('Description of the whole world. Peace be to Ismahel who commissioned this').[49] A third inscription, however, refers to the mantle's later donation by Henry II. It reads: SUPERNE YSYE SIT GRATUM HOC CESARIS DONUM ('May this gift of the emperor be welcome to the highest being'). This phrasing allows for the conclusion that Henry himself turned the precious garment into a pious donation and deposited it into the treasury of Bamberg Cathedral.

From contemporary written records we know that Ismahel was an aristocrat from Bari in Apulia who led several uprisings against the Byzantines between 1009 and 1018. Following a severe defeat in October 1018, Ismahel went north across the Alps in order to gain imperial support for his plans. In April 1020, he was in Bamberg where his advocate, Pope Benedict VIII, celebrated Easter with Henry II.[50] Only a few days after the feast – celebrated on 17 April – Ismahel died. It is recorded that Henry took care of Ismahel's burial in the chapter house of Bamberg Cathedral.[51] The mantle's inscriptions confirm the hypothesis that Ismahel had the vestment made as gift for the emperor whose backing he had hoped to secure. The presentation of the gift must have taken place in the context of the festivities during Holy Week 1020. At his meeting with the emperor, Ismahel received a valuable gift in return: the title of Duke of Apulia (*dux Apuliae*).[52] This kind of 'silk diplomacy' – utilizing precious textiles to establish contacts between gift-giver and recipient – was a common practice at the court of Henry, as Anna Muthesius has demonstrated. She also pointed to this practice as effectively forming a double import from Byzantium: the Byzantine imperial court had long developed a sophisticated system of textile gift-giving, and most silks then circulating in western Europe originated from the Byzantine Empire.[53] Ismahel must have been equally familiar with the meaning of textile gifts, having been raised in a society under Byzantine dominion.[54] Whereas his military efforts were directed against the Byzantine occupation of southern Italy, his silk gift to Henry II was an homage to cultural models of courtly behavior coined by his enemy.

In any case, we know for certain that the gift did not remain for long in imperial possession, as the third inscription explicitly references an imperial donation. The technique and shape of this inscription's lettering, however, do not differ from the other inscriptions on the mantle. This poses several problems, for it indicates that the third inscription was made by the same workshop as the other two. It has thus been suggested that the garment was not made in Italy, but rather in Regensburg or Bamberg.

Yet the assumption that the mantle was a gift from Ismahel to the emperor, which had been presented in an incomplete state, is not totally convincing.[55] The following scenario would appear to be more likely: Ismahel had the robe made by a workshop closely connected to Henry, perhaps partially according to a prior arrangement with the imperial court. Having received the cloak, Henry could have easily returned it to the workshop in order to have his donation to the cathedral treasury recorded by a further inscription. Finally, it is conceivable that Henry never actually wore the imperial mantle and immediately offered it to the cathedral upon receipt, along with other gifts from him.[56]

Irrespective of the actual course of events, the two groups of inscriptions testify to a radical shift in the usage of the garment. It changed from an imperial cloak to be worn at ceremonial occasions to an object forming part of an ecclesiastical treasury. The different placement of the inscriptions is significant, precisely because of this change. Whereas Ismahel's dedication is embroidered along the border, Henry's address to God is positioned exactly in the center of the mantle. As I will show, these two locations have contrasting semantic values that accentuate the different orientation of the two donations.

Recent studies have called attention to the status of the border in terms of medial history, both in antique and medieval textile cultures. In antique weaving techniques, as Ellen Harlizius-Klück has shown, the hemming of fabrics was a result of the construction of the loom.[57] In this tradition, strong borders characterized textiles and thus acted as an intermediary boundary between the robed individual on the one hand, and the society and world on the other. Most recently, Barbara Baert's article on the iconography of Christ's healing of the bleeding woman (Luke 8:43-48) also has drawn attention to the meaning of the area of the hem in medieval culture.[58] In the Bible, Christ heals the *Hemorrhoissa* by merely touching the garment's hem. Within this border zone rests the power that the garment draws from the divine nature of Christ. Visual representations of this miracle do not even show the touching of the hem, but only Christ's proximity to the robe's edge that is evidently sufficient to affect healing (Fig. 12). The garment's hem thus marks the border between the external world and the body. An inferior human being would touch this area when lowering himself to the ground in the gesture of *prostratio* before his superior.

In placing the dedication inscription along the mantle's border, the patron and/or designer of the textile appears to refer to this very concept: the hem as a zone of symbolic power. When applying medial theory to this process, it would seem as if the embroidered inscription acted as the donor's representative. In embroidering the blessing to the emperor, the garment was intended to be charged with a permanent gesture of touching, thus exerting a positive impression upon the immediate recipient of the gift, as well as God.[59]

Henry, in turn, chose a different, but by no means less significant area of the cloak for the inscription that was to record his donation, namely the area beneath Christ in Majesty at the center. This choice was certainly not informed by a lack of available space elsewhere on the cloak. The dense layout of images, texts, and ornaments negated empty space. But even if one were to follow the hypothesis of the mantle's unfinished state at Ismahel's death, it would still be a remarkable coincidence if this highly privileged area was left empty. It is far more likely that space for the inscription had to be provided by removing an evangelist's symbol that would already have been embroidered there.

Furthermore, the decision to install the inscription at precisely this position appears to correspond appropriately to the changed status of the *Sternenmantel*. The imperial donation transformed the object from an item of clothing into a cathedral treasury item.[60] Once the mantle's vestmental function had receded, it could be treated as an embroidered map of the cosmos facilitating a direct communication with God. Whilst the hem forms the garment's border and its inscription addresses the person intended to be robed in it, the zone beneath the *Maiestas Domini* may be defined as threshold that would open a door to God who was represented in the square above.

The *Sternenmantel* has been severely fragmented, and the make up of its pictures and texts was decisively changed by the fifteenth-century restoration. Yet it is still possible to retrace the medieval display of power within this precious pictorial robe. The use of the robe as a wearable vestment turns out to be merely one stage within an entire sequence of performative acts encompassing its making, presenting, changing, and re-presentation. In the course of all these rituals, the robe was

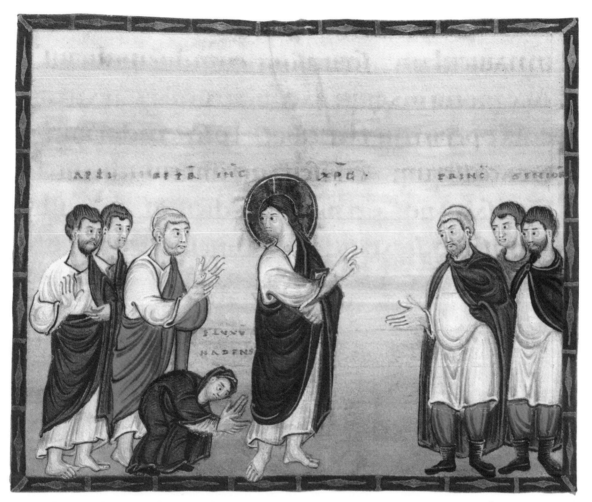

Fig. 12 Christ and the Hemorrhoissa. Codex Egberti, *c.* 980. Trier, Stadtbibliothek, Hs. 24, fol. 24v (from: *Der Egbert Codex. Das Leben Jesu. Ein Höhepunkt der Buchmalerei vor 1000 Jahren*, ed. by Gunther Franz (Stuttgart: Theiss (2005), p. 123)

treated as a topological structure facilitating the formation of references between different realms and settings. The images embroidered into the mantle linked the textile object to an invisible celestial realm inhabited by Christ and the star signs. Inscriptions were inserted into the pictorial surface of the mantle at carefully chosen positions in order to allow the donors to participate in this linkage. What elevated the mantle to a powerful ornament of Europe (*decus Europae*) in the eyes of contemporaries – as articulated by the border inscription – was not a convincing representation of the nocturnal sky, but rather, it was its interweaving of image and script in the topological syntax of the embroidery.

CHAPTER 3

Orthodox Liturgical Textiles and Clerical Self-Referentiality*

Warren T. Woodfin

Introduction

In more than a dozen museums and church treasuries worldwide, one can encounter examples of a remarkable series of textiles with the motif of Christ as high priest.[1] The majority of these heavy fabrics of gold thread and silk have a design of roundels in which Christ is shown at half length, making a gesture of blessing with both hands (Fig. 1). The figure of Christ appears dressed in the vestments of an Orthodox patriarch: the domical miter, the short-sleeved outer tunic, or *sakkos*, and the broad episcopal stole, the *omophorion*. Although older publications have attributed textiles of this type variously to Greece, Russia, or Armenia, more recent scholarship has conclusively demonstrated these and similar liturgical textiles were woven in the Turkish textile workshops of Bursa and Constantinople in the early Ottoman period.[2] While no comprehensive study has yet been made of the textiles with Christian motifs produced in the Ottoman Empire, certain parameters are clear. Accounts of Western ambassadors in early Ottoman Bursa establish the export of textiles from that center as early as 1397.[3] While it seems doubtful that textiles with Christian motifs would have been part of that production, evidence suggests that they were already being woven by the late fifteenth century.[4] By the mid-sixteenth century, records from L'viv (Leopolis) attest that Ottoman merchants there were retailing textiles with motifs of crosses.[5] The popularity of such fabrics in the Orthodox Christian market is attested by their wide distribution in the Balkans and Eastern Europe, from Greece to Russia, in the sixteenth and seventeenth centuries.[6] As intact examples prove, these textiles were made into vestments of similar form to those worn by Christ in the woven images. Members of the clergy, wearing vestments that showed Christ vested in the same garments as they wore, would have blessed their congregations using gestures like the ones Christ is shown making. Iconography, dress, and gesture blend to present the clergy who wore these textiles as images of Christ, and Christ, in turn, is presented as the paradigmatic high priest.[7]

The self-referentiality of these liturgical textiles represents the culmination of a long development in Byzantine ecclesiastical art over the course of the thirteenth through fifteenth centuries. Through a dialogue between painted representations of liturgical vestments and the actual vestments worn by the clergy, a network of visual cross-references was established that reinforced the idea that the clergy were not merely representatives, but *representations* of Christ. I have argued this point in fuller form elsewhere, but it is worth reprising here.[8] The mimetic association of the clergy to Christ is the product of simultaneous developments in several different media: woven textiles and embroideries, wall painting, and the rites of the liturgy itself. One critical component of the background for this kind of mirroring between clergy and Christ is the transformation of Byzantine liturgical dress from a fairly simple, three-tiered system, to a much more complex and hierarchical one. Despite the lack of surviving Byzantine vestments predating the twelfth century, one can trace the system of liturgical vesture from occasional mentions in homilies, canon law, mystagogical treatises, and – by the late Byzantine period – in books of liturgical directions, or *diataxeis*. The most important and

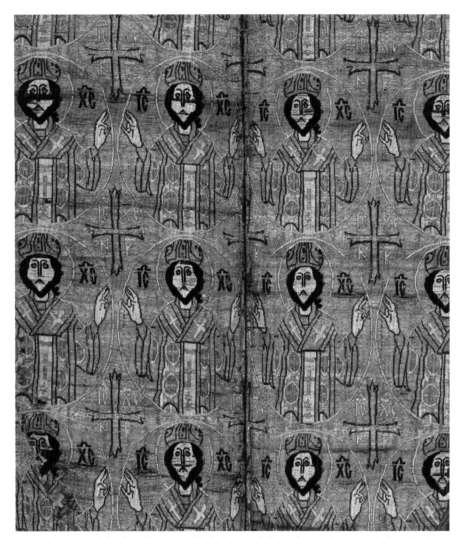

Fig. 1 Ottoman Textile: Christ as High Priest. Silk and metal-wrapped threads, lampas weave, sixteenth–seventeenth centuries. Byzantine Collection, Dumbarton Oaks, Washington, D.C., No. 1952.10.

concentrated body of evidence is, of course, the representation of vestments in works of art.[9] From their earliest developments until the eleventh century, Byzantine liturgical vestments distinguished their wearer according to order, that is, indicating whether he was a deacon, priest, or bishop. Despite the differentiation of various episcopal sees by rank, the patriarchs of the great sees of Constantinople, Alexandria, Antioch, and Jerusalem would have dressed for the liturgy in garments of exactly the same form as any other bishop.[10] Beginning in the eleventh century, however, new insignia were introduced at the highest levels of the hierarchy that helped to distinguish patriarchs, metropolitans, and archbishops from bishops of lower rank. Among these new additions were the *polystavrion phelonion* (or simply, *polystavrion*) – that is, a *phelonion*, or chasuble, decorated with a pattern of many crosses – and the *sakkos*, a garment similar in form to the Western medieval dalmatic, but reserved for the use of patriarchs and other archbishops of particularly exalted rank.[11] Like the *polystavrion*, the *sakkos* was often decorated with multiple crosses (Fig. 2), but it was meant to be worn only on the greatest feasts of the church calendar.[12] Furthermore, unlike the *polystavrion*

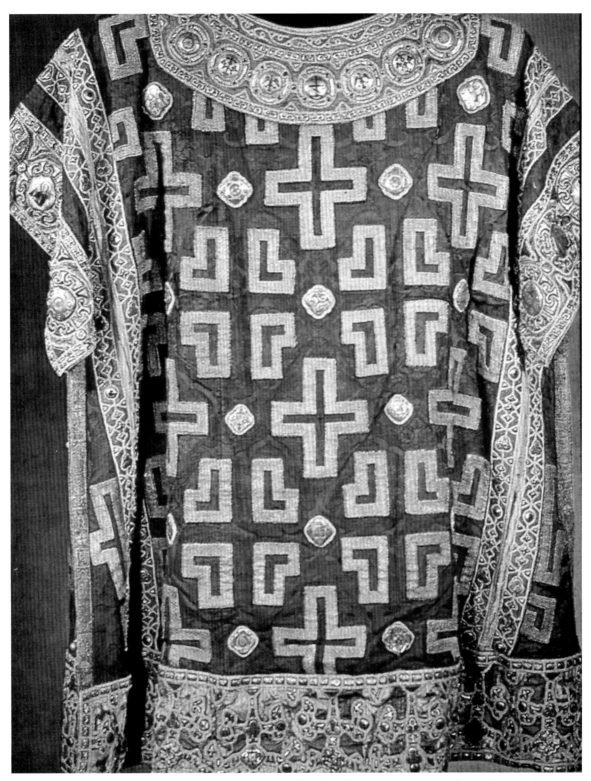

Fig. 2 Sakkos of Metropolitan Aleksei. Silk textile with gold embroidery and gilt-metal appliqués, fourteenth century. Kremlin Armory, Moscow.

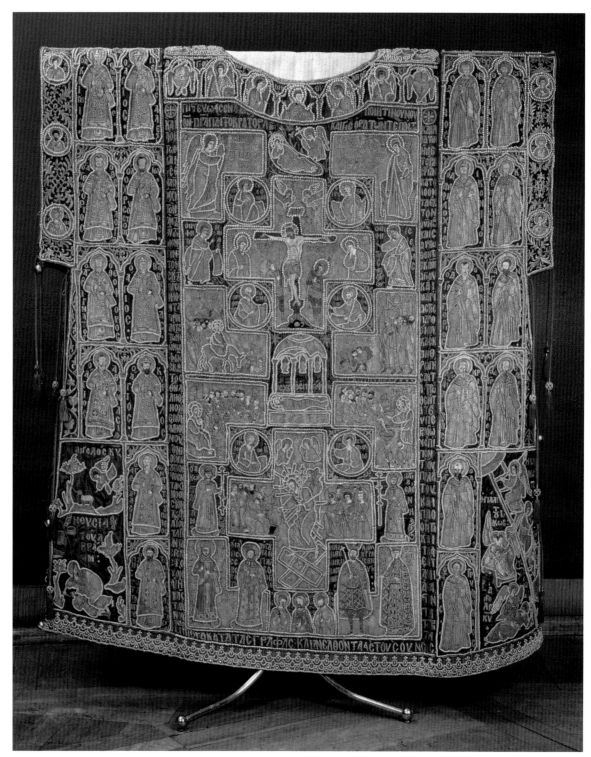

Fig. 3 Major Sakkos of Metropolitan Photios. Silk textile with gold and silk embroidery, pearl stringing, and gilt-metal appliqués, *c.* 1414-17. Kremlin Armory, Moscow.

phelonion, which simply represents the elaboration of a vestment with a long history of ecclesiastical use, the *sakkos* is a garment that seems to be modeled on the ceremonial tunic (also called a *sakkos*) of the emperor himself.[13] Either of these vestments would be worn along with the *omophorion*, the broad stole decorated with crosses, which had become the distinctive mark of Byzantine bishops by the fifth or sixth century.[14] Other insignia, such as the *epimanikia*, or liturgical cuffs, and the *epigonation*, an embroidered lozenge of fabric worn hanging from the belt, were also introduced in this period as the special regalia of bishops and archbishops.[15] As insignia originally exclusive to patriarchs and archbishops were adopted by lower ranks of clergy, the highest prelates in turn donned still more distinguishing vestments. This enlargement of the repertoire of Orthodox liturgical vestments had two effects. One was to introduce visible distinctions into the hierarchy of ecclesiastics comparable, in some respects, to the established distinctions among the ranks of courtiers surrounding the emperor. The second was to allow for a more complex series of visual cross-references between the earthly church and the heavenly realm than had previously been possible, particularly through the introduction of embroidered imagery onto the vestments.

The idea that the bishop or priest ministers *in persona Christi* is a widespread theme in Greek liturgical theology. It is found already in nascent form in the writings of Ignatius of Antioch at the beginning of the second century, but it was only in the late Byzantine period that the vestments of the clergy began to make this function of representing Christ concrete by the addition of embroidered images of Christ and scenes from his life.[16] By wearing Christ's image, both in the form of his iconic portrait and as the pictorial synopsis of the Gospels, the clergy assumed the role not just of representatives of Christ, but literally representations of him. Longstanding Byzantine tradition – inherited from Roman practice – made wearing the image of one's superior a sign of fealty and delegated authority, and the use of Christ's likeness on vestments would have been understood as a sign of the clergy's allegiance to him.[17] The use of embroidered imagery, though, goes further than simply establishing a chain of command. Widespread mystagogical interpretations of the liturgy mapped each action of the ministers onto an event from the Gospels, making the liturgy itself a symbolic re-enactment of the life of Christ.[18] In this context, the sequence of narrative images covering a vestment such as the Major Sakkos of Photios, dating between 1414–17, expressed the wearer's role as the living symbol of Christ (Fig. 3).[19] Such cycles of Christological imagery appear on a large number of the surviving vestments and at various scales, from the relatively large format of the *sakkoi* to the compressed scope of roundels on stoles. Evidence that Byzantine viewers saw these scenes as symbols of the clergy's christomimetic role (whether or not they were fully visible by the laity) is that they are absent from vestments associated with deacons, who symbolically represent not Christ, but the angels.[20]

Contemporaneous developments in wall painting complemented the Christomimesis of the clergy expressed by their embroidered liturgical vestments. Frescoes of the *melismos*, or fraction, show bishop-saints presiding at an altar on which Christ himself appears as the Eucharistic bread. Such images increasingly blurred the line between heavenly and earthly liturgies, sacramental and visible realities.[21] The theme of the Communion of the Apostles – introduced into monumental painting in the eleventh century – presented not the Last Supper as the moment of the institution of the Eucharist, but Christ as liturgical celebrant assisted by angels vested as deacons with the Apostles taking the role of communicating presbyters. From the early fourteenth century, depictions of the Communion of the Apostles begin to depict Christ standing at the altar dressed in the *sakkos* and *omophorion*; that is, vested as a Byzantine patriarch. The earliest examples are found at St Nicholas Orphanos in Thessaloniki and at St Nikita in Čučer, both dating to the second decade

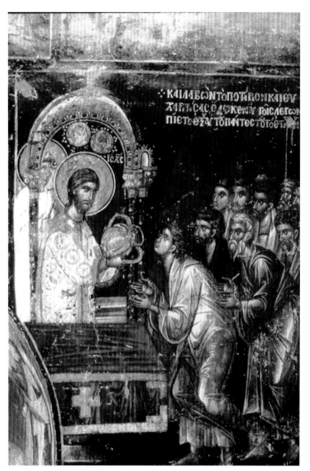

Fig. 4 Communion of the Apostles. Fresco *c.* 1310–20. Church of St Nicholas Orphanos, Thessaloniki.

of the fourteenth century (Fig. 4).[22] This development in the iconography of Christ actually represents a momentous change. With the obvious exceptions for Christ's nudity in the Baptism and Crucifixion, virtually all earlier Byzantine images of the adult Christ show him in antique dress, even when presiding at the altar (Fig. 5). Since the tunic and himation were long obsolete in Byzantium, such ancient costume was, in a sense, semantically 'neutral', without a place in the sartorial hierarchies of either the church or the imperial court. The depictions of Christ as patriarch for the first time represent him in the garments worn by contemporary personages, specifically, members of the Byzantine episcopacy. In both frescoes from Thessaloniki and Čučer, Christ the patriarch appears alongside angels dressed as deacons who assist him at the altar. Such angel-deacons appear in earlier representations of the Communion of the Apostles, as at St Sophia in Kiev and St Sophia in Ohrid, both dating to the eleventh century.[23] In the Palaiologan period, painted images of the liturgy show not only angel-deacons, but angel-priests as well. The frescoes of the Church of the Peribleptos at Mistra depict a Great Entrance procession enacted by angels vested both as priests and as deacons (Fig. 6). As celebrant of this 'Celestial Liturgy' (the title usually given to this iconography by art historians), Christ stands at the painted altar in the role and costume of the patriarch, while angel-priests process towards him carrying veiled chalices, and angel-deacons carry veiled patens balanced on their heads.[24] This unusual posture of the angel-deacons, in fact, precisely reflects the directions of contemporaneous books of liturgical directions, or *diataxeis*.[25] The liturgy of heaven is thus presented as a near mirror image of the earthly rites enacted in the space of the church.

The juxtaposition of Christ as celebrant and angels as assisting clergy with actual clergy performing the same actions in similar vestments must have forcefully impressed on viewers the eschatological dimensions of the liturgy. In the words of Archbishop Symeon of Thessaloniki, the earthly and heavenly liturgies were identical, only that the heavenly one was conducted 'without veils'.[26] This mirroring, or, perhaps better, interchangeability of the earthly and heavenly actors in the liturgy articulated in monumental painting is still more strikingly expressed in an embroidered textile, the iconostasis curtain from Chilandar Monastery on Mount Athos, embroidered in 1399 (Fig. 7).[27] On this veil, Christ appears as a patriarch wearing a *sakkos* decorated with a pattern of crosses in roundels, over which he wears the bishop's stole, or *omophorion*. Saints Basil and John Chrysostom, the authors of the two principle Byzantine eucharistic liturgies, flank him; both bishops wear the

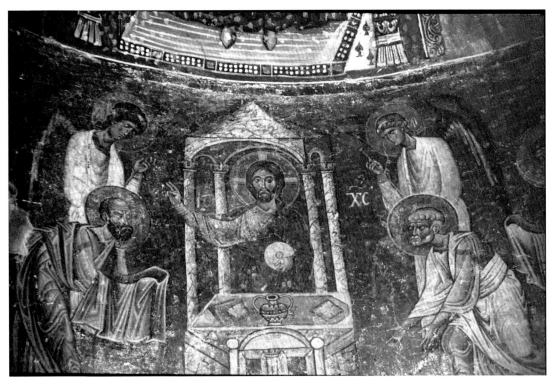

Fig. 5 Communion of the Apostles. Fresco *c.* 1040. Church of St Sophia, Ohrid.

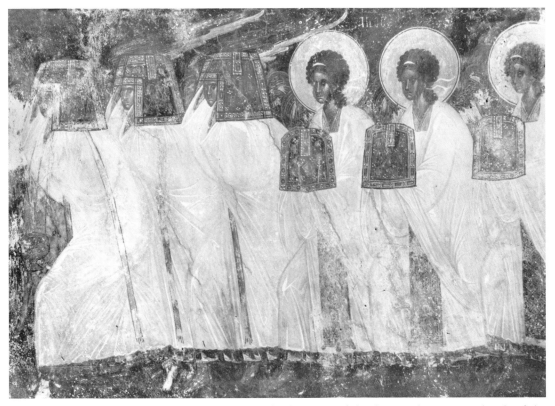

Fig. 6 Great Entrance with Angel Clergy Fresco, third quarter of the fourteenth century. Church of the Peribleptos, Mistra.

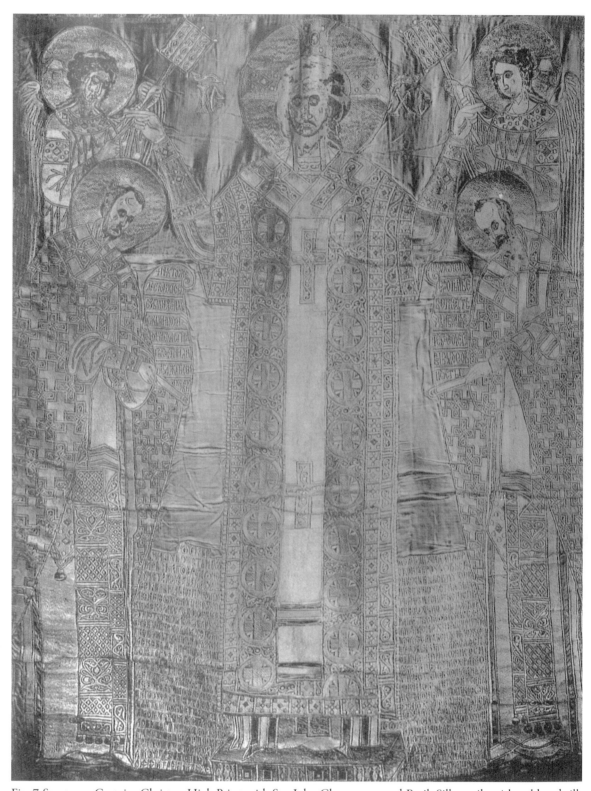

Fig. 7 Sanctuary Curtain: Christ as High Priest with Sts. John Chrysostom and Basil. Silk textile with gold and silk embroidery, 1399. Chilandar Monastery, Mount Athos.

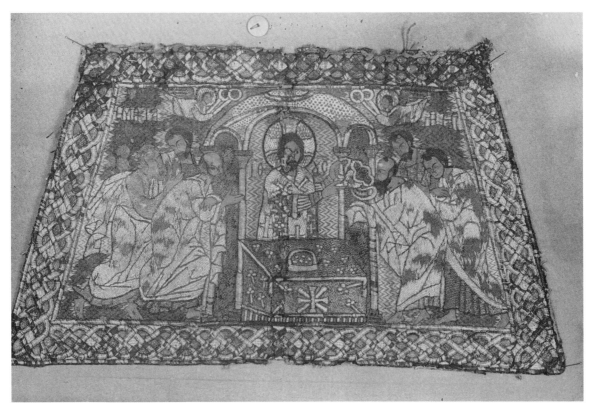

Fig. 8 *Epimanikion*: Communion of the Apostles. Silk textile with gold and silk embroidery, late fourteenth or early fifteenth century. National Museum, Sofia, Bulgaria, No. 1793.

*polystavrion phelonio*n. Comparison with contemporaneous *diataxeis* of the patriarchal liturgy reveals that both the dress and pose of the flanking bishop saints imitate those of the concelebrating bishops who would assist the patriarch at the altar.[28] Angel-deacons, bearing liturgical fans, stand behind the principle figures. This textile would have hung within the central opening of the icon screen, shielding the altar from view. At the moment when the curtain was drawn aside – for the presentation of the bread and wine at the Great Entrance and for their distribution at the Communion – the human celebrant would be revealed standing at the altar table, exactly where the figure of Christ had been visible moments before.[29] It would hardly be possible to articulate more clearly the paradigmatic role of Christ as high priest, embodied in the figure of the actual celebrant of the liturgy. The very function of the object, the curtain shielding the sanctuary from view, evokes the veil of the Tabernacle in the Sinai desert and later in the Temple of Jerusalem.[30] The author of the Epistle to the Hebrews in turn likens this veil (*katapetasma*) to Christ's body, making an extended analogy between the rites of purification by which the Temple priest enters the tabernacle through its veil and Christ's expiation for the sins of mankind by opening a way into heaven 'through the veil, that is to say, his flesh'.[31] Even without figural imagery, the sanctuary veil was already imbued with a significant theological charge through its very function. The embroidered decoration of the Chilandar curtain transforms it further into a kind of spiritual x-ray screen, both hiding the physical altar and clergy from the view of the congregation, and simultaneously making visible the spiritual reality of the celestial liturgy in which the earthly one partakes.[32]

The embroidered image of Christ as patriarch on the Chilandar curtain finds parallels among the motifs embroidered on liturgical vestments in the fourteenth and fifteenth centuries (Fig. 8). In

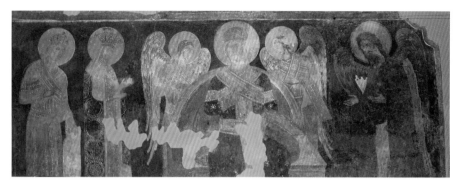

Fig. 9 Royal Deësis. Fresco, 1376/77 or 1380/81. Monastery of Markov, near Skopje.

the case of the *epimanikion*, or liturgical cuff (originally one of a pair) from Sofia, Christ is shown in the act of giving communion to the apostles while wearing pontifical vestments, just as he appears in the earliest instances of the theme in fresco painting, discussed above.[33] Here, the garments of Christ intensify the parallel between his actions and those of his earthly counterpart who would have worn such a cuff. In other cases, though, Christ is shown in patriarchal dress as an iconographic type independent of his participation in any liturgical action. The earliest of these images are found in association with the theme of the Deësis. This composition shows the intercession of the Mother of God and John the Baptist with the central figure of Christ. When other saints – archangels, apostles, bishops, and martyrs – are grouped in pairs according to their class around the central group of Christ, Mary, and John, the composition is referred to as the Great Deësis. While the Deësis and the Great Deësis variant were frequent themes in both frescoes and icon painting since the end of Iconoclasm, they began to undergo new iconographic developments toward the middle of the fourteenth century. Monumental painting in northern Greece and the Balkans began to embrace the theme of the 'Royal Deësis', in which Christ appears in imperial dress, as found at the Church of St Athanasios tou Mousaki at Kastoria (dated 1374–86) or at the Monastery of Markov near Skopje (1376–77 or 1380–81) (Fig. 9).[34] In a subtle argument, Petre Guran has noted the complementary relationship between the painted images of Christ as emperor and as high priest. In the central apse of the church at Markov Monastery, Christ presides over the Celestial Liturgy wearing the patriarchal *sakkos* and *omophorion*, while in the Royal Deësis on its north wall he is depicted in the costume of a Byzantine emperor with the *loros*, or imperial scarf, and the *stemma*, or crown. Guran argues that the former theme relates to Christ's tangible presence through the consecration and consumption of the Eucharist (the *anaphora* and Communion) while he links the theme of the Royal Deësis to the Great Entrance, in which the bread and wine have not yet become the body and blood of Christ. Specifically, the fresco evokes the eschatological theme of the Cherubikon hymn sung during the Great Entrance: '[...] that we may receive the King of all, invisibly escorted by the angelic orders'.[35] Linked to the Second Coming of Christ by writers on the Byzantine liturgy such as Symeon of Thessaloniki, the procession and its hymn evoke the presence of the eternal kingdom of Christ.[36] The two images – Christ as high priest and Christ as emperor – work in tandem, one as a mimetic parallel to the ritual of the church, the other reflecting its anagogical evocation of heavenly realities.

By the last decades of the fourteenth century, these two themes become fused into the single figure of Christ in the Deësis.[37] In an icon now in the Dormition Cathedral of the Moscow Kremlin, Christ appears simultaneously wearing the insignia of a patriarch with those of an emperor (Fig. 10).[38] The icon shows Christ wearing the cross-patterned *sakkos* of a patriarch, along with the

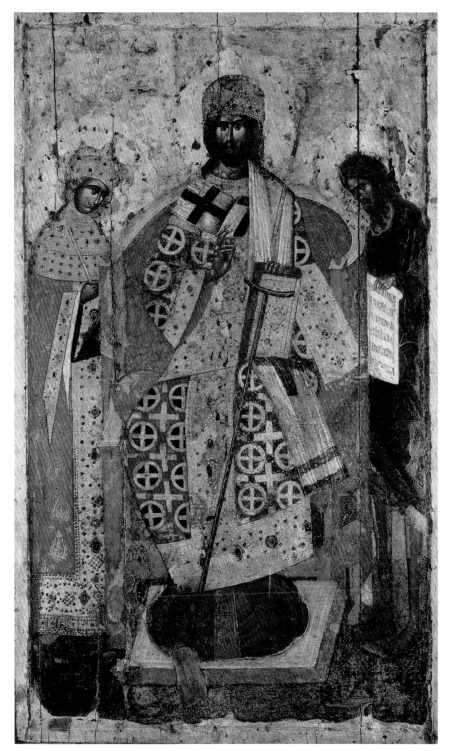

Fig. 10 Royal Deësis. Icon, attributed to Serbia, late fourteenth century. Dormition Cathedral, Moscow Kremlin.

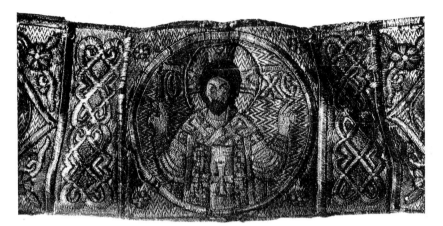

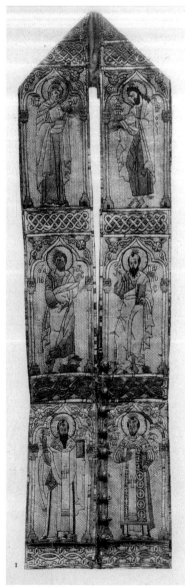

Fig. 11 *Epitrachelion*: Great Deësis with Christ as High Priest. Silk textile with gold and silk embroidery, fifteenth century. Chilandar Monastery, Mount Athos.

imperial *loros*, crown, and scepter. Over the *loros*, he also wears the episcopal *omophorion*. In other words, the imperial attributes are borrowed from the 'Royal Deësis' (note that the Virgin also wears imperial costume), while the patriarchal regalia stem from a fusion of this theme with the imagery of the Communion of the Apostles and Celestial Liturgy.[39] In embroideries of the Great Deësis, on the other hand, the garments of Christ never mix imperial and ecclesiastical insignia. The late fifteenth-century priest's stole, or *epitrachelion*, from Chilandar Monastery is among a number of stoles that preserve the composition of the Great Deësis with Christ as patriarch (Fig. 11). Here, he is shown in a roundel on the neck, while the saints appear under arches running down the length of the stole. The embroideries, therefore, combine in a single composition *both* the mimetic and anagogical aspects articulated through the separate depictions of Christ as emperor and Christ as patriarch. As high priest, Christ is the model for the priest or bishop who wears the stole, while the embroideries simultaneously present his heavenly reign by surrounding him with the assembled representatives of the heavenly court. Furthermore, the portion of the stole showing Christ as high priest would have had a certain visual independence when actually worn. Oriented at a 90-degree angle with respect to the other figures on the stole, it alone would have been visible as an upright image on the neck of the wearer after he donned his *phelonion* or *sakkos*. Thus the wearer would assume a Janus-like aspect, with his own face visible from the front and the face of Christ as high priest visible from the back. The vestments thus convey the paradox that the priest is simultaneously himself and Christ.

Woven textiles with the image of Christ

At a time roughly contemporaneous with the manufacture of the stole from Chilandar Monastery, the motif of Christ as high priest passed from the medium of embroidery into that of woven textiles. The earliest surviving piece with the pattern of Christ as bishop is also among the best preserved: the silk and gold lampas-weave *sakkos* of St Niphon at the Monastery of Dionysiou on Mount Athos (Fig. 12).[40] Amid the upheavals of the Great Church of Constantinople in the decades following the Ottoman conquest, Niphon served three separate – and brief – terms as Patriarch of Constantinople. First elected in 1486, he was deposed in 1489. He was appointed to the office a second time in 1497 and again deposed the following year. He was called once more in 1502 to serve as Ecumenical Patriarch, but refused the post and eventually retired to Mount Athos until his death in 1508.[41] The creation of the *sakkos* can likely be associated with one of his two patriarchates, although it might date to before 1486, when he was serving as Metropolitan of Thessaloniki prior to his first call to the patriarchal throne. The pattern shows Christ, vested as a bishop and making a gesture of blessing, along with Greek crosses and small figures of six-winged seraphim in the interstices of the design. The surface background of the lampas weave is formed of gold filaments; the colored highlights of the design, most visible in the robes of Christ, vary by horizontal register: white, purple, silver, and green appear on the main body of the *sakkos*, while other colors including red and chartreuse appear on the sleeves and on the gores of the flaring sides of the vestment. The lack of any consistent order to the occurrence of the highlight colors suggests that these complementary pattern wefts were chosen *ad libitum* by the weavers as they worked. In addition to the somewhat erratic use of color, the consistent reversal of all the Greek inscriptions suggests that the garment may represent the first loom run of a newly designed textile.[42] Correcting for their orientation, the inscriptions are all quite legible. The crosses bear the abbreviations IC XC N K, for «Ιεσοῦς Χριστός νικᾷ» ('Jesus Christ is victorious'). In addition to the usual $\overline{\text{IC XC}}$ abbreviations for 'Jesus Christ,' on either side of

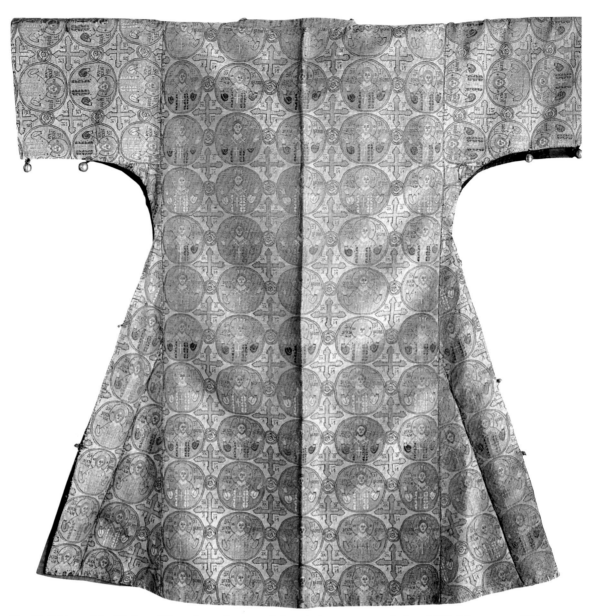

Fig. 12 Sakkos of St. Niphon. Silk and metal-wrapped threads, lampas weave, before 1508, Monastery of Dionysiou, Mount Athos.

his head, the figure of Christ has in the cross arms of his halo the letters «ὁ ὤν» ('he who is').[43] Finally, to either side of the half-length figures is inscribed «ὁ μέγας ἀρχιερεῦς» ('the great High Priest'). This inscription does not occur on any of the other surviving textiles with similar woven motifs, nor does it appear on the closest embroidered parallel, the iconostasis curtain from Chilandar Monastery. Like the figure of Christ in that embroidery, the woven figures appear bareheaded but vested in a *sticharion* with stripes and ornate cuffs, a *sakkos* with Greek crosses enclosed in roundels, and an *omophorion* also decorated with crosses. In each case, Christ blesses with both hands in the manner of an Orthodox bishop.[44]

No other exemplars of the textile of the Dionysiou *sakkos* are known to survive, but is clearly related to the much larger group of silks with the image of Christ as high priest first documented

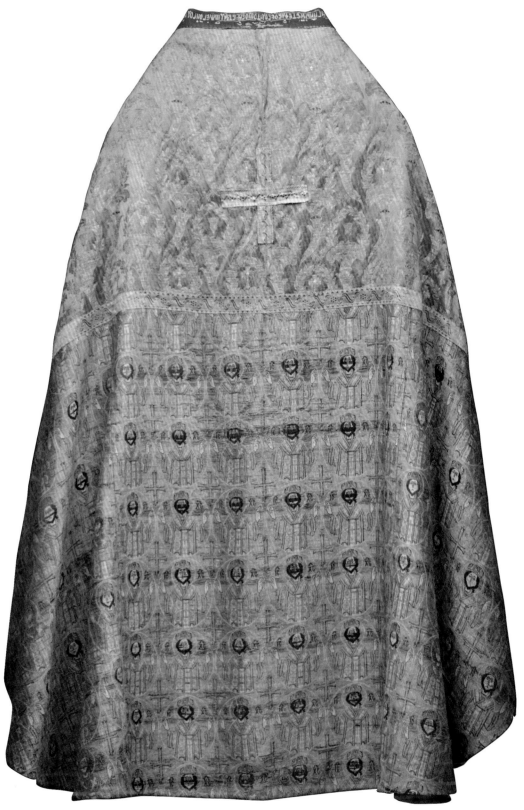

Fig. 13 *Phelonion* with Christ as High Priest. Silk and metal-wrapped threads, lampas weave, with embroidered yoke, dedicated 1614. Putna Monastery.

Fig. 14 Sakkos of Patriarch Joseph. Silk and metal-wrapped threads, *taqueté*, before 1634.

in the early part of the seventeenth century. Two different vestments bear dedicatory inscriptions of the Moldavian ruler Ştefan II Tomşa from the year 7122 (1613/14). The first is found on a *phelonion* in the treasury of the Putna Monastery. The large expanse of the textile, gold with details in ivory and black colored silk, is joined to a velvet yoke, which bears the dedicatory inscription (Fig. 13).[45] The second *phelonion*, presented to the Monastery of Suceviţa and now in the National Museum of History of Romania in Bucharest, consists of multiple fragments of Ottoman textiles joined together with an embroidered yoke. The textile with the image of Christ blessing appears on the back of the garment, in this case with details in ivory and light blue silk on a gold ground. The inscription names the donor as 'Io [John] Ştefan the Voevode, son of Tomşa [...] the 18th of March, 7122 [1614]'.[46] As with all the examples of the type apart from the Dionysiou *sakkos*, the motif shows Christ wearing a domical bishop's miter as well as the *sakkos* and *omophorion*.[47]

The silks in Romania clearly share a common design with the fragments in Athens, Chicago, London, Washington, and the rest. Although the state of preservation varies widely from one sample to another, they share telltale flaws such as the lack of a mark of abbreviation over the letter *nu* (for «νικᾷ»). More technically significant is a design flaw observed in the lowest register of crosses within the depicted *sakkos* worn by Christ. Regardless of the colors used in each example, these crosses consistently appear in the color of the warp threads rather than in the pattern highlight color supplied elsewhere by the complementary wefts. Despite these shared characteristics, the surviving fragments are not completely identical. The variation in the color scheme is obvious enough, as is the variation in the roundels from circular to somewhat oval, attributable to varying tension in the loom. Small details, however, change from piece to piece. The crosses between the roundels on the Dumbarton Oaks fragment, for example, are outlined in the warp color (black) and filled with gold threads, while another example in a private New York collection has crosses entirely filled in with the red color of the warp. Furthermore, the lower ends of the crosses on the Dumbarton Oaks piece are noticeably asymmetrical and jagged, a feature corrected in the New York piece and others. Similarly, the position of the capital *nu* in the inscription moves significantly from one piece to another – without ever gaining its missing abbreviation bar.[48] Even the number of weft colors varies: four are visible in the Dumbarton Oaks fragment, five in the piece at Krefeld.[49] All of these features, not to mention the proliferation of larger and smaller pieces of the fabric, suggest that the same pattern was woven over a matter of decades, with small, discrete refinements (and errors) being incorporated into the design along the way. This development contrasts with the singular, extensive experiment of the Dionysiou *sakkos*. Presumably, had its pattern been woven previously with the same error of direction in the inscriptions, the problem might easily have been remedied by simply reversing the sequence of passes.[50]

Distinct from this widespread type of Ottoman textile with Christ as high priest is the *sakkos* of Patriarch Joseph in the Kremlin Armory, Moscow (Fig. 14). The register of the royal workshops in

Fig. 15 Silk Textile Fragment with Scenes of the Life of the Virgin, late fourth-early fifth century. Abegg Stiftung, Bern.

Moscow mentions that the garment was brought from Constantinople in 1634, and was eventually presented by Tsar Alexei Mikhailovich to Patriarch Joseph IV (r. 1642–52).[51] In contradistinction to the earlier examples in lampas weave, the textile of the *sakkos* is what is known in Ottoman sources as a *serâser*, a form of complementary weft-faced plain weave with inner (main) warps; in modern textile terminology, this would be termed a *taqueté*.[52] The surface is dominated by metallic weft threads wrapped around silk cores of three different hues, imparting shades of white, blue, and yellow to the gold and silver. The pattern repeatedly shows Christ seated on a high-backed throne with a footstool, wearing a plain gold *sakkos* and a silver *omophorion* over his blue inner vestment (the *sticharion*, or alb). He holds an open book of the Gospels in his left hand while blessing with his right. The usual inscription, \overline{IC} \overline{XC}, appears to either side of his shoulders, while the side arms of his halo have the letters ω and ν (the « ό » that should accompany them is precluded by the domical miter that he wears on his head). Small cherubim, represented as heads with haloes and wings, occupy the spandrels between the multi-lobed arches enclosing the enthroned Christ. Reincorporated into the design over a century after the manufacture of the Dionysiou *sakkos* with its seraphim, these cherubim emphasize the heavenly, cosmic nature of Christ's high priesthood.

Self-referentiality and repetition

As established at the outset of this essay, the iconography of these textiles sets up a mimetic relationship between the represented Christ and the clergy who wear his image. Hand-in-hand with the self-referentiality of the motif of Christ as high priest – or, to speak more precisely, the self-referentiality of the clergy who wear such images – is the self-sufficiency of vestments made from textiles with this pattern. The earlier, embroidered liturgical vestments also present the clergy as icons of Christ, but they do so by triangulation: the clergy wear vestments with images of Christ and his life, images paralleled in the frescoes and mosaics of the church interior. These same frescoes at times show Christ himself dressed as a bishop (see Fig. 4). At other times the juxtaposition with other images identifies the minister as a stand-in for Christ, as was the case with the Chilandar iconostasis curtain (see Fig. 7). These links are strong, but, to work, they require the presence of the vested clergy in the image-saturated context of a

Fig. 16 Untitled Cartoon by Paul Noth. *The New Yorker,* 4 October 2010. © Paul Noth/ The New Yorker Collection/ www.cartoonbank.com

Byzantine church. The post-Byzantine textiles with the woven motif of Christ as high priest, on the other hand, need only to be worn for their meaning to be, as it were, 'activated'. The vestments are thus self-sufficient, containing within the single juxtaposition of human wearer and woven image the connections made earlier through a whole web of cross-references among textiles, painted images, and the human celebrants of the liturgy. This self-sufficiency of the woven images in part explains their most salient and – from the point of view of the theology of icons – most peculiar characteristic, their repetitive pattern.

Henry Maguire has called attention to the repetitive images of holy figures on textiles worn by the laity in the early Byzantine period.[53] In the case of textiles like a sleeve band with holy warriors or even the infancy of Christ silk in the Abegg Stiftung in Bern (Fig. 15), the repetition of motifs multiplies the potency of the images for the protection of the wearer. Such use of holy images lies outside the boundaries of the proper use and function of icons as defined in the course of the Iconoclastic controversy of the eighth and ninth centuries. According to the ultimately victorious Orthodox viewpoint, icons are effective vehicles of prayer because they act as 'windows' giving access to the depicted holy figure or sacred event. The self-sufficient images on early Byzantine textiles work by channeling less precisely defined protective powers – unlike 'proper' icons, therefore, the more the images are repeated, the more spiritual forces they activate on behalf of the wearer.

The repetition of motifs is, of course, idiomatic to the medium of weaving. The transition to woven textiles from the earlier (and continued) use of gold embroidery entailed a change from individually executed figures to ones produced in multiples by a mechanical process. The Ottoman tex-

tiles with Christian motifs nonetheless seem to function in a different way from the early Byzantine 'magical' textiles. Unlike many of the warrior-saints or abbreviated narrative scenes on the early textiles, these later figures are readily identifiable and usually labeled, even if the Greek abbreviations are at times reversed or garbled. Their function seems not to be so much magical as ideological. They are worn, after all, by clergy rather than laity, and then only within the controlled context of the liturgical rite. The essential message that the textiles convey is that the ministering clergy are living icons of Christ – a message identical to that articulated through the earlier triangulation among vestments, ritual, and painting. Again, it is the self-sufficiency of the image that sets it apart. In a sense, this was a practical benefit in the era of upheaval in the early Ottoman period, when churches were subject to sudden demolition or appropriation for Islamic use – the message of the textiles was fully portable and not dependent on a specific painted or mosaic program of images.

One might read the closing of the loop of references between Christ and the clergy as a kind of reification of their claims to represent Christ. Certainly, a particular exaltation of clerical status informed the addition of images onto vestments in the first place, and these textiles are no exception. Their extremely rich use of gold and silk threads should leave no doubt as to the ideological aspect of their meaning. There remains, however, a certain reticence; the identification of Christ with the clergy remains solely in terms of outward appearances. A cartoon by Paul Noth that appeared in *The New Yorker* of 4 October 2010 captures this paradox: we are allowed to glimpse what is hidden, but what is revealed is exactly similar in its appearance to what was already visible on the surface (Fig. 16). The nature of representation on these textiles is both chiastic and self-perpetuating. Christ is represented 'as if' a bishop, the bishop is presented 'as if' Christ, who is in turn presented 'as if' a bishop, and so on – a logical relationship that, if only coincidentally, echoes the interwoven structure of the textile into which it is incorporated.

Returning to the Chilandar sanctuary curtain, one can compare it to a later curtain with the same function that was dedicated to the Monastery of Sucevița in Moldavia in the early years of the seventeenth century (Fig. 17).[54] The curtain, measuring approximately 250 x 170 cm, shows an expanse (composed of two loom-widths of fabric) of the familiar Ottoman lampas pattern of blessing Christs in roundels, surrounded by a border with the dedicatory inscription. The Chilandar curtain, with multiple figures playing liturgical roles, has a great deal of mimetic specificity, in that one can essentially pinpoint the ritual moment depicted in the embroidery. The Sucevița curtain lacks this mimetic precision, and the substitution of multiple small motifs for the nearly life-size embroidered images of the earlier piece also renders it considerably less legible. What the Sucevița curtain gains in the exchange is the evocation of eternity through its repeating pattern. The two-dimensional repetition of the image of Christ across the curtain serves as a metaphor for the more transcendent form of repetition reflected in the iconography of the Celestial Liturgy. Just as there are many repetitions of the image, but all represent one Christ, so is each earthly liturgy part of a single, eternal act of worship. The clergy and the liturgy of the church are, in this view, multiple and endlessly repeated, yet finite, icons of the singular and eternal liturgy of heaven. The depiction of the multiple images of Christ as high priest as a veil across the opening of the sanctuary – a threshold described in numerous Byzantine liturgical commentaries as a symbol of the firmament between earth and heaven, between the physical world perceptible by the senses and the noetic realm accessible only to the intellect – makes visible precisely this sense of the eternal and infinite.

Finally, the image of Christ as high priest resonated with the changed political circumstances of the Christian community under Ottoman rule. The Patriarch of Constantinople was titular head of the Orthodox Christian *millet*, although his political position was precarious. On the one hand,

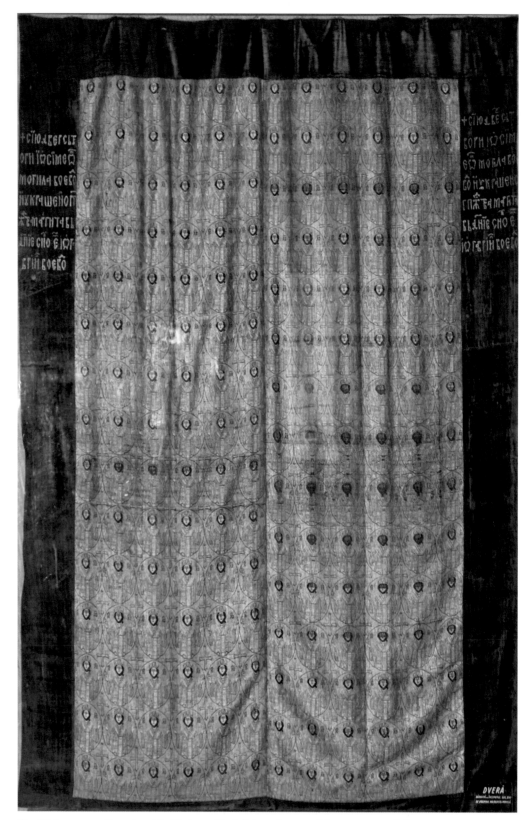

Fig. 17 Sanctuary Curtain with Christ as High Priest. Sucevița Monastery, *c.* 1608-11.

the image of Christ as Great High Priest, which began to be popular in icon painting from the fifteenth century, is typically inscribed with Jesus' words to Pilate at his trial: 'My kingdom is not of this world.'[55] Such a sentiment would have been completely at odds with Byzantine political ideology, which saw the emperor as at least the divinely-appointed vicegerent of Christ's kingdom. On the other hand, the image speaks to the transfer of the aspirations of the Orthodox peoples under Ottoman rule from the political to the ecclesiastical sphere and from an historical to an eschatological context. Thus they aggrandize the clergy as leaders of the Orthodox Christian population while at the same time deflating any ideological support for a political challenge to the authority of the sultan. Viewed in this light, the manufacture of such textiles in the Ottoman imperial workshops no longer seems quite so odd. From an economic and an ideological point of view, these textiles may have been useful both to the Orthodox Christian clergy who wore them and to the Muslim sultans under whose watchful eye they were produced.

CHAPTER 4

The *Epitaphioi* of Stephen the Great

Henry SCHILB

Voivode Stephen III ruled Moldavia from 1457 until his death in 1504.[1] Best known for his military accomplishments, Stephen the Great (Ştefan cel Mare) was a prolific patron of architecture and other arts, especially textiles, a fact that has not escaped scholarly attention.[2] Pauline Johnstone described Stephen's reign as 'the great age of Moldavian embroidery'.[3] Among the many textiles that Stephen the Great donated to monasteries are three large liturgical veils customarily identified as *epitaphioi*. This essay will examine the *epitaphioi* of Stephen the Great and discuss how they might have been used as sites for the display of not only the patron's Orthodox Christian identity but also the legitimacy of his rule and the line of succession.

In the Orthodox Christian tradition, the *epitaphios* (or *epitaphion*) is a type of liturgical veil that is carried in procession and displayed on a table or portable bier in the *naos* of a church on Good Friday and Holy Saturday.[4] The form and function of the *epitaphios* developed from the form and function of the *aër*, a veil that covered both the chalice and the paten on the altar.[5] *Aëres* and *epitaphioi* are characteristic of the Byzantine rite and are not precisely analogous to veils in Western

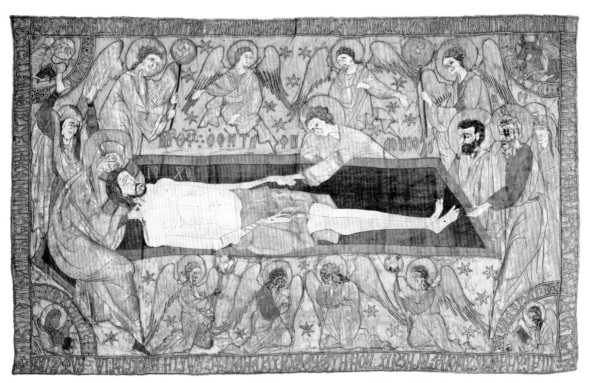

Fig. 1 *Epitaphios* given by Stephen the Great to the Putna Monastery. 1489/90. Silk embroidered with gold, silver, and silk thread. 252 x 166 cm. Putna Monastery Museum, Romania. (Photo: Putna Monastery Photographic Archive)

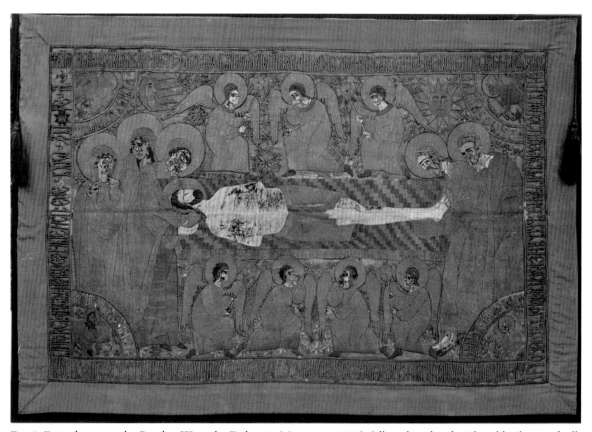

Fig. 2 *Epitaphios* given by Bogdan III to the Dobrovăț Monastery. 1506. Silk embroidered with gold, silver, and silk thread. 180 x 150 cm. The National Museum of Art of Romania, Bucharest. (Photo: The National Museum of Art of Romania)

liturgical practice.[6] It is also difficult to determine whether a liturgical veil made in the fifteenth century was intended for use as an *aër* or as an *epitaphios*, and such a distinction may be a later development.[7] While the inscriptions on the '*epitaphioi*' of Stephen the Great include the word '*aër*' in reference to these textiles, the terms used to refer to these textiles, and perhaps their functions, were more flexible in the fifteenth century than they are in modern usage. For the purposes of this essay, I will refer to the three large liturgical veils commissioned by Stephen the Great as *epitaphioi*.[8]

Patronage of monasteries, including the donation of liturgical implements and textiles, was itself an expression of Orthodox piety, and Moldavian and Wallachian princes followed the example of Byzantine imperial patrons. Beginning in the fourteenth century, as textiles and documents in their treasuries reveal, the monasteries of Mount Athos enjoyed the support of Romanian princes, including Stephen the Great.[9] Although Stephen the Great might have meant to emulate Byzantine emperors, there are features that make these embroideries specific to his reign and the political conditions of fifteenth-century Moldavia.

Of the three *epitaphioi* associated with Stephen the Great, the earliest was made for the Putna Monastery in 1489/90 (Fig. 1). The second was made for the Moldovița Monastery in 1494.[10] The third, commissioned for the Dobrovăț Monastery before Stephen's death in 1504, was completed in 1506 (Fig. 2). All three are embroidered with gold, silver, and colored-silk threads on silk backgrounds over linen supports.[11] They are larger than most *aëres* or *epitaphioi* of the fifteenth century:

the Putna *epitaphios* is 252 by 166 cm; the Moldoviţa *epitaphios* is 206 by 115 cm; and the Dobrovăţ *epitaphios* is 180 by 150 cm.[12]

Long dedicatory inscriptions are embroidered in gold around the borders of all three *epitaphioi*. Each inscription names the patron and the monastery for which the *epitaphios* was made. These inscriptions constitute our only evidence for the original commissions. The Putna *epitaphios* is still at the Putna Monastery in its museum, and the Moldoviţa *epitaphios* is at the Moldoviţa Monastery.[13] The Dobrovăţ *epitaphios* is now in the National Museum of Art of Romania.[14] Johnstone assumed that one workshop was responsible for embroidering all three *epitaphioi*; however, there is no evidence to support her assumption[15]. In fact, very little is known about Late Byzantine or post-Byzantine embroiderers and their workshops.[16] Most of what we know about embroidery in fifteenth-century Moldavia must be deduced from the extant examples. In the case of the *epitaphioi* of Stephen the Great, the dedicatory inscriptions provide some of the most useful and interesting information.

The use of long dedicatory inscriptions on *epitaphioi* was not new, and the inscriptions on the examples associated with Stephen the Great are formulaic and similar in many respects to inscriptions on other *aëres* and *epitaphioi* made in Moldavia during the fifteenth century.[17] The iconography used on these three *epitaphioi* also follows traditional models. These *epitaphioi* can be distinguished from other fifteenth-century examples because Stephen's embroiderers elaborated the traditional formulas in both the dedicatory inscriptions and the iconography.

The *epitaphios* that Stephen of the Great commissioned for the Putna Monastery (see Fig. 1) is larger than the other extant *epitaphioi* of the fourteenth and fifteenth centuries.[18] Among the many monasteries that Stephen the Great endowed, Putna enjoyed a special status as a focus of the voivode's patronage; moreover, it contains his tomb.[19] The iconography embroidered on the Putna *epitaphios* is a version of the *Epitaphios Threnos*, or Lamentation at the Tomb. This iconographic type illustrates the scene as described in the apocryphal Gospel of Nikodemus.[20] The *Epitaphios Threnos* iconography developed originally in other media, especially wall paintings, and the embroidered versions of this iconography expanded upon those established iconographic types.[21]

On the Putna *epitaphios*, the figure of Christ is shown lying with his arms at his sides on what might be interpreted as either the Stone of Unction or the shroud, since the object is shown as a simple trapezoidal shape embroidered in red with a green border.[22] The figure of the Virgin embraces Christ's head. A woman behind the Virgin, presumably Mary Magdalene, raises her hands over her head in a gesture of lamentation. At Christ's feet are two bearded figures. Embroidered in gold is the abbreviation HOC over the head of the figure with the gray beard. The other letters are embroidered just to the right of the angel's wing. This abbreviation is almost certainly meant to identify the figure below it as Joseph of Arimathea, so the figure with the dark beard is probably meant to be Nikodemus. Behind them are mourning women. A beardless male figure, representing John the Theologian, holds Christ's left hand near the middle of the composition. In the area above Christ are four angels, while four more angels appear in the register below Christ. Flower-like stars fill the space around the figures. Each corner is filled with one of the four evangelist symbols.

A few more inscriptions in Greek, also embroidered in gold, identify some of the main characters in the drama. The abbreviation $\overline{\text{IC}}$ $\overline{\text{XC}}$ ('Jesus Christ') is embroidered just above Christ's chest within the red area of the shroud. Above that, within the blue background, are the abbreviations **MP** **ΘΥ** ('*Meter Theou*, Mother of God') and the title O ΕΝΤΑΦΗΑCΜΟC ('The Entombment'). The use of this title rather than '*Epitaphios*' or '*Epitaphios Threnos*' is unusual for this iconography. The title on a Moldavian *epitaphios* made for the Neamţ Monastery in 1436 (Fig. 3) reads

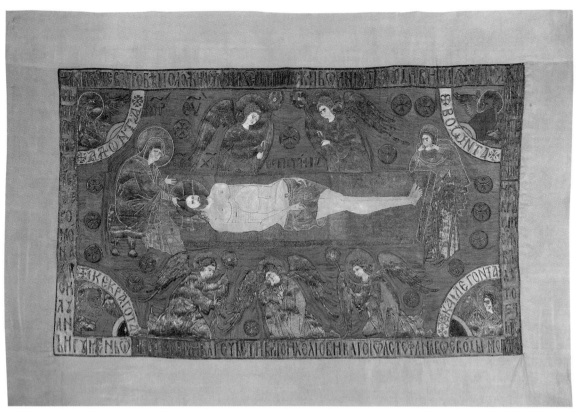

Fig. 3 *Epitaphios* given by Hieromonk Siluan to the Neamț Monastery. 1436. Silk embroidered with gold, silver, and silk thread. 205 x 155 cm. The National Museum of Art of Romania, Bucharest. (Photo: The National Museum of Art of Romania)

Ο ΕΠΙΤΑΦΙΟΣ ('The *Epitaphios*'), while a Wallachian example from the Cozia Monastery dated 1396 (not illustrated), is the earliest extant textile to include the title Ο ΕΠΙΤΑΦΙΟΣ ΘΡΕΙΝΟΣ ('The *Epitaphios Threnos*').[23] An earlier Moldavian *aër* embroidered for the Metropolitan Makarios in 1427/28 bore the title Ο ΕΗΤΑΦΙΑΣΜΟΣ ('The Entombment'), which suggests that it might have been the prototype for the Putna *epitaphios*.[24]

In addition to the figure of Christ and four angels, the Cozia *epitaphios* includes the Virgin and John, but does not show Mary Magdalene, and the border is inscribed with a hymn but no dedication. The Neamț *epitaphios* (see Fig. 3) includes a figure of a lamenting woman, usually identified as Mary Magdalene.[25] The presence of this figure, and even her expressive gesture, suggests that the embroiderers were adapting figures from the iconography of the *Epitaphios Threnos* as it appeared in wall paintings, such as the thirteenth-century example in the Church of St Clement in Ohrid, Macedonia, a painting attributed to Michael Astrapas and Eutychios.[26] The full iconography of the *Epitaphios Threnos* developed later in embroidered veils, proliferating during the fifteenth century in response to developments in the liturgy and under the influence of wall painting and portable icons; but only gradually did embroiderers introduce new figures to accompany Christ and the lamenting angels. While the Neamț *epitaphios* is the earliest Moldavian liturgical veil to include Mary Magdalene in an embroidered version of the *Epitaphios Threnos*, the Putna *epitaphios* developed this tendency toward a 'narrative' iconography even further. Not copying one specific example, the embroiderers of the Putna *epitaphios* incorporated elements also found on more than one earlier Moldavian textile.

On the Putna *epitaphios* (see Fig. 1) the evangelist symbols in the corners are arranged in the same order as the symbols in the corners of both the *aër* of Makarios and the Neamţ *epitaphios*. The evangelists are identified by abbreviations of their names: IꙠ ('John') in the upper left; ЛОуК ('Luke') in the upper right; МРК ('Mark') in the lower left; and МАТѲS ('Matthew') in the lower right. The words that introduce the *Epinikion* Hymn, the Hymn of Victory, are embroidered within the curved borders that surround the evangelist symbols: the word АДОНТА ('singing') fills the arc surrounding the eagle representing John; the word ВОꙠНТА ('shouting') surrounds the ox representing Luke; the word КЕКРАГОТА ('crying out') surrounds the lion representing Mark; and the words КЕ ДЕГОНТА ('and saying') surround the winged man representing Matthew. The earliest embroidered textile with these words is the aër of Makarios.[27] Embroidered in the same order on the Putna *epitaphios*, as on the Neamţ *epitaphios* these words spoken during the Anaphora call attention to the liturgical function of textiles on which they are embroidered.[28]

While the inscriptions discussed above are in Greek, the Cyrillic lettering is in the same style as the long dedication in Slavonic embroidered in gold around the border of the Putna *epitaphios*. The dedication, which begins in the lower left corner and runs clockwise around the entire border, reads:

+ИЗВОЛЕНЇЕ ѼЦА И СЪ ПѼСПѢШЕНЇЕМ СНА И СЪВРЪШЕНЇЕМ СТГѼ ДХА / IꙠ СТЕФАН ВОЕВОДА БЖЇЕЮ МДТЇЮ ГПРЪ ЗЕМЛИ МѼЛДАВСКѼН СН БОГДАНА ВОЕВОДИ И СЪ БЛГОЧЕСТИВОЮ ГПЖДИ ЕГО МАРІИ / И СЪ ВЪЗДЮБЛЕНИМИ ДѢТИ АДЕӡАНДРА И БѼГДАНА ВЛАДА СЪТВѼРИ/ША СЪИ АЕРЪ ВЪ МОНАСТИРИ Ѽ ПꙊТНОИ ИДЕЖЕ Е ХРА ꙊСПЕНЕ ПРѢСТИА БЦИ И ПРИСОДВИ МАРЇА В ЛТѼ ✻SЦ✻СИ[29]

('By the will of the Father, the aid of the Son, and the fulfillment of the Holy Spirit, John Stephen Voivode, by the grace of God Lord of the land of Moldavia, son of Bogdan Voivode, with the very pious Lady Maria and with their beloved children Alexander and Bogdan-Vlad, made this *aër* for the Monastery of Putna, where the Church of the Dormition of the Holy Mother of God and Ever Virgin Mary is, in the year 6998.')

The year, as was usual during this period, is given as the calculated date since the Creation and is equivalent to 1489/90.

In aspects of style and iconography, the Moldoviţa *epitaphios* (not illustrated) appears to emulate a Serbian textile made in the late fourteenth or early fifteenth century, known as the *aër* of Ephemia and Eupraxia (Fig. 4).[30] The Serbian *aër* of Ephemia and Eupraxia is now in the museum of the Putna Monastery.[31] Although it is not known exactly when the *aër* of Ephemia and Eupraxia arrived in Moldavia, details of all three large *epitaphioi* of Stephen the Great, and a number of other Moldavian textiles, have allowed scholars to infer either that the *aër* of Ephemia and Eupraxia had a profound effect—stylistically and iconographically—on Moldavian embroidery beginning in the early fifteenth century or that they all shared a common prototype or set of prototypes.[32] Particularly conspicuous is the proliferation of the flower-like star motif in the space around the figures. Among other features, the use of this motif suggests the possibility that the embroiderers of the Moldoviţa *epitaphios* were familiar with the *aër* of Ephemia and Eupraxia.

The figure of Christ on the Moldoviţa *epitaphios* also resembles the figure of Christ on the *aër* of Ephemia and Eupraxia (see Fig. 4). Christ lies across the central space of the composition but is shown without a shroud or stone. Above the Christ on the Moldoviţa *epitaphios* is the abbreviation I̅C̅ X̅C̅. At Christ's head, however, the seated figure of the Virgin holds Christ's shoulders. The Virgin is identified by the abbreviation мр θυ embroidered within the figure behind her, presumably one of the *myrrophoroi*, the myrrh-bearing women. At Christ's feet is the figure of John the Theologian.

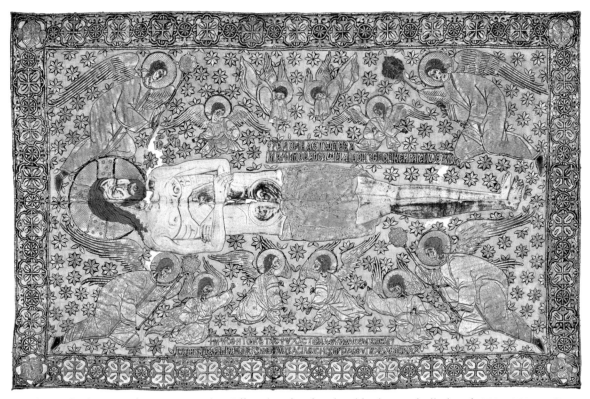

Fig. 4 *Aër* of Ephemia and Eupraxia. *c.* 1405. Silk embroidered with gold, silver, and silk thread. 170 x 111 cm. Putna Monastery Museum, Romania. (Photo: Putna Monastery Photographic Archive)

Behind him, mirroring the figure behind the Virgin, is Mary Magdalene as indicated by the abbreviation MA behind her neck. Five angels hover in the space above the figure of Christ, with four more angels below. An evangelist symbol is embroidered in each corner, although in a different order from those on the Putna *epitaphios*. Only Matthew is identified by an inscription: MA. On the Moldoviţa *epitaphios*, the curved borders around the evangelist symbols are filled with more flower-like stars instead of the words found in the analogous positions on the Putna *epitaphios*. The same star motif also fills the space around the figures in the central panel, as they do on the *aër* of Ephemia and Eupraxia.

The inscription on the Moldoviţa *epitaphios* begins in the upper left corner and runs counter-clockwise:

+ ИЗВОЛЕНЇЕ ѺЦА И СЪ ПОСПѢШЕНЇЕ СНА И СЪВРЪШЕНЇЕ / СТГѺ ДХА ІѺ СТЕФАН ВОЕВѺД БЖЇЮ МЛСТЇЮ ГСПДРЪ ЗМЛИ МОЛДАВСКОН СИ БОГДАНА ВОЕВОД И СЪ БЛГОЧЕСТИВОЮ / ГСЖДЕЮ ЕГО МАРЇИ И СЪ ВЪЗЛЮБЛЕНИМИ СВОИМИ ДѢТИ АЛЕӟАНДРА / [И Б]ОГД[АНА] ВЛ[АДА] СЪТВОРИША СЬИ АЕРЪ ВЬ МОНАСТИРИ Ѻ МОЛДОВИЦИ ИДЕЖЕ Е ХРАМ БЛГОВѢШТЕНЇЕ ПРТѢН БЦИ В ЛТО ✡ЗВ МР А.[33]

('By the will of the Father, the aid of the Son, and the fulfillment of the Holy Spirit, John Stephen Voivode, by the grace of God Lord of the land of Moldavia, son of Bogdan Voivode, and with the very pious Lady Maria and with their beloved children Alexander and Bogdan-Vlad, made this *aër* at the Monastery of Moldoviţa, where the Church of the Annunciation of the Holy Mother of God is, in the year 7002 [1494], March 1.')

This inscription follows the same formula as the inscription on the Putna *epitaphios*, by affirming the legitimacy of Stephen's reign as by 'the grace of God', and mentioning Stephen's father, wife, and children.

Compared to earlier Moldavian examples, embroidery associated with Stephen the Great, including the Putna *epitaphios* and the Moldoviţa *epitaphios*, expanded the *Epitaphios Threnos* iconography, increasing the number of figures to include the *myrrophoroi*, John the Theologian, Joseph of Arimathea, and Nikodemus. Although slightly smaller than the other two, the Dobrovăţ *epitaphios* (see Fig. 2) developed this iconography even further. The figure of Christ lies on what seems to be either the Stone of Unction, or some sort of textile, as is suggested by the geometric pattern around Christ. This area is embroidered with an alternating red and blue diagonal lozenge pattern. The abbreviations IC XC are embroidered just above the shoulder of Christ. The standing figure of the Virgin holds Christ's halo as though it had physical substance. Behind the Virgin are two *myrrophoroi*, one of which holds her hand to her cheek, while the other pulls her own hair in a gesture that recalls the figure of Mary Magdalene on the Neamţ *epitaphios* (see Fig. 3).

In the Dobrovăţ *epitaphios*, the standing figure of Joseph of Arimathea holds Christ's feet, while behind him stands another male figure who appears to be Nikodemus rather than John the Theologian.[34] The sun (on the right) and the moon (on the left) have been added in the area above Christ, between which are three angels. Four angels are depicted in the area below Christ, kneeling among a few plant motifs apparently intended as a limited and stylized landscape. Each corner of the composition includes one of the evangelist symbols with their names fully spelled out. Also embroidered here are the words that precede the Hymn of Victory, as on the Putna *epitaphios*, but which are not found in the Moldoviţa *epitaphios*.

The dedication inscription on the Dobrovăţ *epitaphios* begins in the upper left corner and runs around the border clockwise as follows:

БЛАГОЧСТИВЫИ И ХСТОЛЮБИВЫИ IѠ СТЕФАН ВОЕВОДА БЖІЕЮ МЛСТЇЮ ГСПРЬ ЗЕМЛИ МОЛДАВСКОИ НАЧА СЪТВОРИТИ СЬИ АЕР МОНАСТИРЮ СВОЕМОУ Ѡ ДОБРОВ/ЕЦА И ѸТО ПОСТИЖЕ ЕГО СЪМРТЬ И НЕСЪВРЪШИ ЕГО А СНЪ ЕГО БОГДАН ВОЕВОДА Б/ЖІЕЮ МЛСТЇЮ ГПРЪ ЗЕМЛИ МОЛДАВСКОИ И СЪ МАТЕРЕЮ СВѠЕЮ ГПЖЕЮ МАРІЕЮ СЪВРЪШИША ЕГО И ДАДОША ИХ ИДЕЖЕИѠ БѢЩАНЬ БЫ ВЪ ЗАДШЕ СТГѠ ПОЧИ/ВШАГО ГН СТЕФАН ВОЕВОД И ЗА СВОЕ ЗДРАВІЕ И СПСЕНЇЕ В ЛТѠ ҂ЗДІ ФЕ А

('The very pious and Christ-loving John Stephen Voivode, by the grace of God Lord of the land of Moldavia, had this *aër* begun for the Monastery of Dobrovăţ, but it was incomplete at his death and his son Bogdan Voivode, by the grace of God Lord of the land of Moldavia, and with his mother the Lady Maria, finished it and gave it as promised, for the soul of the late Lord Stephen Voivode, and for his health and salvation in the year 7014 [1506], February 1.')

This is the last extant *epitaphios* associated with the reign of Stephen the Great, and its inscription gives us a sense of how long such a large embroidered textile might have taken to complete. It remains unknown whether work on the embroidery continued apace during the entire period between the date of the commission, sometime before Stephen's death in 1504, and the date of the completion. However, the veracity of the dedication must be questioned. Did Stephen the Great actually make the original commission, or is this claim only a display of filial piety on the part of the new voivode? If we assume the inscription is accurate, and that the work on this embroidery was not interrupted, then it took at least two years to complete. The patron who took credit for having the work completed was Bogdan III. Bogdan's older brother Alexander had died before

Stephen the Great. This is the same Bogdan-Vlad mentioned in the dedicatory inscriptions on both the Moldoviţa *epitaphios* and the Putna *epitaphios*.

Displayed in the *naos* on Good Friday, *epitaphioi* were also carried in processions emulating the funeral cortege of Christ.[35] Anyone visiting the church would have had the opportunity to read the message embroidered on an *epitaphios*. For whom were the messages embroidered on the *epitaphioi* of Stephen the Great intended? That these embroideries were gifts to monasteries means that the monastic community that received them probably would have been the primary audience, and any large textile would have been a significant gift from the donor because gold-embroidered liturgical textiles were expensive to produce. Another intended audience might have been the *boyars*, the local nobility, for whom the phrase 'Lord of the land of Moldavia,' could have been taken as a reminder of Stephen's authority. The inclusion of inscriptions embroidered on these textiles raises the question of literacy as well—would the intended audience of these textiles have been able to read the inscriptions on them? The audience for an embroidered inscription on an *epitaphios* must have been any person who was able to read Slavonic, the language of the liturgy, and who entered the church on Good Friday and Holy Saturday when the *epitaphios* would have been displayed in the *naos*.

Stephen the Great commissioned liturgical textiles of many types, but the large size and conspicuous display of these *epitaphioi* must have made them attractive sites for long inscriptions, or perhaps the long inscriptions necessitated the large size of the textiles. The inscriptions on the Putna, Moldoviţa, and Dobrovăţ *epitaphioi* even displace other types of inscriptions, including hymns, but Stephen the Great was not the first patron to use this type of liturgical textile to express what can be construed as a political message. For instance, a similar example is a large *epitaphios* from the Church of St Sophia, Novgorod (193 x 153.5 cm) on which the embroiderers found space for both a hymn and a long dedication.[36] This example predates the reign of Stephen the Great, and the dedicatory inscription anticipates the types of inscriptions found on the Moldavian *epitaphioi* during the second half of the fifteenth century.

While it is reasonable to identify the St Sophia textile as an *epitaphios* rather than an *aër* (if only because the hymn embroidered around the border is associated specifically with Holy Saturday), at the time the embroidery was made, this hymn ('Let all mortal flesh be silent') was an optional replacement for the Cherubikon in the performance of the liturgy of the Holy Saturday Orthros, but it later became the standard Cherubikon for Holy Saturday.[37] The iconography on this *epitaphios* is a version of the *Epitaphios Threnos*, with the Virgin at the head of Christ. John holds Christ's feet. The figural style is typical of textiles associated with the Grand Princes of Moscow.

The dedicatory inscription was embroidered in the space between two angels in the lower half of the composition, below the figure of Christ, and reads:

В ЛѢТ ҂ЅЦѮ ДЕ МЛСТЬЮ БЬЕЮ / СІИ ВЗДУХ СЪЗДАН БЫС БЛГО/ВѢРНЫ ВЕЛИКИМ КНЗМ ВАСИ/ЛИЕМ ВАСИЛЬЕВИЧЕМ ВСЕѦ РУСИ И СНОМ / ЕГО ВЕЛИКИМ КНАЗЕМ ИВАНОМ ВАСИЛЬЕВИ/ЧЕМ И БЛГОВѢРНОЮ ВЕЛИКОЮ КНАГИНЕЮ / МАРЬЕЮ И СЫНОМ ИХ БЛАГРОДИЫ КНАЗЕМ / ЮРИЕМ ВАСИЛЬЕВИЧЕМ В ДОМ СТЫА СОФІА ПРМДРОСТИ / БЖЫ В ВОТЧИНꙊ ВЕЛИХ КНАЗЕ ВАСИЛА / ИВАНА И ЮРИЯ В ВЕЛИКИЙ НОВГОРОД ПРЕОСВЯЩЕННОМУ АРХИЕПИСКОПУ / ВЛАДЫКЕ ЕВФИМИЮ[38]

('In the year 6960 (or 6964) by the grace of God this *aër* was made by the pious Grand Prince of all Rus' Vasilii Vasilievich and his son Grand Prince Ivan Vasilievich and the pious Grand Princess Maria and their son the noble Prince Iurii Vasilievich in the church of St Sophia of the Holy Wisdom in the lands of the Grand Princes Vasily, Ivan, and Iurii in Great Novgorod of the Archbishop Euphemius.')

The title 'Grand Prince of all Rus'' is used in the first part of the inscription to identify only Basil II, while his son Ivan, is identified as 'Grand Prince Ivan'. Iurii, another son of Basil II, is described only as 'noble'. In a period of war over dynastic succession, Basil used the visual arts as a way to identify his heir; for example, as Janet Martin has noted, coins minted in this period describe Basil and Ivan as 'Lords of all Rus'.[39] While the designation 'of all Rus'' is reserved on the *epitaphios* for Basil himself, the phrase after that refers to Ivan as *his* son. Only after mentioning Basil and his son Ivan does the inscription go on to mention Maria and *their* son Iurii. This embroidery displays the piety of Basil II and his family, and it identifies his heir, Ivan, who would become Ivan III (Ivan the Great).

The message is significant when considering the recipient of the gift. The archbishop mentioned at the end of the inscription would have been Euphemius II of Novgorod (1429–58). According to the inscription, this *epitaphios* was made in either 1451/52 or 1455/56.[40] During the dynastic wars, Novgorod supported Dmitrii Shemiaka, Basil II's first cousin and rival. Dmitrii Shemiaka died in 1453, and the dynastic war finally ended in 1456.[41] After the forces of Basil II attacked in 1456, Novgorod was defeated. Novgorod retained limited autonomy, but was forced to cede territory and pay taxes to the Grand Prince, among other conditions of the Treaty of Iazhelbitsy.[42] If Basil II sent this *epitaphios* to Euphemius in 1451/52, this textile can be seen as part of an effort to persuade Euphemius to back Basil II, a diplomatic gesture announcing Basil's claim to the title 'Grand Prince of all Rus'' and identifying Ivan as his heir. In 1456 this gift would also serve as a reminder that Novgorod had been defeated by Basil II, the Grand Prince of all Rus'.

The inscription on the Putna *epitaphios* (see Fig. 1) is similar to Basil II's *epitaphios* at Novgorod, but it appears in the border in place of a hymn. Since Basil II's *epitaphios* has both a hymn and a dedication, the function of the object is clear. The Putna *epitaphios* has only a dedicatory inscription, and the absence of a hymn is significant. As on the Dobrovăţ *epitaphios* (see Fig. 2), the only reference to the liturgy among the inscriptions are the words that introduce the *Epinikion* hymn embroidered within the curved borders around the evangelist symbols. Otherwise, it is only the iconography that signifies the liturgical function of the Putna and Dobrovăţ *epitaphioi*. The lack of a hymn on any of Stephen the Great's *epitaphioi*, therefore, represents a shift of emphasis to the messages the dedicatory inscriptions were meant to convey.

The 1427/28 *aёr* of the Metropolitan Makarios is the earliest Moldavian example embroidered with an inscription that can be compared to the inscriptions on Stephen the Great's *epitaphioi*. The language is Greek, but the style of the lettering resembles the Cyrillic characters of Slavonic inscriptions, perhaps suggesting a Greek patron and a Moldavian workshop.[43] The arrangement of the text around the border is unusual. It starts in the upper border then continues along the bottom before concluding in the right and left borders. This might be an aesthetic choice of the patron or the embroiderer, but it might also indicate that long border inscriptions were still unusual and demonstrates how the embroiderers attempted to orient the text so that the entire inscription would be legible when the textile was displayed:

ΟΥΤΟΣ Ο ΘΕΙΟΣ ΚΑΙ ΙΕΡΟΣ ΑΜΝΟΣ ΓΕΓΟΝΕΝ ΕΠΙ ΤΗΣ ΑΥΘΕΝΤΕΙΑΣ ΚΥΡΟΥ ΙΩΑΝΝΟΥ ΑΛΕΞΑΝΡΟΥ ΒΟΕΒΟΔΑ ΚΑΙ ΜΑΡΙΝΗΣ ΤΩΝ / ΕΥΣΕΒΕΣΤΑΤΩΝ ΚΑΙ ΤΩΝ ΕΡΑΣΜΙΩΤΑΤΩΝ ΥΙΩΝ ΑΥΤΩΝ ΚΥΡΟΥ ΗΛΙΑ ΒΟΕΒΟΔΑ ΚΑΙ ΜΑΡΙΝΗΣ ΤΩΝ ΕΥΣΕΒΕΣΤΑΤΩΝ / ΔΙΑ ΣΥΝΔΡΟΜΗΣ ΚΑΙ ΕΞΟΔΟΥ ΤΟΥ ΠΑΝΙΕΡΟΤΑΤΟΥ ΜΡΟΠΟΛΙΤΟΥ ΜΟΛΔΟΒΛΑ/ΧΙΑΣ ΚΑΙ ΠΑΡΑΘΑΛΑΣΣΙΑΣ ΚΥΡΟΥ ΜΑΚΑΡΙΟΥ ΕΝ ΕΤΕΙ ≠ЅѽΛЅ[44]

('This divine and holy *Amnos* was made during the reign of Lord John Alexander Voivode and the most pious Marina and their beloved children, Lord Ilias, Voivode and Marina the most pious, through the

assistance and at the expense of the all-holy Metropolitan of Moldovlachia and the Coastlands, Lord Makarios, in the year 6936.')[45]

Alexander the Good (r. 1400–32) and his fourth wife Marina are named in the dedicatory inscription. In this case, however, it was the patron, Metropolitan Makarios, who used a dedicatory inscription to acknowledge the authority of the voivode. The existence of a Moldavian metropolitan was new and controversial in the fifteenth century. One of Alexander's predecessors at the end of the fourteenth century had tried to circumvent the authority of the Patriarch in Constantinople by having bishops appointed by the Metropolitan of Poland, but subsequent patriarchs did appoint Moldavian metropolitans.[46]

In the inscription on the 1436 Neamț *epitaphios* (see Fig. 3) another church official recognized a different Moldavian voivode during a period of political instability. The dedication inscription names the Hieromonk Siluan as the patron.[47] The inscription also mentions Voivode Stephen II (r. 1434–47), one of several of the voivodes of Moldavia during the tumultuous period between the reigns of his father, Alexander the Good, and his nephew, Stephen the Great.

The inscriptions on these two Moldavian examples were not without precedent. An Albanian *aër* bears a similar inscription in which the patron, Bishop Kalistos of Glavenica and Berat, recognized the authority of 'the Great Princes of Serbia and Romania and all Albania the brothers Georgios and Balsha'.[48] That *aër* is dated 1373, but the earliest extant embroidered inscription that announces the relationship between an emperor or prince and a patriarch, metropolitan, or bishop is the *aër* of Andronikos Palaiologos of the late thirteenth or early fourteenth century.[49] In the inscription on the *aër* of Andronikos Palaiologos, the patron (probably the emperor himself) asks the 'Shepherd of the Bulgarians' to remember 'the ruler' (ἄνακτος) during the liturgy, thus announcing the mutual recognition of the emperor and the Bishop of Ohrid.[50]

Anna Muthesius has argued that such early examples associated with an emperor and embroidered with the iconography of the dead Christ would have been recognized as specifically embracing Orthodox Christianity.[51] In the period following the Council of Lyon (1274), at which the Union of the Churches of Rome and Constantinople was negotiated, distinctly Orthodox iconography certainly would have been useful for any patron wishing to signal anti-Unionist sentiment. Furthermore, the association of an emperor with a textile bearing an image of Christ would call attention to the role of the emperor as Christ's representative on earth.[52]

Is it appropriate to interpret textiles associated with patrons other than an emperor as sites for the display of Byzantine or even Orthodox identity? By the seventeenth century, Wallachian and Moldavian voivodes participated in the revivalist tendency that Nicolae Iorga dubbed *Byzance après Byzance*.[53] The art made under Stephen the Great's patronage at the end of the fifteenth century is better understood as expressing Byzantine continuity, however, rather than Byzantine revivalism.[54]

A dynamic period of diplomacy and warfare, Stephen the Great's reign has attracted considerable scholarly attention.[55] The idea of Stephen the Great as defender of the Orthodox Christian faith is common in the histories of medieval Romania.[56] Throughout his long reign, Stephen the Great attempted to control the various factions of the Moldavian nobility.[57] This would have involved violent displays of power, including the mass execution of prisoners, as well as other forms of capital punishment that in the popular imagination today are more commonly associated with Stephen's cousin, Vlad Dracula. Stephen's actions against the *boyars* were intended to make an impression within Moldavia rather than upon his foreign enemies.[58] Stephen the Great was also forced to craft a series of unstable alliances with Moldavia's neighbors. As R. W. Seton-Watson put it, Stephen the Great spent his career 'condemned to a triangular game between Turkey, Hungary and Poland'.[59]

Whether Stephen the Great is regarded as a Christian hero or a pragmatic, early-modern prince, the common themes in nearly every assessment of Stephen's reign are warfare and diplomacy.

The simplest interpretation of Stephen the Great's patronage of liturgical textiles is that he was a pious prince supporting Moldavian monasteries. The appeal to 'the will of the Father, the aid of the Son, and the fulfillment of the Holy Spirit' that begins the inscriptions on the Putna and Moldoviţa *epitaphioi* need not be construed as insincere simply because it is formulaic, but the political conditions within Moldavia must also be considered when we interpret that formula and what follows it. Stephen the Great had come to power after a long period of disunion and civil war. Between Alexander the Good (r. 1400–32) and Stephen the Great (r. 1457–1504), several different voivodes, including Stephen's father, competed to occupy the throne of Moldavia.[60] During the course of his reign, Stephen executed his father's assassin, Peter III Aron, and many other potential pretenders to the throne.[61] Near the end of Stephen's reign, the inscription on the Putna *epitaphios* mentions Stephen the Great's father, indicating the legitimacy of Stephen's rule, which is confirmed 'by the grace of God'. The inscription on the Moldoviţa *epitaphios* follows the same formula. These inscriptions also mention 'the most pious Maria', along with Stephen and Maria's children. In other words, the embroidered dedications on the *epitaphioi* of Stephen the Great make explicit not only Stephen's legitimacy, but also the line of succession.

Perhaps the relatively late dates of the Putna and Moldoviţa *epitaphioi* help to explain the emphasis on succession. Stephen the Great had ruled for more than thirty years by the time they were made. Both *epitaphioi* list his heirs. As Basil II Grand Prince of Moscow had been, Stephen the Great was also understandably concerned to specify the line of succession, especially given the turmoil that preceded Stephen's accession. Stephen the Great used *epitaphioi* to establish a connection to the Byzantine Empire by displaying his Orthodox Christian identity, and to announce his claim to the titles 'Voivode' and 'Lord of the land of Moldavia' for himself and his successor.

The Dobrovăţ *epitaphios* further reinforces the significance of these embroidered textiles as sites for the display of dynastic continuity. According to the inscription, Stephen the Great commissioned it before his death in 1504, but the textile was completed only in 1506, during the reign of Bogdan III (1504–17). The inscription on the *epitaphios* may have signaled Bogdan's intention to continue following the policies of Stephen the Great. By the end of his reign, Stephen had agreed to pay tribute to the Ottoman Empire, and he was not the first Moldavian voivode to do so.[62] This was the price of relative independence for Moldavia.[63] Before his death, Stephen advised Bogdan to continue paying the tribute, and Bogdan's subsequent adherence to this policy meant that relations between Moldavia and the Ottoman Empire remained stable through the duration of his reign.[64] It would have been crucial for Bogdan to take every opportunity to emphasize his relationship to his father and to reinforce the continuity of the dynasty's rule and policies. To any literate person who entered the church on Good Friday when the Dobrovăţ *epitaphios* was displayed, one meaning of the embroidered inscription would have been clear: Stephen's son Bogdan was the new 'Lord of the land of Moldavia'.

CHAPTER 5

Liturgical Textiles as Papal Donations in Late Medieval Italy

Christiane ELSTER

During the late Middle Ages, textiles functioned as a central medium for papal representation. Due to their mobility, these textiles were suitable for demonstrating the magnificence of the papal court within the context of papal liturgy and ceremony, especially during journeys. Liturgical textiles and insignia expressed the secular as well as the spiritual power of the pope and his retinue by interlacing these two aspects of papal rule in a complex manner.[1] Political claims and aspirations, in addition to moral concepts and the self-fashioned identity of the papal court, were communicated not only by the extravagant and costly material of the fabrics themselves, but also by the employment of iconographic programs and ornamental language. Moreover, the various contexts for which the textiles were commissioned and used reveal the values they aimed to communicate.[2]

In this essay, I explore the significance and function of donated liturgical textiles that were originally part of the papal treasury and were used in the context of papal ceremonies. Over a period stretching from at least the early thirteenth century and well into the fifteenth century, popes commonly gave precious textiles as gifts to clerical institutions such as cathedral chapters and convents. A wealth of written sources testifies to these donations, proving the significance of textiles within papal gifting-politics during this period, but few of the garments themselves have survived. Nonetheless, some remarkable cases of correspondence between the written record and surviving physical evidence have come down to us: embroidered liturgical textiles preserved in Ascoli Piceno, Anagni, and Pienza are recorded as having been papal donations by Nicholas IV (1288–92), Boniface VIII (1294–1303) and Pius II (1458–64) to the cathedral chapters of their hometowns.[3] Five copes, which are located in the Vatican Museums, the treasury of St John Lateran, in Bologna and St-Bertrand-des-Comminges, are believed to originate from comparable donation contexts.[4]

As a consequence of having been gifted, these liturgical textiles changed their wearer, their spatial context and their liturgical setting. Apart from the standard indication of their wearer's *ordo* within the clerical hierarchy, the textiles were charged with a new level of meaning because of their donation.[5] I argue that in their new locations, shifting from their original role as liturgical insignia, in part pontifical, these vestments became agents of memorial and political cultures focused on the papal donor.

The central questions of this essay are the following: why were these particular vestments chosen as gifts by the popes? How did textiles that were designed for the papal chapel or for the pope himself change upon being donated? What was the nature of the relationship between the pope and the recipients of his donations? How were such textile-gifts interpreted and used by the recipients?

To approach these issues, I will give an introductory overview of the forms and *modi* of papal textile donations during the late Middle Ages before moving to three case studies, which include the textile gifts of Nicholas IV, Boniface VIII, and Pius II to Ascoli Piceno, Anagni, and Pienza, respectively, in order to explore questions regarding the donors' intentions, as well as the function, use, and reception history of the donated items.

Forms and *modi* of papal textile donations in the late Middle Ages

The tradition of papal donations of precious liturgical textiles can be traced back to the early Middle Ages in the *Liber Pontificalis*.[6] Late thirteenth-century sources permit a distinction between two basic categories of papal textile donations. These might best be described as opposite ends of a spectrum encompassing papal donations of varying character. On the one hand, are the donations accompanying liturgical foundations, namely those connected to the erection of a chantry designed to host the liturgical *memoria* of the benefactor after his death by providing for the necessary personnel and spatial facilities. These include the institution of benefices, and the establishment and furnishing of a chapel or at least an altar. Donated textiles functioned as an integral part of this system. Examples of this practice appear in the records of donations of liturgical textiles by the Popes Nicholas III (1277–80) and Boniface VIII to the rooms of Old St Peter's that were endowed as their future funeral chapels.[7]

On the other hand, textile donations could function as independent acts occurring neither under the umbrella of liturgical foundations and furnishing programs, nor linked to a liturgical commemoration of the donor on specific occasions such as the Mass for the Dead. My research of the written sources thus far suggests two types of such donations: textile gifts not formerly belonging to the papal treasury and those that previously belonged to the papal treasury.

First, there are numerous entries in two preserved papal account books from the pontificate of Boniface VIII that record expenses for textiles given away as donations. These textiles were originally bought to be donated and never became part of the papal treasury. They actually include *panni*, or untailored cloth, which could be made into different types of garments by the receivers, according to their needs; and *tunicae*, which seems to refer to already tailored vestments.[8] The donations described in the papal account books were made during papal visits and journeys, and were given to clerical institutions in or near Rome.[9]

A second type of independent papal textile-gifts comprises textiles that belonged to the papal treasury before being bestowed, namely liturgical vestments and fabrics that were used in the context of the papal liturgy and court ceremonial. The recipients of those donations comprise clerical institutions both inside and outside the Papal states, as well as those who were politically linked to the Roman papacy, including, for instance, the cathedrals of the papal donors' former sees, the prominent churches of their hometowns, or favored religious orders. All the donated textiles were items that could be used in the liturgy of the institutions that received them. In fact, the popes did not donate specific papal insignia, but only textiles that could serve as vestments for the liturgical celebrants or as furniture-coverings for the altar and the interior of the church.[10] Such gifts tended to be single objects marked by the wealth, splendor, and pomp of their materials and characterized by a comparatively prominent visual presence within the liturgical setting. This becomes particularly striking when these fabrics are compared to the kinds of donations popes made to funerary chapel foundations. Inventories record both the liturgical furniture of Boniface VIII's funeral chapel in Old St Peter's and the regular donations of textiles to the Anagni Cathedral.[11] While the donations to the funeral chapel included essentially all the items needed for the celebration of the liturgy – namely liturgical vestments containing undergarments and upper garments, liturgical objects and manuscripts – the stock of items bestowed to Anagni Cathedral is dominated by objects that would have been highly visible during liturgical ceremonies. Indeed, regarding vestments, the Anagni inventory mentions far more outer garments like chasubles, copes, dalmatics, and *tunicellae* than undergarments such as *albae*. The same tendency is also found in regards to the textiles covering the

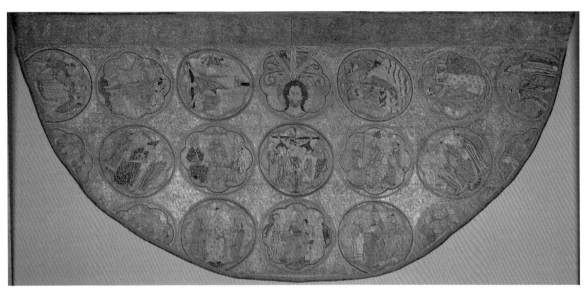

Fig. 1 Cope donated to Ascoli Piceno by Pope Nicholas IV, between 1265 and 1288, Ascoli Piceno, Pinacoteca Civica
Copyright: Ascoli Piceno, Pinacoteca Civica (Stefano Papetti)

altar. At Anagni, in contrast to the funeral chapel of Old St Peter's, many more antependia (*dossalia*) than altar clothes (*tobaleae*) were bestowed, while no *corporalia* were given at all. Sometimes the popes donated other kinds of gifts together with liturgical textiles, such as liturgical objects and reliquaries.[12] In some cases, money was given as well.[13] Frequently, popes favored clerical institutions more than once, donating multiple items over a period of time.[14] As a result, the number of items originating from papal donations grew at these institutions and eventually these donations figured as special ensembles within the treasuries, since they were characterized by a common provenance from the papal treasury.

Having established a rough framework for the varying character of papal textile donations, I will turn to three specific case studies. The first two concern the copes in *opus anglicanum* donated by the Popes Nicholas IV and Pius II to the cathedrals of Ascoli Piceno and Pienza.[15] The third is an ensemble of liturgical textiles with gold-embroideries on a red fabric of weft-faced compound twill, bestowed by Boniface VIII to Anagni Cathedral.[16] All these examples fall under the category of textiles that were originally made for the papal treasury and later bestowed on another church. The provenance of these textile donations from the papal treasury is documented by written sources and, in the case of the Ascoli Piceno cope, by the unusual use of papal iconography.

In 1288, Pope Nicholas IV donated a cope that arrived at the cathedral chapter of his hometown of Ascoli Piceno by envoy (Fig. 1).[17] The exact circumstances of the cope's commission are not known, but the occasion of this lavish donation might have been the three very important and nearly-consecutive feast days of St Emidius (5 August), the cathedral's patron saint, St Laurence (10 August) and the Assumption of the Virgin Mary (15 August).[18] Since the donation of the cope took place only five months after Nicholas IV had assumed the Holy See, it seems likely that it represented a strategic cultivation of political loyalty in the pope's hometown. Indeed, Ascoli Piceno was disturbed by political unrest resulting in anticlerical actions when Nicholas IV took the papal office. In order to strengthen the town's relationship to the papacy, Nicholas IV personally assumed

Fig. 2 Detail from fig. 1: Pope Clement IV. Copyright: Ascoli Piceno, Pinacoteca Civica (Stefano Papetti)

the title of Ascoli's *podestà* immediately after his election and sent the Franciscan friar Lamberto da Ripatransone as a peace broker.[19] It was the same Lamberto who personally delivered the pope's textile gift a few months later.

The idea that Nicholas IV's donation was politically charged is suggested above all by the striking papal iconography of the cope that represents the Roman papacy as authorized by the dual theological concepts of apostolic succession and the pope's symbolic role as the Vicar of Christ. A christological program forms the central vertical axis and includes images of the *vera icon*, the crucifixion and the enthroned Virgin and Child. This line of images is flanked by roundels with martyrdom stories and teaching scenes from the lives of various popes. The first register shows the martyrdoms of six early Christian popes, the second includes six confessor-popes teaching and the third contains four thirteenth-century popes, namely Alexander IV (1254–61), Urban IV (1261–64), Clement IV (1265–68), and Innocent IV (1243–54). The cope can be dated between 1265 (Pope Clement IV's election) and 1288 (the year of its donation to Ascoli by Nicholas IV), and was supposedly originally destined either for Pope Clement IV, the youngest of the four thirteenth-century popes represented, or for his successor for Gregory X (1271–76) (Figs 2 and 3).[20]

As stated in historical sources, beginning in 1528, Pope Pius II Piccolomini donated a cope to the cathedral chapter of his hometown, Pienza, in 1462 (Fig. 4).[21] The donation might have been

Fig. 3 Detail from fig. 1: Pope Gregory the Great. Copyright: Ascoli Piceno, Pinacoteca Civica (Stefano Papetti)

motivated by the dedication of the newly built cathedral, commissioned by Pius II, on 29 August 1462.[22] The cope was part of a larger ensemble of textiles donated to Pienza by Pius II during his pontificate in order to provide the new cathedral with liturgical furnishings. It can be dated between 1316 and 1320.[23] A written source noting a prepayment made in 1317 by the English Queen Isabella (d. 1358), wife of Edward II, probably refers to this cope; Isabella paid for an embroidered cope that she intended to send to Pope John XXII (1316–34) as a gift.[24] The fact that this cope was part of the papal treasury during the fourteenth century is confirmed by an entry in the inventory of the treasury in Avignon from 1369. Since the cope is mentioned as 'opus Anglie' and described very exactly with respect to its material and iconographic characteristics (including the orphrey embroidered with different birds), it is beyond doubt that the entry refers to the cope preserved in Pienza today.[25]

In contrast to the Ascoli cope, the iconography of this garment does not specifically represent a papal program, a difference to which I will shortly return. Three main zones of arcades frame

Fig. 4 Cope donated to Pienza by Pope Pius II, 1316-1320, Pienza, Museo Diocesano. Copyright: Soprintendenza B.S.A.E. di Siena & Grosseto (su concessione del Ministero per i Beni e le attività culturali)

twenty-seven scenes illustrating the life of the Virgin and the lives of St Catherine and St Margaret.[26] Two smaller zones are formed by the spandrels of the arches. The twelve apostles are placed in the lower set of spandrels, each bearing a label inscribed with a sentence from the Credo. The upper spandrels contain eight figures representing ancestors of Christ.

Apart from the examples presented above, other written sources contain evidence for the donations of textiles formerly belonging to the papal treasury. A large number of entries in the papal treasury inventories from 1295 and 1311 refer to red and white fabrics of weft-faced compound twill with heraldic animals in gold-embroidery that are called *opus cyprense*. A specific group of these *opus cyprense* textiles consists of a red fabric of weft-faced compound twill embroidered with double eagles, griffins, and parrots that are inserted in medallions. This fabric corresponds to the cloth of some textiles housed in the treasury of Anagni Cathedral that derive from the donations by Boniface VIII (Figs 5 and 6).[27] Consequently, these preserved garments must have been part of this larger body of liturgical textiles in the papal treasury, as documented in the inventories. In fact, the inventory of 1295 describes three copes, as well as one damaged cope, five fragments that probably once belonged to copes, and one chasuble made of this fabric.[28] The inventory of 1311 still lists three intact copes, one damaged cope, and two further fragments of the cloth. The very elaborate and detailed description of the embroidered cloth in the later inventory corresponds exactly to the fabrics preserved in Anagni.[29]

What message was conveyed by the donations of luxurious liturgical textiles deriving from the papal treasury as compared to the donations of textiles that did not formerly belong to the Holy See? Regarding the textiles originating from the papal treasury, it is quite probable that luxurious textiles, like the cope donated to Ascoli Piceno, had already been reserved for very special liturgical and ceremonial occasions before they were given away. Pope Clement V (1305–14), for instance, wore a splendid, precious cope of *opus anglicanum* during the canonization of Pope Celestine V in 1313.[30] Such precious garments often originated as gifts to the pope from high clerics and noble

Figs 5, 6 Cope donated to Anagni by Boniface VIII (details), 13th century (before 1250?), Anagni, Museo del Tesoro della Cattedrale. Copyright: Christiane Elster (with permission of the Soprintendenza B.S.A.E. di Roma, Graziella Frezza)

laymen, as seen in the example of the Pienza cope, and therefore embodied the power, authority, and centrality of the Roman Church as represented by the political relationships of the papal court.

Did the popes' decision to give away their own vestments represent a special expression of honor for the recipient? The close association to the pope's person, as well as to the papal court ceremonial and liturgy, surely increased the religious and monetary values of the donated textiles. Even more than new fabrics and garments with no papal association, a new worth would have accrued in addition to the material value of the gifts. The donated textiles did not necessarily need to refer iconographically to the papacy, or even carry any association with Rome exclusively through the act of donation; rather, the idea that the pope himself actually used the garments must have strengthened the connection to a notable degree. Historian Sybille Schröder emphasizes that donated vestments served as references to the donors in the gift-exchange culture of court societies in the Middle Ages, especially when the garments had been worn by the donor himself before they were given away. Vestments possess a code that results from their identification with the person wearing them. Once a garment has been transferred to another person it continues to refer back to the former wearer and to the relationship between him and the new owner. Thus the recipient of a vestment-gift is tied to the donor in a particularly visible and ostentatious manner.[31]

Donations of vestments already worn by the donor were a widespread feature in ceremonials of 'honorific robing', which, according to Stewart Gordon, originated in Central Asia and were transmitted to Europe via the Middle East in the early Middle Ages. The robes that a ruler had actually worn were considered to be the most prized of all honorific vestments, because it was believed that some of a prince's essence remained in the clothing.[32] The medieval legal practice of cloak-protection (*Mantelschutz*), which represented a gesture of both protection and binding, may also have bearing on the papal textile donations involving liturgical vestments.[33] By covering a foreigner with one's coat, for example, a donor claimed his kinship. While the donor offered protection to the recipient, the latter in return gave his allegiance and loyalty.[34] Finally, the fact that gifts of vestments and garments were sometimes rendered as a form of compensation must be briefly considered, even if the donor of those gifts had not typically used them before bestowing them. In the Middle Ages, such gifts were a common form of courtly communication, cultivated at the papal court as well. In the thirteenth and fourteenth centuries, popes and cardinals regularly equipped their *familiae* and domestics with vestment gifts.[35] The circle of the courtly *familia* was knit together by unifying its members through vestments.[36]

In the case of the donation to Ascoli Piceno, a written source informs us that Pope Nicholas IV in fact intended this gesture as a particular demonstration of honor to the recipient of the gift, the cathedral of Ascoli. A papal letter, directed to the cathedral chapter of Ascoli, was issued in Rieti on 28 July 1288 and reached the town of Ascoli Piceno a short time after the donation of the cope.[37] Apart from referring to the close relationship of Nicholas IV to his hometown, the letter also stresses the material value of the chosen gift and the virtuosity of its craftsmanship.[38] Similar papal letters accompanied two donations of textiles and liturgical objects by the same pope to the convent of San Francesco in Assisi. Nicholas IV, as a Franciscan himself, emphasized his close relationship to the religious community of the recipients in these cases as well.[39]

Function and reception of the papal textile gifts

Regarding the character of these honorable presents, some fundamental questions arise. One particularly important issue is whether the donated textiles were integrated into the liturgical

settings of the clerical institutions that received these gifts. In other words, were they embedded into a new ritual context, or were they simply kept in the treasuries of the respective churches, thereby having exclusively symbolic functions? There are persuasive factors in favor of the first argument. Apart from some scant evidence in written sources, numerous traces of usage and reworking on the surviving donated textiles bear witness to the garments' liturgical use for centuries after the time of donation.

Some specific instructions survive with regard to the liturgical use of the vestments donated to Anagni and Ascoli Piceno. The inventory of Anagni Cathedral, written around 1300 and containing the gifts of Boniface VIII to the cathedral, includes regulations regarding the liturgical use of two very precious white copes.[40] Only the bishop was allowed to wear them, and then on only two occasions, namely, the two most important feast days of the liturgical calendar in Anagni. These were the feast of St Magnus (19 August), patron saint of Anagni, and a certain, un-named feast day of the Virgin Mary, probably the Annunciation on 25 March, which corresponded to the dedication of the cathedral.[41] Moreover, evidence of reworking on the preserved textiles in Anagni suggests their liturgical usage at least until early modern times. During the late sixteenth century, they were not only reworked for conservational reasons but also adapted for the necessities of the post-tridentine liturgy. The vestments of a weft-faced compound twill and of *opus anglicanum* originating from the former papal donations were reworked into two complete sets of episcopal vestments in the liturgical colors of red and white.[42] Part of the old vestments were preserved through adaption of the garments to sixteenth-century style, as in the case of the red and gold embroidered chasuble of weft-faced compound twill.[43] Other parts of the vestments, however, were destroyed by being completely cut off and reworked into new vestments, as in the case of two new dalmatics made in *opus anglicanum*. These dalmatics were composed of fragments of a former cope representing the martyrdom of different saints, and a dalmatic embroidered with many scenes from the life of St Nicholas from Myra. The main part of the latter vestment, however, was reworked into a chasuble.[44]

Concerning the cope in Ascoli Piceno, as seen in Nicholas IV's letter quoted above, the pope attached certain restrictions to the gift and gave specific orders regarding the preservation and liturgical use of the cope. He instructed the cathedral chapter to use the cope during important feasts and forbade any form of alienation, pledging or gifting of the vestment.[45] Technical and material traces on the cope – including the addition of a new lining, a repair to the orphrey and border, and other evidence of eighteenth-century alterations – suggest that it was sometimes used in the liturgy well into modern times.[46] Similarly, in Pienza, evidence exists showing that the garments donated by Pius II were used liturgically until the nineteenth century. In 1770, for instance, they were still worn by the bishop on the most important feast days of the liturgical calendar.[47]

What was the function of such papal textile donations? According to the theory of the gift developed by the French anthropologist Marcel Mauss in the 1920s, donations create lasting social relationships and are characterized by reciprocity. This concept necessarily includes three elements: giving, accepting, and reciprocating. Having accepted the gift, the receiver is obliged to reciprocate.[48] The principle of reciprocity, however, does not always imply a strictly balanced material exchange; in fact, material goods could be recompensed by immaterial services. The papal textile donations represent such a type of asymmetrical or agonistic exchange.[49] They are not defined by a strictly determined and obligatory transfer of giving and receiving, as for example in the case of liturgical foundations.[50] In fact, the popes seem not to have expected reciprocation for the offered garments in the equivalent form of material goods or (liturgical) services. Instead, by demonstrating their generosity through the material splendor of the donated items, the donors accumulated symbolic capital

of honor.[51] Nevertheless, the inalienability of the donated textiles and the restriction of their liturgical use to certain feast-days were conditions defined by the donor, binding the recipients. Since the gifts were closely associated with the donor's person, office, and partly even with his body, I argue that these articles served as a sort of material reference to the papal donor and the Roman papacy in their new locations. By using them in their own liturgies, the recipients were likely expected to honor the papal donor and to express their political loyalty to the Roman papacy.

Annette Weiner has amplified Mauss's theory by including inalienable goods as a prominent category in the gift-exchange system.[52] Inalienable goods, in fact, offer a new and plausible explanation of the way agonistic gift exchange works:

> [...] the ownership of an inalienable possession establishes and signifies marked differences between the parties to the exchange. The possession not only authenticates the authority of its owner, but affects all other transactions even if it is not being exchanged. For the possession exists in another person's mind as a possible future claim and potential source of power. [...] In other words, things exchanged are about things kept. [...] The motivation for reciprocity is centered not in the gift *per se*, but in the authority vested in keeping inalienable possessions. Ownership of these possessions makes the authentication of difference rather than the balance of equivalence the fundamental feature of exchange. [...] hierarchy resides at the very core of reciprocal exchange.[53]

According to Weiner, the asymmetrical form of reciprocity typical of gift exchange is fundamental to the establishment of social hierarchy and power. This asymmetry does not result only from the donated or exchanged objects themselves. Rather, the balance of power between donor and recipient is dictated by inalienable goods owned by the higher-ranking partner of the gift exchange, which generally never leave his possession. Inalienable possessions are defined, apart from their material value, by an immaterial value resulting from their history and their sacred origins.[54] They represent myths and genealogies (fictive or true) and are further characterized by a memorial function: '[...] inalienable possessions are symbolic repositories of genealogies and historical events, their unique, subjective identity gives them absolute value placing them above the exchangeability of one thing for another.'[55] In contrast to alienable goods, inalienable goods may be physically transferred to new keepers, but they remain, in essence, the property of the original owner.

A characteristic feature of objects preserved in medieval treasuries was their perceived inalienability, which resulted in an increased value at the time.[56] Nevertheless, their inalienable status was not absolute or sacrosanct. When given away as gifts, such items changed their status and became alienable objects. At the same time, as individual objects, they referred back to the identity of the treasury from which they came. This model applies to the papal textile gifts, which continued to interact – so to speak, as *pars pro toto* – with the parts of the papal treasury that were not bestowed. Apart from the great material value of the donated textiles, the stock of objects retained in the papal treasury (including truly inalienable items, such as the papal insignia or political trophies), asserted the superior strength of the papal donor over the recipients and created a dependent relationship.[57] Once given away, the papal textiles became the possession of the favored clerical institutions, resulting in an increase of value and a transformation in the status of the vestments. The custody and liturgical use of the textile gifts by the recipients according to instructions by the papal donor were meant to ensure the institutions' dependence upon the pope and the perpetual cultivation of his memory.

Consequently, the aim of the papal textile donations might have been the establishment of a papal memorial culture. During the celebration of the liturgy, in which the donated textiles were used and seen by clerics and laymen, the papal donor (and former wearer of the vestments) would have

Fig. 7 Mitra Pius' II, detail: Enamel with the papal coat of arms, ca. 1462 (enamel), Pienza, Museo Diocesano. Copyright: Christiane Elster (with permission of the Museo Diocesano di Pienza, Gabriele Fattorini)

been memorialized. The textiles would then have functioned as a visualization of papal authority and power despite being worn by a different person in a new setting.

It seems likely that this 'reference-function' of the donated textiles manifested itself in different settings, influenced both by the specific liturgical and spatial contexts of the new location and by the appearance of the donated textiles. Apart from their exceptional material splendor, the iconographic programs of many donated textiles carried special meaning as well, and this would have been understood by the clerics who wore them. The secular symbols of power that characterize some papal textiles, such as the heraldic animals decorating the set of red Anagni vestments donated by Boniface VIII, or explicit papal iconographies, like those on the cope of Ascoli Piceno, might have been perceived differently from christological or hagiographical pictorial programs, like that on the Pienza cope.[58] While the latter would have fitted into the local feast-calendar more easily, the vestments with papal iconography had ever-present references to Rome literally stitched and woven into their fabrics.

Nevertheless, it is necessary to distinguish between the intention of the papal donor and the reception and ongoing interpretation of the textile gifts by the recipients. The interests of the parties involved in a donation are not always identical; on the contrary, they often differ. Later archival evidence in Anagni, Ascoli Piceno, and Pienza demonstrates that the endowed communities created and reformulated a memorial culture for the papal donor according to their own needs. The papal donor was only commemorated if this process served the creation of the communities' own historical identity. In other words, the memory of the papal donor became a means for the recipients to construct their own identity. Indeed, the recipients tended to mystify the donated textiles by

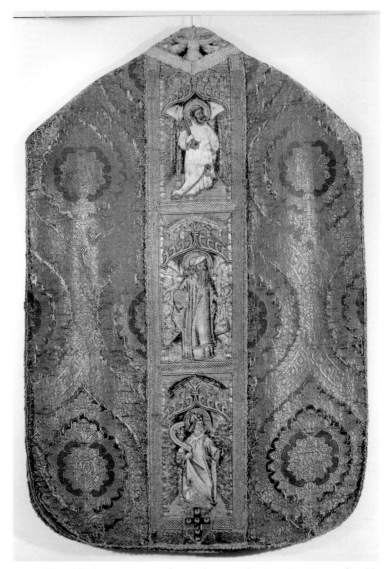

Fig. 8 Chasuble deriving in part from a donation by Pius II to Pienza (back), 15th century (reworked in 17th century), Pienza, Museo Diocesano. Copyright: Soprintendenza B.S.A.E. di Siena & Grosseto (su concessione del Ministero per i Beni e le attività culturali)

attributing them deeper in history, inflating their value, and linking them to historically significant persons.[59]

Written sources in Anagni, Ascoli Piceno, and Pienza, including inventories, resolutions of the cathedral chapters, account-books and descriptions of the cathedrals and their moveable furniture, prove that the memorial function of the donated textiles continued well into modern times, sometimes until the nineteenth century. In most of them, the papal donor is mentioned explicitly by name. Thus, the memory bound to the donated textiles was enshrined in text. The written medium seems to have been used systematically by the recipients, within certain temporal and historical contexts, in order to constitute the meaning of the vestments originating from papal donations. Such written sources may even have compensated for the lack of clear references to the donor on the

Fig. 9 Detail from fig. 8: Papal coat of arms of Pius II Piccolomini at the lower end of the orphrey, Pienza, Museo Diocesano. Copyright: Christiane Elster (with permission of the Museo Diocesano di Pienza, Gabriele Fattorini)

actual textiles themselves. The written form of inventories is particularly instructive in this regard, for, as Lukas Burkart and Jennifer Kingsley point out, inventories possess a value of their own as written versions of a treasury's stores, independent from the real objects.[60]

The composition of the inventory listing the donations of Boniface VIII to Anagni Cathedral demonstrates a specific desire to document the pope's gifts as a memorial to his person. Rather than being integrated into a general inventory, which listed all of the cathedral's moveable furniture, Boniface's donations are described in a separate inventory, listed primarily in the order of the different donation contexts. The papal donor is mentioned again at the beginning of every new paragraph.[61] In the cathedral's later inventories from the sixteenth and seventeenth centuries, the papal textiles continue to be regularly ascribed to Boniface VIII, but Pope Innocent III (1198–1216) is introduced as a papal donor as well.[62] This addition results from a tradition claiming that the Anagninian popes before Boniface VIII had already given textile gifts to the cathedral, thus connecting Innocent III with a part of the preserved garments that actually came from Boniface VIII.[63] The insertion of Innocent III as a papal donor is not surprising. Boniface VIII and Innocent III were the most important popes originating from Anagni and both were central figures in Anagni's local history.[64] Recording gifts by these two popes seems to have been a means of dignifying the cathedral's history. In the context of the reform movements of the sixteenth and seventeenth centuries, the gesture would have served to express Anagni's position as a former papal residence and the enduring connection between the town and the Holy See.[65] Consequently, the commemoration of the donor became conflated with the commemoration of the recipients, serving to construct their own

history and identity. Similar tendencies can be observed in Ascoli Piceno and Pienza. In inventories and other sources, the papal copes and other donations made by Nicholas IV and Pius II have been regularly associated with the name of the donor since the sixteenth century.[66]

In addition to the memory of the donor preserved in the medium of written sources, material traces on some of the donated textiles suggest that they indeed served a memorial function for centuries after the act of papal donation. In this context, the coat of arms served as a medium of papal representation that emphasized the individual personality and the family origins and background of its owner more than the papal office in general. It was indeed Pope Boniface VIII who introduced the coat of arms both into the moveable and the monumental media of papal representation.[67]

Regarding textiles, the inventories of the papal treasury from 1295 and 1311 document a large number of '*panni lucani*' patterned with the coat of arms of Boniface VIII's family, the Caetani.[68] Sometimes these coats of arms were altered with papal insignia like the tiara or the keys, with heraldic animals or even with the coats of arms of European rulers, such as the English and French kings.[69] It seems likely that the textiles with such heraldic patterns functioned as visual references to Pope Boniface VIII and created a link between the stock of the papal treasury in its totality and the actual holder of the papal office as an individual person.[70] The inventory of Boniface VIII's donations to Anagni Cathedral testifies that some of the gifted textiles were marked with the Caetani family's coat of arms as well.[71] Unfortunately, none of those is preserved, but within the total stock of textiles given to Anagni they would have served as specific and strong visual references to the papal donor.

It seems that Pope Pius II systematically continued this tradition. All the items – liturgical textiles and objects alike – preserved from his donations to Pienza Cathedral are marked with the Piccolomini family's coat of arms, crowned by the papal tiara and the keys. By including such a symbol of the donor, the donations are visually marked with their provenance. In addition, some of the liturgical objects are provided with inscriptions naming the papal donor.[72] Enamels attached to the lappets of a reworked miter originally gifted by Pius II show the pope's coat of arms (Fig. 7).[73] The papal coat of arms were applied to two vestments as well. Pienza Cathedral's inventories of 1550 and 1729 mention a hood (*capuccjio*) belonging to the cope in *opus anglicanum* that was decorated with the papal coat of arms of Pius II. This added hood no longer survives, but the description could refer to such a 'provenance mark' ordered by Pius II. In essence, the pope may have effectively marked the cope before donating it to the cathedral of his hometown.[74] On the reverse of the same cope, however, there is a patch made from red lampas cloth from the fifteenth century with Pius II's embroidered coat of arms.[75] In this case, it would have been the recipients who applied the papal coat of arms only after the cope had been gifted, in order to remember the papal donor. In the same manner, on a fifteenth-century chasuble, which derives in part from a donation made by Pius II that was reworked in the seventeenth century, the coat of arms was applied at the lower end of the orphrey on the back (Figs 8 and 9).[76]

The papal textile donations presented in this essay were not bound to foundations dedicated to the liturgical *memoria* of the benefactor after his death, as applies to the liturgical furnishing of chantries. On the contrary, they were independent acts conveying complex and multi-layered messages. Within the context of the broader field of papal donations, it is likely that these gifts aimed to create an obligation for the recipients to honor, support, and remain loyal to the papal donors and the institution of the Roman Papacy. The textile medium, in fact, might have conveyed this intention particularly well because of its materiality. Previously used vestments functioned as especially strong references to the donor because of their physical contact with his body. At the end of the thirteenth century, popes donated both new and used vestments, the latter coming from the

papal treasury. Because of their high symbolic value, it was this second category of textile-gifts that represented a special honor for the recipients. In addition, on a symbolic level, the act of donating papal liturgical vestments invoked the legal custom of the cloak-protection, a gesture that was well known in medieval society.

As a consequence of the donations, the papal textiles were re-contextualized in respect to their wearers, their spatial environment and their liturgical setting. Since, at the same time, they referred back to their provenance from the papal treasury and to their donor, these moveable objects were charged with new meaning. They became bearers of a memorial culture focused on the person of the papal donor. Nevertheless, the memory embedded in the papal textiles could become independent and change over the course of their tenure at the recipients' locations. This can be described as a process of continuing reinterpretation, which depended on the respective social and political contexts. Written sources and physical traces on the textiles themselves demonstrate efforts to establish and to preserve provenance. This form of commemoration, however, served primarily to construct and to reformulate the recipient communities' own identities, and could be transformed according to their needs. By inscribing a papal donor in collective memory, the recipients of textile gifts shaped and elevated their own role in history.

CHAPTER 6

Monument in Linen: A Thirteenth-Century Embroidered Catafalque Cover for the Members of the Beata Stirps of Saint Elizabeth of Hungary*

Stefanie SEEBERG

The precious cloths used to cover the coffin, catafalque or tomb during funeral and memorial masses for the dead were part of most commemorative *memoria* in the Middle Ages.[1] They are mentioned in church inventories and deeds of foundations, and they often appear in illustrations of the mass of the dead in books of hours from the late Middle Ages (Fig. 1). Many of them are described as being made of rich materials such as silk and gold and silver threads with a wide variety of colors and iconographic programs that were either woven or embroidered.[2] The material, hues and iconography of the individual cloths communicated the social and political power of the deceased and honored them as well. Often a tomb cloth or catafalque cover that had been used for the funeral was also used for the memorial mass.[3] So far, there has been no art historical examination of this group of medieval textiles, not even in the extensive research of the last two decades devoted to medieval tombs and memorial culture.[4] This is primarily due to the fact that only a few of these precious textiles have survived. The earliest examples mentioned in the current scholarly literature date from the fifteenth century, however, there is evidence that still older ones survive.[5] These types of textiles were typically reused in different contexts and thus their original designation as tomb cloths has often gone unrecognized.

An exceptional example of an embroidered tomb cloth from the female Premonstratensian convent of Altenberg/Lahn is today preserved in the Museum für Angewandte Kunst in Frankfurt am Main (Fig. 2).[6] This is an early example of a medieval linen embroidery from Germany and has until now been considered to be a table- or altar-cloth.[7] I will argue instead that this embroidery was the cloth of the catafalque that was installed in the church of the monastery on feast days commemorating the family of the Landgrafen von Thüringen and Hessen.[8] An analysis of the cloth itself, as well as testimony found in written documents, the historical context of its making, the architecture of the church, and its stained glass decoration, all provide evidence for this hypothesis.[9] This example, surprisingly made from linen rather than from silk, sheds new light on a heretofore unknown use of catafalque covers in the thirteenth century.

The Embroidery from Altenberg

The Altenberg cloth has an impressive size of 136 by about 327 centimeters. The embroidery is worked with natural linen thread as well as blue-dyed linen thread—now faded—on an undyed white linen ground.[10] The figural program shows male and female figures with crowns and halos, standing under arcades above a sequence of haloed half-length figures holding banderoles. Eleven crowned figures are arranged in two rows in mirror formation along either side of the central axis of the cloth. Grouped in pairs, the gestures of their hands and the direction of their bodies suggest they are in conversation. Since there are an odd number of these royal figures in each row, two queens stand alone at the ends without corresponding partners.[11] Only the first queen of one row holds a

Fig. 1 Book of hours, Jan van Eyck, Turin, Museo Civico d'Arte Antica e Palazzo Madama, Hs. Inv. no. 47, fol. 116r (copyright: Fondazione Torino Musei)

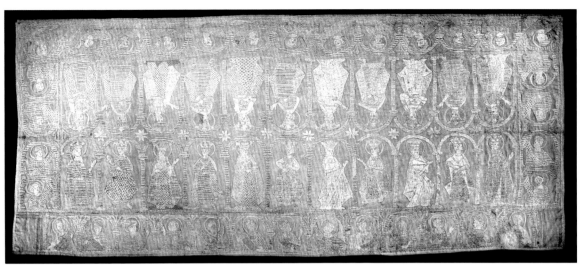

Fig. 2 Catafalque Cover, Altenberg/Lahn (*c.* 1280), Museum für Angewandte Kunst, Frankfurt / Main (Photo: Uwe Dettmar, Frankfurt)

scepter as an additional attribute of her royal power. The fashion of their clothes clearly belongs to the second half of the thirteenth century.[12] For instance, typical of the princely fashion of this time are the cords and tassels that fasten the cloaks across the chest. Furthermore, the gesture of holding the mantle-cord with one hand is also a common representation during the second half of the thirteenth century. Some of the gowns have broad laces decorated with jewelry that are typical of the Romanesque period. Another fashionable detail is the shoulder-length fur trim.[13]

The two rows of royal personages are surrounded on all four sides by a border of thirty-four busts consisting of thirty-two males and two females. All the figures wear halos and hold banners that have only ornamental fillings and no texts. The male figures are shown as men of different ages—some with beards, while others wear caps—but all lack any specific attribute that would help identify them. The two holy women are dressed in veils and wimples.

The iconographic program and its intended meaning are not easy to reconstruct today. In 1880, Joseph Aldenkirchen, who examined the cloth first, suggested that the full-length figures were secular, and speculated that the embroidery had been a tablecloth for princely feasts.[14] In contrast, Leonie von Wilckens believed this to be an altar cloth, first suggesting in her 1960 essay that the figures were saints, while in 1975, she re-identified them as royal couples from the Old Testament.[15] Similarly, Aldenkirchen described the busts as saints, and even though von Wilckens called them saints as well, she also discussed their possible meaning as prophets and apostles.[16]

However, a closer look at these figures together with their organization along the central axis and the measurements of the cloth, allows for a more precise definition of the textile's original function. The clothing worn by the depicted figures, as discussed above, clearly indicate that the embroidery was produced in the second half of the thirteenth century in Altenberg, during the period when Gertrud of Thüringen (1227–1297), daughter of Saint Elizabeth of Thüringen (1207–1231), directed the monastery as *magistra*.[17] I will explore the hypothesis that the cloth was originally made as a catafalque cloth to be used during the memorial days of Gertrud's family, that is the landgraves of Thüringen and their offspring, the landgraves of Hessen. The axial arrangement of the figures under the arcades reflects a design principle and iconographic arrangement found in shrines and tombs of the time. When laid atop on a catafalque, this design would have become even clearer. A valid

interpretation of the pictorial program and the function of the cloth must take into account both the sacred and secular aspects that are closely related to the historic circumstances of its production.

Provenance

It is well documented that the linen cloth belonged to the convent of Altenberg before it was sold to the city of Frankfurt in 1924.[18] The first time the cloth is mentioned in scholarly literature was in 1885 by Aldenkirchen, who saw it at Altenberg before it was sold and described it as an embroidery from Altenberg. Aldenkirchen, who called the textile a table cloth, noted that it had been referred to as a pall (*Leichentuch*) up to that point.[19] Rather than discounting this observation, it provides an important and telling confirmation of the textile's historical function, which apparently was still understood in Altenberg in the nineteenth century.

While there are no archival documents from the convent of Altenberg that mention the embroidery, there is good reason to assume it was manufactured at Altenberg during the thirteenth century. Other surviving textiles and manuscripts can be attributed to Altenberg and suggest that the nuns produced both manuscripts with ink drawings and textiles with figural imagery during the time of Gertrud.[20] For example, a similar thirteenth-century linen embroidery, housed today in the Hermitage in Saint Petersburg, has also been attributed to Altenburg. Its pictorial program includes several aspects of great personal importance for Gertrud and her convent, and displays one scene that is repeated in a drawing in a gospel book belonging to Gertrud that was also probably made in Altenberg.[21] Additional embroideries attributed to the fourteenth century provide further evidence of textile production at Altenberg during the Middle Ages.[22] Indeed, there was an important tradition of women producing textiles, which had been established by Gertrud's mother, Saint Elizabeth, who was known to have spun wool for Altenberg.[23]

Propagandistic Aims of Gertrud von Thüringen, Magistra of Altenberg

The pictorial programs of both the catafalque cover and the cloth containing scenes of the life of Saint Elizabeth dovetail nicely with Gertrud's efforts to elevate the importance of Altenberg during her reign as *magistra* between 1248 and 1297.[24] Elizabeth had given her daughter Gertrud to the small convent when she was still a young child, almost a baby.[25] Before her birth, her parents had promised to offer their child to God if her father Ludwig should die during the Fifth Crusade. When the landgrave died in 1227, Elizabeth decided that she would give up her former life and follow Christ. She left the court at Eisenach, went to Marburg and placed Gertrud in the monastery of Altenberg, some 70 kilometers away. Elizabeth died in 1231 and was canonized shortly thereafter, in 1235. Her veneration was widespread by the thirteenth century and she quickly became one of the most famous saints of the period. The Teutonic Knights built St Elizabeth's in Marburg, which, as the site of Elizabeth's tomb and relics, became an important center of pilgrimage.[26] After the end of the thirteenth century, the south apse of this church became the burial and memorial place of the landgraves of Hessen.[27]

Immediately after her investiture as *magistra* in 1248, Gertrud, who was then twenty-one years old, started to rebuild the nunnery at Altenberg, including the central church and the main parts of the enclosure of the nunnery.[28] We can assume that she was supported by her sister Sophia, who was married to Heinrich II, duke of Lower Lorraine and Brabant, one of the most powerful princes of the Holy Roman Empire.[29] In this same year, Sophia was widowed and had to act as regent for her four year-old son. Meanwhile, she continued her efforts to preserve her and Gertrud's father's

patrimony in Hessen.[30] Sophia chose Marburg as her primary residence and used the fame of her prominent holy mother to strengthen her own political power.[31] Contemporaries revered all three of Elizabeth's children—Sophia, Gertrud and Hermann (1222–41)—for being the children of the saint and were afforded relic-like status because they had been touched and caressed by their holy mother.[32] In turn, the children used the reverence and respect of their contemporaries to strengthen their own influence and to preserve the political position of their father's rule. Both sisters signed documents as 'the daughter of Saint Elizabeth'.[33]

The expansion of the convent of Altenberg was also of interest to the family of the landgraves of Thüringen.[34] Gertrud, supported by her influence and connections as the daughter of Saint Elizabeth and as a daughter of the landgraves, established Altenberg as an important center for the veneration of her mother and a station for pilgrims on their way to Marburg.[35] Through her connections, the monastery possessed relics of Saint Elizabeth, the most important of which was an arm bone placed in a reliquary in the shape of a right arm with a blessing hand.[36] With this visible presence of Saint Elizabeth and an almost-familial connection to her through her daughter Gertrud, the monastery attracted donors and patrons of powerful families who were encouraged to install their *memoria*, since the close relation to the saint promised the best chances of salvation for the souls of the dead.[37] As both a center for the veneration Saint Elizabeth and a dynastic *memoria*, the architectural complex of the monastery had to consider the needs of the nuns, who were cloistered, while ensuring accessibility for pilgrims, visitors, patrons and prestigious local lords. Constructing the monastery with two cloisters and two halls and regulating the use of the church accommodated these different groups.[38]

Gertrud and her sister Sophia established the *memoria* of their father's family in Altenberg. This is documented by a donation in 1268, as well as by the necrological entries in a personal gospel book that belonged to Gertrud.[39] In addition, the day of commemoration is mentioned in the instructions for the sexton written in the sixteenth century.[40] The sisters' foundation not only served the *memoria* and salvation prospects of their ancestors, but also made the presence of their family—the ancestry of the offspring of the landgraves of Thüringen in their new region of Hessen—visible. Of course, as was usual in the Middle Ages, pictorial works reinforced the family's *memoria* and presence.[41]

Precious liturgical objects, as well as wall paintings and stained glass, gave visual evidence of the *memoria*, not only of Gertrud and Sophia, but also of other important patron-families, such as the Earls of Nassau.[42] The windows of the church of Altenberg were sold in 1805 and became a part of a private collection in Erbach. While only a few of the stained glass panels are extant today, four of these are at the Cloisters collection of the Metropolitan Museum of Art in New York.[43] Additional information about the stained glass program survives in descriptions written by Prior Diederich around 1650, as well as in water-color illustrations that were produced at the time of their sale.[44] In the lowest register, there were standing figures of patrons of the monastery with corresponding inscriptions of their names and coats of arms. The most prominent of these, King Adolf von Nassau and his wife Imagina, were included in the window from the central axis of the choir, which was among those that were copied in water-color in 1805 (Fig. 3).[45] Diederich described several of the figures, including the figures of Ludwig IV, the husband of Saint Elizabeth and father of Gertrud and Sophia, as well as their grandparents.

In common with other medieval religious foundations, textiles played an important part at Altenberg.[46] In addition to the catafalque cover, two other textiles have survived from Altenberg dating to the time of Gertrud: a lace made of silk and an embroidery showing scenes of the life of Saint Elizabeth and her husband Ludwig IV, Landgraf von Thüringen.[47] The lace was probably once part of a liturgical vestment and bears a dedicatory inscription that reads: *Gertrudis magistra filia*

Fig. 3 Copy of stained glass with King Adolf of Nassau and his wife Imagina, watercolors, 1805 (?), Erbach, Gräfliche Rentkammer (reproduced after Parello, 2008, p. 79, fig. 14)

beata Elisabeth me fecit ('Magistra Gertrud, daughter of the blessed Elizabeth, made me'). Furthermore, three altar cloths, which once decorated the high altar, the liturgical center of the church, were made in the generation after Gertrud. These textiles, which were made by female members of the founding families who lived in the convent, functioned as an important site for including inscriptions and representations of donors and patrons.[48]

The Altenberg tomb cloth must be seen in the context of the memorial endowments of the landgraves of Thuringia and Hesse. The document that records the donation that Gertrud and Sophia made in 1268 for the *memoria* of their family provides no details about how this *memoria* was to be celebrated, except to say that it should be celebrated with due devotion (*ipsorumque memoria ibidem cum devocione debita iugiter habeatur*).[49] However, as documents for other contemporary *memoria* indicate, provisions would have been made for the liturgy, as well as for the decoration of the church. The liturgical *memoria* consisted of two main parts: the Requiem Mass and the Office of the Dead, which was celebrated in the choir of the convent.[50] The main church decorations used for the feasts of remembrance typically included candles and textiles, either for the tomb or, if there was no tomb, a textile on the floor or on a catafalque.[51] Since the family of the landgraves had no tomb at Altenberg (these were located instead at the monasteries and churches in Rheinhardsbrunn, Eisenach and Marburg) it can be assumed that on memorial days, a catafalque was temporarily installed in the church.[52] The Altenberg cloth in Frankfurt would have suited this purpose perfectly.

As mentioned earlier, the figures on the cloth are depicted as members of a royal family with crowns and sumptuous dresses. In addition, the halos show them as members of the *beata stirps*

Fig. 4 Catafalque, nineteenth century, Klostermuseum Dalheim (copyright LWL/Stiftung Kloster Dalheim. LWL-Landesmuseum für Klosterkultur)

('holy lineage') of Saint Elizabeth. The iconographic type of standing figures under arcades on the one hand refers to the architecture of shrines for relics of saints and underlines the close connection to Saint Elizabeth. On the other hand, this type also references tombs of kinship, a form of tomb that had only recently been developed.[53] For memorial feasts, the cloth would have been laid on a catafalque, which based on the textile's shape and design, was likely in the form of a small house with a gable (Fig. 4). The linen embroidery, which today seems to be a white-on-white embroidery, in fact once had dark, colored outlines that made the imagery more clearly visible. Displaying royal figures and measuring at least forty centimeters in height and 270 centimeters in length, this cover would have been an impressive memorial monument, albeit a temporary one.

Details of the Pictorial Program

Kings and Queens with Halos

The most convincing evidence for the use of the cloth as a catafalque cover is the unusual figural program of the embroidery. It is remarkable that the standing figures wear crowns and halos. Rows of standing kings and queens can be found in some of the sculptural programs of French cathedrals, such as the column-figures on the western facades of Saint-Denis and Chartres, as well as in the stained glass in the Cathedral of Strasbourg.[54] In a biblical context, rows of Old Testament kings show the genealogy of Christ. The tradition of depicting rows of kings in genealogies existed in the Middle Ages, not only for the heavenly king but also for secular kings and powerful dynasties.[55]

Like manuscripts, shrines and tombs provide a prominent place for the representation of geneal-

ogies. One of the most famous examples is the shrine of Charlemagne still located in the Cathedral of Aachen, commissioned by Emperor Frederic II and finished in 1215.[56] Subsequent depictions of genealogies became common on tomb monuments especially in France, Brabant and England.[57] One early example is the tomb of Sophia's husband, Henry II of Brabant (d. 1248), found in the Church of Notre-Dame at the former Cistercian abbey of Villers.[58] This tomb was destroyed during the French Revolution, but drawings made during the seventeenth century provide an idea of its original appearance.[59] On the cover, there was an effigy of the duke dressed in princely clothes, but of particular interest is the figural program on the four perpendicular sides. Six figures standing under an arcade were displayed on the long sides, representing three apostles next to three counts shown in armor with their armorials prominently displayed on their shields. On the end under the head of the duke was a nude, crowned figure in prayer that represented the soul of the count that was being taken to heaven by two angels.[60] The message of the program was comparable to that seen in the Altenberg cloth: the deceased, who is commemorated in the monument, is illustrated as one in a succession of saints and relatives. It is quite likely that the tomb of Sophia's husband in Brabant provided inspiration for the cloth. In fact, the program of the embroidery of Altenberg may have fostered the spread of this new fashion in tomb design in Germany. Although popular in France and Brabant, there are no surviving German tombs with standing figures under arcades from the thirteenth century; the tombs of the landgraves of Hessen in the Elisabethkirche in Marburg of the first half of the fourteenth century are the earliest extant examples.[61] Is it possible that the new fashion of tomb decoration found its way to Hesse through Sophia and that she influenced the concept of the Altenberg catafalque cloth?

Furthermore, the influence of tomb iconography on the Altenberg embroidery is evident in the representations of the individual figures. Effigies of noble men and women became more common on tomb slabs in the thirteenth century. Early examples depicting noble couples, in addition to the aforementioned tombs of Henry II of Brabant and Sophia of Thuringia in Villers, are the tombs of Heinrich der Löwe and his wife Mathilde of England in Braunschweig, and that of Sophia's sister-in-law, Magarete (d. 1230) and her husband Gerhard III of Geldern (1229) in the Cathedral of Roermond.[62] The royal tombs in Saint Denis created under Saint Louis around 1263 became especially influential on the development of tomb art in the second half of the thirteenth century in France.[63] A comparable example is the figure of Guta II (d. 1297) on her tomb in Prague, although her clothing corresponds to the fashion of around 1300.[64] These close parallels between the twenty-two standing men and women on the cloth and representations of noble men and women on thirteenth-century tombs further support the argument that the original function of the cloth was as a catafalque cover or tomb cloth.

The unusual fact that the figures on the Altenberg cloth are crowned and wear halos reflects the view held by the Landgraves of Thüringen and Hessen that they were members of the *beata stirps* of Saint Elizabeth and proclaimed this lineage to legitimate and strengthen their political position.[65] Other pictorial monuments exist in which the landgraves appear as members of a royal family and as members of the *beata stirps*. In the famous *Landgrafenpsalter* of the grandmother of Gertrud and Sophia, the members of the family of the landgraves are shown in a row next to their royal kinship, the kings of Bohemia and Hungary.[66] This corresponds to the ambitious political ambitions of the family during the time of Hermann I (1155–1217) and Ludwig IV (1200–27).[67] In Elizabeth's translation ceremony in 1236, Emperor Frederick II crowned her disembodied head.[68] In addition, the inclusion of the crowns should be seen in the context of tombs as a sign of the rewards for a good Christian life as shown on the tomb of Henry II of Brabant. Here the crown, often held by an angel in the act of coronation, expresses the wish for salvation. Finally, images of Elizabeth and Gertrud receiving

Fig. 5 Embroidery, Wienhausen (?), Museum August Kestner, Hannover (Photo: Museum August Kestner, Hannover)

crowns from angels are found on an Altenberg altarpiece and on Gertrud's tomb from about 1320.[69]

After Elizabeth's canonization, the family began to focus particularly on its genealogical connections to the popular new saint. This is evident not only in written documents signed by Sophia and Gertrud as 'daughter of Saint Elizabeth', but also in pictorial monuments.[70] Sophia incorporated an image of her holy lineage on her seal of 1273. This seal explicitly bases the newly established Hessen dynasty on Saint Elizabeth, by showing Sophia and her son, Heinrich I of Hessen, in a Gothic arcade along with the saint.[71] The seal is thus a visible piece of propaganda showing Sophia and Henry III in the exclusive space of the saint, united by the Gothic arcade. It is very likely that the embroidery was made at about the same time that Sophia had her seal made, as well as when the sisters made their memorial donation in Altenberg (1268). The figures of men and women with crowns and halos as members of the *beata stirps* expressed the new concept of the young dynasty of Hessen founded on Saint Elizabeth. A comparable view of a dynastic succession of royal saints can be found on a slightly later monument (1290–97) that represents another descendent of Saint Elizabeth: the small private altar of King Andrew III of Hungary that was made in Venice. Pairs of royal saints appear in the upper and lower registers of this altar. As in Hessen, the of idea the *beata stirps* was important for the royal dynasty in Hungary.[72] In both examples, kinship with the royal saint strengthened the power and the reputation of her descendants. The embroidery demonstrates this claim in a strikingly self-confident and unusual way. There are no such representations of ancestors with crowns and halos known in thirteenth-century tomb sculpture from the regions of Altenberg, Brabant or France. As an impermanent decoration, the medium of embroidery perhaps offered a better opportunity for such daring representations than a permanent monument would have.

The fact that the standing figures cannot be identified by inscriptions or coats of arms can also be explained in the context of tombs and representations of kinship. There exist examples of tombs with images of generic ancestors that cannot be connected with any particular individual. This can be seen, for instance, in the tomb of Edmund, Earl of Lancaster (d. 1296), in Westminster Abbey, London.[73] Another example that is similar to the Altenberg embroidery is a wool embroidery that was probably originally produced by the convent of Wienhausen for their own use, and which today is found in the Kestner Museum in Hannover (Fig. 5).[74] This textile shows pairs of facing crowned figures standing beneath trefoil-like arches under which is a register with coats of arms. Again the coats of arms do not help to identify individuals, but instead represent the continuity and community of the family. This lack of individualization afforded flexibility for usage for a more general *memoria* of the family of the saint and for the anniversaries of several members. In addition, it was common practice for a social group or family to use one memorial cloth for several tombs or catafalques.[75] Often individual coats of arms (made of textiles, leather or painted wood) were fixed onto or close to the catafalque or tomb, as we know mostly from primary documents and manuscript

illumination. In any case, as Renate Kroos has pointed out, any individuality represented in an effigy would have been lost by covering the tomb with cloth on memorial days.[76]

Busts of Saints

In this context of use as a general *memoria*, the busts of saints in the border make sense. Since they have no individualized attributes, one cannot identify them easily. In 1975, Leonie von Wilckens argued that the thirty-four busts likely represented twelve prophets, twelve apostles and twelve saints, suggesting that the two missing busts would have originally been located in the two corners that are now empty (Fig. 2).[77] In contrast, I believe that these fields are much too narrow to have originally housed such imagery. More likely, the embroidery originally had only thirty-four busts. Other than an altar cloth in Halberstadt that was also described by Wilckens, which included thirty-eight busts of saints, we have no other comparable examples, particularly not in the context of tomb decoration.[78] However, representations of apostles and prophets are a common part of figural programs of tombs from the first half of the fourteenth century.[79] On the embroidery, combining busts of prophets, apostles and saints with the succession of standing royal saints shows a connection between the two groups. These 'old' saints are the basis for and, at the same time, the frame for the 'new' ones, showing their connection to the Gospels and even the Old Testament. Again, this idea might have been due to Sophia's influence on the conception of the figural program. As mentioned above, ancestors of the duke in the guise of knights are depicted next to apostles on the long sides of the tomb of her husband.

Tomb Cloth or Catafalque Cover?

Besides the iconographic program, the other important element that supports the argument for the use of the cloth as a catafalque cover is its size and the organization of its figures. Judging by its size (136 x 325/328 cm) and the pictorial program, it is clearly more likely a tomb or catafalque cover than an altar or table cloth. The inner field of the textile measures 89 by 272 centimeters and therefore is far too narrow and too short for the mensa of the thirteenth-century high altar at Altenberg that measured 165 by 287 centimeters. Second, the mirror arrangement of the figures under the arcades, which divides the middle-axis of the cloth, reflects the iconography of shrines and tombs of the time. Only when draped over a catafalque does this design fall into place and its original function comes to light.

It is possible that the Altenberg cloth was used as a tomb cloth and spread over a tomb during memorial days, as was common in the Middle Ages.[80] But in the second half of the thirteenth century, there did not yet exist any tombs for members of Gertrud's family, and Gertrud's own tomb was not erected before 1320/30. In any case, the size of the cloth would not have fit Gertrud's tomb, as the length of the textile's central field would have been about fifty centimeters too long.[81] It is, therefore, most likely that the cloth was used for a catafalque. Written documents seem to indicate that the substitution of tombs by catafalques on memorial days became more common at the end of the thirteenth century. Michael Viktor Schwarz identified the first known example of a catafalque in Aragon in 1291.[82] Until now, scholars have assumed that the use of catafalques did not begin in Germany until the second half of the fourteenth century.[83] But this claim is only due to a lack of earlier written evidence, since no obvious examples have been preserved. Nevertheless, a structure similar to a catafalque, which was made precisely at the time of the making of the Altenberg cloth, survives not far from Altenberg. The structure was covered with painted linen and covered the shrine

of the relics of Saint Elizabeth in Marburg.[84] The gable length of this frame is 200 centimeters, seventy centimeters shorter than the gable length of the structure that would have been required for the Altenberg cover. It can thus be assumed with some certainty that the frame in Altenberg looked very much like the one covering the shrine of Saint Elizabeth in Marburg.

Location of the Catafalque in the Church of Altenberg

As mentioned above, liturgical *memoria* comprise two main parts—the Requiem Mass and the Office of the Dead. In a monastery, both parts would be celebrated in the stalls in the choir, before the high altar, whereas in a female convent two places were necessary: the choir in front of the main altar for the priest celebrating the mass and the choir of the nuns for the Officium. Both locations would have been possible for the installation of a catafalque. Around 1650, the prior Diederich wrote descriptions about the church of Altenberg in which he mentioned that the memorial place of the family was located in the south part of the transept, between the tomb of Gertrud in the center of the transept and the sacristy on the south side.[85] During the Middle Ages the catafalque might have been installed on memorial days in this place as well.[86]

In female convents, the choir was the place where memorial prayers were said by the nuns for the salvation of the souls of the deceased. In Altenberg, the Office of the Dead was celebrated in the gallery. Although not mentioned in the document concerning Gertrud's anniversary foundation, the office in *choro nostro* is mentioned in more detailed documents, such as the endowment of Archbishop Kuno of Trier of the fourteenth century.[87] Most telling is the fact that the gallery included stained glass windows with depictions of members of Gertrud's family, which supports the hypothesis that this was the central place for the *memoria* of her family in Altenberg. Although these windows have not survived, Prior Diederich described them, offering scholars a sense of what they looked like originally. It is striking that Gertrud's father and grandparents had their place in the windows surrounding the gallery, while other donors had windows over the central nave close to north entrance of the church. It appears, therefore, as if Gertrud gathered her family in the most significant place in the church, around the nun's choir. If the catafalque was installed in the middle of this space, then the figural programs of the stained glass, mural painting and the embroidery would have corresponded and complemented each other. The programs of both the monumental paintings and the embroidery on the catafalque include sovereigns standing on a base of prophets and saints. The nuns regarding and contemplating these figures while singing and praying the Office of the Dead were no doubt aware of the intended message: the individual figures in the windows paralleled and reflected the members of the *beata stirps* in the cover of the catafalque. In the embroidery, as well as in the mural painting, the figures are surrounded by and become part of the sequence of saints, apostles and prophets.[88]

The Materials: Linen versus Silk, Textile versus Marble

The material of the cloth is remarkable. The scholarly literature on tomb or catafalque cloths usually concerns rich cloths in silk.[89] Certainly, in contemporary documents, such as inventories, the majority of such cloths are silk, but there is also evidence of cloths made from linen.[90] A similar impression is given by depictions of the *officium defunctorum* in books of hours from the fifteenth century (Fig. 1), nearly all of which show colorful, rich silk cloths.[91] There was, however, a tradition of linen tomb and catafalque cloths that has not yet received the attention of scholars. Linen was likely used as a less expensive alternative, in contrast to the precious materials, which were reserved

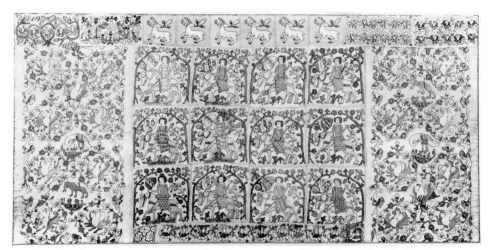

Fig. 6 Embroidery, Herzog Anton Ulrich Museum, Braunschweig (reproduced after Kroos, 1970, fig. 237)

for the upper classes. This is indicated by inventories, which list linen in reference to the poor (*unum tapetum et lintheamen ad paupers defunctorum cooperiendos*).[92] Nevertheless, linen cloths could also be used for high-ranking individuals. This fact is not surprising given the symbolic meaning of linen as the waistcloth and shroud of Christ.[93]

One of the earliest surviving examples is the linen cloth from the Church of the Holy Apostles in Cologne.[94] Scholars believed that it had been made in Egypt in the eighth century. The cloth was designed with mirrored ornament along the middle axis that was stamped in red rather than embroidered. The textile probably covered the sarcophagus of Archbishop Pilgrim during his memorial days.[95] Also, written documents reveal that on anniversaries embroidered linen cloths decorated the tomb of the Emperor Henry III (1017–56), located in Goslar.[96]

In the thirteenth and fourteenth centuries, so-called white-on-white embroidered linen became popular in Germany and it is quite probable that tomb cloths and catafalque covers were also made with this technique.[97] Several embroideries made in this style have survived, the original usages of which are unknown. In addition, many of these embroideries were reused and thus not passed down in their original shape, often having been sewn together with other unrelated fragments, further obscuring their original function. Mainly referred to as hangings or altar cloths by scholars, some of these may actually have been used as tomb or catafalque cloths. Some extant late medieval monochromatic embroidered linens from Northern Germany and Saxony may have been used in this context. One of the striking elements that helps to identify a catafalque cloth is the change in the direction of the design along the central axis. Further investigations of these objects are thus warranted. For example, a fourteenth-century linen cloth, preserved in the Herzog Anton Ulrich Museum in Braunschweig, was possibly used a catafalque cover rather than as altar cloth (Fig. 6).[98] The cloth was modified in later times, when several different cloths, ranging from the early to the late fourteenth century, were stitched together. It is thus impossible to be sure of its original function. Today the piece measures 108 by 220 centimeters. In the central field, equestrians and coats of arms of the families of von Gustedt and von Echte are depicted.[99] If it had been used as an altar cloth, the central field with the coats of arms would have laid on the mensa of the altar, which would have been highly unusual, if not impossible, during the fourteenth century. On both sides dragons alternate with crowned eagles, which frame depictions of a phoenix, an eagle feeding her brood, and a lion, all of

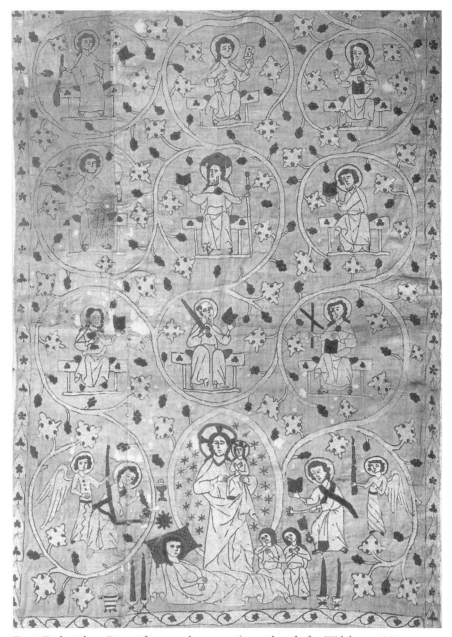

Fig. 7 Embroidery, Preetz, fourteenth century (reproduced after Wilckens, 1991, copyright Frauenstift Preetz)

which symbolize the resurrection. These three main motifs—equestrians, coats of arms and symbols of the resurrection—suggest that the piece was more likely used as catafalque cover.[100]

In northern Germany, several linen embroideries exist that are similar in size and include imagery that changes orientation along the middle axis.[101] Different from the Altenberg cloth, the axis divides the lengths of the cloths into two parts. Because of this, Wilckens has called them '*hohe Handtücher*'.[102] Some of these cloths might indeed have been used as towels during liturgical ceremonies, but if so, it is difficult to explain why the imagery is mirrored along the central axis. Several of the cloths, however, are definitely too wide to be used as liturgical towels. While it may never be possible to determine their original use, it is possible they were catafalque covers.

Since there is not enough surviving material from the Middle Ages concerning catafalque cloths, we have to also consider later objects. A catafalque cloth, made of linen during the seventeenth century, reveals important information. This cloth is preserved in a private collection and measures 347 by 164 centimeters.[103] Its ornamental patterning, coats of arms and inscriptions of names are all oriented in one direction rather than in mirror formation along a central axis. They are embroidered in dyed linen threads of different colors. This cloth must have been placed on a flat catafalque. Its size is comparable to some of the above-mentioned liturgical towels of the Middle Ages. It is quite possible that some of the earlier cloths indeed functioned as catafalque cloths, as seen in the illustration in the Turin-Milan Hours (Fig. 1).[104] Another example with a similar size and pictorial program is the cloth that is still in the monastery of Preetz (Fig. 7).[105] Its subject matter is again typical for the decoration of tombs: the death of the Virgin is depicted on one side, while the Tree of Jesse is shown on the other, in addition to various apostles and prophets.

The use of linen for catafalque covers of highly ranked individuals is not as unexpected as it might seem at first. Linen symbolized humility and purity. As mentioned above, it is also associated with Christ. It was thus a preferred material for those who wanted to express their piety and follow Christ. A monochromatic catafalque cover in linen with a figural program aimed at supporting the status and genealogy of the family was, at once, an intentional expression of humility and a claim to status. Even more, during a period when the new poverty of the Franciscan order found particular resonance, the choice of a simple, humble material for a memorial monument is not surprising. Indeed, the Altenberg catafalque cover might be compared with tombs in the form of painted wall murals instead of marble monuments, which can be found mostly in churches of the mendicant orders—as seen, for example, in the painted tomb of Philipp von Spanheim, Duke of Kärnten, in the Dominican church in Krems from the early fourteenth century.[106] In addition, the use of simple materials was a gesture of humility for noble women, as suggested in the depositions about Saint Elizabeth taken during the papal process of canonization. These point out that she spun wool instead of the silk, which would have been more fitting to her social position as princess of Hungary.[107] An account written in 1240 recommended that the Augustinian canonesses in Heiningen should work with textiles, especially linen. As the description states, linen embroideries '[...] show the pious attitude of those who made it'.[108] Symbolizing humility and piety, linen was therefore considered the most appropriate material for the work of nuns, and it would have been the ideal material for a catafalque cover made to serve the memoria of Elizabeth's family in a female convent. At Altenberg and elsewhere, the commemorative prayers of nuns were considered highly effective for gaining salvation, as is demonstrated by an image of a praying nun on the tomb of Landgraf Henry I and his son Henry the Younger (after 1310) in the Elisabethkirche in Marburg.[109]

Conclusion

The Altenberg embroidery, a relatively unknown monument, is singular and outstanding in its pictorial program. It is a striking example of the possibilities of illustrated textiles—as commemoration of the deceased, as a visual demonstration of power and the social importance of the deceased and their living family members, and, in this case, as an expression the prestigious affiliation with the *beata stirps* of St Elizabeth. No valuable materials such as silk and gold are used to this end, but instead the textile includes an exceptional pictorial program and richly varied and complex embroidery techniques. With the installation of their *memoria* in Altenberg and a catafalque cloth in the humble medium of linen, propaganda for the family and service to God could go hand in hand.

CHAPTER 7

Cultures Re-Shaped: Textiles from the Castilian Royal Tombs in Santa María de las Huelgas in Burgos *

Kristin BÖSE

Among collections of medieval textiles in Europe the one at the Cistercian nunnery of Las Huelgas in northern Spain is outstanding. It results from the house's function as the designated funeral site for the Castilian royal family from the twelfth century until the end of the Middle Ages. Starting with the founding couple, King Alfonso VIII (1155–1214) and his wife, Leonor de Plantagenet (1156?–1214), generations of royals were buried within the church, giving rise to the creation of thirty-five tombs.[1] Although the tombs were opened several times and then raided by Napoleon's troops in 1808, more than eighty textiles survive, some of which are displayed in the convent's museum.[2] Particularly remarkable are the burial cloths from the tomb of the Infante Fernando de la Cerda (1256–75), son of Alfonso X the Wise (1221–84), king of Castile and León, because it is the only tomb that had been left completely untouched since the occupant's burial. The contents of his grave give scholars an idea of the precious furnishings associated with the burials of late medieval Castile.[3]

Fernando de la Cerda's burial garments and the other burial textiles bear witness to the interrelation of two different cultures on the Iberian Peninsula that influenced not only the decoration, but also the fashion of the period. While the patterns oscillate between Christian and Islamic motifs, the types of textiles refer to Christian burial ritual as well as to Castilian courtly fashion. The materials and techniques can mainly be associated with Muslim textile production on the Iberian Peninsula, which was particularly famous for different types of silk.[4]

The wooden coffin and lid were each covered by a samit, a silk fabric, interwoven with gold and silver threads.[5] Whereas the textile covering the sides of the coffin shows pairs of griffins standing on elephants within roundels, pairs of lions and peacocks enclosed in round and hexagonal medallions decorate the lid's covering. These fabrics were produced in Muslim workshops in the south of the Iberian Peninsula. Their designs bear evidence to the imitation of patterns known from Persian textiles, a Spanish tradition verifiable since the twelfth century.[6] Affixed to the top of the samit of the lid is a silver cross. The coffin's interior is lined by a lampas with a horizontal pattern bearing the Arabic cursive *iḥmad allāh* (praise god). Fernando's mummified corpse was vested with a *saya* (a type of a tunic), and a *pellote* (a garment that opened on both sides of the body, allowing a glimpse of the waist and the hip) (Fig. 1).[7] Finally, a mantle covered his body. The *saya*, *pellote*, and mantle all correspond to the fashion at the Castilian court of the thirteenth and fourteenth centuries.[8] These pieces were made from the same samit fabric of interwoven golden and silver threads. Placed on the head of the prince was a hat embroidered with silk, coral, and glass pearls. All these garments are covered by a pattern showing the blazons of Castile and León. Fernando's cloth belt, made of a samit terminating with golden buckles, was ornamented with coats of arms representing his ties to French and English noble families, as shall be discussed below (Fig. 2).[9] Finally, Fernando's head was found resting on four pillows. Each cover was made

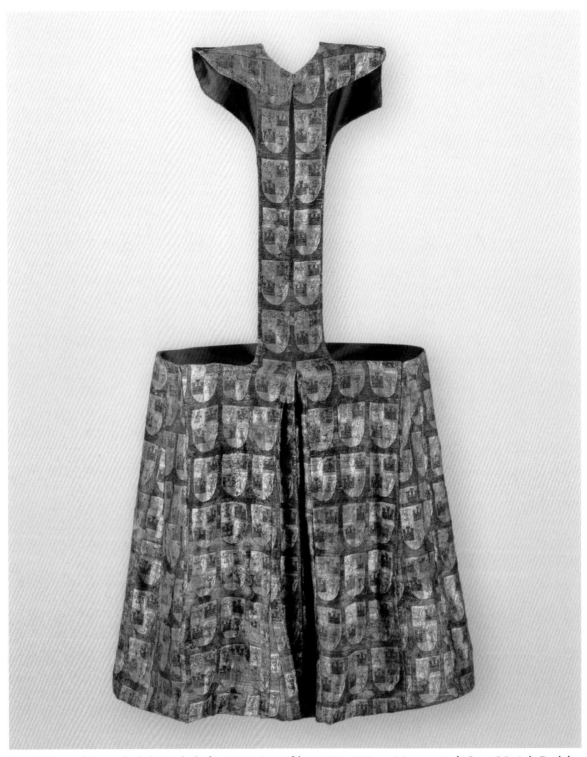

Fig. 1 Pellote of Fernando de la Cerda, before 1275. Samit fabric, 130 x 100 cm. Monasterio de Santa María la Real de Huelgas, Burgos @ PATRIMONIO NACIONAL

Fig. 2 Belt of Fernando de la Cerda, before 1272. 194 x 4,3 cm. Monasterio de Santa María la Real de Huelgas, Burgos @ PATRIMONIO NACIONAL

out of a different material and using different techniques, such as taffeta, embroidered linen, and knitted fabric (Fig. 3).[10]

In this essay, I examine the possible meanings that the compilation of such a variety of burial textiles might have had for the Castilian royal family in the context of contemporary politics. When King Alfonso VIII and his wife Leonor de Plantagenet founded the Cistercian nunnery of Las Huelgas in 1187, and promoted its designation as a special daughter house of Cîteaux in 1199, the re-conquest of Muslim-dominated territories by Christian rulers was reaching its climax.[11] While religious motives increasingly determined military actions from the eleventh century onward, these often conflicted with purely political agendas, such as the competition among Castile, León, and Aragon for hegemony during the re-conquest. Once Castile and León were unified under Castilian rule for dynastic reasons in 1230, Castilian pressure on the remaining Christian and Muslim territories vastly increased. The establishment of Cistercian monasteries was crucial to this process. As James D'Emilio has shown, the foundation and the support of Cistercian monasteries by the Las Huelgas founder, Alfonso VIII, played an important role in establishing Castilian hegemony on the Iberian Peninsula.[12] Las Huelgas was directly dependent on Cîteaux, which allowed the abbey to hold its own Annual Chapter and to assert its control over other Cistercian convents not only within Castilian territory, but also in the neighboring kingdoms of León and Navarre with which Castile was competing.

The royal architecture of Las Huelgas demonstrates the importance of the nunnery for the royal family who resided in the nearby palace.[13] The church, which follows architectural precedents in Paris and the Loire region, was one of the key buildings for the dissemination of Gothic style in northern Spain.[14] This French influence is mirrored in the church's layout: it is a basilica with a small transept terminating in four square chapels and a central polygonal presbytery. This so-called Bernardine plan was first realized sometime between 1133 and 1145/53 for the Cistercian abbey of Clairvaux under the abbacy of St Bernard. This floor plan was crucial to the architectural identity of Cistercian abbeys, but unusual for the Order's nunneries.[15]

It is against this background of hegemonial intentions informing the re-conquest process that the combination of techniques, materials, and patterns of the textiles within the Las Huelgas royal tombs should be seen, reflecting the growing power of the Castilian monarchy. The study of Spanish medieval textiles, especially the so-called 'Andalusí' textiles from funerary contexts, has tended to be

Fig. 3 Pillow cover of Fernando de la Cerda, before 1275. Knitted fabric, 36,5 x 36,5 cm. Monasterio de Santa María la Real de Huelgas, Burgos @ PATRIMONIO NACIONAL

limited to aspects of provenance, material, technique, condition, and dating.[16] More recently, however, the cultural impact of these objects has increasingly occupied scholars' attention.[17] In particular, Maria Judith Feliciano has pointed out the extraordinary value with which these textiles were ascribed at the Castilian court.[18] By solely focusing on their rich materiality – which she proclaimed as being a distinct 'aesthetic vocabulary' without further explanation – Feliciano underestimates not only the textiles' ornamentation and complex mediality, but also their hybridization. In this context, hybridization should be understood as a process of combining different elements that enables the creation of something new.[19] The textiles found in the royal tombs at Las Huelgas bear witness to more intricate patterns of cultural provenance and interrelation: when a silk is decorated with the Castilian coat of arms, or a knitted pillow cover bears Christian symbols, in addition to a Kufic inscription, these combined elements raise questions about a more multifaceted dynamic of artistic interactions and procedures of transfer. It is crucial, therefore, to pay close attention to the interweaving of materials, techniques, and motifs within Castilian royal burial sites. I assert that this process led to the formation of a new style that served the Castilian monarchy as a kind of aesthetic border in its quest to define itself as the leading power on the Iberian Peninsula.[20]

In particular, Yuri Lotman's theories concerning the processes of cultural dialogue can be used to understand the Las Huelgas fabrics.[21] Lotman analyses how cultures organize themselves in space and time, that is, in the *semiosphere*, placing special emphasis on the semiospheric border as a place of constant exchange – a place, where 'what is "external" is transformed into what is "internal," it is a filtering membrane which so transforms foreign texts' and brings a new language into being.[22] While Lotman focused exclusively on the function of texts within this sphere, textiles can also operate in a similar fashion. The hybrid textiles of Las Huelgas can be perceived as a powerful tool within the culture of courtly performance, in particular the royal burial rituals that expressed and reinforced the identity building process.[23]

Textiles in Castilian texts

The written sources from the Castilian court and its circle reveal various discourses surrounding the role of textiles as markers of royal identity. The texts produced in Christian Spain often refer to precious garments and fabrics, even if there is no specific term used for textiles made in Muslim workshops. The frequency and intensity of discussion about cloth depends on the genre of the text and its purpose. It is especially difficult to distinguish textiles specifically originating from Al-Andalus within archival documents, such as inventories and invoices. Most of the time, the documents refer only to *pannos*.[24] In these contexts, this word was generally used as a comprehensive term for many different kinds of fabric.[25] However, such records are nonetheless useful when read closely. The invoices of Sancho IV of Castile (1258–95), son of Alfonso the Wise, for example, give the impression that the king's daily clothes did not have to consist of silk, but rather were woven from high quality wool, such as *escarlata* and green *verdescur*.[26] Both *escarlata* and *verdescur* were fabricated in the Netherlands, France, and England from the end of the twelfth century onward and imported into the Iberian Peninsula.[27] Although *escarlata* was originally not a red fabric, it was exclusively red in color on the Iberian Peninsula.[28] Castilian court regulations concerning dress from the thirteenth and fourteenth centuries prohibited all members of court, with the exception of the sovereign and the highest-ranking officials, from wearing garments made of *escarlata*.[29] On the one hand, the invoices reveal a social hierarchy at the court expressed through the materiality and the color of the garments; on the other hand, it seems likely that silk garments were reserved for state occasions.

Luxury garments are mentioned to a greater extent in legal and didactic texts, where they illustrate a wider spectrum of symbolic meanings. Similar to the invoices, these texts serve to strengthen the social hierarchy within Castilian society and the distinct role of the sovereign. Within the *Siete Partidas*, the Castilian law code commissioned by Alfonso X in 1251, textiles and garments display the body politics of the sovereign. For example, only the king and his family were allowed to be buried with garments made of gold and silver.[30] Furthermore, the text states that the king's splendid silk garments and sumptuous crown allowed him to be readily recognizable in crowded state ceremonies.[31] Thus, textiles lifted the sovereign out of the everyday and the ordinary, and defined communication codes. This is furthermore underscored by the *Castigos e documentos*, a mirror of princes commissioned by Sancho IV at the end of thirteenth century. In this text, textiles serve to describe the ideal prince, whose silk garment is related to his position and dignity, while the gold of the fabric symbolize his fortune and nobility.[32]

An even more precise vocabulary of precious garments and fabrics can be found in Castilian epic poetry of the later Middle Ages. Among the most famous is the poem of El Cid (*Poema de mio Cid*) that describes the adventures of the Castilian nobleman Rodrigo Díaz de Vivar (1043–99).[33] The narration provides insight into the luxurious and cosmopolitan lifestyle of a knight who oscillates between Christian and Muslim worlds. In the third *canto*, there is a detailed description of the robes that El Cid wears while appearing in the Castilian court:

> He was wearing a shirt of linen [*rançal*] as white as the sun, / the garments were made with gold and silver [...]. / Over a silken tunic [*ciclatón*] made of golden threads which shine through, / he was wearing a red fur with a golden border [...] / upon his hair he had a cap of finest linen [*escarín*] with golden threads, [...] / Thus, all men might wonder who it was.[34]

The poem uses different terms to refer to fabrics produced in different regions: the *ciclatón* is a red silk with golden threads that was produced in Almería.[35] Where *rançal* and *escarín* were produced is not clear, but the etymology of *escarín* indicates an Arabic origin.[36] In other parts of the poem *xamete* is mentioned, which refers to an Andalusí textile, as well as *purpura*, a purple silk fabric that was produced in Al-Andalus or imported from either Venice or the Orient, and is related to royal garments in other literary texts.[37] Despite the fact that archival documents tended not to specify the place of manufacture for all but the most exotic textiles, the specificity of vocabulary found in epic poetry, which circulated at the court, indicates that the Castilian royalty were likely aware of the varied provenances of the textiles used in the burial rituals at Las Huelgas.[38]

In the poem, El Cid attracts the attention of the courtiers by wearing vestments that were normally associated with the king, as indicated by the *Siete partidas*, discussed earlier. In this literary context, however, the clothes refer not to a sovereign, but to a person who is a temporary outsider according to the Castilian societal system. Recent scholarship has examined how far El Cid's triumph and reputation can be linked to his social and economic mobility.[39] El Cid's economic, social, and moral status was calculated based not only on the wealth that he attained through the acquisition of booty in battle, but also through his ability to give gifts.[40] Indeed, such displays of economic exchange within a society, which was characterized by permanent military conflicts and shifting boundaries, sets the *Poema de mio Cid* apart from other epics in the Western tradition.[41] As an integral part of booty, textiles are among those movable goods that 'were obviously more highly prized than estates for these knights and other warriors [...], since they could be taken back and converted into money or exchange goods'.[42] Therefore, the socio-economic background of Castilian society reveals very specific and local notions of luxury, wealth, and moral standing as expressed through textiles.

The role of booty in securing nobility and prestige is exemplified by another poem, the *Poema de Fernán González*, written around the middle of the thirteenth century in Castile. By describing how Fernán González defended his dukedom against the Muslims in the tenth century, the poem glorifies the valuable role of Castile, whose victories over the Christian and Muslim neighbors were predestined. After one of Fernando's successful battles, the poem goes on to describe the funeral of one of his allies, the Duke of Tolosa.[43] The poem reveals that the duke was buried in a silk fabric of Andalusian origin (*xamete*) that he had won as a battle trophy.[44] As a spoil of war, it symbolized the fame of the bearer.[45] Thus, when exploring the significance of precious textiles within Castilian society, scholars cannot ignore the role of competition between Christian and Muslim rulers for hegemony on the Iberian Peninsula, as well as the intricate dynamics involved with the re-conquest process.[46]

Hybridization

A closer look at the combination of types of fabrics found at Las Huelgas provides insight into the way Andalusí materials and techniques were used in Castilian burial rituals. First of all, it should be stated that there are other materials than silks that have survived from the Las Huelgas tombs, such as linen fabrics.[47] The linen could have been produced in Al-Andalus or it could have been imported from other European linen centers in the Netherlands, France, or England.[48] Recent studies on textile production within the Christian kingdoms on the Iberian Peninsula show that a professional and specialized production of linen and wool fabrics had fully developed by the fourteenth century and there is even evidence of workshops before 1300. It is, therefore, quite possible that some burial textiles, and in particular those dating from the fourteenth century onward, were made in workshops within the Christian kingdoms on the Iberian Peninsula.[49] The linen fabrics from Las Huelgas' tombs were used primarily to produce pillow covers. Sometimes the pillow covers were later embroidered with Christian symbols. A linen pillowcase from the tomb of Leonor de Plantagenet comprises a cross-like ornament in the center, while castles are placed in the corners, referencing the Castilian coat of arms.[50]

Equally, the silk fabrics exhibit evidence of further manufacturing at different stages. Some of the burial cloths recall Andalusí materials and techniques, but they were clearly adapted to reflect Castilian fashion and the requirements of Christian burial. In particular, the garments, coffin covers, and the pillows are all made of various kinds of silk. They combine different motifs and patterns with Arabic script in a manner that is very typical for silks produced in Andalusian workshops during the Almoravid and Almohad periods.[51] The fabric of the cap that the Infante Fernando (d. 1211), son of Alfonso VIII, was wearing, which consists of a woven tapestry decorated in parallel bands with geometric ornaments and an Arabic inscription, was produced during the Almohad period. However, the shape of the garment corresponds to Castilian court style of that same period.[52]

Sometimes different types of garments deriving from a single tomb were made from the same silk fabric. The same Almohad silk fabric, for instance, was used to create garments worn by Leonor of Castile (d. 1244), daughter of Alfonso VIII.[53] The lampas is decorated with two alternating types of stars, each of which is enclosed in a rhomboidal-shaped frame. It is thus very likely that these fabrics were purchased as raw materials in Andalusian workshops to then be later manufactured into a whole set of garments. This could have been done by the court dress-maker who is actually documented during the reign of Sancho IV.[54]

Some objects show such a complex combination of different artistic traditions that their provenance is difficult to determine. Prominent examples within the Las Huelgas collection are the silk

fabrics with interwoven coat of arms, such as the *saya*, the *pellote* (see Fig. 1), and the mantel of Fernando de la Cerda. An even earlier example includes the fragment of the mantle of Alfonso VIII, dated between 1156 and 1214.[55] This raises the question of how the Christian nobility came to possess these Andalusian textiles. Unfortunately, there is no written evidence documenting the purchase of these special fabrics; however, two possibilities are imaginable. First, these silk fabrics were perhaps commissioned from workshops in Muslim-dominated territories – a purchase that would have probably been made through intermediaries. Alternately, these silk textiles were acquired directly from Muslim workshops within important centers of silk production as they came under Christian control, including Córdoba (1236), Valencia (1238), Murcía (1243), and Seville (1248).[56] Studies show that in Valencia, silk was produced in family-run Muslim workshops that remained in existence after the city was reconquered.[57] A remarkable fragment survives from the tomb of Fernando III (1201–52) in Seville Cathedral, which shows an increasing interest in combining materials, as well as motifs, from different contexts at the Castilian court. The textile consists of two pieces, both tapestry weaves, that were stitched together to form part of a mantle for the deceased king. One piece consists of an armorial showing the coats of arms of León and Castile, and a smaller piece is decorated with the *ataurique* floral ornament typical of Almohad textile production.[58]

A few burial fabrics from Las Huelgas demonstrate the combination of both Christian and Andalusian motifs from the time of their original manufacture. The pattern of one of Fernando de la Cerda's knitted pillow covers includes coats of arms related to Castile, France, and the Holy Roman Empire. On one side of the pillow cover, the heraldic emblems of the eagle and the lily are integrated into a diamond grid of diagonal lines, while on the reverse side, castles alternate with rosettes and swastika-motifs within octagonal frames (see Fig. 3). Although rosettes are a longstanding tradition, they are a particularly prominent ornament in Andalusí textiles available to the Castilians and in the silk remnants from Las Huelgas.[59] Moreover, it is remarkable that the pattern on both sides of the pillow cover is framed by bands containing a Kufic benedictional inscription.[60] The interjection of Arabic script into textiles commissioned by the Castilian court imitates, therefore, the Muslim tradition of ornamental inscriptions containing religious messages on textiles.[61]

This practice is another step within the Castilian assimilation process of Andalusian culture by creating a new visual language through the combination of common artistic traditions. In some ways, this approach is comparable to the developments in architecture from Toledo during the twelfth century.[62] There, converted mosques, such as Santa Cruz, were enlarged with apses to conform to Christian liturgical needs but, at the same time, the decorated arches with Islamic motifs were preserved. If the term *mudejar* describes the combination of 'Islamic motifs, materials or techniques with Christian forms and functions' and can be understood as an 'artistic approach, which enjoyed the presence of Islamic elements', then some burial textiles discussed within this paper can be designated as such.[63] In addition, the textiles that were reshaped due to tailoring, application, or interweaving, illustrate several various approaches of combining different cultural traditions.

One might ask if the notion of combining Christian and Islamic motifs and ornaments in such a way that leads to a new visual language, can be also related to the contemporary refurbishing of the nunnery in order to renew its identification as a royal mausoleum during the reign of Alfonso the Wise.[64] In the last quarter of the thirteenth century, older parts of the monastic complex were decorated with a variety of fine stucco carvings – a technique found in Andalusian buildings, such as the Alcazar of Seville. Since the carvings have a mixture of Islamic forms and motifs, Arabic inscriptions, and the Castilian coat of arms, types of textiles found in the tombs at Las Huelgas served as an example for their style.[65] In particular, the pattern on the ceiling vaults of the cloister of San

Fernando in Las Huelgas resembles that of the silk covering the lid of Fernando's coffin. The stucco is characterized by a grid of alternating medallions of different sizes similar to the pattern of the coffin's cover. In addition, the stucco medallions are also filled with pairs of lions. Because the roundels contain Arabic scripture, as well as castles, the stucco pattern displays a similar combination of Christian and Islamic elements seen in the hybrid tomb textiles.[66] Moreover, the stucco ornamentation demonstrates that the incorporation of Islamic artistic vocabulary was an on-going process across different media. On the whole, this decoration system strongly contrasts the earlier sculptural decoration from the end of the twelfth century located in the older cloister known as *las Claustillas* that depicts the Celestial City in the Gothic style.[67]

To sum up, the textiles, as well as the stucco carvings, are parallel phenomena of an appropriation process within the multicultural Iberian Peninsula. Both media illustrate the continuing dialogue between artistic vocabularies from Christian and Muslim cultural backgrounds. At the same time, the stucco carvings refer to the importance of textiles as transmitters of stylistic features, underscoring the role they played in creating a new visual language. Their role as a medium of transfer – a function also ascribed by the Castilian poetry discussed above – has to be further investigated, particularly in connection to other Castilian artistic media. If we follow Lotman's concept of the *semiosphere*, then the incorporation of an Islamic artistic vocabulary could also be judged as a phenomenon of border construction, but one that is aesthetic rather than geographic.

Christian symbols and Andalusian materiality: the armorial silks

The heterogeneous and hybrid textiles listed in inventory of Las Huelgas reveals that silk vestments decorated with heraldic symbols further reinforced Castilian royal identity. They underline Castilian political claims not only on the symbolic level, but also through their aesthetic and material qualities that would have been performed during courtly ritual. Heraldic emblems covering garments in a grid, sometimes without the blazon, was a widespread phenomenon in the visual arts of thirteenth- and fourteenth-century Castile, but these have hitherto failed to attract the attention of scholars.[68] In the way that repeated coats of arms create a network-like design, the armorial decoration resembles the grid-like patterns on Andalusí textiles.[69] The heraldic textiles tend to be found in the tombs of male members of the royal family, particularly kings, as well as the crown princes.[70] To my knowledge, there is no evidence of these types of silk garments from a woman's tomb, although other kinds of fabrics decorated with the coats of arms have been found, such as the taffeta cover of María de Aragón's wooden coffin from Las Huelgas that displays castles and eagles. However, in Castilian book illuminations of the thirteenth and fourteenth centuries both the king and queen are shown dressed in clothes with armorial patterns.[71] Scholars have been able to identify the term *scutulado*, which was used to describe these royal fabrics.[72] From the chronicle of Alfonso XI (1311–50), we know that he wore such a fabric during his coronation at Las Huelgas in 1312.[73] An investigation into the symbolic and political role of the armorial patterns within these textiles, which also appeared in other media relating to the tomb, such as the decoration of the burial niche as well as of the sarcophagus, reveals just how far these cloths contributed to Castilian political claims.

Coats of arms originated within chivalric society during the twelfth century.[74] In addition to distinguishing allies from enemies during battle, they expressed the corporate affiliation of a specific person and contributed to their commemoration after death. In Christian Spain, the armorial emblem as territorial representation first appeared at the court of León during the second quarter of the twelfth century.[75] King Alfonso VIII was the first to use the castle as an armorial emblem,

which appeared on his burial mantle. After this point, the motif was used to designate the house of Castile rather than the territory. In the first half of the thirteenth century, the circulation of heraldic emblems in different media reached a new climax.[76] Subsequently, coats of arms could also evoke a socio-cultural background in general, instead of referring to certain dynastic ties.[77]

Nevertheless, heraldic symbols also communicated political and social interactions. The tomb of Fernando de la Cerda best exemplifies both of these aspects. Like other tombs from Las Huelgas, Fernando's sarcophagus and surrounding sculptural decoration were ornamented with coats of arms that underscored Iberian alliances. In particular, these armorials show links to other Iberian regions and emphasize the princely genealogy. This can be seen, for example, in the coats of arms of Castile-León and of Aragón, the latter of which was included because Fernando's mother, Violante (1236–1301), was the daughter of Jaime I of Aragón.

The armorial decoration on Fernando's garments from inside the tomb at Las Huelgas further reinforces the claim of a unified Christian kingdom by combining the symbols of Castile-León with the blazons of different European royal and noble families. Fernando's golden belt, for instance, contains a collection of embroidered and enameled coats of arms (see Fig. 2). Those that can be identified refer to the English and French royal houses, including the counts of Champagne and Navarre, as well as Richard I of Cornwall (1209–72). There are strong familial connections between the family of Alfonso the Wise and the English and French royal dynasties. For example, Fernando de la Cerda was married to Blanche of France (1253–1320), daughter of St Louis and Margaret of Provence. The marriage ceremony took place in 1269 at the convent church of Las Huelgas. Fernando's aunt, Leonor of Castile, half-sister of Alfonso the Wise, was Queen of England through her marriage to Edward I, which was also celebrated at Las Huelgas several years earlier in 1254. Furthermore, the incorporation of the coats of arms of Champagne and Navarre within Fernando's belt possibly expressed the hope of political alliances with the Kingdom of Navarre.[78]

The most remarkable coat of arms represented on the belt refers to Richard Cornwall, brother of Henry III, king of England. It is composed of a lion rampant crowned within a bordure bezantée. Although scholars have identified the presence of these devices, their significance to Alfonso the Wise has been overlooked. It should be noted that Alfonso had claim to the title of Holy Roman Emperor as a result of a problematic election as *rex romanorum* in Frankfurt in 1257. The archbishop of Trier and the French royal house both supported Alfonso's claim to the imperial throne. In contrast, the archbishop of Cologne and his allies favored Richard Cornwall, who was crowned King of the Romans in that same year at Aachen. The *interregnum* ended with the death of Richard in 1272. Pope Gregory X induced Alfonso to give up his claim, and one year later, in 1273, Rudolph of Habsburg (1218–91) ascended the Roman throne. Therefore, the inclusion of Richard Cornwall's coat of arms on Fernando's belt, in addition to those of Champagne and Navarre, could indicate that the belt was commissioned before 1272. While it remains unclear whether the belt was commissioned by Alfonso or not, the inclusion of Richard Cornwall's coat of arms on Fernando's belt suggests that Alfonso held onto his claim to the Imperial throne.[79]

Alfonso's imperial claims are also expressed through one of the four pillows on which the head of the Infante was reposed. This pillow, which is embroidered with silk and golden threads, is dominated by a pseudo-heraldic pattern of crowned figures.[80] Each figure holds a lily and an imperial orb and is surrounded by a pair of eagles, both referencing the Holy Roman Empire. Thus, it seems likely that the decoration of Fernando's burial clothes were intended to emphasize the status of the Castilian monarchy within a pan-European political network. Moreover, the tomb textiles indicate the need for continuity of the regency, since it had become threatened by Fernando's early death.[81]

While the coats of arms on burial textiles illustrate Alfonso's genealogy, along with his alliances with European royal dynasties and his political claims, references to Andalusian culture is also discernable through the sumptuous materiality of these silk textiles. The Islamic motifs can be linked to those discourses in literary texts that reflect the role textiles played in communicating the social, economic, and moral positions of their aristocratic protagonists. These ideas had a strong impact on the funeral ritual, the nature of which can be reconstructed from contemporary textual sources, as well as from visual representations of funerary rites found on Castilian tombs, such as the sculpted sarcophagi of Don Felipe (1231–74), son of Fernando III of Castile, and his wife, Doña Inés (d. before 1265), in Villalcázar de Sirga (Palencia).[82] After the deceased was washed and dressed, the body was transferred to the church where further ceremony took place. Ecclesiastical dignitaries, family members, the nobility, as well as representatives of monastic orders and civic leaders of important towns, accompanied the translation of the body to the church.[83] In addition, standard bearers and horses in livery decorated with the coats of arms were part of the funeral cortege. Their colors and costly materials set the royal retinue apart from other participants who, according to court regulation, had to wear black linen. Thus, armorial-patterned textiles gave the assembled entourage a unified appearance within the funeral ceremony and proclaimed to the body politic Castilian's powerful role on the Iberian Peninsula.[84]

The burial textiles of the Las Huelgas tombs represent a heterogeneous and multi-cultural element that can be associated with an enduring appropriation process of Andalusí materials and artistic vocabulary. Therefore, hybridization is a key characteristic of these textiles. Technically based on Muslim culture, the textiles were highly appreciated within the neighboring Christian culture that interwove their signs of political power into them. Their meaning – as luxury goods and as a form of a highly mobile medium – was strongly related to the political and social dynamics resulting from the re-conquest process. These fabrics can be interpreted as aesthetic borders in which a new visual language came into being that contributed to the formation of Castilian royal identity.

PART II
THE REPRESENTED TEXTILE AS SIGN

CHAPTER 8

'So lyvely in cullers and gilting': Vestments on Episcopal Tomb Effigies in England

Catherine WALDEN

In the book of Revelation, John wrote that he saw the twenty-four elders and the souls of martyrs clothed in pure, radiant white (Revelation 4:4, 6:9–11).[1] Further, as stated in Revelation 3:4–5, white garments will be accorded to any person who is proven worthy of everlasting life.[2] In contrast to the biblical text, medieval tomb effigies – which appear to represent the deceased in a glorified, everlasting state – are carved as if dressed in clothing that indicates earthly rank rather than heavenly communion with the saints. Indeed, the representation of status through clothing on medieval effigies is arguably the most striking visual feature of these full-length, recumbent figures. On English episcopal tombs, such as the twelfth- and thirteenth-century examples examined here, vestments were often carved and, as I suggest below, painted to a great degree of elaboration.[3] One primary function of vestments on tomb effigies was to proclaim to the living the deceased's worldly position as an ecclesiastic. Such display no doubt garnered political advantage for the deceased, his family, and his institution. Yet the funerary context also invites interpretation of the effigy and its adornment in terms of spiritual anxiety about the coming resurrection and judgment. This essay explores the relationship between the careful depiction of clothing of status on episcopal tomb effigies and the desire for redemption.

Vestments on effigies: the physical evidence

Vestments are a key decorative component on even the earliest ecclesiastical tomb effigies known in England.[4] Sculptors took care to portray accurately each item in a suit of vestments, and to suggest textured or patterned cloth by working the surface of the stone. An unidentified figure of a bishop at Salisbury Cathedral – one of the oldest surviving effigies in England and dated by stylistic means to the mid-twelfth century – features incised, star-like designs on the chasuble, beaded details in low relief on the alb, dalmatic, and stole, and grooved lines and basket-weave patterns along the edges of the chasuble and dalmatic (Figs 1 and 2).[5] An exquisite effigy at Exeter Cathedral, made c. 1230 perhaps for Bishop Simon of Apulia (d. 1223), demonstrates the considerable lengths to which some sculptors would go to incorporate surface detail into the garments (Figs 3 and 4).[6] Although the effigy is now badly damaged, lozenge and basket-weave patterns in shallow relief are still discernible on the carved maniple and the ends of the stole, and at the base of the alb is a wide decorative band with low-relief medallions (Fig. 5). Over the bishop's shoulders curls a foliate design in low relief, and the Y-shaped orphrey is decorated with elliptical indentations and incised borders. These and similarly carved indentations on the amice, miter, and along the borders of the chasuble, dalmatic, and tunicle suggest the former (or intended) presence of applied ornament, perhaps made of colored paste or glass, to simulate pearls and precious stones (Fig. 6). Indeed, traces of adhesive for applied ornament still survive on three effigies.[7]

The split and sheared damage to the surface of the Exeter effigy testifies to the unsuitability of certain stones to endure such intricately carved ornamentation. This effigy, like many surviving

Fig. 1 Salisbury Cathedral, Tournai stone effigy of a bishop. Photo: author

Fig. 2 Detail of Tournai stone effigy, Salisbury Cathedral: lower section of chasuble, tunicle and dalmatic. Photo: author

early episcopal effigies in England, was sculpted from a local limestone that had a rich, dark hue, and could be polished to a marble-like sheen. For these qualities, stones of this type were much admired, but the geological makeup of the material, a dense composite that includes fossilized shells, makes the stone brittle and prone to fracture.[8] This may in part explain the rarity of surviving effigies as delicately worked as the Exeter effigy. By the second half of the thirteenth century, sculptors were experimenting with volume and behavior of cloth rather than demonstrating virtuosity with fine surface texture and ornament. Even the most plainly carved vestments, however, tended to include a certain amount of sculptured details, such as a carved morse at the bishop's throat, a jeweled miter, and/or low-relief decorative borders along the hems of the robes.

The shift in the middle of the thirteenth century from textured to smooth surfaces on the carved representations of vestments suggests that artists were taking a different approach to depicting fabric on an effigy: instead of carving texture and ornament in low relief, such features could be imitated with paint.[9] By the fourteenth century, the practice of painting tomb effigies seems to have been fairly common, as attested by extant traces of polychromy and by surviving references in documents.[10] For earlier tombs, however, evidence for polychromy is less abundant.[11] The surfaces of the majority of twelfth- and thirteenth-century effigies are today bare. Moreover, since no contracts or other contemporary texts regarding the manufacture of these early monuments survive, there is no documentary evidence stipulating painted surfaces. Yet provisions made during the sculpting stage for applying faux gems indicate that colored enhancement was in fact a desired feature from the outset. Additionally, out of the thirty-six extant twelfth- and thirteenth-century English episcopal tomb effigies, nine have or reportedly once had painted surfaces. At least one abbot's effigy from that time period retains fragments of paint, and the flat lid made for the coffin of Archbishop Walter de Gray (d. 1255) at York Minster has a full-length painted representation of an archbishop. Thus, evidence exists for at least eleven painted ecclesiastical tomb figures from this early period.[12]

While traces of surviving paint in most of these eleven cases are fragmentary, evidence suggests that some of these effigies were originally finished with a high degree of elaboration and care. A freestone effigy placed in Hereford Cathedral for Peter of Aquablanca (d. 1268) not long after the bishop's death features a dark blue or black chasuble, and some gold, red, and black details (Fig. 7). The paint seen today is at least partly from a nineteenth-century restoration: in 1869 Reverend F. T. Havergal wrote that about nine years previously, a 'most indefatigable amateur' had restored 'slight portions of the colored vestments'.[13] Yet the nineteenth-century restorer had recorded the existence of paint prior to his changes, and in 1717 Richard Rawlinson had described the monument as 'formerly curiously embellish'd with Gold, and painted'.[14] High-quality pigments and gold were applied with skill on the full-length painted image on the flat coffin lid made for Archbishop Walter de Gray at York.[15] Although an effigy made of Purbeck stone soon was placed over the painted coffin lid, the quality of the painted work raises the possibility that the colored image of the archbishop originally was intended to be a visible feature of the tomb. The now-smooth wooden effigy representing Archbishop Pecham (d. 1292) at Canterbury was once painstakingly built up with layers of gesso to produce a textured surface that was painted and gilded, according to an account dating from the early part of the nineteenth century.[16]

Where the material used for the effigy is relatively modest – for example, wood or a plain freestone like those just mentioned – it is easy to accept the addition of color to increase the tomb's opulence. Yet, six of the eleven ecclesiastical effigies on which I found evidence of paint were carved of a dark, sumptuous, marble-like stone. Stones of this sort, such as Purbeck, were available in limited supply, required great skill to carve, and were admired in the medieval period for their rich colors, marbled

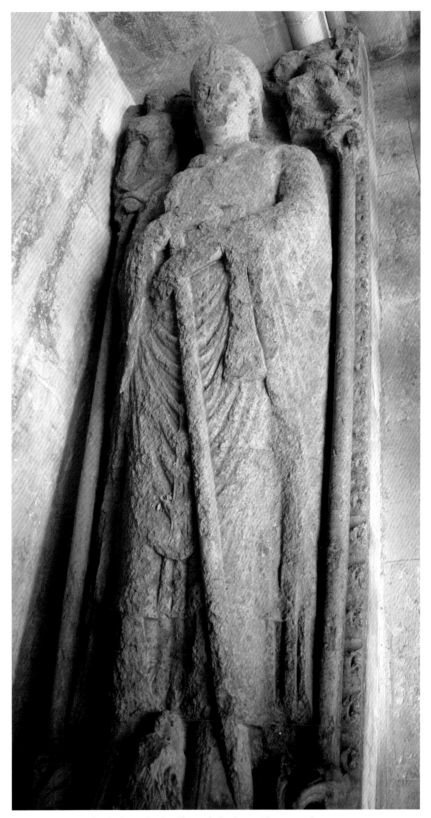

Fig. 3 Exeter Cathedral, Purbeck effigy of a bishop. Photo: author

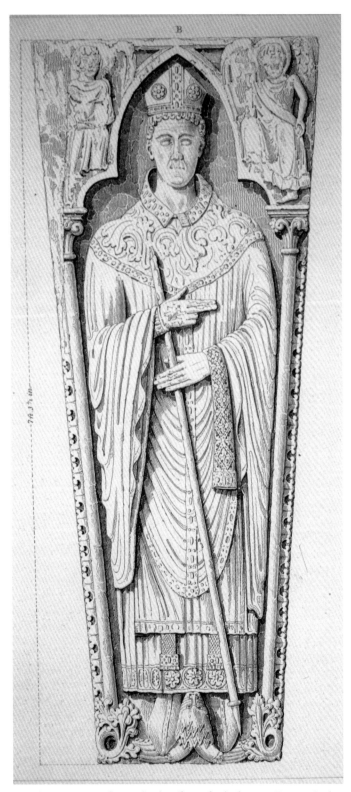

Fig. 4 Engraving of a Purbeck effigy of a bishop in Exeter Cathedral, from John Britton, *The History and Antiquities of the Cathedral Church of Exeter* (London, 1826), plate XX.B. Photo: courtesy of Marion E. Roberts

Fig. 5 Details of Purbeck effigy, Exeter Cathedral: maniple (top), hem of tunicle, stole and alb (bottom). Photos: author

patterns, and polishable surface. Colored stones were chosen to enhance the architectural features of a number of cathedrals, including such high-profile spaces as the Trinity Chapel at Canterbury Cathedral, which held the shrine of Thomas Becket. A description of Lincoln Cathedral by Henry of Avranches (d. 1260) extolled the merits of the Purbeck stone used in that building. He wrote that the stone, 'more polished than a fingernail, presents a starry brilliance to that dazzled sight, for nature has painted there so many varied forms that, if art should toil with sustained endeavour to produce a similar painting, it could hardly copy what nature has done'.[17] Paint appears to have been applied even when the quality of the sculpture was superb. For example, the effigy made in the 1230s for the tomb at Worcester Cathedral of John, king of England (r. 1199–1216), was finely worked in Purbeck, but then was painted.[18] Unfortunately, since evidence for color on most of

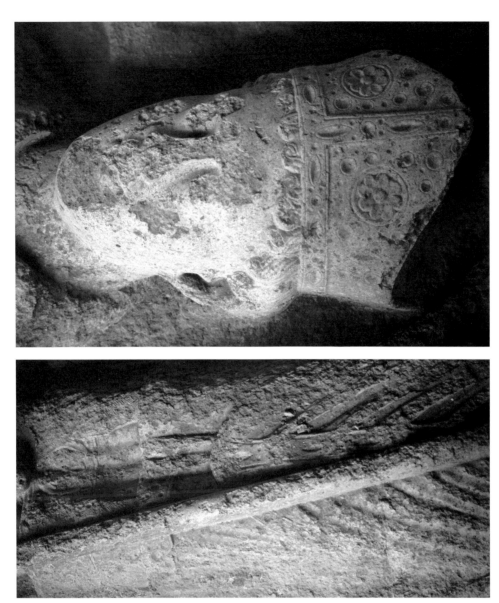

Fig. 6 Details of Purbeck effigy, Exeter Cathedral: miter (top); chasuble, tunicle, dalmatic, stole and alb (bottom). Photos: author

these dark stone ecclesiastical effigies survives only in visitors' accounts or in fragments found deep in crevices of the garments' folds, it is difficult to comment on the extent of the painted schemes.[19]

The most well-known – and deservedly so – example of color on a thirteenth-century tomb is the effigy at Exeter Cathedral made for Bishop Walter Bronescombe around the time of his death in 1280.[20] The completeness of coverage and complexity of color, technique, and detail offer a tantalizing suggestion of how richly other effigies once may have been treated.[21] Every surface, including the slab, the foliage, the architectural features, the pillows, and even the face, is painted (Figs 8 and 9). The quality of carving is extremely high, and it seems that the sculptor worked with the painter in mind; the drapery falls in smooth, supple layers with multiple contours at the sides so as best to show the effects of the rich linings beneath. The colors are vibrant, even today. The miter and the

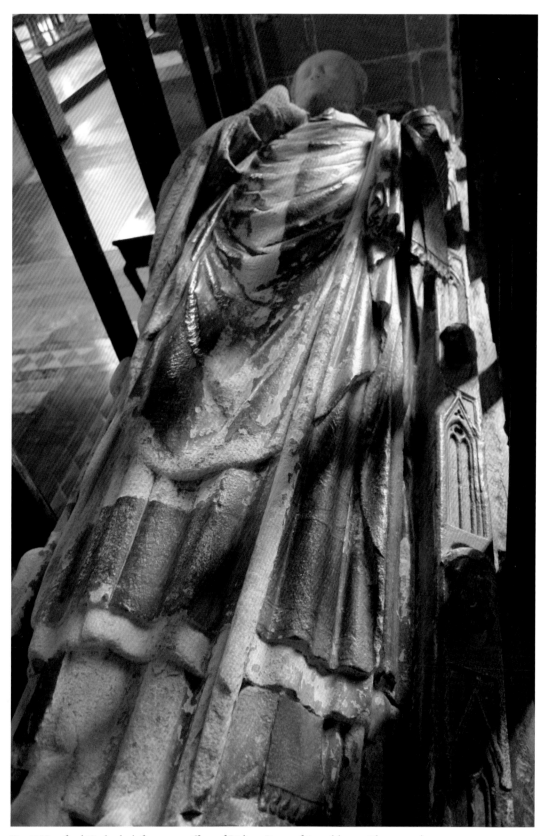

Fig. 7 Hereford Cathedral, freestone effigy of Bishop Peter of Aquablanca. Photo: author

chasuble are both heavily gilded across the front and are lined with a rich red pigment. The dalmatic and tunicle below the chasuble each feature a blue ground sprinkled with a floral motif in gold, a wide gold border, and green lining. Smaller details include geometric patterning along the miter lappets, around the amice, on the maniple, and along the wide borders of the tunicle, dalmatic, and chasuble. Tiny white dots imitating pearls adorn the miter, amice, maniple, the borders of the robes, and the shoulders of the chasuble. E. W. Tristram, who cleaned and studied the effigy in the 1930s, noted the artists' use of an elaborate and refined technique, in which ground pigments and oil were applied in layers over gold or other metal leaf. This resulted in a rich, translucent surface similar in effect to enamel.[22] Even in the absence of any accounts detailing the manufacture of this tomb, it is clear that this is an object on which accomplished specialists spent a great deal of time and talent.

Carved vestments and cloth vestments: a comparison

On the higher quality effigies, the sculptured and painted representations of garments were careful and plausible approximations of actual garments. The sculptor of the effigy at Exeter Cathedral that may have belonged to Bishop Simon of Apulia spent considerable effort to simulate in stone the tactile and visual effects of different types of woven and embroidered fabrics that were used in the making of vestments (see Figs 3 and 4). The lozenge and basket-weave patterns carved in low relief on the maniple and the ends of the stole (see Fig. 5) find close parallels in extant contemporary vestments, such as the fragments of woven and braided work discovered in the coffins of Archbishop Walter de Gray (d. 1255) at York, of Bishop Henry de Blois (d. 1171) at Winchester, and of Archbishop Hubert Walter (d. 1205) at Canterbury.[23] Similarly, the medallions carved in low relief at the base of the alb on the Exeter effigy bear resemblance to embroidered medallions found in episcopal burials, such as the early thirteenth-century tomb of Archbishop Hubert Walter at Canterbury and a mid-thirteenth-century bishop's coffin at Worcester Cathedral.[24] The foliate pattern carved in relief around the neck of the chasuble (see Fig. 4) mimics embroidered cloth apparels.[25]

The settings for imitation gems on stone effigies recreate a notable feature of actual vestments. Gems, pearls, gold plates, and other precious objects were often sewn on to the already sumptuous silks and embroidery of the vestments. Stitching and depressions still visible on the embroidered apparel of an amice found in Archbishop Hubert Walter's tomb, for example, suggest that it once featured applied ornaments in between each medallion.[26] Contemporary descriptions found in English cathedral inventories provide the most comprehensive evidence for the embellishment of garments with precious objects.[27] A late eleventh-century chasuble of Bishop Osmund (d. 1091) at Salisbury was described in the early thirteenth century as having twenty-four precious gems.[28] The black chasubles given to Canterbury Cathedral by Archbishop Lanfranc, which were listed at the top of Canterbury's 1315 inventory of vestments, featured orphreys enriched with gold thread, pearls and gems. Canterbury owned a number of amices, stoles, and maniples described as being similarly adorned.[29] Miters could be especially elaborate. For instance, a miter described in the inventory of 1245 at St Paul's Cathedral in London was enriched with embroidered crescents and stars, gold plates set with peridots, *tau* crosses with gems, stones of topaz and almandine, and pearls.[30] Another miter, described in the Canterbury inventory simply as being golden with precious gems, may have been the miter that was ordered by Archbishop John Pecham at the extraordinary cost of £173 4s. 1d.[31]

Since the effigy of Bishop Bronescombe at Exeter is the only thirteenth-century effigy to survive with enough pigment to suggest an overall decorative scheme, it serves as a particularly valuable

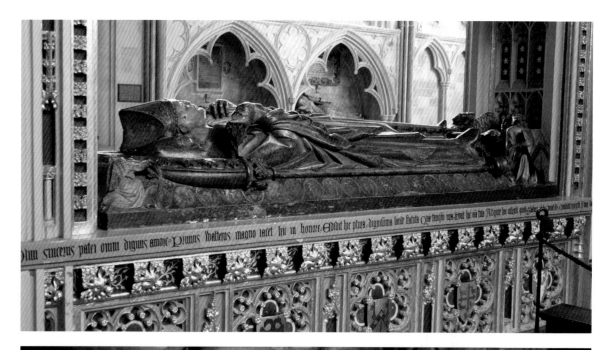

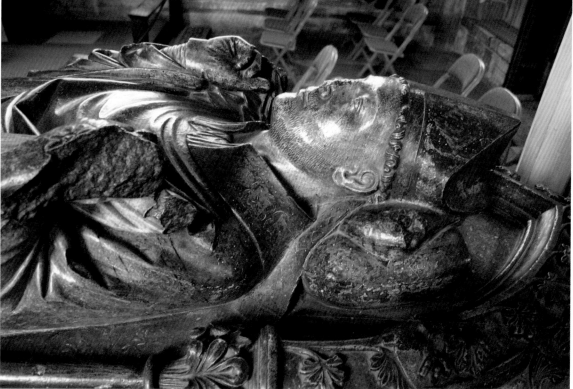

Fig. 8 Exeter Cathedral, painted effigy of Bishop Walter Bronescombe. Photos: author

Fig. 9 Details of effigy of Bishop Walter Bronescombe, Exeter Cathedral: sides of chasuble, dalmatic and tunicle (top); border of the chasuble (middle); maniple (bottom). Photos: Marion E. Roberts

comparison to cloth vestments. Applied ornament is indicated by painted white 'pearls' dotted on the miter, amice, and borders (see Figs 8 and 9). The painted vestments show no human figures, but instead feature foliage and animals, along with a great variety of geometric patterns. Animals and birds inhabit medallions along the sides of the slab and on the orphrey of the bishop's chasuble. Such motifs were not unique to Bronescombe's painted effigy. Two early fourteenth-century ecclesiastical effigies at Canterbury were described in 1599 as having painted garments powdered with gold griffons and lions.[32] The designs of the painted vestments on Bronescombe's effigy are consistent with descriptions in cathedral inventories, which indicate that the majority of vestments had interlaced foliage, flowers, animals, birds, and fantastical creatures woven into or embroidered onto the cloth.[33] Extant vestments also illustrate the popularity of such details, such as the embroidered orphreys on the Pienza cope from the early fourteenth century and the monochrome silk chasuble of tabby lampas weave found in the coffin of Archbishop Hubert Walter.[34] Purely geometrical patterns, such as those painted on the amice, maniple, and miter of Bronescombe's effigy, are usually not mentioned in inventories, yet these designs, too, are found on fragments of embroidered silk from tombs of the period.[35]

Within the confines of their media, medieval sculptors and painters were able to approximate, through surface pattern and texture, the splendor and refinement of ornate liturgical vestments. Although they could not hope to recreate the exquisite subtle textures of delicately woven silks that would shimmer as their wearer moved, effigy sculptors and painters nonetheless succeeded in creating a lively, glimmering surface which would respond to flickering candlelight and the movement of people around the object. Indeed, through the use of oils and metal leaf, the painters of the Bronescombe effigy appear to have come quite close to simulating the shimmering effects of cloth.

Vestments played an important role in establishing the bishop's identity in relation to his cathedral. Splendid robes served to augment the church's ceremony and honor God, but surviving wills and cathedral inventories suggest that garments made for and worn by episcopal leaders also had a commemorative purpose. When a bishop died, he often left to the church (or to several churches) items such as vestments, miters, or copes.[36] In a few instances, personal copes or chasubles included initials, other text, and/or heraldry that identified the donor, although how clearly such identifiers would have been seen when the object was worn is questionable.[37] The association between object and donor is more frequently and consistently made in the written record of the church, where the specific donations were preserved in inventories or in obit calendars.[38] Spiritual benefit to the donor in the form of remembrance of his gift would perhaps have occurred during the vesting of the celebrant, or during the liturgy when the celebrant asked that God remember those who have benefited the cathedral through their generosity. A very direct association between the gift and the act of remembrance is suggested by some cathedrals' obit calendars. At Canterbury Cathedral, donations of vestments and other goods to the cathedral were sometimes inserted directly into the calendar entry for the donor's day of death, and thus may have been mentioned (or even brought out and worn?) at his annual commemoration.[39]

Not enough evidence survives to be able to link actual vestments to those depicted on tombs. Indeed, the Bronescombe effigy's vestments, which are abundantly painted in gold in imitation of garments heavily embroidered with metal threads, seem to be more lavish than the vestments described in contemporary documents. The surviving English inventories describe relatively few items from the thirteenth century so densely worked with gold.[40] The implication is that the effigy was represented in the most sumptuous garments imaginable. This is reinforced by the depiction on most effigies of a *mitra pretiosa* (see Figs 6 and 8), the most heavily enriched type of miter, like those

listed above in the Canterbury and St Paul's inventories. These miters were costly and reserved for the most solemn occasions. While a certain degree of accuracy in depicting vestments on tombs was clearly desired, and was obtained through great skill and expense, patrons also may have wished to be displayed in vestments of the utmost finery, perhaps even more magnificent than those that existed in the cathedral vestry.[41]

Effigies, vestments, and status

Typically not physiognomically accurate portraits, episcopal effigies display, above all, the office or position that the deceased held.[42] On early English ecclesiastical tomb effigies, hints of personal history or of dynastic ties are secondary to the depiction of institutional identity.[43] With its miter, crosier, and pontifical mass vestments, the figure in effigy is instantly recognized as representing the episcopal office. While the bishop could, at certain times in the liturgy, wear garments also worn by others, *only* a consecrated bishop could wear the particular combination of items of clothing that was carved on an effigy. The episcopal mass vestments represented the culmination of all of the lower orders by including aspects of the garments worn by canons, priests, subdeacons, and deacons.[44] Furthermore, the insignia, namely the sandals, episcopal ring, gloves, crosier, and miter, were exclusive to the rank of bishop.

Such elaboration of external attributes of status on ecclesiastical tombs was an expression of worldly status and political might. Yet the episcopal mass vestments that are depicted on bishops' effigies more specifically demonstrate the immense spiritual authority held by the bishop. They proclaimed the bishop's privilege of celebrating the most sacred rituals in the church. The absence on episcopal effigies of a cope, arguably the most splendid item of ecclesiastical attire, is a significant detail in this regard.[45] Copes were heavily embroidered with geometric, foliate, and figural designs in threads of precious metals or silk.[46] To these were added orphreys and embroidered or jeweled clasps. Copes were given as luxury gifts, and their monetary value is demonstrated by the fact that they often appear at the head of the list in inventories of cathedral vestries, with their materials and embellishments carefully noted. These richly decorated cloaks, however, were not exclusive to bishops. Depending on the liturgical calendar, the cope could be worn by other members of the choir.[47] More importantly, despite its intrinsic material worth, the cope was a lesser garment in terms of the celebration of the liturgy. The cope was only used at certain times, usually limited to processions and entrances into the choir. In the Sarum rite, the most widely used liturgy in the British Isles in the thirteenth century, whenever the bishop was to be the celebrant at the altar, he was instructed to enter the choir in a cope, but then to divest himself of it and be vested in the garments canonically required to perform the sacred rite of the mass.[48] William Durandus, in his *Rationale Divinorum Officium*, elaborated at length on the symbolic associations carried by the various garments in a suit of mass vestments. Copes, by contrast, merely received a scant two-page mention in his prologue.[49]

The importance of the bishop's sacred duties above all other responsibilities is demonstrated by the ceremonies of consecration and investiture, which were integrated into a special performance of the mass. After his examination and his entry into the choir of the church, the bishop-elect was vested for the celebration of the Eucharist. The mass was suspended part way through so that the candidate could be consecrated and could accept the episcopal crosier and ring. After communion, the candidate's superior bestowed on him the episcopal gloves and miter. He was then presented to the public in his new office as bishop.[50] Just as the authority to celebrate mass was conferred by the ritualistic donning of a suit of liturgical vestments, the process of becoming a bishop entailed the

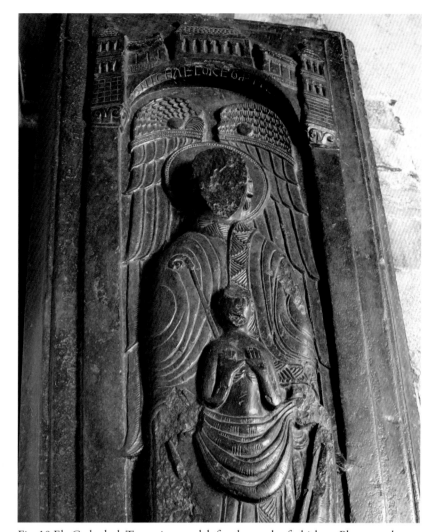

Fig. 10 Ely Cathedral, Tournai stone slab for the tomb of a bishop. Photo: author

ritual acceptance and donning of liturgical vestments and episcopal insignia.[51] The attention paid to vestments and insignia on the tomb effigy reflects how integral these items were in expressing – and indeed in creating – the bishop's role as spiritual leader.

Each item of these vestments and insignia carried with it symbolic significance, as set out by Durandus and others, and, more importantly, as stated in the consecration texts. Each item was conferred with an admonition to the newly consecrated bishop to remain pure in spirit and deed, to maintain authority and teachings, and to exercise justice and discipline in his dealings with clergy and the faithful. While ecclesiastical dress and insignia were not always indicators of virtuous character – after all, medieval artists' renditions of the Last Judgment sometimes show bishops in the arms of demons as well as in the arms of angels – they carried with them the expectation of moral integrity. Durandus cautioned that bishops 'wear not the vestment without its virtue.'[53] To be elevated to such exalted status within the priesthood required, at least in theory, an intense spiritual devotion, and the desire and ability to be a model of Christian behavior.

Vestments in the context of death and burial

While the fully vested effigy represents a historical fact, namely that the deceased had been a bishop, with all the worldly and spiritual privileges and responsibilities that that position entailed, it also affirms the Christian doctrine of the resurrection of the body and is an expression of hope for salvation of the soul. An effigy seems to be a representation of the bishop in a future, post-resurrection state. It is usually housed in an architectural niche – perhaps one of the heavenly 'many mansions' (John 14:2) – and is accompanied by angels who swing censers toward the figure. As a contrast to the buried body in the coffin below, an English episcopal effigy is usually shown as a living being. The figure's eyes are open, he raises a hand in blessing, he holds a crosier, he stands rather than reclines, and he triumphs over a beast at his feet.[54]

Vestments on ecclesiastical effigies, with their color, texture, and pattern, reinforce the idea that the figure represented in effigy was meant to be understood as alive, in perpetuity. During the Middle Ages, it was thought that color imparted life to a statue, endowing it with presence and personality.[55] As one late medieval English commentator with fears about idolatry wrote, 'Ye peyntor makith an ymage forgid with diverse colours til it seme in foolis izen as a lyveli creature.'[56] The anonymous author of the *Rites of Durham,* describing pre-Reformation images in the Galilee Chapel of Durham Cathedral, wrote in 1593 that the figures were 'so lyvely in cullers and gilting'.[57] Both writers described painted figures as lyvely, meaning living or life-like. The effectiveness of ornament and color to express life is most evident in 'cadaver' or *transi* tombs, a type of memorial sometimes used in the fifteenth century. On many *transi* tombs, a brightly colored, 'lyvely' effigy is placed just above a carved image of a corpse that is grey, and wrapped in a grey shroud. Death is represented as the absence of color, while the 'living' effigy is expressed in vivid color and detail.

If we accept that the effigy represents the body in a post-resurrection, revivified state, then the fact that it is dressed at all is a matter of importance. Effigies seem to illustrate a belief that the dead maintain a certain level of distinction after the resurrection, despite the plain white garb described in John's revelation. In fact, John himself saw the dead, 'both small and great' stand to be judged 'according to their works' (Revelation 20:12). The implication was that even at the end of time, a measure of particularity in both form and character was maintained, and that not all of the elect conformed to the same image. Indeed, the idea that heaven's population was not homogeneous appears to have been widely accepted. One source for this way of thinking may be Paul's letter to the Corinthians, in which he compared our celestial, resurrected bodies to the stars, stating that they do not all shine with the same radiance (I Corinthians 15). The concept of differentiation within the community of the elect was thus present from the earliest days of the Christian church. Furthermore, it was maintained throughout the medieval period in the mass sung for the dead, which incorporated this Pauline text. Descriptions of the communion of saints are further indications that heavenly reward was thought to be based on earthly merits. Significantly, martyrs and God's preachers were sometimes described as holding the highest rank in the holy choirs.[58]

A wide variety of medieval works of art portrayed the dead with items of clothing and other markers of status after the demise of the body. The many niches across the thirteenth-century façade of Wells Cathedral house the population of the ranks of heaven, all of whom bear insignia of earthly rank.[59] The resurrection frieze on the same façade shows bodies rising up from the tombs with miters, crowns, tonsures, and other indicators of position. Indeed, on most major church portals that depict the Last Judgment, somewhere between emerging from the tomb and being assembled among the elect or the damned, the individual is re-vested in his identifying apparel.[60] Even souls,

typically depicted as small, nude figures, were sometimes shown bearing an identifying attribute. A miniature crosier is tucked behind the soul that is being carried aloft by the Archangel Michael on a mid-twelfth-century bishop's tomb slab at Ely Cathedral (Fig. 10).[61] Visual representations of the dead in clothing of status had direct precedent in funerary custom. Bishops were dressed in full mass vestments and episcopal insignia in preparation for burial.

The effigy, I suggest, does more than illustrate a belief in resurrection, or even in a heavenly hierarchy. The display of vestments and insignia of the finest quality was important because it served to advertise and reinforce the bishop's station – a station particularly advantageous for achieving salvation. The clergy avowed that because of their spiritual devotion, pastoral vocation, and role as intermediaries, they were closer to God and the saints than were the laity. The link between vocation and salvation is made explicit in masses that were sung for deceased bishops. The post-communion prayer, for example, pleads that bishops, as dispensers of God's gift, be numbered among the elect. Bishops in effigy raise a hand, as if transmitting the word and blessing of God to the general population. Commemorative prayers suggest an association of the bishop with his apostolic and saintly precursors. These request that he who was raised to the dignity of apostolic service be joined in everlasting fellowship with the Apostles.[62] In England, the number of bishops sanctified in the late twelfth and thirteenth centuries provided further impetus to display a bishop's sacerdotal role prominently on a tomb.[63]

Display of status on tombs operated on multiple levels, as propaganda that emphasized worldly accomplishments as well as spiritual aspirations. Tomb effigies express, in a single image, both the past identity of the deceased as well his hope for a glorified, future state of being. Concepts of earthly vocation and future sanctity intermingle. Indeed, the tombs suggest that the deceased hoped to achieve redemption precisely *because* of the status that he had achieved during life. The careful attention paid to representing episcopal vestments and insignia, in texture and polychromy, illustrate the high importance of this feature for the patron. In effect, the effigy, which lay resplendent in the finest vestments, displayed the markers that made the bishop physically recognizable but which also were the visual evidence of his personal devotion to God and – it was hoped – his worthiness of redemption.

CHAPTER 9

Material Evidence, Theological Requirements and Medial Transformation: 'Textile Strategies' in the Court Art of Charles IV*

Evelin WETTER

In recent decades, the rich heritage of textile representation in medieval painting has prompted numerous investigations into the analogies between woven fabrics and those depicted in images. Research on panel painting and polychrome sculpture has tended to focus on questions such as production processes and workshop connections.[1] From a textile history perspective, painted patterns have been investigated to help determine the earliest appearances of motifs, dating, and evidence of the regional dissemination of specific fabrics at a certain period in time.[2] Apart from exploring the collections of museums (especially those assembled from the mid-nineteenth century onward in order to provide historical patterns for the contemporary textile industry[3]), art historians have concentrated on the variety of textiles surviving in medieval treasuries.[4] While studies of medieval and early modern clothing and fashion, as well as its pictorial representation, have attracted increasing interest in recent years,[5] an investigation into the allegorical reading of religious clothing has thus far either been limited to textiles with particular subject matter or has been approached more broadly with regard to clothing depicted in religious paintings.[6] In this paper, I will explore the interpretative potential of an allegorical reading of liturgical vestments. Moving beyond the material culture studies offered by recent publications,[7] this essay will focus on the allegorical reading of different types of liturgical vestments and ecclesiastical textile furnishings in late medieval Prague, and will consider not only surviving textiles, but the evidence of inventory description and the representation of textiles in other works of art. First though, a critical reading of the medieval inventories of Prague Cathedral should offer a better understanding of how luxurious textiles functioned within their medieval settings.[8]

Medieval textiles documented in the treasury of Prague Cathedral

An inventory of St Vitus's Cathedral in Prague, drawn up in 1354, contains a list of newly added chasubles, including:

> a chasuble sewn from violet-brown fabric, given by Queen Elisabeth Grecz; a chasuble of light-colored velvet adorned with lilies and golden letters, which was given by Blanche, Margravine of Moravia [...]; a chasuble of green velvet with fish embroidered in pearls, together with an alb, stole and amice, given by the Queen of Bohemia, the Lady Anne; furthermore the same queen donated an exceedingly sumptuous chasuble with eagles and lions embroidered in pearls on top of a light-colored velvet, together with a precious amice and with an alb and stole.[9]

The royal donations listed in this document clearly illustrate how several fourteenth-century Bohemian queens thus incorporated themselves into the liturgy and the commemoration of rulers that was enacted at Prague Cathedral. Such records commemorating donors, combined with the heraldic ornamentation decorating the objects, guaranteed a long-lasting *memoria*.[10] Unfortunately, all the textiles mentioned above are now lost and the inventory forms the only record of these successive acts of queenly patronage.

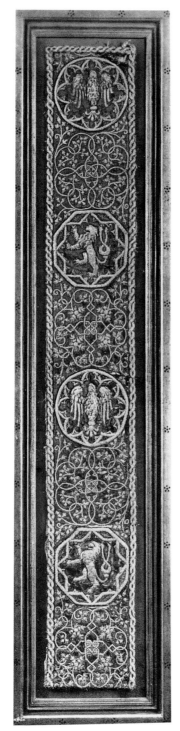

Fig. 1 Orphrey with heraldic eagles and lions, central Europe, Prague (?), second half 14th century to c. 1400. Current location unknown (© Reproduction after Privatsammlung aus Nachlaß Otto Bernheimer, pl. 67)

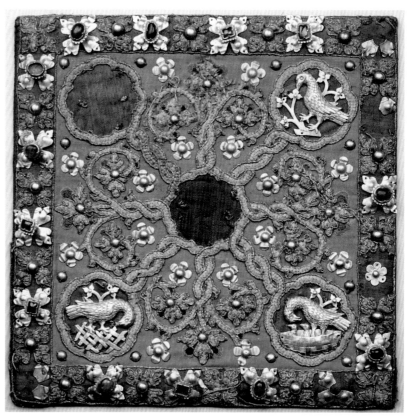

Fig. 2 Palla with eagle, phoenix, and pelican from St Marienstern, central Europe, Prague (?), second half fourteenth century to c. 1400. Panschwitz Kuckau, Convent of female Cistercians St Marienstern (© Janos Stekovics)

Heraldic evidence can be a valuable tool in connecting extant textiles to specific donation records. One such example is the orphrey with eagles and bicaudal rampant lions that was last published in 1960, when the Bernheimer Collection in Munich was auctioned (Fig. 1).[11] Since its current location remains unknown, the embroidery is difficult to fully assess. It is tempting for scholars to connect the Bernheimer orphrey – probably originally serving as an orphrey on a chasuble – to the donation of Queen Anne to Prague Cathedral. Consequently, this connection implies that the two comparable objects, made for and existing until today in the Cistercian convent of St Marienstern in Upper Lusatia should be dated earlier. One is a palla, embroidered with the rising eagle, phoenix, and pelican, while the second one is a related maniple, both of which were previously dated to around 1400 due to a lack of comparable material (Fig. 2).[12]

Relying on heraldic evidence alone can be problematic as well. For example, recent attempts to identify an embroidered chasuble located in the same convent as having been a donation of Charles IV have been in vain (Fig. 3).[13] The textile's combination of motifs,

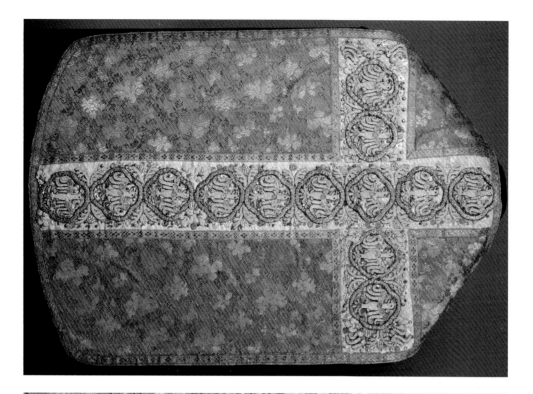

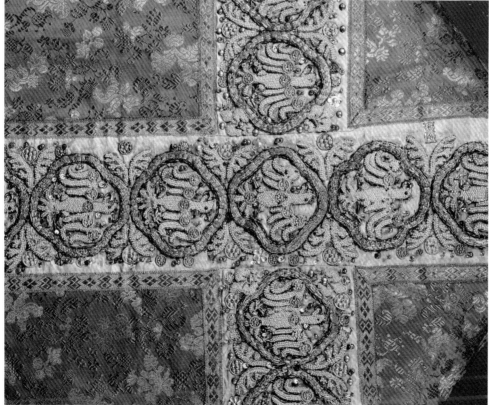

Fig. 3 Chasuble with re-arranged embroidered elements of eagles symbolizing the resurrected Christ, central Europe, Prague (?), second half fourteenth century. Panschwitz Kuckau, Convent of female Cistercians St Marienstern (© Janos Stekovics)

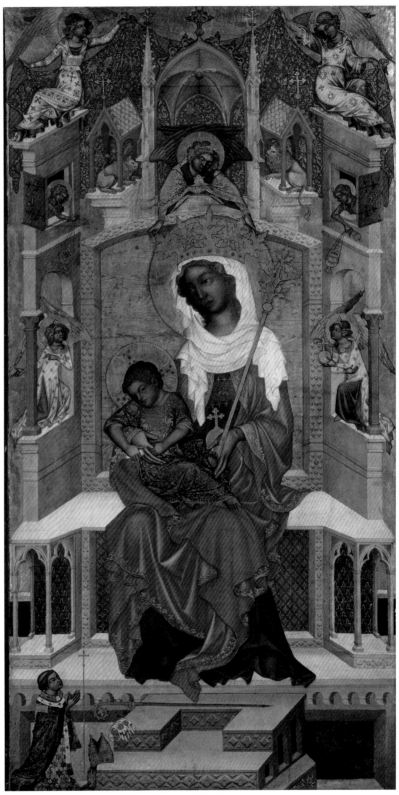

Fig. 4 Glatz Virgin, Prague, *c.* 1350. Berlin, Gemäldegalerie - Staatliche Museen zu Berlin, inv. no. 1624 (© bpk / Gemäldegalerie, SMB / Jörg P Anders)

Fig. 5 Glatz Virgin, detail with the donor, Prague, *c.* 1350. Berlin, Staatliche Museen – Gemäldegalerie, inv. no. 1624 (© Gemäldegalerie SMB, Stephan Kemperdick)

which were seen as heraldic evidence in support of this hypothesis (with the fleurs-de-lis as a reference to Blanche of Valois and the bird as the eagle of St Wenceslas), in fact derives from a substantial reconstruction of the object in 1701, when Abbess Ottilie Hentschel donated it.[14] The material and techniques are clearly different: the fleurs-de-lis and eagles, as well as most of the paillettes and even the sequins (which are surely later, dating to around 1500) were obviously taken from other embroideries of older vestments. Objects such as this clearly cannot be interpreted meaningfully unless a thorough examination of the material evidence has taken place. Moreover, such a heraldic approach ignores the Christological and ecclesiological dimensions of liturgical vestments. As a symbol of Christ's Resurrection, the motif of the rising eagle is found frequently on the orphreys of chasubles, often together with the fleur-de-lis, which was a well-established symbol of the Virgin

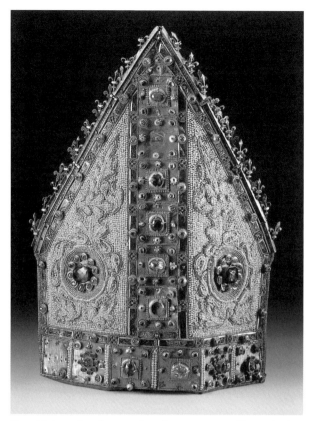

Fig. 6 Miter, Southern Italy, after 1317. Amalfi, Cathedral Museum (© Reproduction after Giorgi, p. 22)

Fig. 7 Fragment of the Cope of St Valerius, Spain, thirteenth century (© Riggisberg, Abegg-Stiftung, Photo : Christoph von Viràg)

Fig. 8 Detail of a dalmatic from Stralsund, with pattern shown in the upright position: Italy or Persia, first half 14th century. Riggisberg, Abegg-Stiftung, inv. no. 152 (© Riggisberg, Abegg-Stiftung, Photo: Christoph von Viràg)

Fig. 9 Gold fabric, Persia, second half 13th century. Riggisberg, Abegg-Stiftung, inv. no. 523 (© Riggisberg, Abegg-Stiftung, Photo: Christoph von Viràg)

and found on various textile furnishings of the altar.[15] This iconographical tradition of liturgical textiles should be seriously taken into account in any interpretation of the Marienstern chasuble, especially since significant heraldic features like the bicaudal lion of Bohemia in the Bernheimer orphrey are missing. The Marienstern chasuble thus demonstrates the difficulties in understanding the heraldic elements of liturgical vestments exclusively in terms of displaying contemporary concepts of sacred rulership.[16] It is actually the materials and iconographic programs of these textiles that functioned allegorically for their original viewers and therefore would have evoked several layers of meaning.

Robes of the groom of the church: The Glatz Virgin

I will now examine specifically the representation of textiles and their meaning in a fourteenth-century Bohemian panel painting, the so-called Glatz Virgin (Fig. 4). This large-scale panel of 187.7 x 102.8 cm was originally made for the church of the Augustinian Canons' convent at Kłodzko (formerly Glatz) in Silesia.[17] The painting depicts the first archbishop of Prague, Arnošt of Pardubice (c. 1300–64).[18] The donor is seen kneeling at the bottom left and raises his hands toward the Virgin and Child who are seated on a spectacular throne that is framed and surmounted by elaborate architecture. This, in turn, is set against a sumptuous cloth of honor held by two angels. Today, the panel appears rather narrow, yet originally it was almost twice as wide, as proven by Bohuslaus Balbin's description, published in 1664.[19] Accordingly, the central Virgin panel was originally surrounded by a series of smaller images showing the Nativity, the Circumcision, the Flight into Egypt, Christ among the Doctors, and others scenes.

Arnošt appears in the full ornate of the bishop, as if robed to celebrate the Eucharist (Fig. 5).[20] Over his undergarment, of which merely one decorated cuff can be glimpsed, he is robed in a golden dalmatic with a pattern of intertwined circles enclosing red and green stars. His chasuble – lined in green – displays a blue fabric ornamented in gold with winged dragons and birds spreading their plumage. Over the chasuble, he wears the archiepiscopal pallium that has its ends decorated with fringe and a gold, jeweled trim. What appears to be punched

Fig. 10 Tunic of Christ child, Detail 'Glatz Virgin' (© Gemäldegalerie SMB, Photo: Stephan Kemperdick)

gilding on the chasuble can be interpreted as a cross-orphrey. The trimming of his amice is also gilded. Circular recesses in the amice are painted in a luster technique that resembles precious stones placed within gold settings. The episcopal miter, which is the *Mitra Pretiosa* type, is ornamented in a similar way, as are the medallions found on the gloves and the crosier. These three episcopal insignia – the miter, gloves, and crosier – together with the drapery of the Virgin's cloak form a kind of cascade that compositionally links the figures. The archbishop's miter rests on the first step that leads up to the throne of the Virgin, while its long lappets hang down towards Arnošt's dalmatic and thus links him directly to the heavenly realm that includes the *Regina* and *Porta Coeli*, the *Stella Maris*, the Black Bride, and the Throne of Solomon. The presentation of Arnošt's episcopal insignia has been interpreted as an act of devotion.[21] What is visualized on the Glatz Virgin is a complex arrangement of numerous Marian titles. Relating the painting to contemporary Marian poetry, Karel Chytil and especially Robert Suckale, have actually characterized the panel as a 'painted anthem to the Virgin'.[22] Stefan Kemperdick has recently modified this reading, contending that one must also take into account the Virgin's role as mediator between the *Civitas dei*, the Heavenly Jerusalem, and the terrestrial world.[23] The specific role of the vestments and luxurious textiles, however, has not yet been taken into account in these interpretations.

When comparing the textiles and episcopal insignia depicted on the panel to surviving liturgical vestments, one might initially believe that each of them was devised according to a material exemplar. Contemporary counterparts to the miter represented in the Glatz Virgin are two miters housed in the treasury of Zagreb Cathedral and in the Cathedral Museum of Amalfi (Fig. 6).[24] Other parallels may also be found. For example, the circular pattern on Arnošt's dalmatic appears to

derive from Spanish fabrics that are characterized by a grid pattern with circles and stars (Fig. 6).[25] The patterns on Arnošt's chasuble, the Christ child's tunic, and the cloth of honor at the top are similar to silks respectively from Italy, Persia, and even central Asia (Figs 8 and 9).[26] Each of the painted examples is mostly formed by a central, wheel-like element, surrounded by leaves and creatures such as qilin, dragons, and phoenix (see Fig. 5; Fig. 10).

As key to understanding the meaning of the textiles and the way they have been depicted in the Glatz Virgin, I will refer to the treatise *Rationale divinorum officiorum* by William Durandus of Mende (1230/31–96).[27] Compiled towards the end of the thirteenth century from various other sources, this collection of allegorical interpretations of the Mass and the furnishings of the church interior was widely disseminated throughout Europe in the late Middle Ages. Not only is there a copy of the rationale listed in the inventories of Prague Cathedral, but there are also references to several of the other sources from which Durandus had synthesized his allegorical interpretation.[28]

Durandus describes the function of vestments as an expression of the ecclesiastical hierarchy that was founded on moral theology. When viewed as such, it becomes clear that one of the aspects addressed in the imagery represented in the Glatz Virgin was the donor's episcopal office. According to Durandus, the bishop robes himself in a sequence of fourteen stages. It begins with putting on the sandals, followed by the amice, the *alba talaris*, the *cingulum*, the stole, and the *tunica iacinctina*, which denotes the tunic of the pontifical vestment.[29] Despite the richly decorated amice, these first stages of episcopal clothing are more or less implicit in every episcopal ornate. They did not need to be depicted explicitly, although the cuff of Arnošt's left hand indicates the presence of the episcopal tunic. The seventh stage of episcopal dress is marked by the dalmatic, symbolizing the holy order both in the sense of clerical status and renunciation of the pleasures of the flesh. The adornment of the following articles would come next: the gloves (to protect the bishop from vain praise); the ring; the chasuble (symbolizing charity); and the maniple. The twelfth vestment to be put on is the cope, although it is not depicted in the painting. Evidently this was done in order to show the pallium, which is only visible if worn over the chasuble, and indicates that the archbishop is the pope's representative.[30] In the two final stages of episcopal dressing, Durandus identifies the miter (the bishop's heavenly crown) and the crosier (an expression of his authority and teaching).

Referring to statements made by the authorities Sicardus and Amalar, Durandus elaborates the significance of the dalmatic as deriving from the unsewn tunic of Christ.[31] Moral theology accounts for the difference between the sleeves of the deacons' dalmatic and those of the episcopal dalmatic, the latter of which are wider in reference to episcopal clemency.[32] Episcopal clemency, indeed, is a topos that plays a significant role in Arnošt's biography, or rather hagiography, since he has been venerated almost as a saint.[33] As an episcopal garment, the dalmatic also serves as an expression of this archbishop's dignity. The representation of the dalmatic in this painting is the most sophisticated detail in terms of technique. Like the episcopal insignia – the miter, the gloves with medallions and rings, as well as the crosier – the depiction of the dalmatic is created by a layer of surface gilding, which is incised and partially punched, and includes polychrome ornamentation in a luster technique.[34] This requires considerable expense, both in terms of material and time. This technique was also used precisely on those vestments and insignia that best express Arnošt's episcopal identity. Distinguished above all are those insignia directly tied to the theological concept of *sponsus* and *sponsa* (bride and groom): the ring (or, rather, rings) and the miter as *corona*. With regard to the ring, Durandus refers directly to this concept: 'For the ninth, the ring, so that he esteem the bride such as himself.'[35] With the miter placed at the thirteenth position, Durandus alludes to the eternal coronation.[36] The Rationale's chapter on the miter itself does not further touch upon this

Fig. 11 Cloth of honor, Detail 'Glatz Virgin' (© Gemäldegalerie SMB, Stephan Kemperdick)

argument.[37] This is because it had been considered much earlier by Honorius Augustodunensis (d. 1151), who summed it up as follows: 'For the miter is the church, whose head is Christ, who again is embodied by the bishop.'[38]

The concept of *sponsus* and *sponsa* plays the most significant role in the hagiography of Arnošt of Pardubice. The authors of his vitae refer to his church as '*suae sponsae*' to which he devoted himself entirely. While the older vita by Wilhem of Hasenburg refers to the figure of Martha as a model for service to a cleric, Beneš Krabice of Weitmil explicitly mentions 'his church, his wife'.[39] Furthermore Beneš Krabice writes: 'In recognition of his desire [...] he was represented with his knees turned toward the ground while in the presence of images of God and the most holy Virgin that he had depicted once in glass and several times as painted panels; at her feet, all [types of] archiepiscopal insignia were depicted, as if he had thrown them away and surrendered them because of God.'[40] Such descriptions of Arnošt's *Devotio* as well as other depictions of him as a donor emphasize all the more strongly the role that his insignia play in the various paintings, expressing his episcopal status through their specific display and their material and technical splendor.[41] In the Glatz Virgin, the depiction of the donor thus becomes an image of betrothal. As re-enacted in the episcopal conse-cration rite, the bride is the church.[42] How is the Virgin-cum-church robed, then? Answering this question includes a discussion not only about the Virgin, but also an analysis of the architectural setting in which she is placed.

The Virgin is characterized by three colors: blue (her dress), red (her cloak), and white (her veil). The Christ child, embodying the *logos* as well as the *sponsus*, holds her finger and wears a green tunic with a golden pattern of pacing dragons. The angel crowning the Virgin is robed in an intricately patterned cope made from a precious golden fabric. Two angels sitting on the architectural but-

tresses gracefully hold a cloth of honor that displays a pattern of foliage motifs encircling loosely arranged animals (Fig. 11).

Comparing these fabrics once again to surviving material artifacts, it becomes clear that these sections of the painting only allude to actual textiles, using painterly means rather than depicting them truthfully. The inscription on Christ's tunic recalls a tirāz, which, however, would not have been woven at the position it occupies on the tunic in the painting.[43] The cloth of honor's fabric even contains two sea-creatures, a fish and a crab, which are quite unusual in a textile design. These might be signs of the zodiac, or perhaps literal representations of the sea underneath the *Stella Maris* that is incised in the gilded ground above.[44] There are considerable differences, however, between the represented textiles and the surviving ones. In fact, realism may not even have been the primary purpose of these representations. Furthermore, there is a contradiction in the fluid folds of the heavily brocaded textiles as represented in the painting that denies their stiff character in reality; thus there is no rapport between the fabric depicted in the painting and how it actually would have hung. Here, the various motifs are arranged so as to convey the impression of a *nachone*, a type of figured gold fabric of oriental origin, also mentioned in the inventories of St Vitus's Cathedral.[45]

The painting visualizes the Virgin as an embodiment of *ecclesia* most obviously through the abbreviated ecclesiastical architecture. In order to investigate this symbolism further, I turn to examine what Durandus summarizes as *ornamenta*, that is, as any moveable furnishings of the church interior, but especially objects for liturgical use.[46] His way of describing these artifacts can be characterized as 'auto-referential' in the sense that their splendor, richness, and materiality become external expressions of the church's inner *Gloria*, which bestows upon them their true radiance.[47] The Christ-child's tunic, the cope of the crowning angel, and the cloth of honor are distinguished by means of their golden patterns – a distinction that has to be seen not only in terms of pictorial highlighting, but also with regard to the theological connotations of luxurious fabrics. In fact, by following the pictorial tradition of clothing the Virgin in a blue dress, a red cloak decorated with only a gold trim, and a pure white veil, the painter creates a contrast to the richly brocaded luxurious fabrics.[48] Regarding the large scale of the painting, it becomes clear that indeed the meticulously painted luxurious textiles also attract the viewer's eye: in an almost increasing rhythm, the viewer is guided from the donor at the bottom of the image, to the Christ-child in the center up to the cloth of honor, overlaying the whole scene.

The cloth of honor, which appears again and again in the pictorial arts, is derived from the *Cortinae* that formed part of the decoration of the church interior. Referring to Solomon's '*Nigra sum sed formosa*', Sicardus of Cremona's interpretation of the *Cortinae* can be applied to the cloth of honor in this panel: 'What is being ornamented internally rather than externally refers to the ornamentation of the bride in a moral sense; her glory consists from within of golden threads which means the steadfastness of good deeds; for even though she may be black on the outside, as result of her hardships, yet she is fair from within, thanks to her virtues.'[49]

This characterization of the church in the painting corresponds to the representation of the Virgin as the Black Bride, and recalls the hagiographical topoi concerning Arnošt's piety mentioned above, particularly in reference to how he devoted himself completely to his bride. It therefore appears as if contemporaries and patrons were highly aware of the symbolic and allegorical meanings of church furnishings in relation to the various ecclesiastical vestments. This is suggested by Sicardus's reference to the cloth of honor as the glory of the Black Bride in Solomon's *Song of Songs* (Canticles 1:4) – a glory that the dark figure of the Glatz Virgin equally radiates – and the repeated invocation of good works by the Glatz Virgin's donor. Indeed, textiles here generate a subtle code in

Fig. 12 Adoration of the Magi, Prague, c. 1355–60. New York, Pierpont Morgan Library and Museum, inv. no. AZ022.1 (Photo: Morgan Library)

Fig. 13 Dormition of the Virgin, Prague, c. 1355–60. New York, Pierpont Morgan Library and Museum, inv. no. AZ022.2 (Photo: Morgan Library)

relation to the patron's self-identity and lead us to a renewed inquiry into Arnošt's role as first arch-bishop of Prague and high-ranking councillor and diplomat in the services of Charles IV.

In 1346, Arnošt of Pardubice led a delegation to Avignon in order to prepare the papal approbation of Charles IV's election as King of the Romans. Following backstage negotiations and agreements, both Arnošt and Pope Clement VI delivered speeches that were entirely concerned with the theme of Solomon[50] – a theme echoed in the Glatz Virgin who appears as the Throne of Solomon, the *Sedes sapientiae*, and thus as *Ecclesia*.[51] Interestingly Arnošt referred explicitly to the holy see using Marian titles like 'the bride without wrinkle and stigma' and 'the closed garden' in his speeches.[52] Furthermore, Clement VI's speech contained a detailed account of the relationship between sacred and secular authority. He argued that it was the church that granted secular lordship – an interpretation known as the two-swords-theory.[53] Accordingly, in the panel, it is the Virgin who holds the scepter and orb. She is meaningfully flanked by two angels: the one on the right confers yet another orb in ceremonial gesture, whereas the other one points to the left. Based on the mid-seventeenth-century description of the painting by Bohuslaus Balbin, it is possible that scenes of the Annunciation and the Adoration of the Magi were placed at the level of these two angels.[54] Echoing the humble presentation of the donor's episcopal insignia, the angel on the right may there-fore allude to the biblical event of the three Magi as representatives of secular power searching for the new born Christ-child. Stephan Kemperdick even discusses the angel with an orb as a devotion-al motif and as allusion to Charles IV – who was referred to by his contemporaries and by himself as King Solomon – paying homage to the new Solomon.[55]

Coming back to the donor, I would like to conclude that in the allegorically-based visual lan-guage of textiles and insignia, Arnošt of Pardubice appears as *spons* of *ecclesia* – ceremonially as groom, and politically as man of the church.

Robes of power: The Pierpont Morgan diptych

The extent to which understanding the visual language of liturgical textiles can help elucidate the subtle roles that figures might play within panel painting can also be demonstrated on a diptych from the Morgan Library and Museum (Figs 11 and 12).[56] The images of the Adoration of the Magi and the Death of the Virgin depict both Charles IV and the pope virtually participating in the sacred events. Charles IV is shown as the second Magus while the pope attends the Death of the Virgin in the guise of St Peter who displays the papal insignia. The representation of St Peter may well allude to Pope Inno-cent VI (r. 1352–62) who had Charles IV crowned as Holy Roman Emperor in 1355. The king's cloak displays a pattern of imperial eagles. The impression that textiles are of the highest possible quality is here evoked through the costly painting technique of *sgraffito*. In the Death of the Virgin, St Peter's cope and the garments of Christ (in the mandorla) are executed in the same way, although the painting above the gilded ground is almost completely lost, perhaps due to abrasion from physical veneration.[57] Christ receives the soul of the Virgin and blesses St Peter as his representative, as indicated by the three-tiered tiara worn by the saint. Focusing on the person of the pope this part of the diptych thus emphasizes the role of the church. Seen next to each other, the two panels give an idea of the delicate relationship of imperial and ecclesiastical power. This decisive political program of the two panels even provoked Jiří Fajt to propose that Charles IV himself had commissioned the Morgan Diptych, 'either for his own devotion or as a diplomatic gift, probably for Pope Innocence VI'.[58]

Focusing again on the depiction of the king's cope, the pattern of stripes with regular rows of eagles alludes to the technique of weaving rather than embroidery. Only the hems around the neck

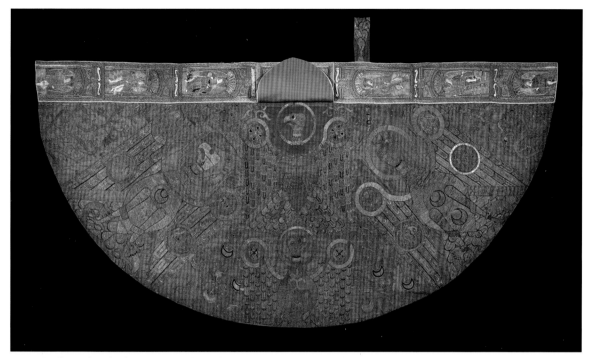

Fig. 14 'Chape de Charlemagne', Sicily, eraly 13th century, with orphreys and hood, France or Flanders, 16th century. Metz, Cathedral treasure (© Reiss-Engelhorn Museen Mannheim, Foto: Jean Kristen)

could be imagined as executed with needle and thread. The eagle is, of course, an important heraldic symbol and, in this context, represents the empire, an association previously established during the reign of the Hohenstaufen dynasty.[59] The motif appears again on the reliquary bust of Charlemagne in Aachen, a precious object probably donated by Charles IV after his coronation there in 1349 or perhaps on the occasion of his pilgrimage to Aachen in 1357.[60] Extant examples of woven textiles with a pattern of monumental eagles are primarily from eleventh- and twelfth-century Spain or Byzantium, and include fragments from the shrine of St Librada in Sigüenza and the chasuble of Bishop Bernard Calvó.[61] The Prague inventories list fabrics with eagles, too.[62]

In this context, the so-called 'eagle dalmatic' now in Vienna, but which in the mid-fourteenth century was still in Prague, is obviously of particular significance.[63] Commissioned by the excommunicated predecessor of Charles IV, Emperor Louis IV of Bavaria, this tunic-like vestment – to which also belonged a cowl (*gugel*) that no longer survives – has a rather secular character. In particular, the textile has embroideries that depict a genealogy of predecessors, thus it strongly alludes to a *surcot*.[64] As Franz Kirchweger convincingly argued, the garment's meaning corresponds to the legal principle advanced by '*licet juris*', a specific law denying the pope's right to approve the elected king of the Romans.[65] As part of the Imperial treasure, the garment was explicitly referred to as a 'gown' and 'cowl' as late as 1355.[66] In the fifteenth century, both items were incorporated into the historiographical tradition of Charlemagne. During this period, the gown was labeled a 'dalmatic', thereby assuming a sacred character, even though it was no longer used for imperial coronations.

The so-called '*Chape de Charlemagne*' is also significant for understanding the diptych. Today, it is housed in the treasury of Metz Cathedral (Fig. 14).[67] Although the cope is certainly not a fourteenth-century object, Charles IV possibly knew of its existence. The textile has been convincingly traced back to the chancellor of the Hohenstaufen Emperor Frederick II, Conrad of Scharfen-

berg, Bishop of Metz and Speyer, who, in 1222, attended Frederick's coronation in Aachen. The chancellor might have received the cope in gratitude for his services and later donated it to Metz Cathedral.[68] It remains an open question as to how the vestment acquired its association with Charlemagne.[69] In a similar association, parts of the imperial coronation vestments were also connected with Charlemagne when Charles IV received them in 1350 from heirs of Louis the Bavarian.[70] Accordingly, it would have been surprising had Charles IV not taken up the vestment's connection with Charlemagne during his visit to Metz, which took place from November 1356 to January 1357, given that this city was the burial site of the Carolingian progenitor St Arnulf, as well as of other Carolingian rulers. One of the relics acquired by Charles IV in Metz was probably the '*Sepulchrum S. Arnophi*', which, together with the main relics of Prague Cathedral, had been evacuated to Karlštejn castle in 1420 due to the Hussite rebellion.[71] Leaving Metz, Charles IV proceeded to Aachen where he presented himself in the full imperial robes – the robes of Charlemagne – on the relic-like throne of his holy predecessor and patron saint.[72] Significantly, the attribution of the Pierpont Morgan Diptych to about 1355–60 coincides with Charles IV's political activities in Metz. Supposing that Charles IV should have known about the Metz '*Chape de Charlemagne*', it is likely that the cope worn by the king in the diptych was meant to evoke a relic that was said to have previously been used as coronation cope as well as a liturgical vestment, thereby explicitly highlighting the sacred dimension of emperorship.

The material evidence, theological requirements, and medial transformation of the various textiles discussed above can therefore be summed up as follows: whereas the donation of ecclesiastical vestments – such as those given to St Vitus's in Prague, discussed at the beginning of this paper – enabled the donor to be present at the actual enactment of the liturgy, the medium of panel painting allowed the donor to be visualized permanently. In the Glatz Virgin as well as the Pierpont Morgan Diptych, textiles are employed as clear statements of the role and status of each patron and donor. Even more, they evoke the political dimensions that shaped the contexts within which these donations were undertaken. Both examples demonstrate the extent to which it is the depiction of precious textiles (regardless of how the actual textile were actually used) that enabled patrons to define their own role and identity within the critical balance of sacred and secular authority. The meaning of such representations, therefore, depends not only on decoding the allegorical meaning of vestments, but also in understanding their technical conditions as well as their material splendor.

CHAPTER 10

Weaving Legitimacy: The Jouvenel des Ursins Family and the Construction of Nobility in Fifteenth-Century France

Jennifer E. Courts

An anonymous, fifteenth-century group portrait of the Jouvenel des Ursins (*c.* 1443–45) captures the images of Jean I Jouvenel, his wife Michelle de Vitry, and their eleven children (Fig. 1).[1] A sumptuous gold and scarlet silk textile encloses the family, which is shown in perpetual prayer within a private choir chapel in a gothic church. A French inscription along the base of the panel records the title and positions of the individuals shown.[2] The inscription emphasizes each figure's titles and proximity to the king, using language that establishes nobility and therefore strengthens the family's claim to noble status. In this painting, the representation of textiles—from the cloth that defines the family's space of prayer to the heraldic devices woven into their clothing—physically and visually reinforced their hard-won identity and status as legitimate members of the French nobility. The descendants of a Troyes cloth dealer, Jean I Jouvenel and his sons waged a textual and visual campaign to redress their mercantile origins. The painting's representation of sumptuous textiles reflects one of their many efforts to weave themselves into the fabric of legitimate nobility.

Ultimately, the painting functions to glorify the family's rise to influence, and it has been suggested that it was executed in 'imitation of a habit practiced by the feudal nobility'.[3] The large-format painted panel, however, was not among the types of objects sought after by the French aristocracy who favored portable items composed of expensive materials such as tapestries woven with precious metal threads, sumptuous and bejeweled *joyaux*, and deluxe illustrated manuscripts contained within costly bindings. Aware of the sumptuous nature of aristocratic taste, the *Jouvenel des Ursins Family Portrait* takes advantage of panel painting's ability to mimetically represent magnificent objects, environments, and individuals. The family's surviving commissions expanded beyond painting to include heraldic tapestries and manuscripts with illuminated miniatures that recreate luxurious fabrics, providing evidence of the Jouvenel des Ursins' interest in the display of elite media, as well as their efforts to be acknowledged as *noblesse ancienne*.[4] The family participated actively in the visual construction of their identity and used material objects to reinforce their legitimacy.

The Question of the Jouvenel des Ursins's Legitimacy

The 'des Ursins' portion of the family's name has undergone scrutiny in historical scholarship as well as by their fifteenth-century peers.[5] Jean II Jouvenel des Ursins (1388–1473), royal advisor, historian, and future archbishop of Reims, sought to validate the use of the supplementary surname in his biography of Charles VI written in 1430.[6] Vernacular royal biographies written by noblemen began in France with Jean de Joinville's *Vie de Saint Louis* (1309), and the trend for chronicling the lives of French kings continued throughout the fourteenth and fifteenth centuries.[7] Set against the background of the Hundred Years' War, vernacular lives of kings provided a means for political commentary that was shaped by their authors' own experiences and circumstances.[8] Jean II took advantage of this genre to insert a history of the Jouvenel des Ursins into the life of Charles VI in-

Fig. 1 *Jouvenel des Ursins Family Portrait, c.* 1443–45, painting on wood panel, 1.7 x 3.5 m., Paris, Musée du Moyen-Âge, Thermes de Cluny, stored for the Musée du Louvre, [inv. no. 9618]. (Photo: RMN-Grand Palais / Art Resource, NY).

cluding that of his father, Jean I Jouvenel.[9] He vaguely describes his ancestors as originating from the Orsini family—Ursins in French. According to Jean II's account, his family had come from Naples and Rome and migrated to France with Neapolin des Ursins, a bishop of Metz.[10] Jean II identifies his grandfather as Pierre Juvenal des Ursins, a descendant of the immigrant Orsini and a key figure in resisting the English along with the Bishop of Troyes at the Battle of Poitiers in 1365.[11] Subsequently, Jean II records Pierre as having died on Crusade while fighting the Saracens.[12] In short, Jean II wove an illustrious history of his family, claiming that the Jouvenel des Ursins were descended from ancient Roman nobility and had served as heroic warriors for both the kingdom of France and the glory of God. This fantastic tale, however, is not based on any legitimate historical record. There is no written evidence of a bishop of Metz named Neapolin des Ursins, nor is there any proof of the heroic activities of Pierre Jouvenel des Ursins at Poitiers or elsewhere.[13] Such a manipulation of historical texts to create social realities was not unusual, however; it had been an important part of the development of vernacular prose in France since the thirteenth century.[14]

Jean II further describes the connections of his family to the Orsini of Rome later in the royal biography. He records the pageantry surrounding the entry of the Holy Roman Emperor Sigismund (1367–1437) into Paris on 1 May 1415, and notes that he was accompanied by the *grand comte* of Hungary, Berthold des Ursins.[15] While the king and his fellow princes entertained the emperor, Jean II records that it was the baron of Trainel, Jean I Jouvenel des Ursins, who held a sumptuous banquet for Berthold complete with women, music, games, and various other types of amusements.[16] Jean I's involvement, according to his son's explanation, was a result of the familial ties between the Hungarian duke and the French baron. Constructing textual documentation and historiographical proof of the Jouvenel des Ursins' claim to having descended from the Roman Orsini was a subsidiary goal for Jean II in his biography of Charles VI. The author was aware of the importance of armorials in signifying legitimacy, as is evident in Jean II's statement that his father held the extravagant banquet in the name of the Hungarian duke because they were related—they shared identical heraldic arms.[17]

Jean II's narrative of the lavish banquet thrown by his father served the additional purpose of

documenting Jean I's enacting of *le vivre noblement*, the noble way of life.[18] To live nobly involved a number of factors including demonstrating ancestral blood ties with established families, military service, and participation in a noble life-style.[19] In order to maintain *nobilitas*, individuals had to participate in courtly activities and spectacles, and constantly be vigilant in maintaining their courtly identities.[20] The requisite performances included events designed to construct and maintain honor outside the field of battle, such as tournaments and hunts, as well as activities that functioned to demonstrate an individual's largesse. Hosting banquets, such as Jean I did for Berthold des Ursins, provided the opportunity for members of the nobility to demonstrate their generosity, as well as to display their material wealth in the form of sumptuous gold plates and luxurious textiles in the home.[21] Jean II's inclusion of the event in the royal biography reinforced the family's status by demonstrating their fulfillment of the behaviors required of the *noblesse ancienne*.

In the *Traité du Chancelier* (1445), an essay dedicated to his brother Guillaume in commemoration of his appointment as chancellor, Jean II expanded on his family history by including a more detailed account of his grandfather's life and an extensive discussion of his father's achievements.[22] Jean II reports that during his four years in Naples, between the Battle of Poitiers and his death at the hands of the Saracens, Pierre fought for Joan I, Queen of Naples (1328–82), and worked to recover the lands that had belonged to his grandfather, 'Juvenal des Urssins'.[23] In addition, Pierre brought back to France 'letters and titles' that he had received while in Naples. This fabrication of historical evidence of the Jouvenel des Ursins' connection to an Italian heritage was designed to legitimize the family's claim to ancient nobility.[24] Jean II's description of older textual documents that attest to the Jouvenel des Ursins' esteemed ancestry set the stage for a *vidimus*—a copy of a document, including an attestation to its authenticity—that materialized in the same year.

The *vidimus*, dated 31 August 1445 and authorized by the pontifical chancellery in 1447, closed important gaps in the French history of the Jouvenel des Ursins family.[25] The document states that Napolio de Ursinis became the bishop of Metz in 1335. The bishop's brother, Juvénal (Giovenale), had two children: an unnamed daughter who married the count of Blammont; and a son, Mathieu (Matteo), who travelled with his uncle to France. The document is signed by Latino degli Orsini, the archbishop of Trani, who claimed to have copied the information contained in the *vidimus* from the archives of the Orsini family in Rome.[26]

Although the *vidimus* and Jean II's accounts present the family as established members of the nobility, archival evidence suggests that they were in actuality descended from a merchant-class family living in Troyes in the fourteenth century. Pierre Jouvenel was a cloth merchant, a fact established by municipal documents that record his participation in collecting money for the ransom of the king, Jean le Bon, in 1360.[27] Pierre's son, Jean I, appears to have simply gone by the name Jouvenel—the 'des Ursins' was only added in posthumous documents. By adopting the Ursins name from the ancient Orsini of Rome, the family attempted to mask its mercantile background. Although not officially taking the title, Guillaume's father first incorporated the Orsini arms into his seal before the end of the fourteenth century.[28] The first reference to the Jouvenel des Ursins name occurs in a papal document dated 25 May 1410 that lists 'Johann Juvenalis de Ursinis', most likely the royal biographer and future archbishop Jean II, as a secretary to Antipope John XXIII (1370–1419).[29]

Documentary records also preserve the subsequent disputation of the title in 1456–57, at which time Guillaume's name is recorded as 'Guillaume Jouvenel dit des Ursins'.[30] The suspicion regarding the validity of the des Ursins title may have been the result of tougher political scrutiny after his appointment as Chancellor of France in 1445. Additionally, this was a difficult period for

King Charles VII, as hostilities between him and his son, the future Louis XI, were exacerbated. Consequently, the Jouvenel des Ursins's long-established allegiance to the crown would have made Guillaume a reasonable target for Charles VII's enemies.

Regardless of the legitimacy of the family's claim to noble heritage, they certainly presented themselves as rightful members of courtly society. Recently ennobled, the Jouvenel des Ursins owed their rise to power to political changes occurring in France during the first century of Valois rule. After his coronation, Charles V instituted a new organization of royal advisors later known as the Marmousets.[31] Jean Jouvenel, as the son of a Troyes cloth dealer, is representative of these upwardly mobile men.[32] He was educated first in his native city of Troyes, and studied civil law at Orléans, and finally canon law at the University of Paris.[33] Beginning his career in the *parlement* of his native city, Jean quickly ascended the social ladder of the late medieval courts. He was linked politically to Bureau de la Rivière, and in 1386 married Michelle de Vitry, the niece of Jean le Mercier.[34] While in Paris, his close connections to the Marmousets assisted him in becoming a *conseiller au Châtelet* in 1381, and in 1389 he was appointed the *prévôt des marchands* of Paris by the royal advisors.[35] Jean was next appointed *avocat général* for the king in the royal *parlement* in 1400, and played a significant role in mediating the Cabochien Revolt in 1413.[36] Later that year, he was named the chancellor to the dauphin, Louis de Guyenne (1397–1415).[37] His service to the crown continued after the death of the dauphin, as evidenced by Jean's relocation to Poitiers with the royal *parlement* in 1418 after their retreat from Paris during the English occupation. In 1420, Jean was named president of the exiled *parlement*, a title he retained until his death in 1431.[38] His high-profile positions within the government resulted in his ennoblement on 22 August 1407, when he was invested as the Baron of Trainel and pledged homage to Charles VI.[39] Jean's impact on the political fabric of late medieval France was not limited to his lifetime: two of his sons, Jean II and Jacques, each became Archbishop of Reims; his daughter Marie became the prioress of the royal abbey of Poissy; and his son Guillaume inherited the title of Baron of Trainel and became the chancellor of France under Charles VII and Louis XI. Although the Jouvenel des Ursins held significant power within the kingdom, Jean II's campaign to promote their connection to the Orsini in his writings implies that a perceived social stigma was still associated with their status as newly titled members of the nobility. The *Jouvenel des Ursins Family Portrait*, recreates the material objects associated with living nobly, and provides a visual pendant to Jean II's verbal argument for *noblesse ancienne* status.

Setting and Location of the Portrait

While scholars have extensively discussed Jean II's writings, the role of the family's artistic commissions in securing their noble status has been largely disregarded.[40] In much the same way that Jean II wrote his family's status into the history of France in his *Life of Charles VI*, the art commissioned by the Jouvenel des Ursins family presents them as members of the French nobility. The family participated in the lavish display of wealth, taste, and excess that created legitimate political personae.

The earliest known location of the family portrait, recorded in 1763, is the family's private chapel, dedicated to Saint-Remi, in the ambulatory of the choir at Notre-Dame in Paris.[41] The chapel, likely acquired after Jean I's death in 1431, was a gift of the Cathedral chapter to Jean I 'in consideration of his zeal for the public well-being, and his fidelity toward his king'.[42] Constructed in the first decades of the fourteenth century, the ambulatory chapels provided those who possessed and endowed them a prestigious location within the Parisian Cathedral for public display and private worship. Physical

Fig. 2 *Bedford Master, Anne of Burgundy Praying to Saint Anne (Bedford Hours), c.*
1410–30. London: British Library, MS Add. 18850, f. 257v. (Photo: Trustees of the
British Library).

access to the chapels was limited—the spaces were closed and locked by a grille, accessible only to
their owners and the members of the clergy who were paid to pray for the family.[43] The messages of
wealth and power in the form of lavish decoration and pious donation, however, were not restricted
to the rarefied few who were granted access beyond the chapel's gates. The ambulatory of the choir
was a multifunctional space that teemed with visitors from all walks of life.[44]

The specific identity of the patron of the large group portrait is unknown. Jean I's death prior
to the execution of the work excludes him as the donor. Three of his sons—Jean II, Jacques, and

Fig. 3 Bedford Master, *John, Duke of Bedford Kneeling Before Saint George (Bedford Hours)*, *c.* 1410–30. London: British Library, MS Add. 18850, f. 256v. (Photo: Trustees of the British Library).

Guillaume—all of whom are featured prominently in the panel, are strong candidates.[45] The painting served as a group memorial and comprised a portion of the family's total donation toward the renovation of the Saint-Remi chapel.[46] Their other gifts included objects such as painted altarpieces, stained glass windows, sculpted monuments, and plaques, all of which, like the *Jouvenel des Ursins Family Portrait*, are characterized by references to the individual donor in the form of portraits, inscriptions, and heraldic symbols that serve as markers of legitimate, noble status.[47]

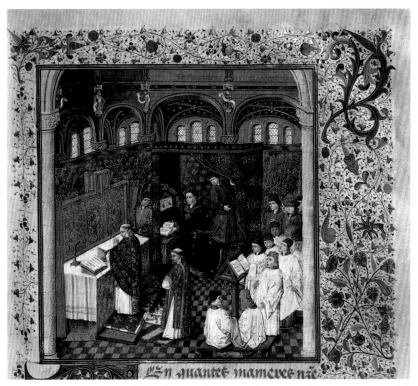

Fig. 4 Jean le Tavernier, Philip the Good at Mass *(Traité sur l'Oraison Domincale)*, after 1457. Bibliothèque royale de Belgique, MS 9092, f. 9r. (Photo: Bibliothèque royale de Belgique)

Constructing Space with Cloth

The subdivision of public and ecclesiastic architectural spaces into increasingly private areas was a feature of early Valois architecture.[48] Moreover, textiles played an important role in the process by constructing new spaces and shifting the ideological meaning of existing spaces, a function evident by their names in written sources—*chapelles*, *salles*, and *chambres*.[49] In the *Jouvenel des Ursins Family Portrait*, the artist employed a sumptuous gold and scarlet silk damask barrier to create a private sacred space, a *chapelle*, within a larger ecclesiastic setting. Fold lines are visible on the fabric, which is decorated in linear, foliate arabesques, and affixed to unseen supports with large nails. Behind the woven screen, an ambulatory, including portions of five chapels, is visible. The ceilings of the chapels are decorated in a celestial pattern of gold stars on a dark blue background. Golden ribs spring from the gilt capitals of the delicate engaged columns, and sculpted figures of apostles and saints decorate niches placed around the ambulatory.[50] Completing the heavenly population of the upper portion of the church, more saints appear in grisaille stained glass lancet windows surmounted by a trefoil depicting a brightly colored shield bearing the arms of the Jouvenel des Ursins family.[51] The central ambulatory chapel in the painting contains seven lancet windows, the center one of which features the Virgin and Child. Rather than provide an approximation of the actual fifteenth-century interior of Notre-Dame de Paris, the *Jouvenel des Ursins Family Portrait* conforms to a popular iconographic type for representing the space of private devotion in the late-fourteenth and fifteenth centuries.[52]

A similar convention is found in late medieval deluxe illuminated manuscripts produced in

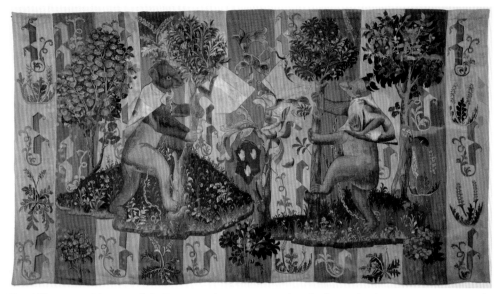

Fig. 5 Fragment, *Tapestry of the Bears, c.* 1450–1500, wool and silk, 2.54 x 4.55 m. Paris: Musée du Louvre, OA 10372. (Photo: RMN-Grand Palais / Art Resource, NY).

Paris. One particularly striking example is the *Bedford Hours* (*c.* 1414–23). For example, folio 257v represents Anne of Burgundy (1404–32) kneeling in prayer before a seated Saint Anne (Fig. 2).[53] Subdividing the sacred space is an elaborate tapestry decorated with a motto and personal emblems that identify the figure as the duchess.[54] Behind the tapestry, ambulatory space is once again represented. As in the *Jouvenel des Ursins Family Portrait*, the ceiling of another chapel is visible in the background. On folio 256v Anne's husband, the Duke of Bedford, appears kneeling before his own patron saint, George; both figures are separated from a less elaborate vaulted space by emblematic textiles (Fig. 3). The presence of the arms of the Duke of Bedford in the windows has been used to suggest that the miniature represents an actual location—the ducal palace.[55] As with the *Jouvenel des Ursins Family Portrait*, however, identification of a real physical location is problematic. Both images display heraldic devices in the windows; yet, it seems unlikely that the presence of the Jouvenel des Ursins shields in the panel painting suggest their ownership of the large church depicted in the background. Rather, the inclusion of the family's arms in the stained glass windows further highlights the status and the identity of the individuals represented.[56] The depiction of the Duke of Bedford before Saint George is a statement of his legitimate right to rule France as English regent. John's surroundings, within the private devotional space as well as the entire folio, are filled with emblems, mottos, livery, and arms that establish his ownership without a doubt.[57] His privileged position within the semi-private space as created by the textiles becomes yet another visual sign of his status. In the end, although neither the panel painting nor the miniatures represent real locations, they do reference the practice of employing textiles in the construction of architectural spaces.[58]

Another *chapelle* that illustrates the use of textiles to create devotional space is found in Jean le Tavernier's illumination from the *Traité sur l'Oraison Domincale* (after 1457).[59] The miniature depicts the Burgundian duke, Philip the Good (1396–1467), at Mass within a *chapelle* defined by hangings (Fig. 4). The scene takes place within the choir of a church defined by red and gold silk hangings that are bordered in green. The textiles, affixed to the choir's columns, define and differentiate the space of the Mass from the surrounding ambulatory and private chapels, enclosing the priests and dignitaries present for the sacrament. A large rug, decorated with the intricate arms

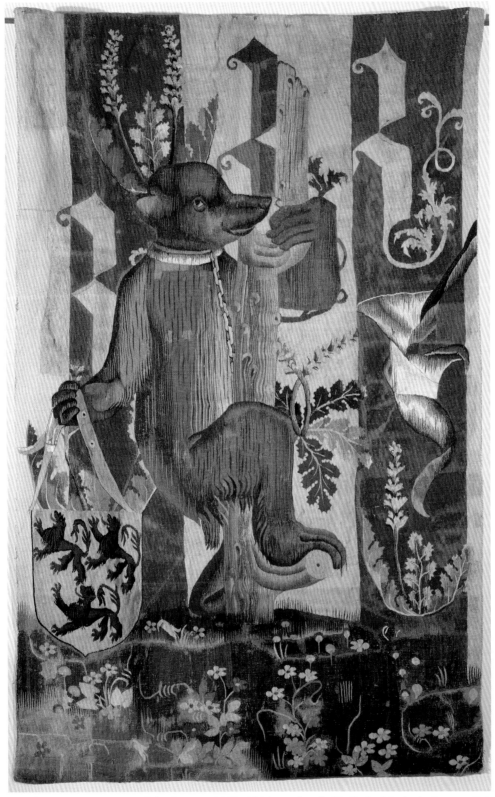

Fig. 6 Fragment, *Tapestry of the Bears,* c. 1450–1500, wool and silk, Paris: Musée du Louvre, OA 10373. (Photo: RMN-Grand Palais / Art Resource, NY).

of Philip the Good, runs beneath the altar and the priest performing the Eucharist. The choir is subdivided further by a *chapelle* that demarcates a private devotional area reserved for the duke. The dark blue silk enclosure, woven with golden firesteels—the personal emblem of Philip the Good—further confirms the identity of the genuflecting figure.

In addition to constructing ecclesiastical space, textiles functioned to subdivide domestic interiors. *Salles* were created within large banquet halls, while *chambres* were designed for the more intimate spaces of luxurious *châteaux* and *hôtels*.[60] A partial suite of tapestry associated with the Jouvenel des Ursins family, known as the *Tapestry of the Bears*, makes prolific use of visual symbols to proclaim the family's nobility.[61] The two panels of heraldic tapestry are abundantly covered with the initial 'J', plant life, bears, and shields, and date to around the second-half of the fifteenth century (Figs 5, 6).[62] Both panels depict playful, chained bear cubs (*oursins*) climbing trees on *mille fleur* islands. The bear depicted to the left on the larger panel wears a cape emblazoned with the arms of the Orsini family tied around its neck, while the wrap worn by the cub on the right is obscured as a result of fading.[63] The red and white stripes of the background are decorated with clumps of flowering *Acanthus mollis* and the ornamental initial 'J' for Jouvenel. This 'J' appears only on the objects associated with Guillaume Jouvenel des Ursins indicating that he likely commissioned the series.[64] The medieval Latin name for the blooming plant was *branca ursina*, or bear's claw, in reference to its distinctive jagged leaves.[65] The plant presents a visual pun on the Ursins family name, therefore creating another visual link with the Orsini family. [66] In the center of the larger panel, between the two bear-inhabited islands, is an independent tree branch that supports two heraldic shields. On the left is a faded example of the Orsini arms—an escutcheon argent, with a rose gules in the chief, a fesse or, and three bends gules.[67] These portable examples of wealth would have graced the walls of residences such as the Hôtel des Ursins, the family's Parisian home that once stood on the banks of the Seine on the Île de la Cîté.[68] Based upon their iconography, the tapestries were likely intended to function as interior domestic decoration in the form of a *salle* or *chambre*.[69]

The use of textiles to subdivide space is found again in the *Mare Historiarum* (*c.* 1447–55), a text written in 1340 by Giovanni Colonna, a Papal historian, that was commissioned by Guillaume Jouvenel des Ursins.[70] The frontispiece to Book One of the *Mare historiarum* establishes Guillaume as the owner, and reinforces his position as chancellor and as a member of the *noblesse ancienne* (Fig. 7). Folio 21r presents a vision of the Holy Trinity upon a large throne draped in a red silk fabric decorated with golden rosettes, recalling the one found in the chief of the Orsini arms. Two figures kneel upon cushions that bear the shield of the Orsini family in front of an emblematic silk cloth, emblazoned with 'J' initials for Jouvenel. Both genuflecting men represent Guillaume Jouvenel des Ursins: one in the robes of an administrator, the other as a knight.[71] This dual persona allows him to simultaneously acknowledge his role as chancellor, a position achieved through his education and ambition, and reinforce his identity as a true member of the *noblesse ancienne*.

In the portrait of Guillaume as chancellor, his clothing indicates that he is a member of the new nobility. He wears a scarlet robe decorated with gold ribbons and an embroidered purse, both signifying his occupation, and underscoring that his position was the source of his *noblesse*. The identification of royal officials by their dress began in the late fourteenth century when specific robes were designated for members of the *Chambre de Comptes* and the royal *parlement*.[72] To the right, Guillaume, now dressed in armor, complete with gilt spurs, and wearing a short, heraldic tabard woven with the red stripes and the rose of the Orsini, recalls the military obligations of historic nobility. The armor and tabard celebrate the ancient noble status cultivated by his family as descendants of a prestigious Roman family.

Fig. 7 The Trinity with Kneeling Guillaume Jouvenel des Ursins *(Mare Historiarum), c.* 1440. Paris: BnF MS lat. 4915, f. 21r. (Photo: Bibliothèque nationale de France).

Guillaume's appearance as a knight in the *Mare Historiarum* is almost identical to the six armed family members represented in the *Jouvenel des Ursins Family Portrait* underscoring the idea that corporate family identity was the primary goal of this painting. The golden details on the collar, spurs, and helmets of the armor of Jean I, Louis, and Guillaume indicate their status as knights, while the remaining armed brothers bear the silver spurs of squires. Not only does the armor reflect the family's claim to legitimate noble status, the arms woven into their tunics reinforce their social position.

The *Jouvenel des Ursins Family Portrait* additionally features liturgical furniture in the form of three *prie-dieux* used by Jean I, Michelle de Vitry, and Guillaume. Each prayer bench is lavishly draped in expensive material and supports an open devotional manuscript, likely a book of hours. The fabrics covering the *prie-dieux* of Jean I and Guillaume are cloth of gold—brocaded velvets woven here in the 'pomegranate' design—which were available only to the wealthiest members of society in the fifteenth century.[73] The costly clothing worn by the two archbishops, Jean II and Jacques, further reinforce the messages of material wealth. Richly embroidered figural bands depicting haloed saints border both men's sumptuous brocaded velvet cloaks, which in turn are fastened by large gold and jewelled clasps. Inflated displays of disposable income also appear in the gilt and jewelled tops of their staffs and in the stunning display of pearls, rubies, and sapphires represented on their miters.

The large V-shaped headdress worn by the fashionable sisters is a variation of a medieval *escoffion*. The enormous headdress appears to defy physics. Gilded, encrusted with a multitude of pearls and large gems and draped in sheer gold tissue, the *escoffions* render the sisters' gold and jewelled collars almost delicate in comparison. Both women are attired similarly in sumptuous gowns with black cloth of gold sleeves and excessively abundant red skirts gathered over their arms. They wear a number of rings, a feature found also on the two widowed female members of the family.[74] The bishops and married women demonstrate the spiritual and material wealth of the family, while the armor and tabards of the remaining six men provide a powerful message about the status of the Jouvenel des Ursins as rightful members of the *noblesse ancienne*.

Conclusion

The *Jouvenel des Ursins Family Portrait* presents a carefully constructed visual genealogy. In text and image, the painting celebrates their prestigious appointments within the church and the government in France. Although the powerful positions were awarded because of the upwardly mobile family's education and ambition—trademarks of the rising new nobility—they are pictured as members of the ancient nobility. Carrying swords within the elaborate church choir and clothed in the arms of the Orsini rather than their robes of office, the Jouvenel des Ursins conceal their mercantile ancestry. The painting works together with the fabricated family history that Jean II wove into his biography of Charles VI, visually establishing the Jouvenel des Ursins as members of the *noblesse ancienne* who traced their lineage to the ancient Roman Orsini family. Designated as a donation for the family's private chapel within the east end of Notre-Dame Cathedral in Paris, the painting would have been visible to the large population of visitors to the choir ambulatory. The choir chapels became places to construct and reinforce identity through spectacular visual endowments; the Jouvenel des Ursins family took advantage of this to promote their position. Additionally, the group portrait makes use of the realistic qualities of oil painting to convincingly depict material objects indicating elite status: sumptuously illustrated books of hours, costly jewels, and particularly luxury textiles. The lavish cloth—from the cloth of gold and brocaded velvets, to the silken hangings—signified the wealth, status and legitimacy of the Jouvenel des Ursins, and illustrates the extent to which textiles were used to create and establish identities in late medieval France.

CHAPTER 11

Textiles in the Great Mongol *Shahnama:* A New Approach to Ilkhanid Dress*

Yuka Kadoi

Among the extant manuscript paintings datable to the period of the Ilkhanate (1256–1353)—a Mongol khanate which was established in modern-day Iran by Hulagu Khan (r. 1256–65), the grandson of Genghis Khan (d. 1227)—the illustrations of the Great Mongol *Shahnama* ('Book of Kings'; Tabriz, *c.* 1335) provide a rich source of information about the textiles and garments of early fourteenth-century West Asia.[1] Because the number of textiles that can be securely attributed to the Ilkhanid period or that can broadly be ascribed to Mongol Eurasia remains relatively limited, it is important to look more closely at the detail of the woven materials depicted in this monumental manuscript in order to trace the stylistic and technical development of Iranian textiles under the Mongols.

This paper intends to examine the textiles in the Great Mongol *Shahnama* by comparing actual surviving examples and other materials from several areas, ranging from the Middle East, Central Asia to China. In addition to analyzing many motifs, this paper also considers the visual function of textiles and garments in the formation of the iconography of *Shahnama* illustrations in the Mongol period. The main focus will be on the following distinct themes: the brocades used in funerary contexts; the depiction of Mongol- and Islamic-style robes; and the decorative elements and various accessories used in certain types of clothing.

Written by the poet Firdawsi around 1010, the significance of the Book of Kings lies not only in its role as the national epic of Iran and its reputation as one of the literary masterpieces of medieval Persian poetry, but also in its intrinsic association with the Iranian psyche.[2] In the field of Iranian visual studies, illustrated copies of the *Shahnama* have often been discussed in the context of Mongol legitimacy over the control of Persian civilization.[3] In addition to the frequent appearance of iconographic and epigraphic elements derived from the Book of Kings in various media of Ilkhanid art, an increasing number of illustrated *Shahnama* manuscripts are known to survive from the early fourteenth century onwards, suggesting a certain degree of Mongol preference for this subject. In particular, an unnamed but powerful patron seems to have commissioned the production of the Great Mongol *Shahnama*.[4] Judging by the generous use of large-size paper by medieval standards, as well as the quality of illustrations and calligraphy, the manuscript was certainly a commissioned work rather than a product of mass production for wide distribution, and it must have been preserved as part of a royal collection.[5] An ideological aspect of the manuscript is further suggested by the choice of episodes that were illustrated, with the possible intention to illustrate the epic history of the Mongols.[6] The depictions of Mongol-looking rulers throughout the *Shahnama* manuscript are also effective, as this serves to stress their portrayal as the legitimated successors of the Persian kings. It is thus intriguing to observe the process of how textiles and garments in the paintings of the Great Mongol *Shahnama* manuscript were assimilated into the visual propaganda of Mongol rulership in West Asia. Regardless of the cultural background of the targeted audiences, minute depictions of such woven materials, especially images of richly donned rulers and heroes, would certainly have impressed viewers.

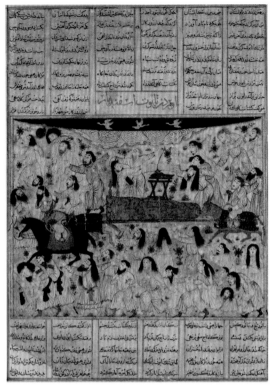

Fig. 1 Isfandiyar's Funeral Procession, page from the Great Mongol *Shahnama*. Iran (probably Tabriz), 1330s. Metropolitan Museum of Art, New York, Joseph Pulitzer Bequest (33.70). Image © Metropolitan Museum of Art.

Fig. 2 Textile with *djeiran* motifs. China, Jin dynasty. Cleveland Museum of Art, Cleveland (1991.4).

Widely known as the Demotte *Shahnama*, after the name of the Belgian-born art dealer, Georges Demotte (1877–1923), who took the manuscript apart for the sake of commercial gains in the early twentieth century, the illustrations of the Great Mongol *Shahnama* have attracted a number of studies, owing to their codicological uniqueness and art-historical significance.[7] Despite its celebrated status in the history of Persian painting, little attention has so far been satisfactorily given to the documentary potential of this manuscript to the study of the textiles and garments of Ilkhanid Iran. This study, thus, aims to reappraise the role of the arts of the loom as a benchmark for understanding the early form of Mongol universalism – the core of Mongol rulership in Eurasia – before the establishment of the modern trade system. The idea of the universal was indeed one of the key political tools in this particular cultural region and under this particular historical framework.[8]

Brocades of the Ilkhanid period

Of particular interest are the textiles in the funerary scenes of the Great Mongol *Shahnama*. The painter adds a pictorial variation by emphasizing the brocade used for covering coffins. In the scene of Isfandiyar's funeral (Fig. 1), his coffin is draped with a rich, Chinese brocade as referred to in the text: 'Then Rustam made a goodly iron coffin; / He draped the outside with brocade of Chin.'[9] Firdawsi does not describe its color or motifs, but the painter chose a textile woven in red and gold with an animal pattern evoking a recumbent deer or *djeiran* (Central Asian antelope) under flower-

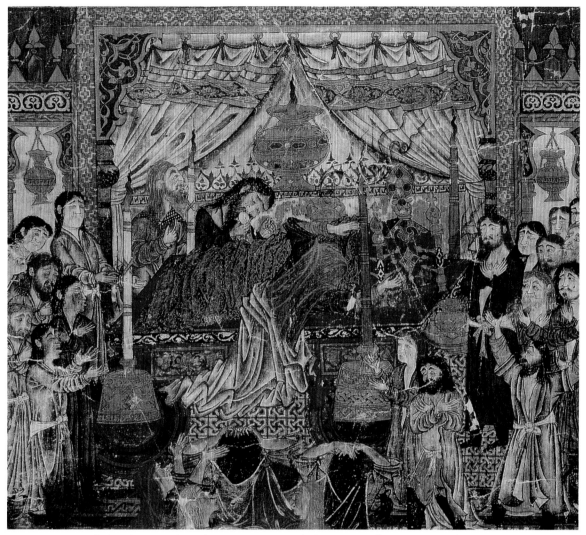

Fig. 3. The Bier of Iskandar, page from the Great Mongol *Shahnama*. Iran (probably Tabriz), 1330s. Freer Gallery of Art, Smithsonian Institution, Washington, DC (38.3).

ing trees. It appears that this type of textile design, which was widely available in Ikhanid Iran, was singled out as a 'Chinese' brocade. Such exotic patterns, which were known to West Asia through the textiles of the Jin period (1115–1234) (Fig. 2), seem to have provided a source of inspiration for Ilkhanid weavers, who incorporated similar patterns into their decorative repertoires.[10] As has been discussed at length by Anne Wardwell, who conducted a pioneering study of the textiles of Mongol Eurasia, the artistic and technical interaction between East and West Asia is clearly reflected in the textiles of the thirteenth and fourteenth centuries produced across Iran, Central Asia, and China.[11] The appearance of similar patterns across regional boundaries indicates that the weavers of Mongol-ruled Eurasia could have shared a decorative vocabulary. This can be explained by considering the potential role of paper cartoons that may have been employed in the process of design-making within Mongol workshops so as to standardize the design scheme throughout the empire.[12]

The rendering of the textiles that cover the coffins of Rustam and Zavara appears very realistic.[13] The painter selected different types of textiles from what was used in the previous funerary scene, contributing to the great variety of the depictions of fabrics, although the text itself does not specify

Fig. 4. Blue and yellow silk damask with floral patterns. China or the Middle East, *c.* 1300, Victoria and Albert Museum, London (314-1898). Image © Victoria and Albert Museum, London.

the design or color of these brocades.[14] Both the green and red brocades have gold disk patterns, but they are arranged in slightly different ways. For example, while single disks are arranged in offset rows in the green textile, the red cloth is decorated with groups of three or four disks. No clear indication of the material of these textiles is given, but some scholars have identified these textiles as the so-called Tartar velvets that were possibly produced in Tabriz during the late thirteenth and early fourteenth centuries.[15] These types of velvet with gold disk patterns were widely favored in West Asia and particularly in Europe, where they are often found noted in church inventories of the period.[16] Some examples have also been preserved in American museum collections, including a chasuble now in Chicago.[17] The brocades found in the illustration of Rustam and Zavara thus serve to suggest both the portability of the materials and the transferability of the designs of textiles produced in Mongol Eurasia, not only within Mongol territory in the Middle East, but also beyond.[18]

The coffin of Iskandar (Alexander the Great) is also covered by a rich brocade, which is appropriate for this dramatic scene (Fig. 3). Here again, this textile is meant to be a Chinese brocade, as the text specifies.[19] In comparison with the previous two examples, however, the rendering of this textile is not articulated enough to reconstruct its entire decorative scheme. The patterns silhouetted against the dark blue background are difficult to identify with certainty, whether they are specifically Chinese or broadly East Asian animal motifs, such as dragons and phoenixes. On the contrary, the design is more Islamic in nature, perhaps based on arabesques or geometrically composed floral patterns. A surviving silk fragment attributed to fourteenth-century Iran, Mongol-ruled Yuan China, or Mamluk Egypt (Fig. 4), appears to be the closest parallel to the brocade on Iskandar's bier.[20]

Sumptuous court dress

The painters of the Great Mongol *Shahnama* placed a significant pictorial emphasis on the detail of dress in the court scenes. Among the thirteen illustrations depicting an enthroned ruler, the scene of Shah Zav is remarkable for its meticulous rendering of clothing (Fig. 5). Here, different types of robes appear side by side. A ruler and some attendants are clothed in Mongol-type robes, whereby the hems cross the chest diagonally from left to right, as seen in an extant robe made of gold brocade

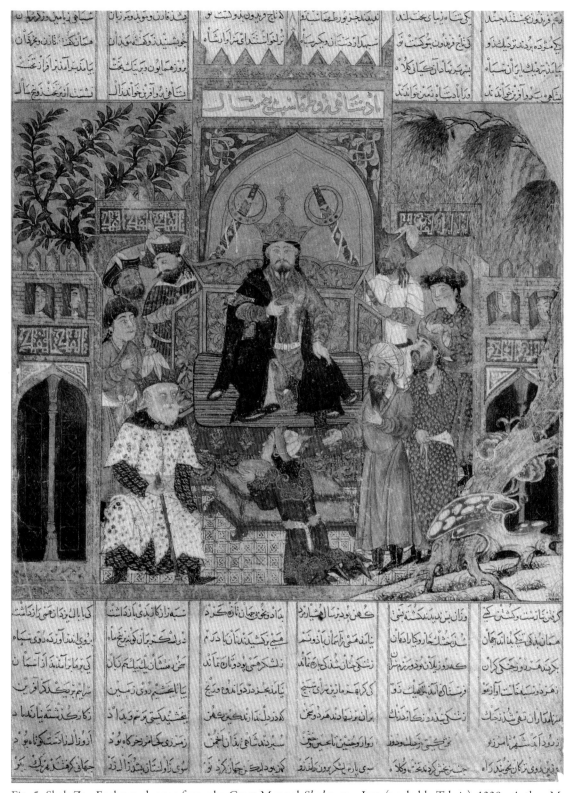

Fig. 5. Shah Zav Enthroned, page from the Great Mongol *Shahnama*. Iran (probably Tabriz), 1330s. Arthur M. Sackler Gallery, Smithsonian Institution, Washington, DC (S1986.107).

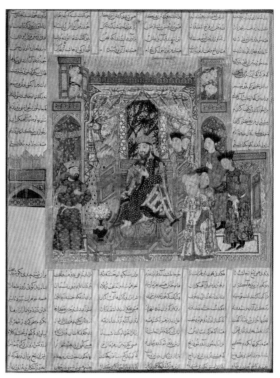

Fig. 6 Silk robe. Mongol Eurasia, thirteenth to fourteenth centuries. Inner Mongolia Museum, Hohhot.

Fig. 7 Isfandiyar Approaching Gushtasp, page from the Great Mongol *Shahnama*. Iran (probably Tabriz), 1330s. Berenson Collection, Villa I Tatti, Florence. Image © President and Fellows of Harvard College.

Fig. 8 Textile with striped design, Iran or Central Asia, *c.* 1300, Victoria and Albert Museum, London (8288-1863). Image © Victoria and Albert Museum, London.

that was discovered in Inner Mongolia (Fig. 6).[21] The luxurious quality of these robes is enhanced by their intricate use of gold patterns. It is possible that some of the patterns used in these garments are mere decorative devices invented by the painter in order to create the appearance of brocades, but others seem likely to have been based on the observation of actual textiles in Mongol-ruled Iran.[22] The Mongol predilection for gold can be demonstrated by a number of silks woven in gold, known as *panni tartarici* or *nasij*.[23-]

While the kaleidoscopic color of these robes enriches the whole scene, the richness of gold is particularly highlighted throughout the manuscript.[24] Since this color had a great symbolic significance for the Mongols, it must have had a considerable role in the formation of the social hierarchy of Ilkhanid Iran.[25] Besides its actual monetary value, gold (*altan*) was closely associated with imperial authority and ideology in Mongol society, as seen in the symbolic link of gold to the sun and to imperial power.[26] Another important chromatic component of the illustrations in the Great Mongol *Shahnama* is blue, which is often used in the robes of main characters, such as Shah Zav's outer dress (see Fig. 5).[27] Blue had been favored in the Middle East since ancient times, and it became a marked feature of art and architecture of West Asia under the Mongols, who were particularly fond of strong colors. Judging by surviving examples, blue was the second most popular color in Ilkhanid textiles after gold, and the combination of two of these favorite colors serves to create striking contrasts.[28] The color blue may also have had certain symbolic associations in Mongol society. It is, for instance, particularly evocative of the image of the blue wolf, the legendary ancestor of Genghis Khan.[29] While decorating the body in blue or wearing blue has its ancient roots as protection from evil spirits, the act of wearing a blue textile conveys further shamanistic connotation in Mongol contexts; the blue dress appears to symbolize a performance as, or communication with, the blue wolf.[30]

The robes depicted in the Great Mongol *Shahnama* are predominantly Mongol in type rather than West Asian types. However, in some illustrations, such as the scene of Isfandiyar approaching Gushtasp (Fig. 7), more Islamic-style robes are depicted. Most of the characters here wear caftans with *tiraz* bands.[31] Compared with the scene of Shah Zav (see Fig. 5), the painter of this illustration pays more attention to the detail of the ruler's clothing. The design of his outer robe consists of bands of undecipherable Arabic inscriptions, along with medallions and light-green colored bands. The accuracy of the depiction of this textile is attested to by surviving examples that are generally attributed to thirteenth-century Eastern Islamic lands, such as a textile with striped patterns in the collection of the Victoria and Albert Museum in London (Fig. 8).[32] Another example with a related striped design, which can reliably be regarded as Ilkhanid, is a gold-and-silk textile with the name of the Ilkhan Abu Sa'id (r. 1317–35) now preserved in the Erzbischöfliches Dom- und Diozesan Museum in Vienna.[33] Thus, while some features of the illustrations, for example Shah Zav's tranquil posture and the loose manner in which he wears an outer coat, are apparently derived from Tibetan sources, such as *thangka*s or illustrations of Buddhist texts, his clothing is subtly replaced by Ilkhanid attire.[34] This illustrates the co-existence of two religions in Mongol-ruled West Asia at this time, which was in the process of transforming its cultural orientation from Buddhism to Islam, even some four decades after the official conversion of Ghazan (r. 1295–1304) to Islam in 1295.[35]

This court scene is further enlivened by the large variety of attendants' clothing. In particular, the robes of four men on the right side of this illustration are worth a closer look. The outer robe of one of the sages, now partly damaged, has a design composed of small squares, recalling those used in Eastern Islamic silk textiles of the thirteenth and fourteenth centuries.[36] The rest are decorated with two different types of floral motifs, both of which are likely to have been of East

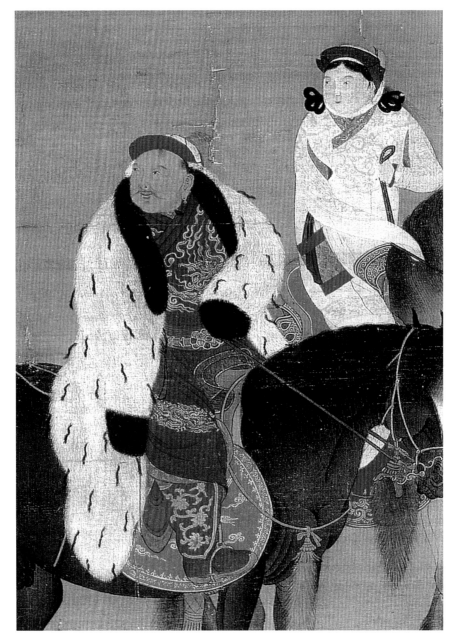

Fig. 9 Liu Guandao, Khubilai Khan Hunting. China, 1280. National Palace Museum, Taipei.

Asian derivation. One is the scattered flower pattern used in the red robe of the mustached man standing in front of green curtains. Surviving textiles ascribed to thirteenth-and fourteenth-century China or Central Asia do not provide conclusive proof of the East Asian origin of this pattern. However, related floral patterns can be found in Chinese pictorial sources of the Mongol period, for example in the border decoration of a red gown depicted in a portrait of Chabi, the wife of the Yuan dynasty founder Khubilai Khan (r. 1260–94).[37] Another type of flowery pattern is used in the robes of two men behind the sage. Perhaps initially inspired by typical floral designs brought from East Asia – for example lotus or peony patterns used in thirteenth-and fourteenth-century Chinese or Central Asian textiles[38] – this kind of flower-and-leaf motif is also incorporated into the cloth-

Fig. 10 (after Tonko bunbutsu kenkyusho [ed.], *Chugoku setsukutsu: tonko batsukoukutsu* [Chinese Stone Caves: Dunhuang] [Tokyo, 1982], vol. 5, cat. no. 162).

ing design of rulers and attendants in other *Shahnama* illustrations produced in Ilkhanid territory during the first half of the fourteenth century.[39] This motif may have gained wide recognition as a component of the *Shahnama* illustrations, suggesting a close cultural association with East Asia.

The two enthronement scenes discussed above reveal the diversity of Mongol wardrobes on ceremonial occasions. The overcoats of both rulers could be identified as robes of honor (*khil'a*), an important form of investiture in the medieval world.[40] This recalls the historical episode about Abaqa (r. 1265–82), who received a robe of honor from Khubilai at the time of his investiture to symbolize his authority.[41]

The variety of headgear depicted in the enthronement scenes also demonstrates the distinctive role of headdress for the designation of social classes and ethnic groups in Mongol society. Main characters, such as rulers and princely figures, wear crowns, while Arab attendants wear turbans, and the Mongol attendants are identified by elaborate headdress, such as double-brimmed hats.[42]

Symbols of authority: decorative accessories

The next subject is concerned with the decorative accessories in vogue among the Mongols

Fig. 11 Bahram Gur Hunting with Azada, page from the Great Mongol *Shahnama*. Iran (probably Tabriz), 1330s. Harvard Art Museums/Arthur M. Sackler Museum, Cambridge, Mass., Gift of Edward W. Forbes (1957.193). Image © President and Fellows of Harvard College.

Fig. 12 Bahram Gur in a Peasant's House, page from the Great Mongol *Shahnama*. Iran (probably Tabriz), 1330s. Rare Books and Special Collections, McGill University Library, Montreal. Image © McGill University Library.

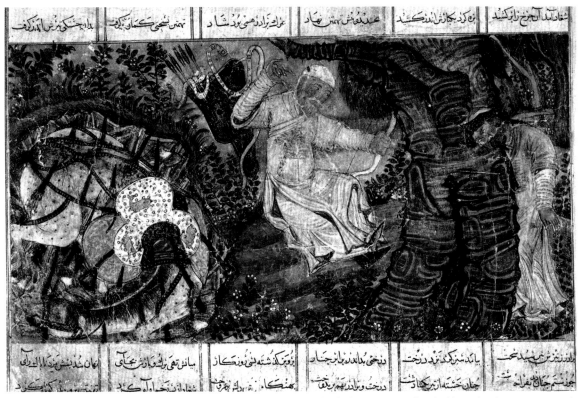

Fig. 13 Rustam Slaying Shaghad, page from the Great Mongol *Shahnama*. Iran (probably Tabriz), 1330s. British Museum, London (1948-12-11-025). Image © Trustees of the British Museum.

Fig. 14 Taynush before Iskandar and the Visit to the Brahmans, page from the Great Mongol *Shahnama*. Iran (probably Tabriz), 1330s. Arthur M. Sackler Gallery, Smithsonian Institution, Washington, DC (S1986.105).

Fig. 15. Playing a Board Game, page from the *Shilin guangji*. China, Chunzhuang Academy imprint of 1328-32.

in East and West Asia during the thirteenth and fourteenth centuries. In the first instance, it is interesting to compare garments depicted in the Demotte *Shahnama* with those found in a Yuan imperial portrait of 1280 entitled *Khubilai Khan Hunting* by Liu Guandao (active *c*. 1279–1300) (Fig. 9).[43] All the characters in the Yuan imperial portrait wear Mongol-type robes in various colors. Chabi's clothing is dull in color, but her white dress is richly decorated with a fine golden cloud collar known as the *yunjian* ('cloud-shoulder'). Similar decorative devices can also be seen on the robe of the kneeling man who offers a bowl to the ruler in the scene of Shah Zav (see Fig. 5). The cloud collar is also used in the robe of Iskandar in his enthronement scene, where the use of gold patterns and a cloud collar serves to accentuate his Mongol identity.[44] The cloud collar is a distinctive element of Mongols dress – it not only functions as a marker of social rank, but also bears various symbolic meanings, including associations with Mongol cosmology.[45] Evidence for the fashion of the cloud-collar decoration among the Mongols in Yuan China is provided by murals found in Dunhuang (Fig. 10) and by surviving examples.[46] It was also widely incorporated into decorative schemes across Mongol Eurasia, ranging from a group of tent hangings now in Copenhagen and Doha, to manuscript illumination and architectural decoration in Ilkhanid territory.[47] The Great Mongol *Shahnama* contains the earliest known representations of cloud collars in Persian painting, suggesting that this device was known in Iran by the early fourteenth century.[48] While the cloud collar seems to have gone out of fashion in China as soon as the Ming dynasty was established in 1368, it survived in Persian painting even after the end of Mongol rule in West Asia. Moreover, it became an essential visual component of clothing styles in later *Shahnama* illustrations, such as those ascribed to one of the painting schools that flourished under the Timurids.[49]

Another fashionable accessory at this time was the device in the form of a square-shaped badge that came to be known as the Mandarin square.[50] In the scene of Bahram Gur hunting with Azada (Fig. 11), Bahram Gur's brown robe has a distinctive square-shaped decoration. The use of the deer motif for the badge that appears to be woven on the chest of his robe is probably intended to evoke the main theme of the illustrated story: 'He (Bahram Gur) came upon a pair of deer and laughing Said to Ázáda: "O my Moon! when I / Have strung my bow and in my thumb-stall notched / The string, which shall I shoot? The doe is young, / Her mate is old." / She said: "O lion-man! / Men do not fight with deer."'[51] Like cloud collars, this type of square badge was fashionable among Mongol nobles in Yuan China (see Fig. 10), but it eventually developed into an important emblematic motif in courtly dress called the *bu zi* ('garment patch') in Ming and Qing China.[52] It seems that the Mandarin square was introduced into Iran by the early fourteenth century, perhaps together with cloud collars, and it was soon incorporated into the iconography of *Shahnama* illustrations, as seen in the Small *Shahnamas* (probably north-west Iran or Baghdad, *c*. 1300).[53] However, compared with such small, less detailed depictions of the badge, the incorporation of the square badge with the distinctive motif into Bahram Gur's robe can be seen as one of the most visible adaptations of East Asian themes into *Shahnama* iconography.

Closely related to the Mandarin square is a type of embroidered chest decoration. This type of decoration is often seen in the images of rulers and heroes. For example, in the scene where Bahram Gur is seated on cushions (Fig. 12), the chest of his blue robe has a clearly defined floral decoration outlined in white. Such decorative emphases on the upper torso seem to have been inspired by the embroideries often seen in Mongol-type robes, evoking those worn by Khubilai Khan (see Fig. 9). The white outline of the decoration on Bahram Gur's robe is presumably intended to represent pearl embroidery – another distinctive element of Mongol dress.[54]

In one of the illustrations depicting the Iranian hero Rustam, he is shown wearing a Mongol-type

robe (Fig. 13) instead of the more traditional tiger-skin coat (*babr-i bayan*), an iconographic device that later became conventional in the visual arts of the Iranian world.[55] His white robe is unique in terms of its decorative schemes: it is not patterned throughout, but contains one decorative motif placed on the chest. When looked at closely, the pattern seems to be composed of an animal under a leafy tree; this design is somewhat reminiscent of the *djeiran* (see Fig. 2). The same subject is illustrated in the Edinburgh portion of the *Jami' al-Tawarikh* ('Compendium of Chronicles'; Tabriz, 1314).[56] It could be argued that given both manuscripts were produced at the same or related workshop, the composition of this Demotte leaf was derived from the *Jami' al-Tawarikh* manuscript.[57] The chest decoration of the Edinburgh Rustam is, however, different from that of the Demotte Rustam in that his robe is decorated with an array of flame-like patterns forming a square shape.

A final observation should be made about the dress of Iskandar, who is represented in twelve illustrations of the manuscript.[58] In terms of decorative accessories, he is depicted as a Mongol ruler. Along with the cloud collar used on his crimson robe in the enthronement scene, the use of a large lotus-like motif for the chest part of his blue robe in the scene of 'Iskandar Building the Iron Rampart' is effective in portraying him as a splendidly-attired Mongol ruler on horseback.[59] In the scene of Iskandar's visit to the Brahmans (Fig. 14), both his robes are clearly of Mongol type and are decorated in gold. What is interesting here is that both the chest and the back bear square-shaped decorative accessories, perhaps intended to depict the Mandarin square. The decoration on the back of his red robe is closely comparable to that found in Yuan woodblock prints, for example the *Shilin guangji* (1328–32) (Fig. 15).[60] This suggests that the backs of robes were also of great importance in Mongol dress, and the idea was to some extent introduced to West Asia in the course of the Mongol invasion.

Mongol textiles as propaganda: a concluding remark

Textiles and garments serve as key visual components of iconography in the illustrations of the Great Mongol *Shahnama*, functioning as something more than mere presentations of woven materials. The funerary scenes show the wealth of textiles that were available in Ilkhanid Iran, some of which were brought from East Asia as the Mongols moved westward into the Iranian world, while others were produced in West Asia.[61] This enabled the painters to diversify their representations of brocades and in turn to enrich their pictorial conventions of textiles. The depiction of robes in the court scenes is particularly illustrative of the textile-conscious society in Ilkhanid Iran, where costly fabric was an essential part of formal dress. The occurrence of various types of robes in this manuscript also serves to bring the diverse culture of Mongol-ruled Iran into clear visual relief. The key to understanding the major characteristics of Mongol-type robes is their decorative accessories, such as cloud collars, square badges, and chest and back decorations. The painters successfully depicted the detail of clothing, not only reflecting current fashions but also incorporating distinctive Mongol elements into the epic images of the *Shahnama*.

It is interesting to speculate as to the extent of the patron's involvement in the choice of textiles and garments in the Great Mongol *Shahnama*. Given the interpretation that it functioned as a visual tool of political propaganda, it would not be surprising if the choice of textile designs and decorative accessories in this manuscript was oriented by a desire to stress Mongol elements and ultimately to visualize Mongol political hegemony over a vast area of the Eurasian Continent – *Pax Mongolica*.

NOTES TO THE TEXT

Notes to Chapter 1

1. Roland Barthes, 'History and Sociology of Clothing: Some Observations', in *The Language of Fashion*, trans. by Andy Stafford (Oxford/New York: Berg, 2006), p. 7.

2. Roland Barthes, *The Fashion System*, trans. by Matthew Ward and Richard Howard (New York: Hill and Wang, 1983), p. 246.

3. An excellent recent study that takes into account an expanded concept of dress is Janet Snyder, *Early Gothic Column–Figure Sculpture in France: Appearance, Materials, and Significance* (Surrey/Burlington: Ashgate, 2011).

4. This approach reflects a similar strategy to that of Susan Crane, who has analyzed identity as a kind of social performance whereby the agency of the performer is mediated by the social conventions of ritual framework so that any performance is embedded within prior performance and contingent upon how others understood it; Susan Crane, *The Performance of Self: Ritual, Clothing, and Identity During the Hundred Years War* (Philadelphia: University of Pennsylvania Press, 2002).

5. Maurice Merleau-Ponty, *Phenomenology of Perception*, trans. by Colin Smith (London: Routledge & Kegan Paul, 1967).

Notes to Chapter 2

1. I would like to express my gratitude to the Deutsche Forschungsgemeinschaft and the Zukunftskolleg at the University of Konstanz whose generous funding facilitated the research from which this paper is drawn. For the translation of the German manuscript into English, I wish to thank Andreas Puth, Leipzig.

2. The bibliography on the mantle is not too extensive; the most important contributions include: Ernst Maass, 'Die Inschriften und Bilder des Mantels Kaiser Heinrichs II', *Zeitschrift für Christliche Kunst*, 11 (1899), col. 321–42 and 361–76; Elizabeth C. Waldron O'Connor, 'The Star Mantle of Henry II' (unpublished doctoral dissertation, Columbia University, New York, 1980); Jacques Paul, 'Le manteau couverte des étoiles de l'empereur Henri II', in *Le soleil, la lune et les étoiles au Moyen Âge* (Marseille: Laffitte, 1983), pp. 262-91; Renate Baumgärtel-Fleischmann, 'Der Sternenmantel Kaiser Heinrichs II. und seine Inschriften', in *Epigraphik 1988. Fachtagung für mittelalterliche und neuzeitliche Epigraphik, Graz, 10.–14. Mai 1988*, ed. by Walter Koch (Vienna: Verlag der Österreichischen Akademie der Wissenschaften, 1990), pp. 105-25; Renate Baumgärtel-

Fleischmann, 'Die Kaisermäntel im Bamberger Domschatz', *Bericht des Historischen Vereins Bamberg*, 133 (1997), pp. 93-126 (pp. 94-96); Stephen C. McCluskey, *Astronomies and Cultures in Early Medieval Europe* (Cambridge/New York: Cambridge University Press, 1998), pp. 140-45; Dieter Blume, Mechthild Haffner and Wolfgang Metzger, *Sternbilder des Mittelalters: Der gemalte Himmel zwischen Wissenschaft und Phantasie, vol. 1: 800–1200* (Berlin: Akademie, 2012), pp. 183-88; Christoph Winterer, 'Kosmos als Bildthema und Vorbild textiler Kunst (800-1100)' in *Beziehungsreiche Gewebe: Textilien im Mittelalter, ed. by Kristin Böse and Silke Tammen* (Frankfurt/Berlin/Bern: Peter Lang, 2012), pp. 77-107 (pp. 94-101)

3. See O'Connor, pp. 21-27; Baumgärtel-Fleischmann, 'Der Sternenmantel', pp. 109-10. By making use of the evidence of the accounts of the *Domkustorei* ('cathedral verger's office'), Baumgärtel-Fleischmann proved that the restoration had taken place as early as 1453/54 rather than in 1502/03, as assumed previously by O'Connor.

4. Since the fifteenth-century restoration, and possibly even earlier, the mantle was in the shape of a chasuble. It was restored as a cloak in preparation for the 1950 exhibition *Ars Sacra* in Munich; see Baumgärtel-Fleischmann, 'Der Sternenmantel', p. 110, no. 24

5. See Baumgärtel-Fleischmann, 'Der Sternenmantel', pp. 113-18.

6. See Baumgärtel-Fleischmann, 'Der Sternenmantel', p. 125: '*Die auf dem Mantel dargestellte descriptio totius orbis und damit den eigentlichen Sinnhehalt des Geschenks zu interpretieren, wird nicht mehr gelingen.*'

7. See *Lacan: Topologically Speaking*, ed. by Ellie Ragland and Dragan Milovanovic (New York: Other Press, 2004); *Topologie. Falten, Knoten, Netze, Stülpungen in Kunst und Theorie*, ed. by Wofram Pichler and Ralph Ubl (Vienna: Turia + Kant, 2009).

8. The analysis of the eleventh-century remnants beneath the embroideries proved that about 90 per cent of the images were in their former position; see O'Connor, pp. 23-26.

9. See O'Connor, pp. 41-46; Francesca Luzzati Laganà, 'Meles (Melo)', in *Lexikon des Mittelalters*, 9 vols (Munich/Zurich: Artemis & Winkler, 1980–98), VI (1993), col. 492; Horst Enzensberger, 'Bamberg und Apulien', in *Das Bistum Bamberg in der Welt des Mittelalters*, ed. by Christine and Klaus van Eickels (Bamberg: University of Bamberg Press, 2007), pp. 141-50.

10. The earliest written record of the *Sternenmantel* is the 1452/53 *Domkustorei* invoice that refers to it as '*casula seu pallium Ysmahelis ducis Apulie*' (Archiv des Erzbistums Bamberg, Rep. I, no. 241a, unfol., cited from Baumgärtel-Fleischmann, 'Der Sternenmantel', p. 107). It was not until the eighteenth century that the mantle became linked to Henry II; Baumgärtel-Fleischmann, 'Der Sternenmantel', p. 108. As a birthname, Ismahel had strong Islamic connotations, see Isidore of Seville, *Etymologiae libri XX*, ed. by W. M. Lindsay, 2 vols (Oxford: Clarendon Press, 1962), I, IX.2.6: '*Ismael filius Abraham, a quo Ismaelitae, qui nunc corrupto nomine Saraceni*'. Thus, Ernst Maass hypothesized that Ismahel was a Saracene craftsman who was responsible for designing the mantle (cf. Maass, col. 371), yet written sources leave little doubt that Ismahel and a nobleman from Bari otherwise recorded as 'Meles' or 'Melus' were one and the same person, making it likely that Ismahel/Meles had Lombardic origins; see the literature cited in note 9.

11. The exact dimensions are 2.97 meters in width and 1.54 meters in height. For astronomical cycles in early medieval illuminated manuscripts, see Fritz Saxl, *Verzeichnis astrologischer und mytholigischer Handschriften des lateinischen Mittelalters*, 3 vols (Heidelberg: Winter 1915, 1927, and 1953); Patrick McGurk, *Catalogue of Astrological and Mythological Illuminated Manuscripts of the Latin Middle Ages. 4. Astrological Manuscripts in Italian Libraries (Other than Rome)* (London: Warburg Institute, 1966); Blume, Haffner and Metzger.

12. '*Man weiß ja nur wenig mehr vom Zeremoniell jener glänzenden, teuer erkauften Festzüge, die so mancher deutsche König zur St. Petersbasilika hin unternommen hat, um nach vielen Fährlichkeiten in der Hauptstadt der Welt die Krone der Cäsaren zu empfangen. [...] Aber hie und da ist doch in den entlegensten Winkeln der unerschöpflichen Old Curiosityshop [...] das ein oder andere Requisit jenes weltbedeutenden Mummenschanzes liegen geblieben. Und mitten unter all diesen [...] schimmert nun wirklich seltsamerweise ein kostbarer Mantel, dessen halberhabene Goldstickereien auf ursprünglich tiefblauem Grund den Himmel und alle Sternbilder darstellen wollen.*' Robert Eisler, *Weltenmantel und Himmelszelt. Religionsgeschichtliche Untersuchungen zur Urgeschichte des antiken Weltbildes* (Munich: C. H. Beck, 1910), p. 5.

13. To my knowledge, no critical inquiry into Eisler's book has been undertaken as yet. It would be particularly interesting to examine the affinities of his approach to Aby Warburg's nearly contemporaneous interest in the intercultural migration of astronomical and astrological imagery.

14. '[...] *sondert sich der Bilderschmuck in zwei Teile, einen christlichen und einen profanen.*'; Maass, col. 323.

15. O'Connor, p. 58.

16. Baumgärtel-Fleischmann, 'Der Sternenmantel', pp. 117-18.

17. As has been pointed out extensively by O'Connor, pp. 58-112.

Like Maass, O'Connor still assumed the inscriptions – coming from the so-called *Recensio Interpolata* – to be original. Yet, even if the Ottonian captions were taken from a different source, there is no reason for doubting that the iconographic formulae were borrowed from pictorial cycles of the Aratos group. Baumgärtel-Fleischmann's arguments against this hypothesis fail to convince; see Baumgärtel-Fleischmann, 'Der Sternenmantel', p. 112. For a survey of this iconographic tradition, see Mechthild Haffner, *Ein antiker Sternbilderzyklus und seine Tradierung in Handschriften vom frühen Mittelalter bis zum Humanismus. Untersuchungen zu den Illustrationen der 'Arathea' des Germanicus* (Hildesheim/Zürich/New York: Olms, 1997). There are further illustrated catalogues of the constellations, including: Pseudo-Bede's *De signis coeli*, the Carolingian compilation *De ordine ac positione stellarum in signis* (both derived from the Aratos tradition), and Hyginus's *De astronomia*. See also A. W. Byvanck, 'De platen in de Aratea van Hugo de Groot', *Mededeelingen der Koninklijke Nederlandsche Akademie van Wetenschappen, Afdeling Letterkunde*, 12.2 (1949), pp. 169-233; Rembrandt Duits, 'The Survival of the Pagan Sky: Illustrated Constellation Cycles in Manuscripts', in *Images of the Pagan Gods: Papers of a Conference in Memory of Jean Seznec*, ed. by Rembrandt Duits and François Quiviger (London: Warburg Institute, 2009), pp. 97-128, esp. pp. 101-05; Blume, Haffner and Metzger, pp. 11-30, 137-148.

18. Compare the two depictions of the *Maiestas Domini* in the Metz Sacramentary fragment (Paris, Bibliothèque Nationale de France, Ms. lat. 1141, fol 5r and fols 5v-6r). See Tobias Frese, 'Die Maiestas Domini als Bild eucharistischer Gegenwart', in *Intellektualisierung und Mystifizierung mittelalterlicher Kunst. 'Kultbild': Revision eines Begriffs*, ed. by Martin Büchsel and Rebecca Müller (Berlin: Mann, 2010), pp. 41-61. Also see Herbert L. Kessler, 'Facies bibliothecae revelata: Carolingian Art as Spiritual Seeing', in *Testo e immagine nell'alto medioevo*, 2 vols (Spoleto, 1994), I, pp. 533-94.

19. There are, of course, other early medieval picture cycles combining Christian and astronomical motifs, the best known of which are linked with imperial patronage: the Cathedra Petri commissioned by Charles the Bald, and two ivory caskets depicting apostles and zodiacal signs that were later given to St Servatius in Quedlinburg by Henry I (now Quedlinburg, Stiftskirche) and to St Stephanus in Bamberg by Henry II (now Munich, Bayerisches Nationalmuseum, MA 174–76). A later Christian-astronomical cycle, almost contemporary to the Star Mantle, is included in the canon tables of the Bamberg Gospels (early eleventh century, Munich, Staatsbibliothek, Clm 4454, fols 17v–20), a manuscript donated to the treasury of Bamberg Cathedral by Henry II. A common denominator of all these programs is their focus on the twelve signs of the Zodiac instead of the larger group of constellations that are depicted on the Star Mantle.

20. See Anna Muthesius, *Byzantine Silk Weaving AD 400 to AD 1200* (Vienna: Fassbaender, 1997); Regula Schorta, *Monochrome Seidengewebe des hohen Mittelalters. Untersuchungen zu Webtechnik und Musterung* (Berlin: Deutscher Verlag für Kunstwissenschaft, 2001).

21. See Renate Baumgärtel-Fleischmann, 'Blauer Kunigundenmantel' and 'Reitermantel', in *Kaiser Heinrich II. 1002–1014*, ed. by Josef Kirmeier et al. (Augsburg: Haus der Bayerischen Geschichte, 2002), pp. 380-81 and 383-84. See also Warren F. Woodfin, 'Presents Given and Presence Subverted. The Cunegunda Chormantel in Bamberg and the Ideology of Byzantine Textiles', *Gesta*, 47.1 (2008), pp. 35-50 (p. 36).

22. See Anna Muthesius, 'The Role of Byzantine Silks in the Ottonian Empire', in *Byzanz und das Abendland im 10. und 11. Jahrhundert*, ed. by Evangelos Konstantinou (Cologne: Böhlau, 1997), pp. 301-17 (p. 302).

23. These figures are derived from early medieval manuscript illuminations, as are the constellations; for more see O'Connor, pp. 103-07.

24. O'Connor, p. 110. The author continues: 'By the same token, the Mantle could not have been meant to function as a horoscope. For that the zodiacal signs would have been in correct sequence, and the position of the planets in them [...] should be indicated.' In fact, the complete absence of planets, apart from Sol and Luna, is a strong counter-argument against Baumgärtel-Fleischmann's claim that the mantle's original program might have been determined by astrological reasons; see Baumgärtel-Fleischmann, 'Der Sternenmantel', pp. 117-18.

25. Furthermore, the mantle does not reflect the sequence of star signs as given in the Aratos compilations. In the Aratos cycles, the sequence of the first constellations is as follows: Arcturus Maior, Arcturus Minor, Draco, Hercules Serpentarius, Scorpion, Bootes, Virgo, Gemini, Cancer; for the precise location of these signs on the Star Mantle, see O'Connor, pp. 69-83.

26. For the implicit spatial order of constellations of the three classical star catalogues which were transmitted and illustrated in the Middle Ages (Aratos' *Phaenomena*, Hyginus' *De astronomia* and Ptolemy's *Syntaxis*), see Duits, pp. 101-05.

27. Gregory of Tours, 'De cursu stellarum ratio' in *Gregorii episcopi Turonensis miracula et oper minora*, ed. by W. Arnd and B. Krusch (Hannover: Hahn, 1885), pp. 404-24. See McCluskey, pp. 101-10.

28. Miscellany, Montecassino, fourth quarter of the eighth century, Bamberg, Staatsbibliothek, Msc. Patr. 61, fols 75v–82v. This manuscript was among Henry II's donations to the Bamberg Cathedral Library. For more, see Gude Suckale-Redlefsen, *Die Handschriften des 8. bis 11. Jahrhunderts der Staatsbibliothek Bamberg* (Wiesbaden: Harrassowitz, 2004), pp. 3-10.

29. See Baumgärtel-Fleischmann, 'Der Sternenmantel', pp. 114-16.

30. See Vera Trost, *Gold- und Silbertinten. Technologische Untersuchungen zur abendländischen Chrysographie und Argyrographie von der Spätantike bis zum hohen Mittelalter* (Wiesbaden: Harrassowitz, 1991); Ulrich Ernst, 'Farbe und Schrift im Mittelalter unter Berücksichtigung antiker Grundlagen und neuzeitlicher Rezeptionsformen', in *Testo e immagine nell'alto medioevo*, 2 vols (Spoleto: Presso la Sede del Centro, 1993), I, pp. 343-415.

31. '*Hoc sidus cancri fert nociva mundi.*' See O'Connor, p. 81; Baumgärtel-Fleischmann, 'Der Sternenmantel', pp. 114-15.

32. Baumgärtel-Fleischmann, 'Der Sternenmantel', pp. 114-15.

33. See Maximilian Scherner, '"Text". Untersuchungen zur Begriffsgeschichte', *Archiv für Begriffsgeschichte*, 36 (1996), pp. 103-60; '*Textus' im Mittelalter. Komponenten und Situationen des Wortgebrauchs im schriftsemantischen Feld*, ed. by Ludolf Kuchenbuch and Uta Kleine (Göttingen: Vandenhoek & Ruprecht, 2005).

34. See below, "A twofold donation". For the Macrobian notion of *contextio*, see Gerhard von Graevenitz, '*Contextio* und *conjointure*, Gewebe und Arabeske. Über Zusammenhänge mittelalterlicher und romantischer Literaturtheorie', in *Literatur, Artes und Philosophie*, ed. by Walter Haug and Burghart Wachinger (Tübingen: Niemeyer, 1992), pp. 229-57.

35. For the significance of the ornamental in early medieval art, especially see Jean-Claude Bonne, 'De l'ornemental dans l'art médiéval (VIIe–XIIe siècle). Le modèle insulaire', in *L'Image. Fonctions et usages des images dans l'Occident médiéval*, ed. by Jérôme Baschet and Jean-Claude Schmitt (Paris: Léopard d'Or, 1996), pp. 207-40; Jean-Claude Bonne, 'Intrications (à propos d'une composition d'entrelacs dans un évangile celto-saxon du VIIe siècle)', in *Histoires d'ornement: actes du colloque de l'Académie de France à Rome, Villa Médicis, 27–28 juin 1996*, ed. by Patrice Ceccarini et al. (Paris/Rome: Klincksieck/Adcadémie de France à Rome, 2000), pp. 75-108.

36. See Eisler, p. 10; Paul, p. 268. It was also considered whether the garment was designed as a chasuble from the beginning; see Maass, col. 323; Joseph Braun, *Die liturgische Gewandung im Occident und Orient nach Ursprung und Entwicklung, Verwendung und Symbolik* (Freiburg im Breisgau: Herder, 1907), p. 230; and, most recently, Winterer, pp. 97-8. However the inscription on the hem is a very strong argument against this reconstruction of the mantle as a liturgical vestment.

37. More details regarding the dating will be discussed in the final section of this paper.

38. O'Connor, pp. 149-54.

39. '*In veste enim poderis quam habebat totus erat orbis terrarum et parentum magnalia in quattuor ordinibus lapidum erant sculpta et magnificentia tua in diademate capitis illius erat scripta.*' A reference to this passage can also be found in another source, which has been discussed in the context of the Star Mantle, namely Helgaud of Fleury's *Vita Roberti* (*c.* 1030). The gifts that Adelheid gave to St Martin of Tours are mentioned: '*Cui et aliud*

ornamentum contexuit, quod vocatur orbis terrarium, illi Caroli Calvi dissimilimum'. Cited after Helgaud of Fleury, *Vita Roberti regis*, in *Recueil des historiens des Gaules et de la France*, ed. by Martin Bouquet, 13 vols (Paris: Palmé 1869–1904; reprint Farnborough: Gregg, 1967–68), X (1874), p. 104.

40. Paul, p. 269.

41. See O'Connor, p. 153.

42. Philo, *Works*, trans. by F. H. Colson and G. H. Whitaker, 10 vols (London: William Heinemann, 1929–62), V (1936), pp. 405-07. Also see Ellen Harlizius-Klück, 'Weben, Spinnen', in *Wörterbuch der philosophischen Metaphern*, ed. by Ralf Konersmann (Darmstadt: Wissenschaftliche Buchgesellschaft, 2007), p. 499.

43. Compare the debate in O'Connor, pp. 147-59.

44. The somewhat corrupted Latin text is analyzed by O'Connor, pp. 37-38, and Baumgärtel-Fleischmann, 'Der Sternenmantel', pp. 120-21. For the English translation, see O'Connor, p. 38, no. 4.

45. Wendy R. Larson, 'Narrative Threads: The Pienza Cope's Embroidered Vitae and their Ritual Setting', *Studies in Iconography*, 24 (2003), pp. 139-63 (p. 157). See also Felix Thürlemann, 'Die Chormäntel des Wiener Paramentenschatzes im Gebrauch. Für eine Pragmatik der Textilkunst', in *Kleider machen Bilder. Vormoderne Strategien vestimentären Bildsinns*, ed. by David Ganz and Marius Rimmele (Emsdetten: Edition Imorde, 2012), pp. 53-66.

46. See O'Connor, p. 79.

47. For the problems concerning the visibility/non-visibility of images in general, see Paul Veyne, 'Conduct without Belief and Works of Art without Viewers', *Diogenes*, 36.1 (1988), pp. 1-22; Beat Brenk, 'Visibility and Partial Invisibility of Early Christian Images', in *Seeing the Invisible in Late Antiquity and the Early Middle Ages: Papers from 'Verbal and Pictorial Imaging: Representing and Accessing Experience of the Invisible. 400–1000'* (Turnhout: Brepols, 2005), pp. 140-83.

48. See Alfred Gell, *Art and Agency: An Anthropological Theory* (Oxford: Clarendon Press, 1998), pp. 12-72.

49. O'Connor, p. 40.

50. See Erich Freiherr zu Guttenberg, *Die Regesten der Bischöfe und des Domkapitels von Bamberg* (Schöningh: Würzburg, 1963), p. 73.

51. Freiherr zu Guttenberg, p. 75.

52. Freiherr zu Guttenberg, p. 75. On the relationship at work during the mutual act of gift-giving at the meeting of Henry

and Ismahel, see Ludger Körntgen, *Königsherrschaft und Gottes Gnade. Zu Kontext und Funktion sakraler Vorstellungen in Historiographie und Bildzeugnissen der ottonisch-frühsalischen Zeit* (Berlin: Akademie, 2001), pp. 404-08.

53. For more, see Anna Muthesius, 'The Role of Byzantine Silks in the Ottonian Empire', in *Byzanz und das Abendland im 10. und 11. Jahrhundert*, ed. by Evangelos Konstantinou (Cologne: Böhlau, 1997), pp. 301-17; Anna Muthesius, *Studies in Byzantine, Islamic and Near Eastern Silk Weaving* (London: Pindar Press, 2008), pp. 116-31. See also Woodfin, esp. pp. 43-45.

54. Ismahel gave a Greek name to his son, Argyros. According to Enzensberger, p. 143, this could indicate Ismahel's affinity to Byzantine culture.

55. As the smaller border inscription contains the peace formula *Pax Ismaheli*, it has been deduced that the mantle was only completed after Ismahel's death at the behest of the emperor. See, among others, O'Connor, p. 45. Yet as Enzensberger shows ('Bamberg und Apulien', p. 145), the use of the peace formula is not limited to dead persons in the early Middle Ages.

56. On Henry's donations of textiles, see Anna Muthesius, *Studies in Byzantine*, pp. 38-51.

57. Harlizius-Klück, 'Weben, Spinnen', p. 505.

58. See Barbara Baert, 'Touching the Hem: The Thread between Garment and Blood in the Story of the Woman with the Haemorrhage (Mark 5:24b–34parr)', in *Kleider machen Bilder. Vormoderne Strategien vestimentären Bildsinns*, ed. by David Ganz and Marius Rimmele (Emsdetten: Edition Imorde, 2012), pp. 159-82.

59. Other pictorial robes whose borders were particularly charged through inscriptions or pictures include the Hungarian Coronation Mantle, a former chasuble that was produced in the same workshop as the Sternenmantel and in which portraits of the two donors, King Stephen II and his wife Gisela, are placed in the central hem zone, and the Mantle of Roger II, made in the Sicilian palace workshop in 1133–34 (where kufic inscriptions along the hem offer blessings to the wearer of the robe). See *The Coronation Mantle of the Hungarian Kings*, ed. by István Bardoly (Budapest: Hungarian National Museum, 2005); William Tronzo, 'The Mantle of Roger II of Sicily', in *Robes and Honor: The Medieval World of Investiture*, ed. by Stewart Gordon (New York: Palgrave, 2001), pp. 241-53.

60. At a later point in time the mantle was sewn together at its front and thus changed into a chasuble, a vestment to be worn once again. This must have happened before the mid-fifteenth century when the mantle is referred to as *'casula [...] recte Ismahelis'* (see above, note 10).

Notes to Chapter 3

˙ The revision and expansion of this essay were undertaken as a postdoctoral member of the European Research Council-funded project, 'TEXTILE: An Iconology of the Textile in Art and Architecture', at the Kunsthistorisches Institut of the University of Zurich. I would like to thank my colleagues in the project and especially its director, Professor Tristan Weddigen, for helping me to think through some of the implications of the textile works presented here. I would also like to thank Branislav Cvetković in Jagodina, Serbia, Elisabeth Dimitrova in Skopje, Aleksei Barkov in Moscow, and Fr. Alexie Cojocaru of Putna Monastery in Romania for generously sharing their photographs.

1. This group, along with related Ottoman textiles bearing Christian motifs, has been the subject of two brief studies: Rudolf M. Riefstahl, 'Greek Orthodox Vestments and Ecclesiastical Fabrics', *The Art Bulletin*, 14 (1932), pp. 359-73; and David Talbot Rice, 'Post-Byzantine Figured Silks', *Annual of the British School at Athens*, 46 (1951), pp. 177-81. In addition, several examples are featured and discussed as a group in Nurhan Atasoy et al., *İpek: Imperial Ottoman Silks and Velvets* (London: Azimuth Editions, 2001), pp. 178, 241, 243-47, 331.

2. Compare Riefstahl (note 1) in which he assumes a Greek origin for the majority of the textiles under consideration, and Adèle Coulin Weibel, *Two Thousand Years of Textiles: The Figured Textiles of Europe and the Near East* (New York: Pantheon, 1952), p. 136, cat. no. 204, which describes the fragment in Chicago as Armenian.

3. Heath Lowry, *Ottoman Bursa in Travel Accounts* (Bloomington: Indiana University Press, 2003), pp. 40-42, 63-64.

4. See the *sakkos* of Patriarch Niphon at Dionysiou Monastery, Mount Athos, with a *terminus ante quem* of 1508, notes 40 and 41.

5. J. M. Rogers, H. Tezcan, and S. Delibaş, *Topkapı Costumes, Embroideries, and Other Textiles* (Boston: Little, Brown, 1986), p. 29.

6. The group of similarly patterned silk and metallic thread lampas weaves (*kemha*) is represented by exemplars in Germany (Krefeld: Deutches Textilmuseum, inv. no. 05158); Greece (Athens: The Benaki Museum, inv. nos. 828 and 843 and The Byzantine & Christian Museum, Athens, inv. no. BXM 1695); Romania (Bucharest: the treasuries of Putna Monastery and Suceviţa Monastery and the National Historical Museum); Russia (formerly Zolotikovo, near Tver, now presumed lost); Switzerland (the Abegg Stiftung, Riggisberg, inv. no. 648); the United Kingdom (the former David Talbot Rice collection, Edinburgh and The Victoria & Albert Museum, London, inv. no. 885-1899); and the United States (The Art Institute of Chicago, inv. no. 1916.378; Dumbarton Oaks, Washington, DC, inv. no. 1952.10; and in a New York private collection).

7. It is also worth noting that liturgical writings of this period refer to the bishop not as *episkopos*, the normal patristic term for the office, but as *archiereus*, 'high priest'. Already in the twelfth century, a *diataxis* of the pontifical liturgy of Hagia Sophia uses *archiereus* throughout to mean bishop. Robert F. Taft, 'The Pontifical Liturgy of the Great Church According to a Twelfth-Century Diataxis in Codex *British Museum Add. 34060*', *Orientalia Christiana Periodica*, 45 (1979), pp. 279-307, (pp. 284-306).

8. Warren T. Woodfin, *The Embodied Icon: Liturgical Vestments and Sacramental Power in Byzantium* (Oxford: Oxford University Press, 2012); and 'Celestial Hierarchies and Earthly Hierarchies in the Art of the Byzantine Church', in *The Byzantine World*, ed. by Paul Stephenson (London/New York: Routledge, 2010), pp. 303-19.

9. Woodfin, *Embodied Icon*, pp. 7-20.

10. Witness Liurprand of Cremona's indignation at finding the Greek bishops uniformly wearing the *omophorion*, equivalent to the *pallium*, without the special privilege attached to it as a papal gift in the west. *Relatio de Legatione Constantinopolitana* 62, ed. by P. Chiesa (Turnhout: Brepols, 1998), p. 215; Josef Braun, *Die liturgische Gewandung im Occident und Orient nach Ursprung und Entwicklung, Verwendung und Symbolik* (Freiburg im Breisgau: Herder, 1907), p. 666.

11. Braun, p. 237; Athanasios Papas, *Studien zur Geschichte der Messgewänder im byzantinischen Ritus* (Munich: Institut für Byzantinistik und Neugriechische Philologie der Universität München, 1965), p. 755; Σύνταγμα τῶν θείων καὶ ἱερῶν κανόνων, ed. by Georgios A. Rhalles and M. Potles, 6 vols (Athens: G. Chartophylakos, 1852–59), II, p. 260. The twelfth-century canonist Theodore Balsamon attempts to restrict the *polystaurion* to patriarchs exclusively. See Theodore Balsamon, *Responsa ad Marcum*, in *Patrologiae cursus completus, Series graeca*, J.-P. Migne, ed., 161 vols (Paris: Migne, 1857–66), 138: col. 989A; Balsamon, *Meditata*, in *Patrologiae...graeca*, 138: cols. 1020C, 1025D, 1028B.

12. Demetrios Chomatenos, in *Patrologiae...graeca*, 119: col. 952A.

13. Papas, p. 125. On the imperial *sakkos*, see Maria G. Parani, *Reconstructing the Reality of Images: Byzantine Material Culture and Religious Iconography, 11ᵗʰ–15ᵗʰ Centuries* (Leiden: Brill, 2003) pp. 23-24; Michael F. Hendy, *Catalogue of the Byzantine Coins in the Dumbarton Oaks Collection and in the Whittemore Collection IV (1081–1261)* (Washington, DC: Dumbarton Oaks, 1999), p. 157.

14. Braun, pp. 664-66; B. Berthod, 'Le pallium, insigne des évêques d'Orient et d'Occident', *Bulletin du CIETA*, 78 (2001), pp. 14-25.

15. Nicole Thierry, 'Le costume épiscopal byzantin du IXᵉ au

XIIIe siècle d'après les peintures datées (miniatures, fresques)', *Revue des études byzantines*, 24 (1966), pp. 308-15.

16. Ignatius, *Letter to the Smyrnaeans*, 8.1, ed. by P. Thomas Camelot, *Ignace d'Antioche, Polycarpe de Smyrne: Lettres*, 3rd edn. (Paris: Éditions du Cerf, 1958), p. 162.

17. Ida Malte Johansen, 'Rings, Fibulae and Buckles with Imperial Portraits and Inscriptions', *Journal of Roman Archaeology*, 7 (1994), pp. 223-42; Warren T. Woodfin, 'An Officer and a Gentleman: Transformations in the Iconography of a Warrior Saint', *Dumbarton Oaks Papers*, 60 (2006), pp. 111-43.

18. Hans-Joachim Schulz, *Die byzantinische Liturgie: Glaubenzeugnis und Symbolgestalt*, 3rd edn. (Trier: Paulinus, 2000), pp. 155-93; René Bornert, *Les Commentaires byzantins de la divine liturgie du VIIe au XVe siècle* (Paris: Institut français d'études byzantines, 1966).

19. N. A. Mayasova, *Medieval Pictorial Embroidery: Byzantium, the Balkans, Russia* (Moscow: Moscow Kremlin State Museums, 1991), pp. 44-50.

20. Marlia Mango, *Silver from Early Byzantium: The Kaper Koraon and Related Treasures* (Baltimore: Walters Art Gallery, 1986), pp. 150-54; Woodfin, *Embodied Icon*, p. 121.

21. On the theme of the celestial liturgy, see Christopher Walter, *Art and Ritual of the Byzantine Church* (London: Variorum, 1982), pp. 217-21; Schulz, pp. 175, 209-14.

22. Walter, *Art and Ritual*, p. 216.

23. Viktor N. Lazarev, *Mozaiki Sofii Kievskoi* (Moscow: Iskusstvo, 1960), pl. 33, 34; Richard Hamann-MacLean and Horst Hallensleben, *Die Monumentalmalerei in Serbien und Makedonien vom 11. bis zum frühen 14. Jahrhundert*, 2 vols. (Giessen: Schmitz, 1963), II, pp. 224-25, pl. VI.

24. Suzy Dufrenne, *Les programmes iconographiques des églises byzantines de Mistra* (Paris: Klincksieck, 1970), p. 14, fig. 62.

25. Robert F. Taft, *The Great Entrance: a History of the Transfer of Gifts and Other Preanaphoral Rites of the Liturgy of St John Chrysostom* (Rome: Pontificium Institutum Studiorum Orientalium, 1975), pp. 206-07; Αἱ τρεῖς Λειτουργίαι κατὰ τοὺς ἐν Ἀθήναις κώδικας, ed. by Panagiotes Trempelas (Athens: Patriarchikēs Epistēmonikēs Epitropēs pros Anatheōrēsin kai Ekdosin tōn Leitourgikōn Vivliōn, 1935), p. 9; Patriarchal *Diataxis* of Gemistos the Deacon, ed. by Aleksei Dmitrievskii, *Opisanie liturgicheskikh rukopisei*, 3 vols. (Kyiv: Typofgrafiia Imp. Universiteta Sv. Vladimira, 1901; repr. Hildesheim: Georg Olms, 1965), II, p. 317.

26. Symeon of Thessaloniki, *Contra Haereses, Patrologiae . . . graeca* 155: col. 340; R. Taft, 'The Living Icon: Touching the Transcendent in Palaiologan Iconography and Liturgy', in

Byzantium: Faith and Power (1261–1557): Perspectives on Late Byzantine Art and Culture, ed. by Sarah T. Brooks (New York: Metropolitan Museum of Art, 2006), p. 55.

27. Gabriel Millet, *Broderies religieuses de style byzantin* (Paris: E. Leroux, 1939–47), pp. 76-78, pl. CLIX.

28. Patriarchal *Diataxis* of Gemistos the Deacon, ed. by Dmitrievskii, pp. 303, 310.

29. On the curtain in the sanctuary entrance: Taft, *The Great Entrance*, pp. 411-16.

30. For example, Exodus 26:31–37, 36:35–37. On the veil of the Temple, see Joan R. Branham, 'Penetrating the Sacred: Breaches and Barriers in the Jerusalem Temple', in *Thresholds of the Sacred: Architectural, Art Historical, Liturgical, and Theological Perspectives on Religious Screens, East and West*, ed. by Sharon E. J. Gerstel (Washington, DC: Dumbarton Oaks, 2006), pp. 7-24 (pp. 20-22); Margaret Barker, *Temple Themes in Christian Worship* (London: T. & T. Clark, 2007), pp. 93-95.

31. Hebrews 10:20. The extended comparison with the temple rite begins at Hebrews 9:1.

32. For a reflection on the double function of the sanctuary screen, see N. Constas, 'Symeon of Thessalonike and the Theology of the Icon Screen', in *Thresholds of the Sacred: Architectural, Art Historical, Liturgical, and Theological Perspectives on Religious Screens, East and West*, ed. by Sharon E. J. Gerstel (Washington, DC: Dumbarton Oaks, 2006), pp. 163-83 (pp. 168-79).

33. National Museum, Sofia, inv. no. 1793; Millet, p. 62, pl. CXXIII.

34. Kastoria: Lena Grigoriadou, 'L'image de la Déésis royale dans une fresque du XIVe siècle à Kastoria', in *Actes du XIVe Congrès internationale des études byzantines*, 3 vols. (Bucharest: Editura Academiei Republicii Socialiste România, 1975), II, pp. 47-59; Stylianos Pelekanides and Manolis Chatzidakis, *Kastoria* (Athens: Melissa, 1985), pp. 106-19, pl. 1-14; Henry Maguire, 'The Heavenly Court', in *Byzantine Court Culture from 829 to 1204*, ed. by Henry Maguire (Washington, DC: Dumbarton Oaks, 1997), pp. 247-58, (pp. 257-58). Markov: Cvetan Grozdanov, 'Iz ikonografije Markovog manastira', *Zograf*, 11 (1980), pp. 83-93.

35. Petre Guran, 'Les implications théologico-politiques de l'image de la "Deèsis" à Voroneț', *Revue Roumaine d'Histoire*, 44 (2005), pp. 39-67, (pp. 50-51).

36. Symeon of Thessaloniki, *Expositio de divino templo, Patrologiae . . . graeca* 155: col. 728D; Guran, p. 52.

37. The outlier in Guran's argument, an icon of the Deèsis with Christ in patriarchal garments in the National Gallery of Art, Sofia, cannot be dated as early as the late fourteenth or early fifteenth century, as published in the exhibition catalogue *Kunst-*

schätze in bulgarischen Museen und Klöstern (Essen: Villa Hügel, 1964), p. 158, cat. no. 262; Guran, p. 46. A more realistic attribution, dating the icon to the turn of the sixteenth century, is given in Atanas Bozhkov, *Die bulgarische Maleri. Von den Anfängen bis zum 19. Jahrhundert* (Recklinghausen: A. Bongers, 1969), fig. 123.

38. Guran, p. 54; L. Lifshits et al., *Vizantiia, Balkany, Rus': Ikony XIII-XIV vekov* (Moscow: Gos. muzeev Moskovskogo Kremlia, 1991), p. 229, cat. no. 229.

39. The same combination appears in the frescoes of Kovalevo, near Novgorod, dated *c.* 1380. Guran, p. 55; Viktor Lazarev, 'Kovalevskaia rospis' i problema iuzhnoslaviankikh sviazei v russkoi zhivopisi XIV veka', *Ezhegodnik Instituta Istorii iskusstv, 1957* (Moscow: Akademii Nauk SSSR, 1958), pp. 233-78.

40. Anna Ballian in *Treasures of Mount Athos,* ed. Athanasios Karakatsanis (Thessaloniki: Ministry of Culture, Museum of Byzantine Culture, Holy Community of Mount Athos, Organization for the Cultural Capital of Europe Thessaloniki 1997, 1997), pp. 386-87, cat. no. 11.1; Atasoy et al., p. 241, cat. no. 8.

41. Manouel Gedeon, Πατριαρχικοὶ πίνακες, 2nd edn. (Athens: Syllogos pros Diadosin Offelimōn Vivliōn, 1996), pp. 368-72, 374-75; Manuel Malaxos, *Historia politica et patriarchica Constantinopoleos*, ed. by I. Bekker (Bonn: Weber, 1849), pp. 127-32; Nicolae Iorga, *Byzance après Byzance. Continuation de l'histoire de la vie byzantine* (Bucharest: Institut d'études byzantines, 1935), pp. 84-85; Claude D. Cobham, Adrian Fortescue, and H. T. F. Duckworth, *The Patriarchs of Constantinople* (Cambridge: Cambridge University Press, 1911), pp. 94, 103.

42. Note that the illustration in Atasoy et al., p. 241, cat. no. 8, incorrectly reverses the image so that the inscriptions read correctly, left to right.

43. This is the usual Greek substitute for the Tetragrammaton, regularly appearing in Christ's halo in post-Byzantine iconography, with reference to the Septuagint rendering of Exodus 3:14.

44. Riefstahl (p. 364) believes the symmetrical blessing gesture to be an error possibly motivated by the symmetry of the woven design, but this is clearly not the case, given parallels in embroidery and other media. A thorough study of the blessing gestures used in iconography is a desideratum.

45. Atasoy et al., pp. 244-45, no. 29; Oreste Tafrali, *Le trésor byzantin et roumain du monastère de Poutna* (Paris: P. Geuthner, 1925), pp. 69-70, cat. no. 16, pls LIX-LX.

46. O. Tafrali, 'Le monastère de Sucevița et son trésor', in *Études sur l'histoire et sur l'art de Byzance. Mélanges Charles Diehl*, 2 vols. (Paris: E. Leroux, 1930), II, pp. 207-29 (p. 214, no. 10). This *phelonion* is one of several vestments with similar inscriptions naming the same donor and date.

47. The date at which the miter became a regular part of the attire of Orthodox bishops is an open question. Its use does not seem to have become general before the eighteenth century (Braun, p. 491, with reservations as to an exact date). There is certainly evidence for some forms of head covering for bishops in the fourteenth century, but the domical form of the miter may be a later development. Guran (pp. 59, 63-65) places its differentiation from the imperial crown in the later part of the sixteenth century; the frescoes of the ecumenical councils at Tŭrnovo show the Roman pope in a Western-style, pointed miter and the four Eastern patriarchs wearing domed miters. Christopher Walter, *L'iconographie des conciles dans la tradition byzantine* (Paris: Institut français d'études byzantines, 1970), p. 80, fig. 37; André Grabar, *Peinture religieuse en Bulgarie* (Paris: P. Geuthner, 1928), pp. 279-80, pl. XLVII.

48. The phelonion at Putna Monastery, dated by inscription to before 1614, has the N in the same position as the fragment at Dumbarton Oaks.

49. Atasoy et al., p. 331, entry under pl. 54.

50. It is, of course, also possible that a previously correct pattern was inadvertently reversed in the weaving of the Dionysiou *sakkos*, but it would be impossible to determine without such a textile coming to light.

51. Atasoy et al., pp. 246-47, cat. no. 41.

52. Atasoy et al., pl. 10, pp. 48-49, 220-22, 324.

53. Henry Maguire, 'Magic and the Christian Image', in *Byzantine Magic*, ed. by Henry Maguire (Washington, DC: Dumbarton Oaks, 1995), pp. 51-71; and 'Garments Pleasing to God: The Significance of Domestic Textile Designs in the Early Byzantine Period', *Dumbarton Oaks Papers*, 44 (1990), pp. 215-24.

54. The curtain was the donation of Simion Movilă and his wife Marghita, *c.* 1608–11. Tafrali, 'Monastère de Sucevița', p. 215, no. 20.

55. Η βασιλεία ἡ ἐμὴ οὐκ ἔστιν ἐκ τοῦ κόσμου τούτου' (John 18:36); P. Guran, p. 42; T. Papamastorakes, 'Ἡ μορφὴ τοῦ Χριστοῦ-Μεγάλου Ἀρχιερέα', *Deltion tēs Christianikēs Archaiologikēs Hetaireias*, 17 (1993/94), pp. 67-76.

Notes to Chapter 4

1. Eugen Denize, *Stephen the Great and His Reign* (Bucharest: The Romanian Cultural Institute Publishing House, 2004), p. 21.

2. See, for example, *Repertoriul Monumentelor și Obiectelor de Artă din Timpul lui Ștefan cel Mare*, ed. by Mihai Berza (Bucharest: Academia Republicii Populare Române, 1958);

Gabriel Millet, *Broderies religieuses de style byzantin* (Paris: Ernest Leroux, 1939–47); Pauline Johnstone, *The Byzantine Tradition in Church Embroidery* (Chicago: Argonaut, 1967).

3. Johnstone, p. 83. For a survey of textiles associated specifically with Stephen the Great, see Berza, pp. 279-334.

4. *The Oxford Dictionary of Byzantium*, ed. by Alexander P. Kazhdan, 3 vols (Oxford: Oxford University Press, 1991), I, pp. 720-21; Robert F. Taft, *The Great Entrance: A History of the Transfer of Gifts and Other Preanaphoral Rites of the Liturgy of St John Chrysostom* (Rome: Pontificium Institutum Studiorum Orientalium, 1975), pp. 217-19.

5. *The Oxford Dictionary of Byzantium*, I, p. 27; Taft, pp. 5-7. For a catalogue of known examples of *aëres* and *epitaphioi* of the fourteenth and fifteenth centuries, see Henry Schilb, 'Byzantine Identity and Its Patrons: Embroidered Aëres and Epitaphioi of the Palaiologan and Post-Byzantine Periods' (unpublished doctoral dissertation, Indiana University, 2009), pp. 221-495.

6. For vestments of the Byzantine and Latin rites, see Joseph Braun, *Die Liturgische Gewändung in Occident und Orient nach Ursprung und Entwicklung, Verwendung und Symbolik* (Darmstadt: Wissenschaftliche Buchgesellschaft, 1964); Comité International d'Histoire de l'Art, *Paramente der christlichen Kirchen: systematisches Fachwörterbuch* (Munich: K. G. Saur, 2002); Mary Symonds and Louisa Preece, *Needlework in Religion: An Introductory Study of Its Inner Meaning, History, and Development; Also a Practical Guide to the Construction and Decoration of Altar Clothing and of the Vestments Required in Church Services* (London: Sir Isaac Pitman & Sons, 1924), pp. 41-55.

7. Warren Woodfin, 'Liturgical Textiles,' in *Byzantium: Faith and Power (1261–1557)*, pp. 296-97. Features sometimes cited as evidence that a textile belongs to one type or the other include its size, iconography, and hymns embroidered in the inscriptions. See *The Oxford Dictionary of Byzantium*, I, pp. 27, 720-21.

8. Among textiles associated with Stephen the Great that could be categorized as *aëres* rather than *epitaphioi* is an example in the Putna Monastery dated 1481 and measuring 85 x 58 cm. See Maria Ana Musicescu, *Broderia veche Românească* (Bucharest: Editura Meridiane, 1985), p. 36, cat. no. 18; Oreste Tafrali, *Le Trésor byzantin et roumain du monastère de Poutna* (Paris: Paul Geuthner, 1925), pp. 35-36. In Tafrali's catalogue, this *aër* is number 65, however its photograph is actually of another *aër* (cat. no. 85), an error that later misled some scholars. See Millet, p. 108, and I. D. Ştefănescu 'Le voile de calice brodée du monastère de Vatra-Moldoviţei', in *L'art byzantin chez les Slaves: Les Balkans* (Paris: Paul Geuthner, 1930), pp. 303-09 (p. 306). The tomb cover of Stephen's second wife, Maria of Mangop, is probably the most famous textile associated with Stephen the Great. It is sometimes referred to as an '*epitaphios*', but the term '*epitaphios*' is misleading in this case because it refers only to the function of this cloth as a tomb cover. It is identified as an '*epitaphios*' in, for example, *Byzantium: Faith and Power (1261–1557)*, ed. by

Helen C. Evans (New Haven: Yale University Press, 2004), p. 59.

9. Nicolae Iorga, *Byzantium after Byzantium*, trans. by Laura Treptow (Portland, Oregon: The Center for Romanian Studies, 2000), pp. 80-81.

10. For photographs of the Moldoviţa *epitaphios*, see Millet, pls. 190, 214-16; see also Musicescu, *Broderia veche Românească*, fig. 25.

11. Musicescu, *Broderia veche Românească*, pp. 37, 40, cat. nos 22, 24, and 37.

12. Musicescu, *Broderia veche Românească*, pp. 37, 40. For a comparison of the sizes of *aëres* and *epitaphioi* of the fourteenth and fifteenth centuries, see Schilb, pp. 221-495.

13. For a catalogue of the Putna Monastery's treasury, see Tafrali, *Le Trésor byzantin et roumain du monastère de Poutna*. The Putna *epitaphios* is number 66 in Tafrali's catalogue, p. 36, pl. 22. The Putna *epitaphios* seems to have been at Putna ever since it was made for (and possibly at) the monastery. The Moldoviţa *epitaphios* was intended for the early fifteenth-century monastery at Moldoviţa that was destroyed in the late fifteenth or early sixteenth century and then rebuilt nearby in 1531 by Peter IV Rareş, an illegitimate son of Stephen the Great. At some point, the Moldoviţa *epitaphios* had been moved to the Dragomirna Monastery. It was moved from Dragomirna to the Suceviţa Monastery in 1816. The Moldoviţa *epitaphios* is now in the museum at the Moldoviţa Monastery. See Nicolae Iorga and Gheorghe Balş, *Histoire de l'art roumain ancien* (Paris: E. de Boccard, 1922), pp. 47, 114; Dimitrie Dan, *Mânăstirea Sucevita: Cu anexe de documente ale Suceviţei si Schitului celui Mare: Aprobat de Academia Română* (Bucharest: Tipographia Bucovina, 1923), p. 52.

14. Musicescu, *Broderia veche Românească*, p. 40.

15. Johnstone, p. 123.

16. Woodfin, p. 295.

17. For example, the *aër* of the Metropolitan Makarios and the Neamţ *epitaphios* include inscriptions that may be regarded as prototypes for the inscriptions on the *epitaphioi* of Stephen the Great. For the *aër* of Makarios, see Ludwik Wierzbicki and Marian Sokołowski, *Wystawa archeologiczna polsko-ruska urzadzona we Lwowie w roku 1885* (Lwów: 1886), p. 8, pl. 29; Maria Ana Musicescu, 'La broderie roumaine au moyen-âge', *Revue Roumaine d'Histoire de l'Art*, 1 (1964), pp. 61-83 (pp. 64-65). For the Neamţ *epitaphios*, see Johnstone, pp. 122-23, figs 102-04. The *aër* of the Makarios and the Neamţ *epitaphios* will be discussed below.

18. Smaller than the Putna *epitaphios* but of comparable size to the Moldoviţa *epitaphios* is a textile made for the Archbishop Euphemius of Novgorod in 1440/41. It measures 205 x 125

cm (255 x 175 cm with later addition). That textile is now in the State Historical Museum, Moscow (inv. no. TK-65). See N. A. Mayasova, *Drevnerusskoe litsevoe shit'e*, (Moscow: Krasnaia ploshchad', 2004), pp. 90-93; V. N. Lazarev, *Iskusstvo Novgoroda* (Moscow: Iskusstvo, 1947), p. 130, pl. 133.

19. For an account of Stephen's patronage, see Randal H. Munsen, 'Stephen the Great: Leadership and Patronage on the Fifteenth-Century Ottoman Frontier', *East European Quarterly*, 29, no. 3 (September 2005), pp. 269-97.

20. Johnstone, p. 39.

21. While the *Epitaphios Threnos* became a standard iconography for embroidered *epitaphioi*, some examples show the figure of the dead Christ without other figures or with only angels. For differing accounts of the development of the *Epitaphios Threnos* iconography, see Kurt Weitzmann, 'The Origin of the Threnos', in *De Artibus Opuscula XL: Essays in Honor of Erwin Panofsky*, ed. by Millard Meiss, 2 vols (New York: New York University Press, 1961), I, pp. 476-90; Maria G. Soteriou, 'Entafiasmos-Threnos', *Deltion tes Christianikes Archaiologikes Hetaireias*, 7 (1973–74), pp. 139-48; and on the embroidered image see Hans Belting, 'An Image and Its Function in the Liturgy: The Man of Sorrows in Byzantium', *Dumbarton Oaks Papers*, 34/35 (1980–81), pp.1-16.

22. The *Lithos* or Stone of Unction, also sometimes called the Red Stone of Ephesus, was the stone on which the body of Christ was prepared for burial. According to Niketas Choniates, Emperor Manuel I Komnenos brought the relic from Ephesus to Constantinople in the twelfth century. Niketas Choniates, *O City of Byzantium: Annals of Niketas Choniatēs*, trans. by Harry Magoulias (Detroit: Wayne State University Press, 1984), p. 125; *Nicetae Choniatae Historia*, ed. by Jan Louis van Dieten, 2 vols (Berlin: De Gruyter, 1975), I, p. 222; on the Stone of Unction in this iconography see Ioannis Spatharakis, 'The Influence of the Lithos in the Development of the Iconography of the Threnos', in *Byzantine East, Latin West*, ed. by Doula Mouriki et al. (Princeton, NJ: Department of Art and Archaeology, Princeton University, 1995), pp. 435-46.

23. The dating of the Cozia *epitaphios* is disputed, but it certainly predates the Neamţ *epitaphios*. See Iorga and Balş, *Histoire de l'art roumain ancien*, p. 36; N. P. Kondakov, *Pamiatniki khristianskago iskusstva na Afonje* (St Petersburg: Izdanie Imperatorskoi Akademii Nauk, 1902), p. 264; Millet, p. 104; Émile Turdeanu, 'La Broderie religieuse en Roumanie: les épitaphes moldaves aux XVe et XVIe siècles', *Cercetări Literare*, 4 (1940), pp. 164-214 (p. 171).

24. The *aër* of the Metropolitan Makarios has been missing since World War II, but it was photographed before then. It is sometimes referred to as the Żółkiew *aër* or *epitaphios* because the monastery at Żółkiew was its last location before it was moved to a museum in Lwów, which is its last known location. It was in the Moldavian Metropolitan Church in Suceava until John III Sobieski took it and other treasures from Suceava to

Poland in 1686. Musicescu, *Broderia veche Românească*, p. 34. For a photograph, see Wierzbicki and Sokołowski, pl. 29; Musicescu, 'La broderie roumaine au moyen-âge', p. 65, fig. 4.

25. Johnstone, p. 83.

26. Sharon E. J. Gerstel, *Beholding the Sacred Mysteries: Programs of the Byzantine Sanctuary* (Seattle: University of Washington Press, 1999), pp. 100-01; John Lowden, *Early Christian and Byzantine Art* (London: Phaidon, 1997), pp. 404-08. Sharon Gerstel has argued that these painters also had a hand in designing the famous Thessaloniki *epitaphios*, see Sharon E. J. Gerstel, 'The Aesthetics of Orthodox Faith', *Art Bulletin*, 87 (June 2005), pp. 331-41 (p. 334). The Thessaloniki *epitaphios* can be attributed to Michael Astrapas and Eutychios on stylistic grounds, and the treatment of the iconography showing the Communion of the Apostles is comparable. The Thessaloniki *epitaphios* is now in the Museum of Byzantine Culture, Thessaloniki, Greece.

27. Johnstone, p. 83; Turdeanu, p. 201.

28. Johnstone, p. 83.

29. In this and the other transcriptions in this paper, I have not expanded abbreviations nor have I attempted to normalize spelling. For transcriptions of inscriptions on textiles associated with Stephen the Great, I have followed most closely the work by Teodora Voinescu and M. A. Musicescu, 'Broderii şi Tesături', in *Repertoriul Monumentelor şi Obiectelor de Artă din Timpul lui Ştefan cel Mare*, ed. by Mihai Berza (Bucharest: Academia Republicii Populaire Romîne, 1958), pp. 290-313. For the inscriptions on the *epitaphios* at Putna, see also Dimitrie Dan, *Mânăstirea şi comuna Putna* (Bucharest: Carol Göbl, 1905), pp. 65-66. In the date on this *epitaphios*, the symbol ≠C is used as a *koppa* representing the number 90. This type of *koppa* was used on other Moldavian textiles; see Millet, p. 87.

30. For the Moldoviţa *epitaphios*, see Millet, p. 107, pl. 190. For the *aer* of Ephemia and Eupraxia, see Millet, pp. 99-100, pl. 185.

31. Johnstone suggests that Serbian refugees from the Turks might have taken it with them to Putna, but this can only be speculation. Johnstone, p. 85.

32. Johnstone, p. 118.

33. My transcription follows that provided by Voinescu and Musicescu. Berza, p. 301. See also Dimitrie Dan, *Mânăstirea Sucevita: Cu anexe de documente ale Suceviţei si Schitului celui Mare: Aprobat de Academia Română* (Bucharest: Tipographia Bucovina, 1923), pp. 51-52. Although little of the embroidered inscription on this *epitaphios* is completely illegible, there is room for interpretation. I have introduced some slightly different readings where the lettering is difficult to decipher. I have indicated damaged sections with square brackets. Also, my line breaks differ from those in the transcription provided by Voinescu and Musicescu. The date may be interpreted in

two ways since it is possible to read the final character in the inscription either as 'A' or as 'Λ'. Gabriel Millet read the date as 'March 30' (Millet, p. 107). Although the final character is easy to mistake for 'Λ', the shapes of the two letters are consistently distinct within the border inscription, and the final character is almost certainly an 'A'

34. Even though this would be an unusual representation, Johnstone has identified the figure as John; however, this is unlikely as John is usually represented without a beard; Johnstone, p. 124.

35. Woodfin, p. 296; see also Taft, pp. 216-19.

36. This *epitaphios* is now in the collections of the Novgorod State United Museum Preserve (ДРТ 2130) and measures 193 by 153.5 cm. E. V. Ignashina, *Old Russian Embroidery from the Collection of the Novgorod Museum* (Novgorod, 2002), pp. 6-7, illustration on p. 16 (The photographs for the *epitaphioi* on pp. 16 and 19 have been transposed, so their captions are incorrect). See also A. N. Svirin, *Drevnerusskoe shit'e* (Moscow, 1963), p. 34, photograph on p. 39.

37. Taft, pp. 76-77.

38. Svirin, p. 34.

39. Janet Martin, *Medieval Russia: 980–1584* (Cambridge: Cambridge University Press, 2007), p. 271.

40. Readings of the date embroidered on this *epitaphios* vary. A. N. Svirin read the year as ҂ЅЦѮ (6960 or 1451/52), but N. P. Kondakov gives the year 1456, apparently reading the date as ҂ЅЦѮД (6964). Both dates are within the reign of Basil II. Svirin, p. 34; Kondakov, p. 268.

41. Martin, p. 270.

42. Martin, p. 277.

43. Because of the iconography, Johnstone thought that this *aër* 'was clearly based on a Byzantine type, if not actually Greek work'. Johnstone, p. 83.

44. There are a few more characters in this inscription, but their meaning is obscure. See Turdeanu, p. 203, no. 1.

45. The word '*Amnos*' in the inscription refers to the iconography of the dead Christ as the 'Lamb of God'. The term sometimes refers to liturgical veils bearing this iconography, as it does in this inscription.

46. D. J. Deletant, 'Some Aspects of the Byzantine Tradition in the Rumanian Principalities', *The Slavonic and East European Review*, 59, no. 1 (Jan. 1981), pp. 1-14 (p. 2).

47. Siluan was the *hegoumenos* (abbot) of Neamţ; Johnstone, p. 122.

48. Now in the National Museum of History, Tirana, Albania, this *aër* measures 218 x 118 cm. It is the earliest liturgical textile in the Byzantine tradition to identify the embroiderer by name in the inscription, attributing the work to 'Georgios Arianites'. For the inscription, see Theofan Popa, 'Të dhëna mbi princët mesjetarë shqiptarë në mbishkrimet e kishave tona', *Buletin i Universitetit Shtetëror të Tiranës, Seria shkencat shoqërore*, 11, no. 2 (1957), pp. 196-206 (pp. 198-99).

49. Thought to be missing for some time after the Balkan Wars of the early twentieth century, this textile is now in the National History Museum, Sofia, Bulgaria. Although it is often identified as an *epitaphios*, Ana Gonosová rightly identifies this textile as an *aër* in *The Oxford Dictionary of Byzantium*, I, p. 27. For an illustration and the transcription, see *Byzantium: Faith and Power (1261–1557)*, pp. 314-15.

50. For dating, attribution, and a discussion of Andronikos Palaiologos and the Bishop of Ohrid, see Ihor Ševčenko and Jeffery Featherstone, 'Two Poems by Theodore Metochites', *Greek Orthodox Theological Review*, 26 (1981), pp. 1-46 (p. 11).

51. Anna Muthesius, *Studies in Silk in Byzantium* (London: The Pindar Press, 2004), pp. 194-95.

52. Muthesius, p. 194.

53. See note 9.

54. The effect of Byzantine art on art in Moldavia and Wallachia was certainly not new, even in the time of Stephen the Great. Aspects of the fourteenth-century cycle of wall paintings at Curtea de Argeş suggest the direct influence of the program of mosaics in the main church of the Constantinopolitan Chora Monastery (the Kariye Camii). See Daniel Barbu, 'L'Église et l'empereur au XIVe siècle selon le Témoignage de la peinture murale de Valachie', *Revue Roumaine d'Histoire*, 34, nos 1–2 (1995), pp. 131-39 (p. 132); see also Maria Ana Musicescu and Grigore Ionescu, *Biserica domneasca din Curtea de Argeş* (Bucharest: Meridiane, 1976), pp. 21-23.

55. For a bibliography of works dealing with Stephen the Great, see Ştefan Andreescu, *Stephen the Great, Prince of Moldavia (1457–1504): Historical Bibliography* (Bucharest: The Romanian Cultural Institute Publishing House, 2004).

56. Denize, p. 74; Alain Ruzé, 'Étienne le Grand, défenseur de la Chrétienté et "Athlète du Christ"', *Revue Roumaine d'Histoire*, 42, 1-4 (2003), pp. 61-80. Nicolae Iorga even used the title 'Étienne-le-Grand comme défenseur de l'orient chrétien' for the section dealing with Stephen the Great in his *Histoire des Roumains et de la romanité orientale*, 10 vols (Bucharest: L'Académie Roumaine, 1937–45), IV (1937), pp. 147-301.

57. Denize, p. 14; Kurt W. Treptow, 'The Social and Economic Crisis in Southeastern Europe in the Time of Vlad Ţepeş', in *Dracula: Essays on the Life and Times of Vlad Ţepeş*, ed. by Kurt.

W. Treptow (New York: Columbia University Press, 1991), pp. 63-80.

58. Denize, p. 31; Alexandru Simon, 'Anti-Ottoman Warfare and Crusader Propaganda in 1474: New Evidence from the Archives of Milan', *Revue Roumaine d'Histoire*, 46 (2007), pp. 25-39; Constantin C. Giurescu, 'The Historical Dracula', in *Dracula: Essays on the Life and Times of Vlad Țepeș*, ed. by Kurt. W. Treptow (New York: Columbia University Press, 1991), pp. 13-27.

59. R. W. Seton-Watson, 'Roumanian Origins', *History* (January 1923), pp. 241-55 (p. 254).

60. Denize, p. 27.

61. Denize, pp. 30-31.

62. Denize, p. 198.

63. Denize, p. 199.

64. Denize, pp. 199-200.

Notes to Chapter 5

1. The research presented in this essay derives from my dissertation on papal textile donations in the late Middle Ages, which focuses on the textile gifts of Pope Boniface VIII to Anagni Cathedral (University of Cologne, in progress). This essay was developed from a paper given at the CAA conference in Chicago in February of 2010. I would like to express my gratitude to Margaret Goehring and Kate Dimitrova for inviting me to present my research in their session, and I thank the Kress Foundation for the travel grant that made my attendance possible. Finally, my personal thanks to Beatrice Kitzinger for her support of both my journey to the US and the writing of this essay.

2. The importance of textiles for papal representation is clearly demonstrated by the huge number of textiles stored in the papal treasury, to which the inventories of 1295 and 1311 testify. For example, excluding manuscripts, the former contains 1657 entries ordered in eighty-five chapters, thirty-six of which are completely dedicated to textiles. These textiles were used both for the papal liturgy and the court household. See 'Inventaire du trésor du Saint Siège sous Boniface VIII (1295)', ed. by Émile Molinier, *Bibliothèque de l'École des Chartres*, 43 (1882), pp. 19-310, 626-46; 45 (1884), pp. 31-57; 46 (1885), pp. 16-44; 47 (1886), pp. 646-67; 49 (1888), pp. 226-37; 'Inventarium thesauri ecclesiae Romanae apud Perusium asservati iussu Clementis Papae V factum anno MCCCXI', *Regesti Clementis Papae V ex vaticanis archetypis sanctissimi domini nostri Leonis XIII Pontificis Maximi iussu et munificentia nunc primum editi cura et studio Monachorum Ordinis S. Benedicti*, 10 vols (Rome: Typographia Vaticana, 1885–92), X, pp. 369-513. The fact that

300 pack animals were needed in order to transport the papal treasury from Naples to Rome in February 1295, shortly after the election of Boniface VIII, gives an idea of the treasury's size. Lucas Burkart, *Das Blut der Märtyrer. Genese, Bedeutung und Funktion mittelalterlicher Schätze* (Cologne/Weimar/Vienna: Böhlau Verlag, 2009), p. 124; Agostino Paravicini Bagliani, *Bonifacio VIII* (Turin: Einaudi, 2003), pp. 85. For an important overview about textiles as media of papal representation, see Thomas Ertl, 'Stoffspektakel. Zur Funktion von Kleidern und Textilien am spätmittelalterlichen Papsthof', *Quellen und Forschungen aus italienischen Archiven und Bibliotheken*, 87 (2007), pp. 139-85.

3. Ascoli Piceno, Pinacoteca Civica, inv. no. 343; Anagni, Museo del Tesoro della Cattedrale (no inventory number); Pienza, Museo Diocesano (no inventory number). For essential bibliography of the textiles in Ascoli Piceno and Pienza see notes 17 and 21, for Anagni see notes 27, 43 and 44.

4. The cope in the Vatican Museums (Vatican City, Musei Vaticani, inv. no. T 180 (4001)) was possibly a gift by Pope Boniface VIII to the Chapter of Old St Peter's. A cope in *opus anglicanum*, which might correspond to the preserved object, is mentioned in an inventory of the treasury of Old St Peter's of 1361. See Nigel Morgan, 'Opus Anglicanum in the papal treasury', *Bulletin du CIETA*, 78 (2001), pp. 26-40 (pp. 31-32); Archibald Grace I. Christie, *English Medieval Embroidery* (Oxford: Clarendon, 1938), pp. 94-96, cat. no. 51. Legend states that the cope, which is still preserved in the treasury of St John Lateran (no inventory number), was donated by Pope Boniface VIII to the Lateran, but this does not correspond to the stylistic features of the cope, which instead suggest a date between 1320 and 1340. See Maria Andaloro, 'Il Tesoro della basilica di S. Giovanni in Laterano', in *San Giovanni in Laterano*, ed. by Carlo Pietrangeli (Florence: Nardini, 1990), pp. 271-97 (pp. 282-85); Christie, pp. 149-52, cat. no. 78. The cope in Bologna (Bologna, Museo Civico Medievale, inv. no. 2040) might have been donated by Pope Benedict XI (1303–04) to the convent of San Domenico in Bologna. See Francesca Bignozzi Montefusco, *Il piviale di San Domenico* (Bologna: Pàtron, 1970); Christie, pp. 159-61, cat. no. 86. Finally, there are two copes in the treasury of Saint-Bertrand-de-Comminges (Haute Garonne), Cathédrale Notre-Dame (no inventory number) that are believed to originate from donations of Pope Clement V (1305–14). See Odile Brel-Bordaz, *Broderies d'ornéments liturgiques XIIIe–XIVe siècles* (Paris: Nouvelles Éditions Latines, 1982), pp. 147-59, cat. nos 6-7, 178-80; Christie, pp. 124-29, cat. nos 66-67.

5. See, for example, the description of the clerical vestments for the coronation of the pope in Gregory X's Ceremonial: '[...] omnes cardinales et alii prelati et subdiaconi, *quilibet in gradu suo*, induetur vestimentis pretiosis albi coloris, episcopi pluvialibus, presbiteri casulis, diaconi dalmaticis, subdiaconi tunicellis, acoliti superpelliciis et alii capellani, episcopi, archiepiscopi, abbates et patriarche pluvialibus' [my emphasis]. *Le Cérémonial Papal de la fin du Moyen Âge à la Renaissance*, ed. by Marc Dykmans, 4 vols (Brussels: Bibliothèque de l'Institut historique

belge de Rome, 1977–1985), I, pp. 171-72 or the instruction in the 'Rationale' of Durandus from Mende: 'Celebraturus itaque missam episcopus, aut presbyter, *indumentis suo ordini congruentibus* se exornat, et uestium cultui actionis, queque conueniant ornamenta' [my emphasis] (Liber III, I 6, 116–18), *Guillelmi Duranti Rationale Divinorum Officiorum*, ed. by A. Davril and T. M. Thibodeau, 3 vols (Turnhout: Brepols 1995), I, p. 180. The corpus of medieval Christian liturgical vestments and insignia is defined by a principle of addition. As a cleric moved through the hierarchy of the different offices and levels of consecration, every new grade was visualized by the addition of new pieces of clothing and special insignia. This is especially true for bishops and the pope whose vestments and insignia symbolically represent the multiple levels of consecration through which they had passed; see Tristan Weddigen, *Raffaels Papageienzimmer. Ritual, Raumfunktion und Dekoration im Vatikanpalast der Renaissance* (Berlin: Imorde, 2006), pp. 29-39, 95-97.

6. During the pontificates from Adrian I until Leo IV (772–885), the most important Roman churches were furnished with textiles donated by the popes; see Maria Andaloro, 'Immagine e immagini nel Liber Pontificalis da Adriano I a Pasquale I', in *Atti del colloquio internazionale 'Il Liber Pontificalis e la storia materiale'. Roma, 21–22 febbraio 2002*, ed. by Herman Gertman (Assen: Van Gorcum, 2003), pp. 45-103; Marielle Martiniani-Reber, 'Tentures et textiles des églises romaines au haut Moyen Âge d'après le Liber Pontificalis', in *Mélanges de l'École Française de Rome*, 111 (1999), pp. 289-305; Victor Saxer, 'Le informazioni del Liber Pontificalis sugli interventi dei papi nella decorazione tessile delle chiese romane: l'esempio di S. Maria Maggiore (772–844)', *Rendiconti*, 69 (1996–97), pp. 219-32. Some of the donations were addressed to churches outside Rome as well. The Cathedral of Anagni, for example, received five precious textiles as gifts from Pope Leo IV (847–55): '[...] in ecclesia beate Dei genitricis semperque virginis Mariae domine nostre, qui ponitur infra civitate quae vocatur Anagnias, obtulit vestem de fundato cum IIII gammadiis auro textis I, et vela de fundato IIII'. *Le Liber Pontificalis*, ed. by L. Duchesne, 3 vols (Paris: E. de Boccard 1892; repr. 1955), II, p. 125.

7. The donated textiles are described in inventories of St Peter's treasury that are included in Old St Peter's 'Liber Benefactorum'; see Arthur L. Frothingham, 'Gifts of Pope Nicholas III to the Basilica of S. Pietro in Vaticano', *American Journal of Archaeology*, 4 (1888), pp. 326-28; Eugène Müntz and Arthur L. Frothingham, 'Libro dei Benefattori della Basilica di S. Pietro, Il Tesoro della basilica di S. Pietro in Vaticano dal XIII al XV secolo con una scelta d'inventari inediti', *Archivio della R. Società Romana di Storia Patria*, 6 (1883), pp. 11-13. An introduction to an edition of the entire *Liber Benefactorum* is given in *Necrologi e libri affini della privincia romana*, ed. by Pietro Egidi, 2 vols (Rome: Istituto Storico Italiano, 1908), I, pp. 167-283.

8. *Libri Rationum Camerae Bonifatii Papae VIII (Archivum Secretum Vaticanum, Collect. 446 necnon Intr. et ex. 5)*, ed. by Tilmann Schmidt (Vatican City: Scuola Vaticana di Paleografia, Diplomat-

ica e Archivistica, 1984). The surviving account books of the Apostolic Chamber are from the fifth and eighth year of Boniface's VIII pontificate, 1298/99 and 1301/02, respectively. An entry in the inventory of Nicholas III's donations to Old St Peter's includes interesting information regarding the re-working of '*panni*' originating from papal donations. A 'pannus ad aurum' donated by Nicholas was reworked into an antependium and a cope: '[...] Item contulit et hic Basilice nostre pannum unum ad aurum, de quo factum fuit unum dorsale pro altari maiori, et unum pulchrum pluviale ad ymagines sanctorum contextum de opere Anglicano'. Frothingham, 'Gifts of Pope Nicholas III', p. 327.

9. Within Rome, stational churches received textile gifts when the pope was celebrating specific feasts there, as in the case of the dedication feasts of St John Lateran on 9 November 1299 (*Libri Rationum*, p. 178, no. 1302: twenty-five *tunicae*) and of the churches of Old St Peter's and St Paul's on 18 November 1299 (*Libri Rationum*, p. 188, no. 1415: thirty *tunicae*, given during the papal procession between the Lateran and Old St Peter's). When residing in Anagni, Boniface VIII also visited important churches and convents on the occasion of their local feasts, and donated textiles to them. The Benedictine monastery S. Margherita di Colle Fusano (north of Anagni) received a *pannus ad aurum* in July of 1299, probably on the occasion of its patron's feast on 20 July (*Libri Rationum*, p. 140, no. 997). It was likely on the same occasion of the patron's feast—in this case the feast of Saint James on 25 July in the same year – the Dominican monastery San Giacomo (situated north-west of Anagni) received fourteen *tunicae* and a *pannus sericus* (*Libri Rationum*, p. 139, nos 979, 991). Two further entries show the donation of fifteen *tunicae* and a *pannus sericus* to a 'ecclesie Sancte Marie' to mark the Assumption of our Lady on 15 August 1299 (*Libri Rationum*, p. 146-47, nos 1049, 1055). It remains unclear if this church was the Cathedral of Anagni, which was dedicated to Maria Annunziata. In other sources, Anagni Cathedral is called 'Ecclesia Anagnina' or 'Ecclesia Sancta Maria de Anagnia'; see 'Gesta Innocentii III', *Patrologia Latina Database*, 221 vols (Alexandria: Chadwyck-Healey, 1996), CCXIV, item no. CCIX A. Tilmann Schmidt supposes that the 'ecclesia Sancte Marie' mentioned in the account books refers to the Cistercian monastery Sancta Maria della Gloria near Anagni. See *Libri Rationum*, p. LII.

10. The papal insignia included, for example, the *pallium*, *fanone*, *subcinctorium* and non-liturgical papal vestments, such as the *mantum* and the *cappa magna*. Non-textile papal insignia, such as the *tiara*, were not donated either; see Joseph Braun, *Die liturgische Gewandung im Occident und Orient nach Ursprung und Entwicklung, Verwendung und Symbolik* (Freiburg im Breisgau: Herder, 1907, repr. 1964), pp. 52-57, 117-25, 348-58, 498-509, 620-76; Gerhart B. Ladner, *Die Papstbildnisse des Altertums und des Mittelalters*, 3 vols (Vatican City: Pontificio Istituto di Archeologia Cristiana, 1984), III, pp. 266-307.

11. Regarding the inventory of the pope's donations to Anagni Cathedral, see note 12; for the inventory of the liturgical furniture of Boniface VIII's funeral chapel, see note 7.

12. An inventory from about 1300 (Anagni, Archivio Capitolare, Registri, 2) that lists the gifts of Pope Boniface VIII to Anagni Cathedral includes 101 entries, ninety of which describe liturgical textiles, whereas the other eleven refer to liturgical objects and '*ymagines*' of ivory and silver. Edited by Vincenzo Fenicchia, 'L'inventario dei paramenti e degli oggetti di sacra suppellettile donati da Bonifacio VIII alla cattedrale di Anagni', in *Palaeographica Diplomatica et Archivistica. Studi in onore di Giulio Battelli*, 2 vols (Rome: Edizioni di Storia e Letteratura, 1979), II, pp. 513-25. In addition, see *Anagni negli anni di Bonifacio VIII 1280–1303. Mostra documentaria di pergamene dell'Archivio capitolare*, ed. by Gioacchino Giammaria (Anagni: Istituto di storia e di arte del Lazio meridionale, 1998), p. 43.

13. Pope Nicholas IV, for example, gave money to San Francesco in Assisi, along with textiles and liturgical objects, as part of his first donation to this convent after his election (24/25 February 1288); see *Bullarium Franciscanum. Romanorum Pontificum Constitutiones, Epistolas, ac Diplomata continens tribus ordinibus minorum, clarissarum, et poenitentium*, 5 vols (Rome: Typis Sacrae Congregationis de Propaganda Fide, 1768), IV, p. 4, no. II; Silvestro Nessi, *La basilica di S. Francesco in Assisi e la sua documentazione storica*, 2nd edn (Assisi: Casa Editrice Francescana, 1994), pp. 58-60. Pope Innocent III (1198–1216), too, gifted textiles, liturgical objects and money to churches inside and outside of Rome; see 'Gesta Innocentii III', *Patrologia Latina Database*, CCXIV, item no. CCIII A-CCXI A.

14. This is the case for the three pontificates investigated in this essay. For Nicholas IV's donations to Ascoli Piceno and San Francesco in Assisi, see Stefano Papetti, 'I papi marchigiani e l'arte. Da Niccolò IV a Pio IX: strategie, condizionamenti e riflessi del mecenatismo pontificio nelle Marche', in *I Papi Marchigiani. Classi dirigenti, committenza artistica, mecenatismo urbano da Giovanni XVIII a Pio IX*, ed. by Fabio Mariano and Stefano Papetti (Ancona: Progetti Editoriali srl, 2000), pp. 201-67 (pp. 208-13); Nessi, pp. 58-60, 387-88. For Boniface VIII's gifts to Anagni Cathedral, see Inventario Cattedrale di Anagni, which mentions explicitly that the objects originated from several different donations by this pope. For the gifts of Pius II to Pienza Cathedral, see Fabiana Bari, *Munifica Magnificenza. Il Tesoro Tessile della Cattedrale di Pienza da Pio II Piccolomini agli inizi dell'Ottocento* (Siena: Protagon Editori Toscani, 2004), pp. 13-28.

15. The term *opus anglicanum* can be found primarily in inventories and testaments written on the European mainland in the thirteenth and fourteenth centuries; in England, on the contrary, it seems that the moniker was not used. Scholars have continued to interpret the term as an indication of provenance until recently, without considering that an original indication of provenance might have become a *terminus tecnicus* indicating certain manufacturing techniques typical for these embroideries. The *opus anglicanum* style of embroidery was imitated on the European mainland during the thirteenth and fourteenth centuries, a fact which is demonstrated, for example, by an orphrey

preserved in the Abegg-Foundation, Riggisberg, the origin of which is demonstrably Spanish; see Evelin Wetter, 'Defining a Model of Worship: An Embroidered Orphrey with Depictions Based on the Cantigas de Santa María', in *Iconography of Liturgical Textiles in the Middle Ages*, ed. by Evelin Wetter (Riggisberg: Abegg-Stiftung, 2010), pp. 89-99. Consequently, the provenance of the copes cannot be determined only by considering technical and stylistic features; see Thomas Ertl, 'Die Gier der Päpste nach englischen Stickereien. Zu Bedeutung und Verbreitung von Opus Anglicanum im späten Mittelalter', in *Reiche Bilder. Aspekte zur Produktion und Funktion von Stickereien im Spätmittelalter. Beiträge der internationalen Fachtagung des Deutschen Textilmuseums Krefeld und des Zentrums zur Erforschung antiker und mittelalterlicher Textilien an der Fachhochschule Köln (20–21 November 2008)*, ed. by Uta-Christiane Bergemann and Annemarie Stauffer (Regensburg: Schnell & Steiner, 2010), pp. 97-114 (pp. 97-99, 103, 106, 109-10).

16. In the papal inventories of 1295 and 1311, these textiles are described with the term *opus cyprense* (see the quotation below, notes 28 and 29). As in the case of the *opus anglicanum*, this moniker should not be interpreted as an indication of provenance in scientific terms. Further research regarding these terms will be presented in my forthcoming dissertation.

17. For a brief summary of the current state of research, see Ertl, 'Die Gier der Päpste', pp. 104-06; the cope is discussed as well in Ertl, 'Stoffspektakel', pp. 144-48; Giannino Gagliardi/ Marilena Piccimini, *Il Piviale di Ascoli* (Ascoli Piceno: G. G. Editore, 1990) (bibliography included); *Il piviale duecentesco di Ascoli Piceno. Storia e restauro*, ed. by Rosalia Bonito Fanelli (Ascoli Piceno: Cassa di Risparmio di Ascoli Piceno, 1990) (bibliography included); Christie, pp. 89-94, cat. no. 50.

18. A papal letter, which refers to the donation, dates from 28 July 1288 (see note 37). The document states that the cope had been '*nuper*' (recently) delivered to Ascoli by an envoy. The importance of these three feasts in the liturgical calendar of Ascoli Piceno Cathedral is demonstrated by their lavish decoration with ornamental initials in the *Proprium de Sanctis* of a fourteenth century gradual from the cathedral's possession (Ascoli Piceno, Archivio Capitolare, no inventory number).

19. *Ascoli Pontificia. Vol. 2 (dal 1244 al 1300). Regesti a cura di Laura Ciotti*, ed. by Antonino Franchi (Ascoli Piceno: Istituto Superiore di Studi Medioevali, 1999), pp. 176-81, nos 156-88; Maria Elma Grelli: 'Niccolò IV (Girolamo d'Ascoli)', in Mariano and Papetti, *I Papi Marchigiani*, pp. 268-74 (pp. 272-73); Antonino Franchi, *Nicolaus Papa IV, 1288–1292: Girolamo d'Ascoli* (Ascoli Piceno: Porziuncola, 1990), pp. 163-70, 268.

20. Clement IV's importance is visually stressed by his position to the proper right of the enthroned Virgin. Gregory X, on the other hand, is not represented on the cope; however, Pope Gregory the Great is prominently placed to the proper right of

the crucifixion, which might be evidence pointing to the saint's namesake, Gregory X, as a recipient of the cope's program. Regarding the research history of the object, see Ertl, 'Die Gier der Päpste', pp. 104-06.

21. Laura Martini, 'Il piviale trecentesco di Pienza. Storia di un Opus Anglicanum', in *La terra dei musei. Paesaggio Arte Storia del territorio senese*, ed. by Tommaso Detti (Florence: Giunti, 2006), pp. 358-63; *Il Piviale di Pio II*, ed. by Laura Martini (Milan: Silvana Editoriale SpA, 2001) (with extensive bibliography included); Bari, p. 29; Christie, pp. 178-83, cat. no. 95.

22. Sigismundi Titii, *Historiarum Senensium ab origine ad annum MDXXVIII, Vol. V: Dall'anno 1459 all'anno 1486* (Vatican City, Biblioteca Apostolica Vaticana, Ms. Chigiano, G.I.35, fol. 23v–24r). The contemporary Sienesse historian Tizio reports that Pius II went to Pienza in May 1462, after a stay in Bagni di San Filippo. While there, he donated a relic containing one half of the Apostle Andrew's head, in addition to the cope to the cathedral: 'Quapropter Tummiate post moram dimisso ad Pientinam Urbem Pontifex direxit iter, mansionibus palatiorum iam iam adexcipiendum idoneis. Itaque primum Ecclesiae a se constitutae capitis divi Andreae reliquiam dimidiam partem cum pluviale illud, Pius dono dedit. Haec profecto sacra vestis universas opere et artificio inter Christianos excedere videtur. Textura enim aurea compacta, Sanctorum parvulis figuris ita claret, ut intuentes vivere illas pene credant, tum subtili arte atque opere ita est elaborata, ut opus universum margaritis plurimis contextum et insignitum cunctos in admirationem adducat et praetio nequeat modico extimari: incomparabilis tamen iudicata si ampliori longitudine protenderetur quam nos aliquando studiose induimus.' (This transcription is from Isabella Errera, 'Aucora sul Piviale di Pio II' in *Vita d'Arte* 6 (1910), p. 72; for a translation into English, see Christie, p. 179, note 1).

23. Laura Martini describes formal analogies between the Pienza cope and another cope from the Vatican that no longer survives, but is documented by a watercolor drawing in the Walker Art Gallery in Liverpool; Christie, pp. 183-86, cat. no. 96). Christie identified the latter cope with an entry in an inventory of Old St Peter's from 1361. This entry describes a cope originating from a donation of Pope John XXII (1316–34) to St Peter's, the iconographic program of which corresponds to that of the cope documented by the drawing; see Martini, 'Il piviale in opus anglicanum i Pio II' in Martini, *Il Pivale di Pio II*, pp. 15-25 (p. 18). Nevertheless, the fact that Pope John XXII donated this cope does not necessarily mean that he originally ordered or received the vestment as well; however, stylistic evidence, as argued by Christie, indeed suggests that it dates to the same period.

24. It was entrusted to a certain Rose, the wife of a citizen and merchant in London named John de Bureford: 'On May 17, 1317, fifty marks, in part payment of a hundred, were given by Queen Isabella's own hands to Rose, the wife of John de Bureford, citizen and merchant of London, for an embroidered cope for the choir, lately purchased from her to make a present to the Lord High Pontiff from the Queen.'; *Issues of the Exchequer:*

Being a Collection of Payments Made out of His Majesty's Revenue, from King Henry III to King Henry VI Inclusive, ed. by Frederick Devon (London: J. Murray, 1837), p. 133; cited in Christie, p. 36. Regarding the identification of the cope mentioned in the prepayment with the Pienza cope, see Martini, 'Il piviale in opus anglicanum', pp. 18-19; May Morris, 'Opus Anglicanum III – The Pienza Cope', *The Burlington Magazine*, 7 (1905), pp. 54-65 (p. 60, no. 15). This represents one of the four documented copes donated to Pope John XXII by English royalty and English bishops. See Donald King, 'Ricami Inglesi nell'Italia del Medioevo', *Il piviale duecentesco di Ascoli Piceno*, ed. by Fanelli, pp. 27-31 (p. 30).

25. 'Item aliud pluviale cum diversis ymaginibus et laqueis de perlis per totum auro contextum de opere Anglie, cuius aurifrizium est cum laqueis perlarum, cum diversis avium ymaginibus in capicio operato perlis et lapidibus, subtus est coronacio, deinde nativitas, in circumferencia vero ultima est passio beatarum Katherine et Margarete virginum et Safre, ultimus est operatus de perlis, foderatus de sindone rubea', *Die Inventare des päpstlichen Schatzes in Avignon: 1314–1376*, ed. by Hermann Hoberg (Vatican City: Biblioteca Apostolica Vaticana, 1944), p. 423; Martini, 'Il piviale in opus anglicanum', p. 15.

26. Regarding the iconographic program of the cope, see Wendy R. Larson, 'Narrative Threads: The Pienza Cope's Embroidered Vitae and their Ritual Setting', *Studies in Iconography*, 24 (2003), pp. 139-63; Susan Leibacher Ward, 'Saints in Split Stitch: Representations of Saints in Opus Anglicanum Vestments', *Medieval Clothing and Textiles*, 3 (2007), pp. 41-54.

27. *Bonifacio VIII e il suo tempo*, ed. by Marina Righetti Tosti-Croce (Milan: Electa, 2000), p. 240, cat. no. 1. According to earlier research, the embroidery in Anagni might have been produced in the circle of the royal workshops in Palermo. Many of the textiles produced there are characterized by the embroidered imitation of Byzantine silk fabrics woven in the imperial workshops; see *Nobiles Officinae. Die königlichen Hofwerkstätten zu Palermo zur Zeit der Normannen und Staufer im 12. Und 13. Jahrhundert*, ed. by Wilfried Seipel (Milan: Skira, 2004); for the Byzantine imperial silks, see Anna Muthesius, *Byzantine Silk Weaving AD 400 to AD 1200* (Vienna: Fassbaender, 1997), pp. 44-57. However, since these embroideries are termed *opus cyprense* in the papal inventories, Cyprus should be considered as an alternative location for their production—even, if as mentioned above (note 16), this moniker must not be interpreted as an indication of provenance in scientific terms. All issues regarding the provenance of the *opus cypresne* embroideries are discussed in my forthcoming dissertation.

28. 'XLVI. Pluvialia [...]
890.– Item unum pluviale de examito rubeo brodatum ad aurum de opere ciprensi cum rotis in quibus sunt grifones et aquile cum duobus capitibus, et due aves respicientes quemdam florem, cum aurifrixio deaurato [ad aurum] filatum laboratum ad medias imagines in rotis de uno filo perlarum satis grossarum, sine firmali, foderatum zendato ialdo. [...]

893. – Item, unum pluviale de examito rubeo brodatum de opere cyprensi ad rotas in quibus sunt grifones et aquile ad duo capita et aves duplices respicientes quemdam florem, cum frixio de perlis minutis inter quas sunt caricule serici diversorum colorum, sine firmali, foderatum zendato ialdo.

894. – Item, unum pluviale de xamito rubeo brodatum de opere cyprensi ad rotas in quibus sunt grifones et aquile cum duobus capitibus, et aves duplices respicientes quemdam florem, cum frixio laborato in eodem examito ad duplices imagines stantes in arcubus; et est sine capucio, et foderatum.

895. – Item, unum medium pluviale de examito rubeo brodatum de opera cyprensi ad rotas in quibus sunt grifones, aquile ad duo capita et aves respicientes florem, et quinque frustra de simili panno. [...]

XLVIII. Paramenta de rubeo [...]

945. – Item, planetam brodatam de opere cyprensi ad grifones et aquilas ad duo capita et duas aves in rotis cum aurifrixio cum imaginibus hominum [et] animalibus ad aurum tractitium, et vitibus de perlis cum bullis de auro.' Molinier, 'Inventaire du trésor' (1885), pp. 25-26, 29-30, nos 890-95, 945.

29. 'Item aliud pluviale pulcrum de samito rubeo de opere cipri, laboratum ad magnos compassus rotundos cum duobus circulis de auro et serico, et inter ipsos circulos sunt vites et folia de auro filato, et in medio aliquorum compassuum sunt grifones, et in aliquibus aliis sunt papagalli duplices et in aliis aquile cum duplice capite. Et inter dictos compassus sunt alii minores compassus cum quatuor foliis que folia habent lilium in capite. [...] Item aliud pluviale pulcrum de samito rubeo de opere ciprensi, laboratum de opere proximi precedentis, ... Item aliud pluviale pulcrum de samito rubeo de opere cipri, laboratum ad magnos compassus rotundas cum duobus circulis de auro et serico, inter quos circulos sunt vites et folia de auro filato; et in medio aliquorum compassuum sunt grifones de auro et in aliquibus aliis sunt duo papagalli in quolibet de auro, et in aliis in quolibet aquila de auro cum duobus capitibus. Et inter dictos compassus sunt compassus minores cum IIII foliis de auro, que habent lilium in capite. [...] Item unum magnum frustum de samito rubeo de opere ciprensi laboratum ad compassus rotundas in quibus sunt duo circuli, et inter circulos, vites et folia de auro; et in medio compassuum sunt in aliquibus papagalli, in aliquibus grifones, et in aliquibus aquile cum duobus capitibus. Et inter dictos compassus sunt alii minores compassus cum quatuor foliis de auro; et habet in una parte in giro parum de foderatura de zendado croceo; et videtur fuisse de pluviali vel planeta; et cum dicto frustro est aliud parvum frustum quasi de eodem opere. Item unum pluviale de samito rubeo de opere ciprensi, quasi de consimili opera cum proximo precedenti frustro magno, et est incisum in dextero latere per transversum omnino [...]', 'Inventarium thesauri ecclesiae Romanae (1311)', pp. 419, 420, 427. The entire ensemble of the *opus cyprense* textiles belonging to the papal treasury will be discussed in my forthcoming dissertation. Regarding the provenance of the *opus cyprense* see note 58.

30. 'Anno Domini M°CCC°XIII, die sabbati, scilicet die quinta magii intrantis, Avinione, in ecclesia cathedrali, presentibus cardinalibus et prelatis, [...] ascendit papa pulpitum parvum factum post chorum, navem ecclesie respiciens. [...] *Dominus papa*, propter loci altitudinem, cum duobus cardinalibus diaconibus ministrantibus tantum et aliquibus et paucis capellanis et suis familiaribus in ambitu post prelatos paratos, *mutavit mantum, et accepit mantum seu pluviale valde pulcrum de opere anglicano et ymagines* et mitram de pernis. [...]' [my emphasis], L.-H. Labande, 'Le Cérémonial romain de Jacques Cajétan et les données historiques qu'il renferme', *Bibliothèque de l'École des Chartes*, 54 (1893), pp. 45-74 (p. 65). See also Julian Gardner, 'Legates, Cardinals and kings: England and Italy in the thirteenth century', in *L'Europa e l'arte italiana. Per i cento anni dalla fondazione del Kunsthistorisches Institut in Florenz* (Venice: Marsilio, 2000), pp. 74-93 (p. 93, no. 93); and Nigel Morgan, 'L'Opus Anglicanum nel tesoro pontificio', in *Il Gotico europeo in Italia*, ed. by Valentino Pace and Martina Bagnoli (Naples: Electa Napoli, 1994), pp. 299-309 (p. 302).

31. Sybille Schröder, *Macht und Gabe. Materielle Kultur am Hof Heinrichs II. von England* (Husum: Matthiesen, 2004), p. 206.

32. See Stewart Gordon, 'A World of Investiture', in *Robes and Honor. The Medieval World of Investiture*, ed. by Stewart Gordon (New York: Palgrave, 2001), pp. 1-19 (pp. 8-9).

33. The gesture of the *Mantelschutz* was particularly practiced by high-ranking individuals in order to offer protection and support to needy and disenfranchised persons. The iconographic type of the 'Schutzmantel-Madonna' (the Madonna with the protective cloak) originated from this custom; G. M. Lechner, 'Schutzmantel', in *Lexikon des Mittelalters*, ed. By Norbert Angermann et al., 10 vols (Munich: Artemis, Stuttgart: Metzler, 1980–99), VII, pp. 1597-98.

34. See Karl von Amira, *Germanisches Recht.*, 4th edn, 2 vols (Berlin: Walter de Gruyter & Co, 1960–67), II, pp. 66-71; Jacob Grimm, *Deutsche Rechtsaltertümer*, 4th edn, 2 vols (Leipzig: Dieterich'sche Verlagsbuchhandlung, 1899), I, pp. 219-21.

35. In the papal account books from the pontificate of Boniface VIII, entries regularly refer to summer and winter vestments gifted to the papal *familia*. These were included as part of the salaries to the curial official apparatus in the retinue of the pope; See *Libri Rationum*, pp. 190-91, no. 1448, p. 302, nos 2324-26, p. 353, nos 2776-79, p. 380, no. 3024; Friedrich Baethgen, 'Quellen und Untersuchungen zur Geschichte der päpstlichen Hof- und Finanzverwaltung unter Bonifaz VIII', in *Quellen und Forschungen aus italienischen Archiven und Bibliotheken*, 20 (1928/29), pp. 114-237 (p. 130).

36. See Ertl, 'Stoffspektakel', pp. 156-57.

37. '[... Esculana.] ‚Precordialis dilectionis affectum et zelum [...] Esculanam ecclesiam ab ineunti etatis nostre [...s]tudiis continuatis benivolis prosequi non cessamus claris [...ind]iciis et signis evidentibus aperi, pluviale quoddam exameti [...] texti per totum ac variis ymaginibus et figuris aliorumque diversorum operum

quibus ingenium commendatur artificis multiplici varietate distincti, cui utique pluviali pretiosis margaritis ornatum amplum aurifrisium est annexum, per dilectum filium fratrem Lambertum de Ripatransonis, ordinis fratrum minorum, nuper eidem ecclesie duximus destinandum, ut illo, prout vestra viderit decere discretio, diebus utamini sollempnibus et festivis. Ut autem ipsius pluvialis usu predictam non contingat ecclesiam imposterum defraudari, auctoritate presentium districtius inhibemus ne pluviale prefatum pro quavis ipsius necessitate vendatur ecclesie vel obligetur pignori aut quomodolibet distrahatur. Datum Reate, v kalendas augusti,' *Les Registres de Nicolas IV. Recueil des Bulles de ce pape*, ed. by Ernest Langlois, 2 vols (Paris: Fontemoing, 1905), II, p. 959, no. 7101.

38. '[...] Precordialis dilectionis affectum et zelum [...] Esculanam ecclesiam ab ineuntis etatis nostre [...s]tudiis continuatis benivolis prosequi non cessamus claris [...ind]iciis et signis evidentibus aperi, pluviale quoddam exameti [...] texti per totum ac variis ymaginibus et figuris aliorumque diversorum operum quibus ingenium commendatur artificis multiplici varietate distincti, cui utique pluviali pretiosis margaritis ornatum amplum aurifrisium est annexum [...].' *Les Registres de Nicolas IV*, II, p. 959, no. 7101.

39. See *Bullarium Franciscanum*, IV, p. 4, no. II, pp. 92-93, no. CXLVI (papal letters from 24/25 February 1288 and 7 August 1289).

40. See note 12. The original context of the inventory was lost when the four sheets of parchment were rebound at the beginning of the eighteenth century. It seems likely that the inventory was commissioned by the cathedral chapter in order to register all the objects originating from Boniface's donations within the total stock of the cathedral's treasury, possibly after Boniface's death in 1303.

41. 'In primis unum pluuiale ad aurum, cum grifis et auibus de auro, et aurifrisio cum pernis, portandum per dominum episcopum tantum in festis beati Magni. Item unum aliud nobile pluuiale album auro contextum, cum auibus et diuersis operibus, cum aurifrisie de pernis, cum Centum septuaginta duobus petijs auri quasi pro smaltis, et quatuor bectonibus de auro et pernis, que solus Episcopus debet uti tantum in festis beate Virginis.' Inventario Cattedrale di Anagni, p. 523, nos 62-63.

42. In 1573, the Anagninian bishop Benedetto Lomellino (1572–79) asked Pope Gregory XIII (1572–85) for permission to sell the gems and precious stones that had been applied to the cathedral's ancient textiles. The income would be used to buy landed property, the revenues of which, in turn, would be invested in the necessary conservation of the vestments themselves. Gregory XIII, in reply to this request, instructed the bishop of Veroli to examine the request and to give the permission. See Salvatore Sibilia, *Guida storico-artistica della cattedrale di Anagni. Con un riassunto della storia di Anagni ed un'appendice sugli altri principali monumenti* (Anagni: Rolando Celliti, 1936), p. 163; Pietro Zappasodi, *Anagni attraverso i secoli*, 2 vols (Veroli: Reali

1908), II, p. 99. The episcopal letter of Lomellino, preserved at Anagni's Archivio Capitolare, cannot presently be consulted because the inventory number indicated by Sibilia no longer exists and no concordance was made during the new inventory of the archive in the 1980s. The papal brief of Gregory XIII to the bishop of Veroli, dating from 1 April 1573 is in the Vatican Archives (Vatican City, Archivio Segreto Vaticano, Sec. Brev. Reg., Vol. 63, fol. 314).

43. The former bell-chasuble was cut according to the relatively narrow, straight design common for chasubles in the late sixteenth century. The remaining fragments of the former vestment were used for the production of two dalmatics in order to complete the episcopal vestments. See Righetti Tosti-Croce, p. 240, cat. no. 1; Luisa Mortari, *Il Tesoro della Cattedrale di Anagni* (Roma: De Luca Editore, 1963), pp. 20-22, cat. no. 2-4. The state of research of Mortari's catalogue is out-dated; I provide new documentation for these vestments, including a reconstruction of the former bell-chasuble, in my forthcoming dissertation.

44. During the conservation of the Anagninian textiles in the 1960s, the two dalmatics were cut again in order to reconstruct the former cope with the martyrdom of saints. The chasuble, in contrast, was preserved in its late sixteenth-century form. See Righetti Tosti-Croce, p. 242, cat. no. 3, p. 244, cat. no. 5; Mortari, pp. 28-33, cat. nos 8-10; Christie, pp. 101-10, cat. nos 55-57. I provide a new documentation of these textiles in my forthcoming dissertation.

45. '[...] ut illo, prout vestra viderit decere discretio, diebus utamini sollempnibus et festivis. Ut autem ipsius pluvialis usu predictam non contingat ecclesiam imposterum defraudari, auctoritate presentium districtius inhibemus ne pluviale prefatum pro quavis ipsius necessitate vendatur ecclesie vel obligetur pignori aut quomodolibet distrahatur.' *Les Registres de Nicolas IV*, II, p. 959, no. 7101. In the same manner, the papal letter of Nicholas IV that accompanied the donation of an *aurifrisium* to San Francesco at Assisi on 7 August 1289 strictly prohibited any form of the textile's alienation. See *Bullarium Franciscanum*, IV, pp. 92-93, no. CXLVI.

46. A resolution of Ascoli Piceno's cathedral chapter dating from 27 July 1748, in which a '*ricupero*' (restitution) of Nicholas IV's cope to the sacristan was ordered, becomes particularly interesting in this context. A preceding resolution, dating from 28 December 1747, had demanded the acquisition of damask and wool as filling materials for the restoration of the cathedral's white copes, because of their precarious state of preservation. Even if the chapter did not approve the latter resolution, it seems possible that conservational interventions on the copes were conducted in the first half of 1748 and, as a consequence, the cope was not located in the cathedral's sacristy (Ascoli Piceno, Archivio Capitolare, *Libro delle Risoluzioni Capitolari dal anno 1730 infino al 1753*, no inventory number).

47. See *Libro dei paramenti da usarsi durante le funzioni, 1770*

(Pienza, Archivio del Capitolo della Cattedrale di Pienza, XI Registri diversi, 2).

48. Marcel Mauss, *Die Gabe: Form und Funktion des Austauschs in archaischen Gesellschaften*, trans. by Eva Moldenhauer (Frankfurt am Main: Suhrkamp, 1990). See also Karl-Heinz Kohl, *Die Macht der Dinge. Geschichte und Theorie sakraler Objekte* (Munich: Beck, 2003), pp. 133-34; Maurice Godelier, *Das Rätsel der Gabe. Geld, Geschenke, heilige Objekte* (Munich: Beck, 1999), pp. 20-153. Regarding the historic context in which Mauss developed his theory of gift-giving, see Beate Wagner-Hasel, 'Egoistic Exchange and Altruistic Gift: On the Roots of Marcel Mauss's Theory of the Gift', in *Negotiating the Gift: Pre-Modern Figurations of Exchange*, ed. by Gadi Algazi, Valentin Groebner, and Bernhard Jussen (Göttingen: Vandenhoeck & Ruprecht, 2003), pp. 141-71.

49. Mauss describes such a system of gift exchange using the example of the potlatsch of North American native tribes. See Mauss, *Die Gabe*, pp. 77-103. Regarding the agonistic exchange, see also Peter M. Blau, *Exchange and Power in Social Life* (New York: Wiley, 1964; repr. 1986) and Frank Adloff and Steffen Mau, 'Zur Theorie der Reziprozität', in *Vom Geben und Nehmen. Zur Soziologie der Reziprozität*, ed. by Frank Adloff and Steffen Mau (Frankfurt a. M./New York: Campus-Verlag, 2005), pp. 9-57 (pp. 27-29).

50. On the definition and the difference between foundation and donation see Peter Jezler, 'Jenseitsmodelle und Jenseitsvorsorge. Eine Einführung', in *Himmel Hölle Fegefeuer. Das Jenseits im Mittelalter*, ed. by Peter Jezler (Zurich: Verlag Neue Zürcher Zeitung, 1994), pp. 13-26 (pp. 22-26).

51. The model of the courtly gift (*höfische Gabe*), developed by Jan Hirschbiegel, describes a specific form of agonistic exchange in early modern court societies that aimed to establish relations of acknowledgement rather than strictly balanced material exchange; Jan Hirschbiegel, Étrennes. *Untersuchungen zum höfischen Geschenkverkehr im spätmittelalterlichen Frankreich der Zeit König Karls VI. (1380–1422)* (Munich: Oldenbourg, 2003). pp. 16-17, 127-31; on the 'höfische Gabe', see also Helmuth Berking, *Schenken. Zur Anthropologie des Gebens* (Frankfurt am Main/New York: Campus Verlag, 1996), pp. 185-206.

52. See Annette B. Weiner, *Inalienable Possessions. The Paradox of Keeping-While-Giving* (Berkeley/Los Angeles/Oxford: University of California Press, 1992). Mauss already conceptualized the distinction between alienable and inalienable goods. In fact, he distinguished between commodities and precious things (which he termed *sacra*); yet, he did not explicitly include this differentiation in his gift-exchange theory; see Mauss, *Die Gabe*, pp. 103-11.

53. Weiner, pp. 10-11, 40, 42.

54. Weiner, pp. 32-33, 51, 150.

55. Weiner, p. 33.

56. Burkart, *Das Blut der Märtyrer*, p. 68.

57. The throne of Emperor Frederic II of Hohenstaufen is an exemplary political trophy preserved in the papal treasury; see Paravicini Bagliani, *Bonifacio VIII*, pp. 85-86. The throne is described in the treasury's inventory from 1295; Molinier, 'Inventaire du trésor' (1882), pp. 632-34, nos 341-55. Other truly inalienable objects preserved within the papal treasury are those originating from the 'Treasury of Constantine'. They are explicitly mentioned in inventories of the papal treasure far into the fourteenth century; an inventory from 1371 even dedicates an entire paragraph to the 'Thesaurus Constantini'; see Burkart, *Das Blut der Märtyrer*, pp. 32-41, 101-03 and 108-09 (p. 37).

58. The heraldic animal motifs represent an appropriation of secular political iconography that might have originated from fabrics with animal motifs produced for the imperial court in Byzantium. Byzantine fabrics with animal motifs were well known at the papal court of the late thirteenth century. This is indicated by numerous entries in the papal inventory of 1295. In the sections labelled *Panni de Romania* and *Xamita*, fabrics with a Byzantine provenance (*de opere Romanie*) are mentioned. These are decorated with typical designs of heraldic animals encased by medallions: see Molinier, 'Inventaire du trésor' (1886), pp. 646-67 (pp. 647-48, nos 1181-95). A later entry refers to a dalmatic made out of a Byzantine cloth decorated with double eagles: 'Item, dalmaticam rubeam de panno imperiali de Romania ad aquilas magnas cum duobus capitibus sine ornamentis; [in] manicis tamen habet frixia anglicana antiqua et in spatulis de Venetiis.' Molinier, 'Inventaire du trésor' (1885), pp.16-44 (p. 30, no. 959). The phrase '*pannus imperialis de Romania*' shows not only that the Byzantine provenance of the fabric was well known, but also that its rank as a cloth exclusively reserved for the Byzantine emperor or court was consciously remembered.

59. Similar processes are described by Jennifer Kingsley, Pierre Alain Mariaux, and Philippe Buc, all of whom refer to treasury objects of the high Middle Ages originating from clerics' and laymen's donations, and discuss their contexts of use and reception; Jennifer Kingsley, 'The Bernward Gospels: Structuring Memoria in Eleventh-century Germany' (unpublished doctoral dissertation, John Hopkins University, 2007); Pierre Alain Mariaux, 'Der Schatz als Ort der Erinnerung. Anmerkungen zur Neuordnung der Kirchenschätze im 12. Jahrhundert', in *Vom Umgang mit Schätzen. Internationaler Kongress Krems an der Donau 28. bis 30. Oktober 2004*, ed. by Elisabeth Vavra, Kornelia Holzner-Tobisch, and Thomas Kühtreiber (Vienna: Verlag der Österreichischen Akademie der Wissenschaften, 2007), pp. 345-57; Philippe Buc, 'Conversion of Objects', *Viator*, 28 (1997), pp. 99-143.

60. The written enshrinement of treasures in texts had different functions and meanings, central to which is the production of memory, see Lucas Burkart, 'Das Verzeichnis als Schatz. Überlegungen zu einem Inventarium Thesauri Romane Ecclesie

der Biblioteca Apostolica Vaticana (Cod. Ottob. lat. 2516, fol. 126r–132r)', *Quellen und Forschungen aus italienischen Archiven und Bibliotheken*, 86 (2006), pp. 144-207 (pp. 145-46, 164-66); Jennifer Kingsley, 'Picturing the treasury: the power of objects and the art of memory in the Bernward Gospels', *Gesta*, 50 (2011), pp. 19-39. Regarding miniatures depicting medieval treasuries and their memorial function, see Kingsley, 'The Bernward Gospels', pp. 147-58.

61. 'Hec sunt paramenta que donauit Ecclesie Anagnine sanctissimus pater dominus Bonifatius papa Octauus, diuersis temporibus. [...] Hec sunt paramenta que misit idem dominus papa per magistros Jacobum de sancto germano et Matheum de Anagnia, canonicos Anagninis, tertio anno pontificatus sui, mense Maij, die prima. [...] Isti sunt panni donati ecclesie Anagnine ex quo dictus dominus papa cepit uenire Anagniam. [...] Hoc est Inuentarium argenti et auri laborati, Dati ecclesie Anagnine per predictum dominum papam.' Inventario Cattedrale di Anagni, pp. 518-24. The textiles and liturgical objects are in fact not ordered according to the manufacturing techniques pointing to their provenances. All of these are classification schemes that were applied in the contemporary inventories of the papal treasury.

62. This becomes clear thanks to an inventory collection from the period of 1576 to 1688 containing the moveable furnishings preserved in the sacristy of Anagni Cathedral. The surviving textiles from the donations of Boniface VIII continue to be named in the inventories that were written at regular intervals. During the first decades, they are described exclusively with reference to their materials and forms. After 1662, however, they are associated with their donors, such as Popes Boniface VIII and Innocent III. The first is credited with donating the white set of vestments of *opus anglicanum*, whereas the latter is introduced as the donor of the red set of vestments with gold embroidery on the cloth of weft-faced compound twill (*opus cyprense*): '[...] Un altro Pluviale rosso con Lavoro di figure a ricamo d'oro detto di Innocentio / Un altro Pluviale bianco pretioso detto di Bonifacio [...] Una Pianeta pretiosa rossa con figure, e ricamo d'oro con stola e manipulo con fregio di perle in mezzo detta d'Innocentio / Un altra Pianeta pretiosa bianca con figure simili al Pluviale e stola e manipulo detta di Bonifacio [...] Un Paio di Tonicelle rosse pretiose con stola e manipulo dette d'Innocentio simili al Pluviale e Pianeta / Un altro paio di Tonicelle bianche pretiose figurate con stola e manipulo dette di Bonifacio, simili al Pluviale e pianeta dette di sopra con loro Cassetta dove si conservano [...].' Inventory from 1 July 1688 (Anagni, Archivio Capitolare, Serie 4: Finanze e Patrimonio (1566–1962), 1. Inventari (1576–1688)).

63. Regarding the early Middle Ages, a textile donation by Pope Leo IV to Anagni Cathedral has been proven (see note 6). The 'Gesta Innocentii III' testify that Pope Innocent III bestowed Anagni Cathedral with textile gifts. According to this written source, Innocent III donated 'Ecclesiae Anagninae, unum catassamitum cum listis aureis, et unum bacile argenti.' Furthermore, he gave a *pallium deauratum* to an 'Ecclesia Sancta Maria de Anagnia'. *Patrologia Latina Database*, CCXIV, item

no. CCIX A; see also Sibilia, *Guida cattedrale Anagni*, p. 148. It remains unclear to which church the latter passage refers; it might be the monastery Santa Maria della Gloria near Anagni (see note 9). Consequently, the later attributions of textiles originating from Boniface VIII's donations to Innocent III have a historical basis.

64. See Gioacchino Giammaria, 'La presenza in Anagni del papato itinerante', in *Itineranza pontificia: la mobilità della curia papale nel Lazio (secoli XII–XIII)*, ed. by Sandro Carocci (Rome: Istituto Storico Italiano per il Medio Evo, 2003), pp. 279-305 (pp. 286-305); Salvatore Sibilia, *La città dei papi. Storia di Anagni dagli Ernici a Mussolini* (Rome: Palombi, 1939), pp. 130-97; Zappasodi, I, pp. 201-452.

65. The Anagninian bishop Antonio Seneca (1607–26) cultivated contacts with important personalities of the Catholic Reform in Rome; see Zappasodi, II, pp. 145-67. Historical interest and awareness increased within the circles of Anagninian clerics at the beginning of the eighteenth century, which is when the first works of Anagninian historiography were created; see Gioacchino Giammaria, 'Gli archivi ecclesiastici di Anagni: il capitolare e lo storico diocesano', in *La memoria silenziosa. Formazione, tutela e status giuridico degli archive monastici nei monumenti nazionali* (Rome: Ministero per i beni e le attività culturali, Ufficio Centrale per i beni archivistici, 2000), pp. 270-93 (p. 274); Sibilia, *La città dei papi*, pp. 308-10.

66. An entry from 1595 in an inventory containing the moveable furniture of Ascoli Piceno Cathedral states: '[...] Vn Piviale [...] tutto figurato, et racamato di perle, donato alla chiesa da papa Nicola d'Ascoli [...]'; Fascicolo di libri d'Inventarij spettanti alla Cattedrale. I. Inventarium (Ascoli Piceno, Archivio Capitolare, I 18, fol. 10). A guide to the same town as late as 1805 mentions between the '[...] [d]oni che Ascoli conserva in memoria di questo suo cittadino Pontefice [Nicholas IV]' the cope donated by Nicholas; see Luigi Pastori, Le Patrie Memorie e del Medio, e dell'Infimo Evo appartenenti alla storia civile della città di Ascoli, 1805, fol. 63 (Ascoli Piceno, Biblioteca Comunale, A II 12, Ms. Pastori 1). Inventories of Pienza Cathedral use similar language. An inventory of 1729 describes '[...] Un piviale antico con arme di Pio II raccamato con perle e diverse figure del Nuovo e Vecchio Testamento [...] di fila d'oro con piccole perle le quali per l'antichità son tutte cadute, donato dalla S.M. di Pio II. [...].' Inventario di tutti l'argenti, sacre suppellettili, utensili et ogn'altro esistenti nella chiesa et sacrestia della Cattedrale di Pienza 1729 (Pienza, Archivio Diocesano di Pienza, Inventari ordinati per vicariato, 998: Inventari di luoghi pii della città e diocesi, fol. 62v–77r). Extracts are edited by Bari, pp. 132-34 (p. 132). An entry in a further inventory of 1784 says that the cope is preserved 'in memoria di detto Sommo Pontefice [Pius II]' in the treasury of Pienza Cathedral; Inventario di tutti gli arredi sacri, mobili, legnami, materiali etc spettanti all'Opera della Cattedrale di Pienza, fatto in esecuzione del benigno rescritto di S.A.R. del 20 ottobre 1784 (Pienza, Archivio dell'Opera della Cattedrale di Pienza, Inventari di mobili, arredi e oggetti d'arte, 597, fol. 56v–57r).

67. It seems that the coat of arms has been used for papal representation since the pontificate of Urban IV (1261-64). However, it is not before Boniface VIII that a systematic use of such devices can be seen in either sculpture or painting; see Donald Lindsay Galbreath, *Papal Heraldry. A treatise on ecclesiastical heraldry* (London: Heraldry Today, 1972, 2nd ed. rev. by Geoffrey Briggs), pp. 38-44; B. Heim, 'Heraldik, III. Kirchliche Heraldik', in *Lexikon des Mittelalters*, IV (1989), p. 2145.

68. See Molinier, 'Inventaire du trésor' (1886), pp. 649-50, nos 1216, 1217; 'Inventarium thesauri ecclesiae Romanae (1311)', pp. 422, 430, 433-41.

69. A fragment of such a silk fabric combining the coat of arms with the papal tiara is in the Museo Diocesano of Osimo (no inventory number).

70. Burkart, 'Das Verzeichnis als Schatz', pp. 149-50.

71. Inventario Cattedrale Anagni, pp. 518-24, nos 6, 20, 55, 59, 89.

72. This is the case on a situla and a crozier donated by Pius II to Pienza. The inscription on the situla reads 'PIUS PAPA II SENENSIS A.D.MCCCCLXII'. The crozier is inscribed by the following words: 'ECCLESIAE PIENTINAE PIUS SECUNDUS PON/TIFEX/ MAXIMA PROPRIA IMPENSA FIER/I/ FECIT'; *Museo Diocesano di Pienza*, ed. by Laura Martini (Siena: Protagon Editori Toscani 1998), pp. 70-71, 74.

73. The enamels, produced in a Florentine workshop around 1462, come from a papal miter that was bestowed to Pienza by Pius. During the eighteenth century, they were removed and applied to a new miter that was again reworked in 1825; *Museo Diocesano di Pienza*, pp. 75, 88; Bari, pp. 30-34.

74. Inventario ecclesiae chatedralis Pientia 1550 (Pienza, Archivio Diocesano di Pienza, Inventari ordinati per vicariato, 998: Inventari di luoghi pii della città e diocesi, fols 1r–17r); Inventario di tutti l'argenti 1729 (Pienza, Archivio Diocesano di Pienza). Extracts are edited by Bari, pp. 128-34 (pp. 130, 132).

75. Bari, p. 36. The fabric with the embroidered coat of arms might have derived from other textiles donated by Pius II to Pienza that were truncated in the course of reworking and conservation.

76. Bari, pp. 57, 60; *Museo Diocesano di Pienza*, pp. 76-77, 87-88.

Notes to Chapter 6

* This essay presents the main aspects of my argument on this cloth in relation to my current research project on the textiles of the Praemonstratensian nunnery of Altenberg/Lahn from the thirteenth and fourteenth centuries as part of the church furnishings; see Stefanie Seeberg, *Textile Bildwerke im Kirchenraum, Leinen-stickereien im Kontext mittelalterlicher Raumausstattungen aus dem Prämonstratenserinnenkloster* (Altenberg/Lahn, Petersberg: Michael Imhof Verlag, 2014).

1. Renate Kroos, 'Grabbräuche–Grabbilder', in *Memoria, Der geschichtliche Zeugniswert*, ed. by Karl Schmid and Joachim Wollasch (Münster: Fink, 1984), pp. 285–353 (pp. 299–304); Paul Binski, *Medieval Death, Ritual and Representation* (London: British Museum Press, 1996), p. 190.

2. For several examples of written sources, see Kroos, 'Grabbräuche', pp. 313–16.

3. Kroos, 'Grabbräuche', pp. 299–303 and pp. 311–13. A tomb cloth can be laid on the tomb and a catafalque cover is a textile especially made to cover the catafalque, a wooden structure that either supports the tomb or coffin or stands in place of it.

4. A few more recent examples of the seventeenth century can be found in Imke Lüders, *Der Tod auf Samt und Seide, Todesdarstellungen auf liturgischen Textilien des 16. bis 19. Jahrhunderts im deutschsprachigen Raum* (Kassel: Arbeitsgemeinschaft Friedhof und Denkmal e.V., 2009).

5. Joseph Braun, 'Bahrtuch', in *Reallexikon zur Deutschen Kunstgeschichte*, ed. by Otto Schmitt et al., 10 vols (Stuttgart: Druckenmüller 1937), I, col. 1384; Leonie von Wilckens, 'Bahre, Bahrtuch', in *Lexikon des Mittelalters*, 9 vols (Munich: Artemis, 1980), I, col. 1349–50.

6. Frankfurt am Main, Museum für Angewandte Kunst, inv. no. 5869; Leonie von Wilckens, 'Hessische Leinenstickereien des 13. und 14. Jahrhunderts' in *Anzeiger des Germanischen Nationalmuseums*, 1954–1959 (Nürnberg 1960), pp. 5–20 (pp. 9–10); Leonie von Wilckens, 'Zwei hessische Leinenstickereien der zweiten Hälfte des 13. Jahrhunderts' in *Festschrift für Peter Wilhelm Meister zum 65. Geburtstag am 16. Mai 1974*, ed. by Anneliese Ohm and Horst Reber (Hamburg: Hauswedell, 1975), pp. 121–24.

7. Joseph Aldenkirchen, 'Frühmittelalterliche Leinen-Stickereien', *Jahrbücher des Vereins von Alterthumsfreunden in den Rheinlanden*, 79 (1885), pp. 256–272, (p. 270); Wilckens, 'Zwei hessische Leinenstickereien', p. 123; Leonie von Wilckens, *Die textilen Künste von der Spätantike bis um 1500* (Munich: Beck, 1991), p. 200.

8. For more details see Seeberg, *Textile Bildwerke*, Chapter III. C.

9. On color in medieval linen embroidery see Birgitt Borkopp-Restle and Stefanie Seeberg, 'Farbe und Farbwirkung in der Bildstickerei des Hoch- und Spätmittelalters', in *Farbe im Mittelalter, Materialität – Medialität – Semantik*, ed. by Ingrid Bennewitz and Andrea Schindler, 2 vols (Berlin: Akademie Verlag, 2011), I, pp. 189–211.

10. The examination of the cloth, which I conducted in 2006 together with Andrea Schwarz, a conservator at the Museum für Angewandten Kunst in Frankfurt, clearly indicated that there are no figures missing.

11. Wilckens, 'Zwei hessische Leinenstickereien', pp. 123–24.

12. Elke Brüggen, *Kleidung und Mode in der höfischen Epik des 12. und 13. Jahrhunderts* (Heidelberg: Carl Winter, 1989), pp. 81–86, 100.

13. Aldenkirchen pointed out that it was common during the Middle Ages to show still-living princely persons with halos; Aldenkirchen, p. 270.

14. Wilckens, 'Bahre, Bahrtuch', p. 10; Wilckens, 'Zwei hessische Leinenstickereien', p. 123; and Wilckens, *Die textilen Künste*, p. 200.

15. Aldenkirchen, p. 270; Wilckens, 'Zwei hessische Leinenstickereien', p. 123; Wilckens, *Die textilen Künste*, p. 200.

16. Gertrud had been *magistra* of the female convent of Altenberg, although Altenberg depended on the monastery of Rommersdorf and was subordinate to its abbot. On the dating of the embroidery, see Aldenkirchen, p. 269; Wilckens suggests in her first essay that the cloth was made in the fourteenth century; Wilckens, 'Hessische Leinenstickereien', p. 9; whereas later, in 1975, Wilckens claimed that it was produced in the second half of the thirteenth century, Wilckens, 'Zwei hessische Leinenstickereien', p. 124.

17. Museum für Angewandte Kunst, Frankfurt, register no. 5869.

18. Aldenkirchen (p. 270) gives no references where the cloth is called a 'Leichentuch'.

19. Paula Väth believed that Gertrud made the drawings herself, see Paula Vätha, 'Die selige Gertrud von Altenberg und das Skriptorium im Kloster der Prämonstratenserinnen', in *Scrinium Berolinense, Tilo Brandis zum 65. Geburtstag*, ed. by Peter Jörg Becher et al. (Wiesbaden: Reichert, 2000), pp. 74–84. ; Seeberg, *Textile Bildwerke*, Chapter I. B., Chapter III. A.

20. Stefanie Seeberg, 'Leinenstickerei mit Szenen aus dem Leben der Heiligen Elisabeth', in *Elisabeth von Thüringen, Eine Europäische Heilige*, ed. by Dieter Blume and Matthias Werner (Petersberg: Imhof, 2007), p. 272 ; Seeberg, *Textile Bildwerke*, Chapter III. B.

21. On these embroideries see Seeberg, *Textile Bildwerke*; Stefanie Seeberg, 'Women as Makers of Church Decoration: Illustrated Textiles at the Monasteries of Altenberg/Lahn, Rupertsberg an Heiningen (13th–14th c.)', in *The Role of Women as 'Makers' of Art and Architecture in the Middles Ages*, ed. by Therese Martin (Leiden: Brill, 2012), pp. 355–391; Seeberg, *Textile Bildwerke*, Chapter IV.

22. Dicta quatuor Ancillarum (January 1235), no. 39; *The Life and Afterlife of St. Elizabeth of Hungary: Testimony from Her Canonization Hearings,* trans. and ed. by Kenneth Baxter Wolf (Oxford: Oxford University Press, 2010), pp. 207–08.

23. Christian Schuffels,'"Beata Gertrudis, Filia Sancte Elyzabet", Gertrud, die Tochter der heiligen Elisabeth, und das Prämonstratenserinnenstift Altenberg an der Lahn', ed. by Blume and Werner, pp. 229–44; Seeberg, *Textile Bildwerke*, Chapter I. B.

24. Elizabeth, princess of Hungary, was married to Ludwig IV, landgrave of Thuringia. For more on Saint Elizabeth, see *Elisabeth von Thüringen, Eine Europäische Heilige*, ed. by Blume and Werner; Wolf, *The Life and Afterlife of St. Elizabeth*. On Altenberg and Gertrud von Thüringen, see Schuffels, 'Beata Gertrudis', p. 229.

25. Dieter Grossmann, 'Der Dreikonchenchor der Elisabethkirche zu Marburg', in *Katalog Sankt Elisabeth Fürstin, Dienerin, Heilige. Aufsätze Dokumentation, Katalog, Ausstellung zum 750. Todestag der hl. Elisabeth* (Sigmaringen: Thorbecke 1981), pp. 494–97. Andreas Köstler, *Die Ausstattung der Marburger Elisabethkirche: Zur Ästhetisierung des Kultraums im Mittelalter* (Berlin: Reimer, 1995). On the shrine of Saint Elisabeth see Viola Belghaus, *Der erzählte Körper, Die Inszenierung der Reliquien Karls des Großen und Elisabeths von Thüringen* (Berlin: Reimer, 2005), pp. 121–214.

26. Joan Holladay, 'The Tombs of the Hessian Landgraves in the Church of St. Elizabeth at Marburg' (unpublished doctoral dissertation, Brown University, 1982).

27. In the Praemonstratensian order, female convents were affiliated with a monastery. The *magistra* was the head of the convent, but subordinate to an abbot of the motherhouse. On the architecture of Altenberg see Schuffels, 'Beata Gertrudis', pp. 231–35 (with further bibliography); for more details, see Seeberg, *Textile Bildwerke*, Chapter III. A.

28. On Heinrich II see 'Heinrich Neu, Heinrich II, Herzog von Brabant', in *Neue Deutsche Biographie*, 24 vols (Berlin: 1969), VIII, p. 348.

29. Karl E. Demandt, *Geschichte des Landes Hessen*, 2nd ed. (Kassel: Bärenreiter-Verlag, 1972), pp. 179–180.

30. On Sophia von Thüringen, see Werner Goez, *Gestalten des Hochmittelalters, Personengeschichtliche Essays im allgemeinhistorischen Kontext* (Darmstadt: Wiss. Buchgesellschaft 1983), pp. 378–79; Ulrich Hussong, 'Sophie (Sophia) von Brabant', in *Neue Deutsche Biographie*, 28 volumes (Berlin: Duncker & Humblot, 2010), XXIV, pp. 586–88; on Gertrud, see Thomas Doepner, *Das Prämonstratenserinnenkloster Altenberg im Hoch- und Spätmittelalter, Sozial- und Frömmigkeitsgeschichtliche Untersuchung* (Marburg: Elwert, 1999), pp. 56–60. Schuffels, 'Beata Gertrudis', pp. 229–44.

31. For Gertrud, see Christian Schuffels, 'Gertrud, Tochter der Heiligen Elisabeth', ed. by Blume and Werner, pp. 246–47. Jean de Joinville mentions in his 'Vie de Saint Louis' (1305–09) that Blanche of Castile kissed the boy Herman on his forehead, because this was where his mother had kissed him often; Jean de Joinville and Jacques Monfrin, *Vie de Saint Louis* (Paris: DUNOD, 1995), p. 96.

32. For Sophia, see Mathias Kälble, 'Reitersiegel der Herzogin Sophie von Brabant', ed. by Blume and Werner, cat. no. 179. For Gertrud, see Thomas Doepner, 'Das älteste erhaltene Selbstzeugnis der Magistra Gertrud', ed. by Blume and Werner, cat. no. 164, p. 252.

33. For example in 1270, a court of law was held by the landgraves of Hessen in Altenberg; Doepner, *Das Prämonstratenserinnenkloster Altenberg,* pp. 22–23.

34. Doepner, *Das Prämonstratenserinnenkloster Altenberg,* p. 55.

35. For more about the reliquary, see Stefanie Seeberg, 'Armreliquiar der heiligen Elisabeth', ed. by Blume and Werner, pp. 247–49.

36. The most influential family had been the earls of Nassau; Doepner, *Das Prämonstratenserinnenkloster Altenberg,* pp. 184–90.

37. On the regulations of the buildings of the monastery, see Seeberg, *Textile Bildwerke,* Chapter II.

38. Thomas Doepner, 'Verfügung über Geldzahlung aus Gertruds Anteil an dem ludowingischen Erbe' ed. by Blume and Werner, pp. 252–253; Jürgen Petersohn, 'Die Ludowinger. Selbstverständnis und Memoria eines hochmittelalterlichen Reichsfürstengeschlechts', *Blätter für deutsche Landesgeschichte,* 129 (1993), pp. 30–39.

39. '*anniversariu der langrafen zu hessen so S. Gertrud hat gestiftet*', instructions for the sexton, copied by prior Petrus Diederich in Antiquitates Aldenbergensis (1653, 1656–59), Schloss Braunfels, Fürst zu Solms-Braunfels'sches Archiv, Altenberger Akten, Abt. 1 no. 14, 406.

40. On these aspects compare, for example, the investigations on the monastery of Doberan by Annegret Laabs, *Malerei und Plastik im Zisterzienserorden, Zum Bildgebrauch zwischen sakralem Zeremoniell und Stiftermemoria 1250–1430* (Petersberg: Imhof, 2000); Tanja Michalsky, *Memoria und Repräsentation, Die Grabmäler des Königshauses Anjou in Italien* (Göttingen: Vandenhoeck & Ruprecht, 2000).

41. On the most important patrons of Altenberg at this time see Doepner, *Das Prämonstratenserinnenkloster Altenberg,* pp. 182–93.

42. On the stained glass see Daniel Parello, *Die mittelalterlichen*

Glasmalereien in Marburg und Nordhessen (Berlin: Deutsche Verlag für Kunstwissenschaft, 2008), pp. 71–91.

43. The descriptions by Diederich are cited in Parello, p. 515.

44. Parello, p. 79, fig. 14, p. 515.

45. Prominent examples are the papal donations with an impressive number of textiles, documented in the *Liber Pontificalis*; see Marielle Martiani-Reber, 'Tentures et textiles des eglises romaines au haut moyen age d'apres le liber pontificalis', *Melanges de l'École Francaise de Rome, Moyen Age,* 111/1 (1999), pp. 289–305. On textiles as part of papal donations see also the article by Christiane Elster in this volume.

46. The lace is today located in the Germanisches Nationalmuseum Nürnberg, inv. no. T 1214; Regula Schorta, 'Band mit gestickter Inschrift' ed. by Blume and Werner, no. 169, pp. 259–60; the embroidery with scenes of Saint Elizabeth is in Saint Petersburg, Hermitage, inv. no. T–3728; Seeberg, 'Leinenstickerei', pp. 269–72.

47. Seeberg, *Textile Bildwerke,* Chapter III; Seeberg, 'Women as Makers'.

48. Lateinische Textstelle mit Übersetzung: Thomas Doepner, 'Verfügung über Geldzahlungen aus Gertruds Anteil an dem Ludowingischen Erbe', no. 165, p. 253.

49. Caroline Horch, *Der Memorialgedanke und das Spektrum seiner Funktionen in der Bildenden Kunst des Mittelalters* (Königstein im Taunus: Langewiesche, 2001), p. 26. On the liturgical *memoria* in monasteries in the thirteenth and fourteenth centuries, see Laabs, pp. 142–47; Brigitte Kurmann-Schwarz, *Die mittelalterlichen Glasmalereien der ehemaligen Klosterkirche Königsfelden* (Bern: Stämpfli, 2008), pp. 36–37.

50. Kroos, 'Grabbräuche', p. 318; Laabs, pp. 144–47.

51. The sixteenth-century sexton's instructions in Altenberg for the memorial day of Gertrud lists only candles. Diederich, Antiquitates, p. 266. On the tombs of the landgraves in Rheinhardsbrunn, Eisenach and Marburg amongst others, see Ernst Schubert, 'Drei Grabmäler des Thüringer Landgrafenhauses aus dem Kloster Rheinhardsbrunn', in *Dies dicem docet: ausgewählte Aufsätze zur mittelalterlichen Kunst und Geschichte in Mitteldeutschland, Festgabe zum 75. Geburtstag,* ed. by Ernst Schubert and Hans-Joachim Krause (Cologne: Böhlau, 2003), pp. 266–89; and Holladay.

52. On the form of tombs in the thirteenth century, see Anne McGee Morganstern, *Gothic Tombs of Kinship in France, the Low Countries and England* (University Park: Pennsylvania State University Press, 2000).

53. Johann Georg von Hohenzollern, *Die Königsgalerie der*

französischen Kathedrale. Herkunft, Bedeutung, Nachfolge (Munich: Fink, 1965); Wolfgang Schenkeluhn, 'Monumentale Repräsentation des Königtums in Frankreich und Deutschland', in *Krönungen. Könige in Aachen, Geschichte und Mythos,* ed. by Mario Kramp (Mainz: von Zabern, 2000), pp. 369–78.

54. Ursula Nilgen, 'Amtsgenealogie und Amtsheiligkeit: Königs- und Bischofsreihen in der Kunstpropaganda des Hochmittelalters', in *Studien zur mittelalterlichen Kunst 800–1250, Festschrift für Florentine Mütherich zum 70. Geburtstag,* ed. by Katharina Bierbrauer, Peter K. Klein and Willibald Sauerländer (Munich: Prestel, 1985), pp. 217–34; Ursula Nilgen, 'Herrscherbild und Herrschergenealogie in der Stauferzeit', in *Krönungen. Könige in Aachen, Geschichte und Mythos,* ed. by Mario Kramp (Mainz: von Zabern, 2000), pp. 357–67.

55. Nilgen, 'Herrscherbild', pp. 361–62.

56. Morganstern, *Gothic Tombs.*

57. The tomb also provided a space for Sophia (d. 1275); Morganstern, *Gothic Tombs,* pp. 29–31, figs 12, 13; Thomas Coomans, *L'abbaye de Villers-en-Brabant. Construction, configuration et signification d'une abbaye cistercienne gothique* (Brussels: Editions Racine, 2000), pp. 256–57; Hadrien Kockerols, *Les gisants du Brabant Wallon* (Namur: Les Éditions Namuroises, 2010), p. 43.

58. Brussels, Bibliothèque royale de Belgique, ms. 22483C, fols 60v–61r, reproduced in Coomans, p. 256.

59. On the opposite end were three standing figures under an arcade, see Morganstern, *Gothic Tombs,* p. 29.

60. Gerhard Lutz, 'Repräsentation und Affekt. Skulptur von 1250 bis 1430', in *Geschichte der bildenden Kunst in Deutschland,* ed. by Bruno Klein and Thorsten Albrecht, 8 vols (Munich: Prestel, 2007), III, pp. 360–61, no. 104; Ulrike Bergmann, *Das Chorgestühl des Kölner Doms,* 2 vols (Neuss: Neusser Druckerei, 1987), I, pp. 142–58 and II, pp. 137–41, figs 84–92; and Holladay.

61. Kurt Bauch, *Das mittelalterliche Grabbild: figürliche Grabmäler des 11. bis 15. Jahrhunderts in Europa* (Berlin: de Gruyter, 1976), pp. 106–11.

62. Willibald Sauerländer and Max Hirmer, *Gotische Skulptur in Frankreich, 1140–1270* (Munich: Hirmer, 1999) p. 273; Alain Erlande-Brandenburg, *Le roi est mort, étude sur les funerailles les sépultures et les tombeaux des rois de France jusqu'à la fin du XIIIe siècle* (Geneva: Droz, 1975), p. 106; Stephan Albrecht, *Die Inszenierung der Vergangenheit im Mittelalter, Die Klöster von Glastonbury und Saint-Denis* (Munich/Berlin: Deutscher Kunstverlag, 2003), pp. 204–21; Lutz, 'Repräsentation und Affekt', p. 343.

63. *Karl IV.—Kaiser von Gottes Gnaden: Kunst und Repräsentation des Hauses Luxemburg 1310–1437,* ed. by Jiří Fajt (Munich:

Deutscher Kunstverlag, 2006), p. 47, fig. II.8.

64. On the importance of being a member of the family of the saint, see Doepner, *Das Prämonstratenserinnenkloster Altenberg,* p. 57; Uwe Geese, *Reliquienverehrung und Herrschaftsvermittlung. Die mediale Beschaffenheit der Reliquien im frühen Elisabethkult* (Darmstadt: Hessische Historische Kommission, 1984), pp. 155–56.

65. Stuttgart, Württembergische Landesbibliothek, ms. HB II 24, fols 174v, 175v, 176; Petersohn, p. 24; Volkhard Huth, 'Bildliche Darstellungen von Adeligen in liturgischen und historiographischen Handschriften des hohen Mittelalters', in *Nobilitas, Funktion und Repräsentation des Adels in Alteuropa,* ed. by Otto Gerhard Oexele and Werner Paravicini (Göttingen: Vandenhoeck & Ruprecht, 1997), pp. 101–176 (pp. 126, 158–59).

66. Petersohn, pp. 1–39; Harald Wolter von dem Knesebeck, *Der Elisabethpsalter in Cividale del Friuli. Buchmalerei für den Thüringer Landgrafenhof zu Beginn des 13. Jahrhunderts* (Berlin: Deutsche Verlag für Kunstwissenschaft, 2001), p. 349; Wolter von dem Knesebeck, 'Der Landgrafenpsalter', ed. by Blume and Werner, no. 22, pp. 70–71.

67. See Belghaus, p. 133.

68. On the Altenberg altarpiece, see Stephan Kemperdick, 'Flügel des Altenberger Altares', in *Deutsche Gemälde im Städel 1300–1500,* ed. by Stephan Kemperdick and Bodo Brinkmann (Mainz: Zabern, 2002), pp. 3–32. On the tomb of Gertrud in Altenberg, see Schuffels, 'Gertrud Beatis', p. 246–47.

69. See fn. 33.

70. Matthias Kälble, '"Elisabethsiegel" der Herzogin Sophie von Brabant', cat. no. 180, p. 283.

71. Bern, Bernisches Historisches Museum, inv. no. 301; Dieter Blume, 'Hausaltar des Königs Andreas III. von Ungarn', ed. by Blume and Werner, cat. no. 205, pp. 308–12.

72. Edmund Earl of Lancaster (d. 1296) in Westminster Abbey, London; Morganstern, *Gothic Tombs,* pp. 70–71, figs 35, 36.

73. Kestner Museum, Hannover, WM XXII, 18; Ruth Grönwoldt, *Textilien I, Webereien und Stickereien des Mittelalters, Bildkataloge des Kestner-Museums Hannover VII* (Hannover: Kestner Museum, 1964), no. 55, pp. 79–83; Tanja Kohwagner-Nikolai, *'per manus sororum...' Niedersächsische Bildstickereien im Klosterstich (1300–1583),* (Munich: Meidenbauer, 2006), no. 26.

74. Kroos, 'Grabbräuche', p. 314.

75. Kroos, 'Grabbräuche', p. 313.

76. Wilckens, 'Zwei hessische Leinenstickereien', p. 123.

77. Wilckens, 'Zwei hessische Leinenstickereien', p. 123.

78. For examples on tombs in Lübeck and Schwerin, see Bauch, p. 294.

79. Kroos, 'Grabbräuche', pp. 299–304.

80. The length of Gertrud's tomb in Altenberg is 216 centimeters (Schuffels, 'Beata Gertrudis', p. 243, note 54).

81. Schwarz, 'Chichele's Two Bodies', in Viktor Schwarz, *Visuelle Medien im christlichen Kult: Fallstudien aus dem 13. bis 16. Jahrhundert* (Vienna: Böhlau, 2002), pp. 131–171 (pp. 158–59).

82. Jürgen Bärsch, *Allerseelen: Studien zu Liturgie und Brauchtum eines Totengedenktages in der abendländischen Kirche* (Münster: Aschendorff, 2004); Kroos, 'Grabbräuche', p. 318.

83. C. Graepler, 'Schutzgehäuse für den Elisabeth-Schrein', in *Katalog Sankt Elisabeth Fürstin, Dienerin, Heilige. Aufsätze Dokumentation, Katalog, Ausstellung zum 750. Todestag der hl. Elisabeth* (Sigmaringen: Thorbecke, 1981), no. 165; Köstler, p. 28.

84. Diederich, Antiquitates, p. 82.

85. On the role of visual objects for commemoration of the deceased, see Horch, p. 257; Anne McGee Morganstern, 'The Tomb as Prompter for the Chantry: Four Examples from Late Medieval England', in *Memory and the Medieval Tomb*, ed. by Elizabeth Valdez del Alamo (Aldershot, England/Brookfield, VT: Ashgate, 2000), pp. 81–97.

86. Doepner, *Das Prämonstratenserinnenkloster Altenberg,* p. 193, fn. 211.

87. On the correspondence between the textile and the monumental paintings in the gallery in Altenberg, see Seeberg, *Textile Bildwerke*, Chapter III. C.

88. Braun, 'Bahrtuch', col. 1382–83.

89. Kroos, 'Grabbräuche', p. 300.

90. For examples, see the illuminations shown in *Himmel Hölle Fegefeuer, das Jenseits im Mittelalter*, ed. by Peter Jezler (Munich: Wilhelm Fink Verlag, 1994), p. 65, fig. 39, p. 275, no. 84; *Death and Dying in the Middle Ages*, ed. by Edelgard E. DuBruck and Barbara I. Gusick (New York: Peter Lang, 1999), figs 12–18.

91. Witcham, *c.* 1278; see Kroos, 'Grabbräuche', p. 301.

92. Josef Sauer, *Symbolik des Kirchengebäudes und seiner Ausstattung in der Auffassung des Mittelalters*, (Freiburg im Breisgau: Herder, 1924), pp.167–69; Kirstin Faupel-Drevs, *Vom rechten Gebrauch der Bilder im liturgischen Raum, Mittelalterliche Funktionsbestimmungen bildender Kunst im 'Rationale divinorum*

officiorum' des Durandus von Mende (1230/1–1296) (Leiden: Brill, 2000), pp. 326–28.

93. The cloth is preserved today in two parts in the collections of the Schnütgen-Museum in Cologne (inv. no. 39) and at the Deutsches Textilmuseum, Krefeld; see Gudrun Sporbeck and Gottfried Stracke, 'Die liturgischen Gewänder im Mittelalter, Paramente und Reliquienkult nach Ausweis Kölner Grabornate und Textilien des 11. Jahrhunderts', in *Kunst und Liturgie im Mittelalter, Akten des internationalen Kongresses der Bibliotheca Hertziana und des Nederlands Instituut te Rome Rom, 28.–30. September 1997,* ed. by Nikolas Bock (Munich: Hirmer 2000), pp. 191–203 (p. 196, fig. 4).

94. Sporbeck and Stracke, p. 196.

95. *Sepulcrum imperatoris aperietur et tapecibus adornetur* (Stadtarchiv Hildesheim, Bestand 52, Nr. 350); Wolfgang Beckermann, *Das Grabmal Kaiser Heinrich III. in Goslar* (Göttingen: Edition Ruprecht1998), pp. 65–70; more details are in Seeberg, *Textile Bildwerke*, Chapter III. C.

96. For linen and white-on-white embroidery or *opus teutonicum*, see Margarete Wagner, *Sakrale Weissstickereien des Mittelalters* (Esslingen: Schneider 1963); Renate Kroos, *Niedersächsische Bildstickerei des Mittelalters* (Berlin: Deutscher Verlag für Kunstwissenschaft, 1970); Peter Barnet, 'Opus Teutonicum, A Medieval Westphalian Lectern Cover', *Hali: Carpet, Textile and Islamic Art*, 79 (1995), pp. 98–100; Borkopp-Restle and Seeberg, pp. 195–206.

97. Braunschweig, Herzog Anton Ulrich Museum, inv. no. MA 54; Renate Kroos designates it as an altar cloth and mentions, in addition, the possibility that it might have been a lectern cover; Kroos, *Niedersächsische Bildstickerei*, p. 116, no. 7.

98. Identification of the coats of arms by Kroos, *Niedersächsische Bildstickerei*, p. 116.

99. The cover was found 1836 in the Paramentenschrank of the church of Saint Martin in Braunschweig, see Kroos, *Niedersächsische Bildstickerei,* p.116, no. 7.

100. The size of the embroideries range from 280–360 by 75–152 centimeters, see Leonie von Wilckens, 'Unbekannte Buchmalerei und Leinenstickerei des 14. Jahrhunderts im Umkreis von Lübeck', *Niederdeutsche Beiträge zur Kunstgeschichte*, 15 (1976), pp. 71–98.

101. Wilckens, 'Unbekannte Buchmalerei', p. 91.

102. For the documentation of the conservation on this cloth, see Runhild Dewenter, 'Restaurierung eines Katafalk-Überwurfes, Ein Arbeitsbericht', *Restauro* 94 (1988), pp. 108–12.

103. Turin, Museo Civico d'Arte Antica e Palazzo Madama, Hs. inv. no. 47, fol. 116r.

104. On the cloth in Preetz (115 x 330 cm), see Wilckens, 'Unbekannte Buchmalerei', p. 91, figs 36, 37.

105. Ulrich Söding, 'a modo di sepultura', in *Original – Kopie – Zitat, Kunstwerke des Mittelalters und der Frühen Neuzeit: Wege der Aneignung – Formen der Überlieferung*, ed. by Wolfgang Augustyn and Ulrich Söding (Passau: Dietmar Klinger Verlag, 2010), pp.151–184 (pp. 157, 173, 179).

106. In the depositions taken before the papal commission in 1235 from her four closest companions, see 'Dicta quatuor ancillarum', in *The Life and Afterlife of St. Elizabeth of Hungary: Testimony from her Canonization Hearings*, trans. by Kenneth Baxter Wolf, (New York/Oxford: Oxford University Press, 2011), pp. 207–208; Renate Kroos, 'Zu frühen Schrift- und Bildzeugnissen über die heilige Elisabeth als Quellen zur Kunst- und Kulturgeschichte', in *Katalog Sankt Elisabeth Fürstin, Dienerin, Heilige. Aufsätze Dokumentation, Katalog, Ausstellung zum 750. Todestag der hl. Elisabeth* (Sigmaringen: Thorbecke 1981), pp. 181–239 (p. 191).

107. 'religionem in eis commendent et exhibeant que fecerunt', cited in *Urkundenbuch des Hochstifts Hildesheim und seiner Bischöfe*, ed. by H. Hoogeweg, 6 vols (Hannover/Leipzig: Hahn, 1901), II, p. 290, no. 583; Kroos, *Niedersächsische Bildstickerei*, p. 160, no. 12.; Falk Eiserman, *Die Inschriften auf den Textilien des Augustiner-Chorfrauenstifts Heiningen* (Göttingen: Vandenhoeck & Ruprecht, 1996), p. 236.

108. Bergmann, I, p. 142–43; Kroos, 'Grabbräuche', p. 297; On women and *memoria* of the families in the Middle Ages, see G. Althoff, *Adels- und Königsfamilien im Spiegel ihrer Memorialüberlieferung. Studien zum Totengedenken der Billunger und Ottonen* (Munich: Fink, 1984), pp. 163–66; Brigitte Kurmann-Schwarz, 'Gender and Art, in: A Companion to Medieval Art' in *Romanesque and Gothic in Northern Europe*, ed. by Conrad Rudolph (Oxford: Blackwell, 2006), pp. 128–50.

Notes to Chapter 7

* Warm thanks due to Margaret Goehring and Kate Dimitrova for revising my paper at different stages, as well as for all their fruitful comments. I also thank Julia Pauli and Markus Späth for their part in revising my paper. In addition, I would like to thank Beatrice Gruendler for deciphering the Arabic inscriptions on the textiles.

1. Since not all the successive kings of Castile were buried at Las Huelgas, it remained a family rather than a dynastic burial site. Nevertheless, the enduring importance of Las Huelgas is underlined by the fact that female members of the royal family continued to regularly enter its nunnery to assure royal commemoration and to affirm the power of the family's lineage: such as Leonor and Constanza, daughters of the Las Huelgas' founders; Constanza (d. 1242), daughter of Alfonso IX of León and Berenguela of Castile; Blanca of Portugal (d. 1321), niece of Alfonso X the Wise; and Berenguela (1230–88), daughter of Fernando III. Furthermore, royal weddings and coronations took place within the abbey church and male members of the royal family were knighted there. On patronage of the female members of the Castilian royal house, see Miriam Shedis, 'Piety, Politics, and Power: The Patronage of Leonor of England and Her Daughters Berenguela of León and Blanche of Castile', in *The Cultural Patronage of Medieval Women*, ed. by June Hall McCash (Athens: University of Georgia Press, 1996), pp. 202-27; David Raizman, 'Prayer, Patronage, and Piety at Las Huelgas: New Observations on the Later Morgan Beatus (M. 429)', in *Church, State, Vellum, and Stone: Essays on Medieval Spain in Honor of John Williams*, ed. by Therese Martin and Julie A. Harris (Leiden/Boston: Brill, 2005), pp. 235-73 (pp. 247-48).

2. Manuel Gómez-Moreno, *El Panteon Real de las Huelgas de Burgos* (Madrid: Consejo Superior de Investigaciones Científicas, 1946); Dorothy G. Sheperd, 'The Textiles from Las Huelgas de Burgos', *Bulletin of the Needle and Bobbin Club*, 35 (1951), pp. 1-26; Concha Herrero Carretero, *Museo de las Telas Medievales. Monasterio de Santa María la Real de Huelgas* (Madrid: Patrimonio Nacional, 1988); *Vestiduras Ricas: El Monasterio de Las Huelgas y su época 1170–1340*, ed. by Mateo Mancini (Madrid: Patrimonio Nacional, 2005).

3. *Vestiduras Ricas*, pp. 37-40, cat. nos 10-14.

4. Florence Lewis May, *Silk Textiles of Spain: Eighth to Fifteenth Century* (New York: The Hispanic Society of America, 1957); Robert B. Serjeant, *Islamic Textiles: Material for a History up to the Mongol Conquest* (Beirut: Librairie du Liban, 1972), pp. 165-76.

5. *Vestiduras Ricas*, pp. 213-14, cat. nos 37-38.

6. For similar examples where animals are arranged in pairs on either side of a tree, as well as where chains of pearls are used as framing devices, see a silk fragment, probably from eastern Persia, seventh or eighth century, that was found with the relics of St Amon (Nancy, Musée Lorrain), in addition to a samit made around 800 in eastern Persia from the Capella Sancta Sanctorum in Rome (Vatican, Monumenti, Musei e Gallerie Pontificie T 114). Leonie von Wilckens, *Die textilen Künste. Von der Spätantike bis um 1500* (Munich: C. H. Beck, 1991), pp. 46-47.

7. For both types of garments, see Carmen Bernis Madrazo, *Indumentaria medieval española* (Madrid: Instituto Diego Velázquez, 1956), pp. 22.

8. For medieval Castilian fashion, see Amalia Descalzo, 'El vestido entre 1170 y 1340 en el Panteón Real de las Huelgas', in *Vestiduras Ricas*, pp. 107-18.

9. See p. 26. For a discussion concerning the belt's provenance, see Ilse Fingerling, *Gürtel des hohen und späten Mittelalters* (Munich: Dt. Kunstverlag, 1971), pp. 53-55, cat. no. 61; *Vestiduras Ricas*, pp. 164-65, cat. no. 14.

10. On knitting in medieval Europe, see Irena Turnau, 'The Diffusion of Knitting in Medieval Europe', in *Cloth and Clothing in Medieval Europe*, ed. by Negley B. Harte and Kenneth G. Ponting (London: Heinemann, 1983), pp. 368-89.

11. On the anachronism of the term 're-conquista', see Thomas F. Glick, *Islamic and Christian Spain in the Early Middle Ages* (Princeton: Princeton University Press, 1979), p. 44.

12. James D'Emilio, 'The Royal Convent of Las Huelgas: Dynastic Politics, Religious Reform and Artistic Change in Medieval Castile', *Studies in Cistercian Art and Architecture*, 6 (2005), 191-228.

13. Henrik Karge, 'Die königliche Zisterzienserinnenabtei Las Huelgas de Burgos und die Anfänge der gotischen Architektur in Spanien', in *Gotische Architektur in Spanien*, ed. by Christian Freigang (Frankfurt am Main: Vervuert, 1999), pp. 13-40 (p. 14).

14. Karge, pp. 35-36.

15. Matthias Untermann, *Forma Ordinis. Die mittelalterliche Baukunst der Zisterzienser* (Munich/Berlin: Deutscher Kunstverlag, 2001), p. 625.

16. In recent studies the term 'Andalusí' is used to describe objects produced in Muslim workshops so as to avoid designations such as '*hispano-musulman*' as well as 'Islamic' because of their religious associations. For a further discussion of these terms, see Maria Judith Feliciano, 'Muslim Shrouds for Christian Kings? A Reassessment of Andalusí Textiles in Thirteenth-Century Castilian Life and Ritual', in *Under the Influence: Questioning the Comparative in Medieval Castile*, ed. by Cynthia Robinson and Leyla Rouhi (Leiden/Boston: Brill, 2005), pp. 101-31 (p. 106).

17. See in particular Etelvina Fernández González, 'El artesano medieval y la iconographía en los siglos del románico: la actividad textil', *Medievalismo. Boletín de la Sociedad Española de Estudios Medievales*, 6 (1996), 63-119, and most recently, Etelvina Fernández González, 'Que los reyes vestiessen paños de seda, con oro, e con piedras preciosas. Indumentarias ricas en la Península ibérica (1180–1300): entra la tradición islámica y el occidente cristiano', in *El legado de al-Andalus. El arte andalusí en los reinos de León y Castilla durante la Edad Media*, ed. by Manuel Valdés Fernández (Valladolid: Fundacion del Patrimonio Histórico, 2007), pp. 367-408. For the cultural significance of garments within Andalusian society, see Manuela Marín, 'Signos visuals de la identidad andalusí', in *Tejer y vestir: de la Antigüedad al Islam*, ed. by Manuela Marín (Madrid: CSIC, 2001), pp. 137-80.

18. Feliciano, p. 109: 'But a more profound examination of the taste for Andalusí silks shows that their value went beyond their obvious ornamental quality and into the realm of functionality, as objects of both ritual and symbolic significance in the Castilian cultural map.'

19. On the term 'hybridization', see *Metzlers Lexikon Literatur-und Kulturtheorie*, ed. by Ansgar Nünning (Stuttgart: Metzler, 2001), pp. 259-60.

20. Concerning the limits of the identity-building process, see Mary Douglas, *Purity and Danger: An Analysis of Pollution and Taboo* (London: Routledge, 1993); for an application of the social anthropological approach to the phenomena of the border within the Iberian Peninsula, see Patrick Henriet, 'Les clercs, l`espace et la mémoire', in *Á la recherche de légitimités chrétiennes. Représentations de l'espace et du temps dans l'Espagne médiévale (IXe– XIIIe siècle)*, ed. by Patrick Henriet (Lyons: ENS, 2003), pp. 11-25 (p. 15).

21. Yuri M. Lotman, *Universe of Mind. A Semiotic Theory of Culture*, trans. by Ann Shukman (London/New York: I. B. Tauris, 2001), especially Chapter 9.

22. Lotman, pp. 136-37.

23. For the meaning of the term 'cultural performance', see Abner Cohen, *Masquerade Politics: Explorations in the Structure of Urban Cultural Movements* (Oxford: Berg, 1993), pp. 1-9 and 148. Cohen works on the question of how far cultural re-shaping processes within an event, drama or ritual can be perceived as a battle over power. For a further discussion of Abner Cohen's ideas, see David Parkin, 'Introduction: The Power of the Bizarre', in *The Politics of Cultural Performance*, ed. by David Parker, Lionel Caplan and Humphrey Fisher (Providence: Berghahn 1996), pp. xv-xi. I owe thanks to my colleague Julia Pauli from Hamburg University for directing me toward this approach.

24. Fernando Gutiérrez Baños, *Las empresas artísticas de Sancho IV el Bravo* (Salamanca: Junta de Castilla y León, Consejería de Educación y Cultura, 1997), p. 92; see also, Asunción López Dapena, *Cuentas y gastos (1292–1294) del rey don Sancho IV el Bravo (1284–1295)* (Granada: Monte de Piedad y Caja de Ahorros, 1984).

25. Jesusa Alfau de Solalinde, *Nomenclatura de los tejidos espanoles del siglo XIII* (Madrid: Real Academia Española, 1969), p. 142.

26. Feliciano, however, suggests otherwise. She took the lack of any description concerning Andalusí-style fabrics for funerary purposes as an argument for their everyday occurrence; Feliciano, p. 117. The invoices are published by Asunción López Dapena, *Cuentas y gastos (1292-1294) del rey don Sancho IV el Bravo (1284-1295)* (Granada: Monte de Piedad, 1984); see also Gutiérrez Baños, pp. 91-93.

27. For both terms, *escarlata* and *verdescur*, see Alfau de Solalinde, pp. 95-99, pp. 180-81; María del Carmen Martínez Meléndez, *Los nombres de tejidos en castellano medieval* (Granada: Universidad de Granada, 1989), pp. 76-86, pp. 183-85.

28. George S. Colin, '<Latinus Sigillatus > Roman siglaton et escarlat', *Romania* LVI (1930), pp. 178-90 (p. 188). By the

thirteenth century, the Muslims were actually imitating their Christian neighbors by wearing mantles made of *escarlata*. For further documentation on the imitation of Christian fashion styles by the Muslim elite during the thirteenth century, which can be seen as a consequence of the increasing power of the Christian kingdoms, see Marín, p. 144.

29. Gutiérrez Baños, pp. 91-92. For an extensive list of documents on *escarlata* from the thirteenth century onward, see Martínez Meléndez, *Los nombres de tejidos* p. 79.

30. *Primera partida: segun el manuscrito add. 20.787 del British Museum*, ed. by Juan Antonio Arias Bonet (Valladolid: Università de Valladolid, 1975), title XIII, law 16.

31. *Las Siete Partidas del Rey Don Alfonso el Sabio*, 3 vols (Madrid: Imprenta Real, 1807)II, title V, law 5.

32. Gutiérrez Baños, pp. 89-90.

33. The dating of the poem is not certain – it was written as early as the mid-eleventh century or as late as the thirteenth century; see Hans-Jörg Neuschäfer and Sebastian Neumeister, *Spanische Literaturgeschichte* (Stuttgart: Metzler, 2006), p. 29.

34. 'Vistio camisa de rançal tan blanca commo el sol, / con oro e con plata todas las presas son, / al puño bien estan, ca el selo mando; / sobr'ella un brial primo de çiclatón, / obrado es con oro, pareçen por o son; / sobr'esto una piel vermeja, las bandas d'oro son, / siempre la viste mio Çid el Campeador; / una cofia sobre los pelos d' un escarín de pro, / con oro es obrada, fecha por razon, / que non le contalassen los pelos al buen Çid Canpeador. [...] / De suso cubrio un manto que es de grant valor, / en el abrien que ver quantos que i son.' *Poema de mio Cid*, ed. by Colin Smith (Madrid: Cátedra, 1994), p. 255.

35. Alfau de Solalinde, pp. 78-82; Germán Navarro Espinach, 'El comercio de telas entre Oriente y Occidente (1190–1340)', in *Vestiduras ricas*, pp. 89-106 (p. 102). Martínez Meléndez, *Los nombres de tejidos*, pp. 290-91.

36. Alfau de Solalinde, pp. 93-95; Martínez Meléndez, *Los nombres de tejidos*, pp. 399-400.

37. See the description of El Cid's palace: *Poema de Mio Cid*, p. 224: 'Penssaron de adobar essora el palaçio; / por el suelo e suso tan bien encortinado, / tanta porpola e tanto xamed e tanto paño preçiado [...].' For *xamete*, see Alfau de Solalinde, pp. 185-87; Martínez Meléndez, *Los nombres de tejidos*, pp. 306-10. For *purpura*: Alfau de Solalinde, pp. 148-51; Navarro Espinach, 'El comercio de telas', p. 104. For how *purpura* was related to royal garments, see the examples cited by Martínez Meléndez, *Los nombres de tejidos*, p. 321.

38. The diversity of textile terms used to describe the clothing of the leading characters is also found in other poems of Spanish courtly literature; see, for example, the *Libro de Alexandre*: 'El

emperant, vestido de un xamit Bermejo [...]'. *Book of Alexander (Libro de Alexandre)*, trans. by Peter Such and Richard Rabone (Oxford: Oxbow, 2009), p. 292.

39. Jerrilynn D. Dodds, María Rosa Menocal, and Abigail Krasner Balbale, *The Arts of Intimacy: Christians, Jews, and Muslims in the Making of Castilian Culture* (New Haven/London: Yale University Press, 2008), pp. 38-43.

40. Joseph J. Duggan, *The Cantar de mio Cid. Poetic Creation and its Economic and Social Contexts* (Cambridge: Cambridge University Press, 1989), pp. 16-42.

41. See Duggan, p. 146.

42. Duggan, pp. 20.

43. *Poema de Fernán González*, ed. by Juan Victorio (Madrid: Cátedra, 1981), 116: 'Quando le ovo el conde de todo despojado, / lavo le e vistio lo d'un xamete preçiado, / echo lo en un escaño sotil mientre labrado, / ovo lo en la batalla de Almançor ganado. / El conde castellano con todo su consejo / fizieron le ataut bien obrado, sobejo / guarnido rica miente de un paño bermejo, de clavos bien dorados que luzien commo espejo.' ('They unclothed, washed and dressed him in a precious silk garment, which he won in the battle against Almansor [al-Manṣūr (976–1002)]; and ordered the construction of a coffin whose cover was made of a red tissue fixed with golden nails shining as a mirror.')

44. On the term *xamete*, see note 37.

45. Duggan, p. 27.

46. The Cistercian monastery Santa María de las Huelgas possesses an Andalusian textile popularly known as the Banner of Las Navas de Tolosa, which had long-thought to have been a trophy from the battle of Navas de Tolosa in 1212, where Alfonso VIII defeated the Almohad Caliph. Recent stylistic analysis suggests, however, that it was more likely made in the fourteenth century. Nonetheless, the banner was housed in the church treasury and was seen as a symbol of victory and booty. See Miriam Ali-de-Unzaga, 'Qur'anic Inscriptions on the so-called "Pennon of Las navas de Tolosa" and the Three Marinid Banners', in *Word of God, Art of Man: The Qur'an and its Creative Expressions*, ed. by Fahmida Suleman (Oxford: Oxford University Press, 2010), pp. 239-55.

47. Furthermore, wool fabrics survive, such as the pillow cover of Alfonso de la Cerda dated between 1271 and 1333, see *Al-Andalus: las artes islámicas en España*, ed. by Jerrilynn D. Dodds (Madrid: Viso, 1992), fig. 96.

48. Martínez Meléndez, *Los nombres de tejidos*, pp. 9-15.

49. Linen was produced in Madrid, Molina de Aragón, Murcía, Cuenca, and Puzol (Valencia); see Martínez Meléndez, *Los nombres de tejidos*, pp. 401-02. For linen production in the kingdom

of Castile, see Paulino Iradiel Murugarran, *Evolución de la industria textil castellana en los siglos XIII-XVI. Factores de desarrollo, organización y costes de la producción manufactuera en Cuenca* (Salamanca: Universidad de Salamanca, 1974); for the kingdoms of Aragón and Valencia, see Germán Navarro Espinach, 'La industria textil en los reinos de Aragón y Valencia en la Edad Media', in *El món urbà al la corona d'Aragó del 1137 als decrets de nova planta*, 3 vols (Barcelona: Universitat de Barcelona, 2003), I, pp. 475-91; for Murcía, see M. Martinez Martínez, *La industria del vestido en Murcía (siglos XIII-XV)* (Murcía: Universidad de Murcía, 1986–87); for Mallorca, see Miquel J. Deyá Bauzá, *La manufactura de la lana en Mallorca (1400–1700): gremios, artesanos y comerciantes* (Palma: Universidad de Palma de Mallorca, 1996–97).

50. Gómez-Moreno, pl. CXXVI.

51. Cristina Partearroyo, 'Almoravid and Almohad Textiles', in *Al-Andalus*, pp. 105-13.

52. See, Partearroyo, 'Almoravid and Almohad Textiles', p. 110; *Vestiduras ricas*, p. 177, cat. no. 21.

53. *Saya, pellote*, and the mantle; see *Vestiduras ricas*, pp. 170-72, cat. nos 18 and 19.

54. Gutiérrez Baños, pp. 90-91.

55. *Vestiduras ricas*, pp. 154-55, cat. no. 8.

56. See also Gutiérrez Baños, p. 97.

57. Documentation of Muslim weavers who converted to Christianity on exists from the fourteenth century onward; see Paulino Iradiel Murugarran and Germán Navarro Espinach, 'La seda en Valencia en la edad media', in *España y Portugal en las rutas de la seda. Diez siglo de producción y comercio entre oriente y occidente* (Barcelona: Universitat de Barcelona, 1996), pp. 184-200 (p. 187). See also, Germán Navarro Espinach, *Industria y artesanado en Valencia, 1450–1525. Las manufacturas de seda, lino, cáñamo y algodón*, 4 vols (unpublished doctoral dissertation, Universidad de Valencia, 1995).

58. Partearroyo, 'Almoravid and Almohad Textiles', p. 110, fig. 5.

59. See a Persian samit from the sixth century today in Lyon, Musée Historique des Tissus (Inv. No. 26.812[15]): Wilckens, p. 21; concerning the motif of the rosette within the Las Huelgas textile collection see, for example, the brocade fabric that covered the wooden coffin of Constanza II (d. 1242), daughter of Berenguela and Alfons IX of León, and the samit lid cover from the coffin of Fernando de la Cerda. Octagonal frames are also represented on the pattern of the pillow cover from Leonor de Aragón's tomb: Gómez-Moreno, pls LXXIX and LIX.

60. *Al-baraka* ('blessing').

61. A very precious example is the head-covering of Fernando (1189–1211), son of Alfonso VIII. The textile headdress dates to around the end of the twelfth or the beginning of the thirteenth century: *Vestiduras ricas*, p. 177, cat. no. 21.

62. Dodds, Menocal, and Krasner Balbale, pp. 138-61.

63. On the changing significance of the term *mudejar* since the nineteenth century, see Mariam Rosser-Owen, *Islamic Arts from Spain* (London: V&A, 2010), p. 79. For a similar approach to defining *mudejar* as a cultural concept, see Gonzalo M. Borrás Gualis, 'Consideraciones para una definición cultural del arte mudéjar', in *El legado de al-Andalus. El arte andalusí en los reinos de León y Castilla durante la Edad Media*, ed. by Manuel Valdés Fernández (Valladolid: Fundacion del Patrimonio Histórico, 2007), pp. 411-21. See also María Teresa Pérez Higuera on the term *mudejarsimo* to describe Islamicized, Hispanic society: 'Arquitectura mudéjar en los antiguos reinos de Castilla-León y Toledo', in *El arte mudéjar*, ed. by Gonzalo M. Borrás Gualis (Saragossa: Unesco-Ibercaja, 1996), pp. 31-61 (p. 71). For another perspective, which considers the role of Jewish artisans who have been excluded from earlier discussions of Mudejar art, see Jerrilynn D. Dodds, 'Mudejar Tradition and the Synagogues of Medieval Spain: Cultural Identity and Cultural Hegemony', in *Convivencia: Jews, Muslims, and Christians in Medieval Spain*, ed. by Vivian B. Mann, Thomas F. Glick, and Jerrilynn D. Dodds (New York: George Braziller/The Jewish Museum, 1992), pp. 113-31 (pp. 113-14); on 'mudejarismo', see Dodds, Menocal, and Krasner Balbale, p. 138.

64. Gema Palomo Fernández and Juan Carlos Ruiz Souza, 'Nuevas hipótesis sobre Las Huelgas de Burgos: Escenografía funeraria de Alfonso X para un proyeto inacabado de Alfonso VIII y Leonor Plantagenet', *Goya*, 316-17 (2007), pp. 21-44.

65. First mentioned by Sheperd, p. 19.

66. Palomo Fernández and Ruiz Souza, p. 36. The authors suppose that Fernando de la Cerda's remains were translated through the cloister of San Fernando to the church during the funeral. For reproductions, see Dodds, Menocal, and Krasner Balbale, pp. 189 and 111.

67. Rose Walker, 'The Poetics of Defeat: Cistercians and Frontier Gothic at the Abbey of Las Huelgas', in *Spanish Medieval Art: Recent Studies*, ed. by Colum Hourihane (Tempe: Arizona Center for Medieval and Renaissance Studies, 2007), pp. 187-213.

68. Recently Etelvina Fernández González has treated these garments as a distinct feature in thirteenth-century Castile. She also discusses their distribution and their relation to other media: see 'Que los reyes vestiessen', pp. 388-97. I thank Christiane Elster for bringing to my attention the written evidence of vestments commissioned by Boniface VIII in thirteenth-century Italy that were also decorated with several coats of arms. Due to the fact, however, that no single piece survives, scholars will never have a clear sense if they had a similar appearance to the Spanish examples cited here.

69. See, for instance, the pattern on the vestments of Leonor of Castile (d. 1244); *Vestiduras ricas*, pp. 170-72, cat. nos 18 and 19.

70. Such as Alfonso VIII's mantle and Fernando de la Cerda's vestments at Las Huelgas. Similarly decorated clothes survive from other royal burial sites, such as the sepulcher of Fernando III in the Cathedral of Seville and from the tomb of Sancho IV in Toledo Cathedral. Navarro Espinach, '*El comercio de telas*', p. 41. Furthermore, the burial textiles of bishops and archbishops were also decorated with coats of arms. See the pillow cover from the tomb of the archbishop Rodrigo Ximénez de Rada in Santa María de Huerta, Soria: Faustino Menéndez Pidal, 'Estudio heráldico del almohadón', in *Vestiduras pontificales del arzobispo Rodrigo Ximénez de Rada. Su estudio y restauración* (Madrid: Instituto de conservación y restauración de bienes culturales, 1995), pp. 28-43. For an overview of the burial places of the kings and queens of Castile and León, see *El panteon real de Las Huelgas de Burgos. Los enterramientos de los reyes de León y de Castilla*, ed. by Juan C. Elorza (León: Junta de Castilla y León, 1990).

71. See, for instance, the representations in an illuminated manuscript of the *Cántigas de Santa María* from the thirteenth century (Real Biblioteca de San Lorenzo de El Escorial, Ms. T.I.1); José Guerrero Lovillo, *Las Cántigas. Estudio arqueológico de sus miniaturas* (Madrid: Consejo Superior de Investigaciones Científicas, 1949), figs 135 and 186.

72. Navarro Espinach, '*El comercio de telas*', pp. 104-05; Martínez Meléndez, *Los nombres de tejidos*, p. 331.

73. *Vestiduras ricas*, p. 15.

74. Georg Scheibelreiter, *Heraldik* (Vienna: Oldenbourg, 2006), pp. 122-23; see also Kilian Heck, *Genealogie als Monument und Argument. Der Beitrag dynastischer Wappen zur politischen Raumbildung der Neuzeit* (Berlin/Munich: Deutscher Kunstverlag, 2002), pp. 16-20.

75. Faustino Menéndez Pidal, *Leones y castillos. Emblemos heráldicos en España* (Madrid: Real Academia de la Historia, 1999), pp. 197-212; and Faustino Menéndez Pidal, 'Panorama heráldico español. Épocas y regiones en el período medieval', *Príncipe de Viana*, 68 (2007), pp. 533-53.

76. Menéndez Pidal, 'Panorama heráldico', p. 539.

77. Menéndez Pidal, 'Almohadón', p. 37.

78. The attempt to connect both families through marriage would fail in 1273 upon the death of Theobald, son of Henry I (1244–74), count of Champagne and king of Navarre, who had been promised to one of Alfonso's daughters.

79. Where the belt was manufactured is far from clear. The belt's heraldic decoration refers to both English and Spanish traditions. Fingerling supposes for stylistic reasons that the belt was produced in Spain, see note 9; in opposition to *Vestiduras ricas*, pp. 164-65, where it is stated that it was made in France and functioned as a marriage present to Fernando de la Cerda. The ribbon, on which the pearls were embroidered, recalls other similar Spanish examples also represented in the Las Huelgas collection (Gómez-Moreno, pls CX–CXI), although those fabrics were exported to England: Heidi Blöcher, 'Beobachtungen zum Opus Anglicanum an Mitren aus dem 13. Jahrhundert', in *Reiche Bilder. Aspekte zur Produktion und Funktion von Stickereien im Spätmittelalter*, ed. by Uta-Christiane Bergemann and Annemarie Stauffer (Regensburg: Schnell & Steiner, 2010), pp. 83-96, figs 7-9.

80. Gómez-Moreno, pl. CCIII.

81. Manuel Ginzález Jiménez, *Alfonso X el Sabio. Historia de un reinado 1252–1284*, 2nd edn (Burgos: Deputación Provincial de Palencia, 1999), pp. 166-82.

82. Nuria Torres Ballesteros, 'La muerte como aspecto de la vida cotidiana medieval: los sepulcros de Villasirga', in *Vita Cotidiana en la España Medieval*, ed. by Miguel Ángel Garcia Guinea (Madrid/Aguilar de Campo: Ediciones Polifemo, 1998), pp. 427-56, figs 1-10.

83. For the chronicles, see Ariel Guiance, *Los discursos sobre la muerte en la Castilla medieval (siglos VII–XV)* (Valladolid: Junta de Castilla y León Consejería de Educación y Cultura, 1998), pp. 318-24; *Siete Partidas*, II, title XIII, law 19.

84. On the significance of coats of arms for communicating the body politic, see Hans Belting, *Bild-Anthropologie. Entwürfe für eine Bildwissenschaft* (Munich: Fink, 2001), pp. 115-18.

Notes to Chapter 8

1. These and other biblical citations are taken from the Douay-Rheims edition of the Vulgate text. Other references to white clothing are found in Revelation 7:9, 3:18, 19:8, and 19:14.

2. 'But thou hast a few names in Sardis which have not defiled their garments: and they shall walk with me in white, because they are worthy. He that shall overcome shall thus be clothed in white garments: and I will not blot out his name out of the book of life.'

3. Among the earliest surviving tomb effigies in England are thirty-six effigies of bishops dating from *c.* 1150–1300. These monuments and others are discussed and catalogued in Catherine Walden, 'Redemption and Remembrance: The English Ecclesiastical Tomb in the Twelfth and Thirteenth Centuries' (unpublished doctoral dissertation, University of Virginia, 2011).

4. Carving an image of the deceased on a tomb monument had

been popular in Antiquity, but the practice fell into disuse in Western Europe and then re-emerged around 1100. The effigy of Rudolf of Swabia in Merseburg Cathedral is generally considered the earliest known medieval effigy in relief; see Thomas Dale, 'The Individual, the Resurrected Body, and Romanesque Portraiture: The Tomb of Rudolf von Schwaben in Merseburg', *Speculum*, 77 (2002), pp. 707-43. In England, effigies were being commissioned by *c*. 1150. For general surveys of tomb sculpture, see Erwin Panofsky, *Tomb Sculpture: Four Lectures on Its Changing Aspects from Ancient Egypt to Bernini* (New York: Harry N. Abrams, 1964; repr. 1992); Kurt Bauch, *Das Mittelalterliche Grabbild: Figüreliche Grabmäler des 11. bis 15. Jahrhunderts in Europa* (Berlin: Walter de Gruyter, 1976); and for medieval monuments in England, see Nigel Saul, *English Church Monuments in the Middle Ages: History and Representation* (Oxford: Oxford University Press, 2009).

5. This monument has been the subject of much debate over its date and whom it represents. The two most common recent suggestions are that it was made for Bishop Roger (d. 1139) or made retrospectively for Bishop Osmund (d. 1091). For a summary of past scholarship, see Walden, cat. no. 17. It should be noted that a sculpture of an abbot now mounted on the exterior of St Nicholas's church, Bathampton (Somerset) has been put forth as a possible early twelfth-century tomb effigy; see Sally Badham, 'Our Earliest English Effigies', *Church Monuments Newsletter*, 23:2 (winter 2007/08), pp. 9-13; and Saul, *English Church Monuments*, pp. 29-30. Based on comparison to other English tombs, I might argue a date closer to mid-century; see Walden, p. 63, fn. 24. Its original function as an effigy is not certain.

6. Walden, cat. no. 7.

7. Adhesive survives in the eye sockets of the beast at the feet of the Exeter effigy, in the depressions on the morse and miter of an ecclesiastical effigy in Worcester Cathedral, and in the indentations on the morse, miter, maniple, and hems of a second effigy at Worcester. On the likelihood that the adhesive at Worcester is original, see David Park, 'Survey of the Medieval and later Polychromy of Worcester Cathedral: a Report for the Dean and Chapter' (unpublished report, Courtauld Institute, 1997), no. 19. I thank David Park for sharing this and for generously allowing me access to the archive of the National Survey of Medieval Wall Painting at the Courtauld Institute. Lawrence Stone, *Sculpture in Britain: The Middle Ages* (Harmondsworth: Penguin Books, revised ed., 1972), pp. 104-05, briefly mentions the similarity of Purbeck effigies to metalwork, particularly in the provision for 'glass or paste jewellery'. Where there are indentations but no longer any evidence of adhesive, it is possible that applied ornament was intended but never added.

8. John Blair, 'Purbeck Marble', in *English Medieval Industries*, ed. by John Blair and Nigel Ramsey (London: Hambledon Press, 1991), pp. 41-56; Sally Badham and Geoff Blacker, *Northern Rock: The Use of Egglestone Marble for Monuments in Medieval England* (Oxford: Archaeopress, 2009), pp. 9-15. On funerary effigies in Purbeck, see G. Dru Drury, 'Early Ecclesiastical Effi-

gies', *Proceedings of the Dorset Natural History and Archaeological Society*, 53 (1932), pp. 250-64 and G. Dru Drury, 'The Use of Purbeck Marble in Medieval Times', *Proceedings of the Dorset Natural History and Archaeological Society*, 70 (1948), pp. 74-98. An interest in textured effigies continued through the Middle Ages, albeit with materials that were much easier to work with, such as alabaster and freestone. Texture could also be obtained through building up layers of gesso or similar material. Brodrick and Darrah found on the Arundel tombs a raised wax appliqué specifically patterned to imitate brocades; see Anne Brodrick and Josephine Darrah, 'The Fifteenth Century Polychromed Limestone Effigies of William Fitzalan, 9th Earl of Arundel, and his Wife, Joan Nevill, in the Fitzalan Chapel, Arundel', *Church Monuments*, I:2 (1986), pp. 65-94.

9. Edward Prior and Arthur Gardner, *An Account of Medieval Figure Sculpture in England* (Cambridge: Cambridge University Press, 1912), p. 601, suggested that the shift in the style of figure carving around the middle of the thirteenth century was a result of the desire for painted surfaces, and that this preference for paint may have caused the end of the Purbeck trade in effigies altogether. See also Arthur Gardner, *English Medieval Sculpture* (Cambridge: Cambridge University Press, 1951), pp. 157-58; Stone, pp. 134-35.

10. Among the extant examples are the fourteenth-century effigies of Archbishop Reynolds (d.1327) and Prior Eastry (d. 1331) at Canterbury Cathedral. On Reynolds' effigy, see Wilson, 'Medieval Monuments', *A History of Canterbury Cathedral*, ed. by Patrick Collinson, Nigel Ramsay, and Margaret Sparks (Oxford: Oxford University Press, 1995), p. 465, citing the notes taken by Richard Scarlett in 1599 and by John Philipot in *c*. 1613–15. Some paint can still be seen on the chasuble and dalmatic. For Eastry's effigy, see Wilson, p. 491, fn. 176, in which he cites evidence from Scarlett. Fragments are visible on the chasuble, the apparel of alb, and the cushion. A fourteenth-century bishop's tomb at Rochester had been bricked up, and then rediscovered in 1825. Descriptions of the find attest that a large amount of color, particularly on the vestments, had survived. See the *Gentleman's Magazine*, XCV:1 (January 1825), pp. 76-77 and XCV:2 (September 1825), p. 226; Alfred John Kempe, 'Description of the sepulchral effigy of John de Sheppy, Bishop of Rochester, discovered in Rochester Cathedral, AD 1825', *Archaeologia*, XXV (1834), pp. 122-26; George Henry Palmer, *The Cathedral Church of Rochester: A Description of its Fabric and a Brief History of the Episcopal See*, Bells Cathedral Guide (London: George Bell and Sons, 1897); M. Covert, 'The Cottingham Years at Rochester', *Friends of Rochester Cathedral Report* (1991–92), pp. 6-14.

11. The bibliography on painted sculpture in Britain has grown considerably over recent decades, particularly with the close analyses of large architectural schemes such as the west fronts of cathedrals at Exeter, Wells, and Salisbury, and the interior sculpture at Exeter. David Park, 'The Polychromy of English Medieval Sculpture', in *Wonder: Painted Sculpture from Medieval England*, ed. by Stacy Boldrick and Stephen Feeke (Leeds: Henry

Moore Institute, 2002), pp. 31-54, discusses recent developments in the field. A survey of painted funerary monuments has not yet been undertaken; paint on tombs tends to be discussed in more focused studies of one or a few tombs, for example, Marie Louise Sauerberg, Ray Marchant and Lucy Wrapson, 'The Tester over the Tomb of Edward, the Black Prince: the Splendour of Late-Medieval Polychromy in England', in *Monumental Industry: The Production of Tomb Monuments in England and Wales in the Long Fourteenth Century*, ed. by Sally Badham and Sophie Oosterwijk (Donington: Shaun Tyas, 2010), pp. 161-86; Brodrick and Darrah; Sarah Houlbrooke, 'A Study of the Materials and Techniques of the 13th Century Tomb of Aveline, Countess of Lancaster, in Westminster Abbey', *The Conservator*, 29 (2005–06), pp. 105-17; Matthew Sillence, 'The Two Effigies of Archbishop Walter de Gray (d. 1255) at York Minster', *Church Monuments*, XX (2005), pp. 5-30. For a brief mention of paint on thirteenth-century secular tombs, see H. A. Tummers, *Early Secular Effigies in England: The Thirteenth Century* (Leiden: Brill, 1980), pp. 17-18. Sally Badham, '"A new feire peynted stone": Medieval English Incised Slabs?' *Church Monuments*, XIX (2004), pp. 20-52, discusses ccolor on incised effigies and flat slabs. C. E. Keyser, *A List of Buildings in Great Britain and Ireland Having Mural and Other Painted Decorations* (London: Eyre and Spottiswoode, 1883), notes many examples of painted tombs in the late medieval period. For a general discussion of the importance of color to late medieval testators and for some examples of late medieval painted effigies in England, see Saul, *English Church Monuments*, pp. 88-90.

12. The nine episcopal effigies with evidence of paint are a *c.* 1292 wooden effigy for Archbishop Pecham at Canterbury Cathedral; an unidentified *c.* 1255 Purbeck effigy at Carlisle Cathedral; the *c.* 1280 effigy of Bishop Bronescombe in Exeter Cathedral; a *c.* 1270 freestone effigy for Bishop Peter of Aquablanca in Hereford Cathedral; two mid-thirteenth-century effigies of dark stone in Lichfield Cathedral; a *c.* 1290 freestone miniature effigy at Salisbury Cathedral; a freestone figure made in the early thirteenth century at Wells Cathedral; and the *c.* 1300 Purbeck effigy for Bishop Giffard in Worcester Cathedral. The (unidentified) abbot's effigy is at Peterborough Cathedral, and dates *c.* 1230. Each of these is discussed in the catalogue in Walden.

13. Francis T. Havergal, *Fasti Herefordenses, and other Antiquarian Memorials of Hereford* (Edinburgh: R. Clark, 1869), pp. 176-77.

14. Richard Rawlinson, *The History and Antiquities of the City and Cathedral Church of Hereford* (London: R. Gosling, 1717), p. 183. Peter's will of 1268 survives, but the form his tomb was to take at Hereford was not prescribed. See Julian Gardner, 'The Tomb of Bishop Peter of Aquablanca in Hereford Cathedral', in *Medieval Art, Architecture, and Archaeology at Hereford*, ed. by David Whitehead (London: British Archaeological Association, 1995), pp. 105-10, and the summary of scholarship in Walden, cat. no. 10.

15. This painted figure was discovered during the tomb's restoration in the 1960s; see H. G. Ramm et al., 'The Tombs of Archbishops Walter de Gray (1216–55) and Godfrey de Ludham (1258–65) in York Minster, and their Contents', *Archaeologia*, CIII (1971), pp. 101-47; Sillence, 'The Two Effigies of Archbishop Walter de Gray'; and summary in Walden, cat. no. 36. This painting is more accurate in terms of representing the archiepiscopal office than the effigy that was placed over it. The miter is white with gold bands; the apparel of the alb is gold; the chasuble is vermilion with a border (possibly once gold); the dalmatic is blue with a gold border, and the tunicle green. Both Sillence and Badham, '"A new feire peinted stone"', discuss evidence for other painted lids similar to Archbishop Walter's.

16. London, British Library, Add Ms 17733, fols 5 and 7 in the topographical notes and drawings of D. T. Powell. Powell wrote that 'the wood is covered with a thin delicate plaister [*sic*] on which the gilding and painting the [*sic*] front robe has been of gold richly ornamented'. See Wilson, 'Medieval Monuments', pp. 463-64, fn. 50. Keyser, pp. lxxxiii-xxxiv, discusses the use of paint on later medieval wooden effigies on tombs for the laity: 'There can be no doubt that the wooden effigies were invariably overlaid with colour and gilding, or, in a few instances [...] with plates of metal enriched with enamel.'

17. Henry of Avranches, *Metrical Life of St Hugh*, ed. and trans. by Charles Garton (Lincoln: Honywood Press, 1986), p. 55. See also Paul Binski, *Becket's Crown: Art and Imagination in Gothic England, 1170–1300* (New Haven: Yale University Press, 2004), pp. 55-57.

18. David Park states, 'it is hard to believe that this beautiful, dark polished limestone was generally intended to be concealed, but there is ample evidence that at least in some cases – such as King John's effigy in Worcester Cathedral – it was originally fully polychromed'; see Park, 'The Polychromy of English Medieval Sculpture', p. 45. See also Park, 'Survey of the Medieval and later Polychromy of Worcester Cathedral', no. 18; and more generally on the tomb, Ute Engel, *Worcester Cathedral, An Architectural History*, trans. by Hilary Heltay (Chichester: Phillimore Press, 2007), pp. 206-10. Some red pigment still survives in tiny fragments, and the evidence for paint is supported by Stothard's colored plate and written description in his *Monumental Effigies*, published in 1817. Polychromy was recorded on a few thirteenth-century lay effigies made of Purbeck, including some effigies of knights at Temple Church in London, for which see, E. Richardson, *Monumental Effigies of the Temple Church with an Account of their Restoration* (London: Longman, Brown, Green, and Longmans, 1843), and most recently, the detailed study by Philip Lankester, 'The Thirteenth-Century Military Effigies in the Temple Church', in *The Temple Church in London: History, Architecture, Art*, ed. by Robin Griffith-Jones and David Park (Woodbridge: The Boydell Press, 2010), pp. 93-134. For discussion of paint on Purbeck military effigies, see Claude Blair, John Goodall, and Philip Lankester, 'The Winchelsea Tombs Reconsidered', *Church Monuments*, XV (2000), pp. 5-30, esp. fn. 18. Prior and Gardner, p. 601, stated that 'in the last half of the

Purbeck period there seems little doubt that effigies were entirely painted'. Drury, 'The Use of Purbeck Marble', p. 92, agreed with Prior and Gardner.

19. At Lichfield Cathedral, a *c.* 1250 Purbeck bishop's effigy has red paint on his right shoe, and two fragments of red under the folds of the chasuble on the right side; see Walden, cat. no. 12. A second effigy of dark stone at Lichfield has red paint on the dalmatic and on the underside of the chasuble; see Walden, cat. no. 11. The Purbeck effigy of Bishop Walter Giffard at Worcester, made before the bishop's death in 1301, retains color and gilding. See Park, 'Survey of the Medieval and later Polychromy of Worcester Cathedral', no. 20 and Park, 'The Giffard Monument', *Archaeology at Worcester Cathedral: Report of the Sixth Annual Symposium* (1996), pp. 20-21. More generally on the tomb, see Christopher Guy and Catherine Brain, 'Medieval Ecclesiastical Effigies in Worcester Cathedral, Part I', *Archaeology at Worcester Cathedral: Report of the Fifteenth Annual Symposium* (2005), pp. 17-23, and Walden, cat. no. 35. Additional visual and written evidence for paint on Giffard's effigy exists from the first half of the nineteenth century. A Purbeck bishop's effigy in Carlisle Cathedral, dating from around the mid-thirteenth century, retained paint and gilding at least until 1884, despite its heavily battered condition. See R. S. Ferguson, 'Monuments in Carlisle Cathedral', *Transactions of the Cumberland and Westmoreland Antiquarian and Archaeological Society* (1884), pp. 259-70 (pp. 259-64); Walden, cat. no. 2. On an abbot's effigy at Peterborough, red paint can be seen under the folds where his right arm is raised and just below his right wrist on the chasuble; see Walden, cat. no. 51.

20. Its excellent survival when none of the Purbeck effigies retain more than tiny fragments of polychromy might be due to the physical properties of the stone itself. Where Purbeck is prone to moisture damage and splitting and shearing, the basalt stone apparently used here is of much denser composition and impervious to moisture. See Anna Hulbert, 'Medieval Paintings and Polychromy', in *Exeter Cathedral: A Celebration,* ed. by Michael Swanton (Exeter: printed for the Dean and Chapter, 1991), p. 95, and in the same volume, Bridget Cherry, 'Some Cathedral Tombs', pp. 159-60. As so little bare stone is visible, I was not able to make an assessment of the material: Walden, cat. no. 9. E. W. Tristram, *English Medieval Wall Painting* (Oxford: Oxford University Press, 1950), p. 385, attributed the paint's survival to the protection provided by later layers of paint, whitewash, and varnish. See also E. W. Tristram 'Three Specimens of Medieval Art', *Friends of Exeter Cathedral Report* (1930), pp. 8-9, and in the same report, H. E. Bishop, 'Notes on the decoration of the Bronescombe effigy', pp. 11-12. For a nineteenth-century description of the tomb, as well as a color lithograph, see William Richard Crabbe, 'Some account of the Tomb of Bishop Bronescombe in Exeter Cathedral', *Transactions of the Exeter Diocesan Society*, 4 (1852), pp. 228-37.

21. The question of whether effigies were painted as part of the original manufacture, or were painted at a later date, is for most effigies unanswered. Although to my knowledge no scien-

tific analysis of the pigments has been carried out, according to Tristram and Cherry, the paint on Bronescombe's effigy is original to the effigy's fabrication. Given that the practice of painting other statues, shrines, and architectural sculpture was well established in the thirteenth century, it seems likely that at least some of the paint found on these ecclesiastical monuments is original to the time of manufacture.

22. Tristram, *English Medieval Wall Painting*, pp. 385, 401, and 406; he called this the 'translucida' technique. Hulbert, p. 95, similarly noted that the vestments are 'often minutely executed in crimson and green translucent glazes over gold leaf'. See also Stone, p. 135.

23. The textiles found in Walter de Gray's tomb are documented and illustrated in Ramm et al., pp. 127-31, pls LV-LVIII, and fig. 6. Seven different geometrical patterns of gold braiding were found in the Henry de Blois coffin at Winchester; see James Gerald Joyce, 'On the Opening and Removal of a Tomb in Winchester Cathedral', *Archaeologia*, 42:2 (1869), pp. 309-21, illustrated in pl. XVII. For a detailed study of the contents of Hubert's tomb, see Neil Stratford, Pamela Tudor-Craig, and Anna Maria Muthesius, 'Archbishop Hubert Walter's Tomb and its Furnishings', in *Medieval Art and Architecture at Canterbury before 1220*, ed. by Nicola Coldstream and Peter Draper (Leeds: Maney and Sons, 1982), pp. 71-93 (pp. 80-87). The textured patterns carved on the Exeter effigy can also be compared to fragments of braided and tablet-woven pieces found in excavations in London, discussed in Elisabeth Crowfoot, Frances Pritchard, and Kay Staniland, *Textiles and Clothing c. 1150–c. 1450: Finds from Medieval Excavations in London* (Woodbridge: The Boydell Press, 2001, new edn), pp. 130-49. For a useful overview of ecclesiastical garments at this time period, see Janet Mayo, *A History of Ecclesiastical Dress* (New York: Holmes and Meier Publishers, 1984), pp. 33-61. Kay Staniland, *Embroiderers* (Toronto: University of Toronto Press, 1991), includes many surviving examples of elaborate ecclesiastical garments.

24. The apparel of Hubert Walter's amice is silk damask, with seven embroidered medallions, each encircling a figure and having foliate decoration in the spandrels. See *English Romanesque Art, 1066–1200: Hayward Gallery, London, 5 April–8 July 1984* (London: Arts Council of Great Britain, 1984), cat. no. 493b; A. G. I. Christie, *English Medieval Embroidery* (Oxford: Clarendon Press, 1938), no. 17, pl. XI; Stratford, Tudor-Craig, and Muthesius, pp. 80-87; W. H. St John Hope, 'On the tomb of an Archbishop recently opened in the Cathedral Church of Canterbury', *Vetusta Monumenta*, VII:1 (1893). The apparel of an alb in the coffin at Worcester has paired lions within circular medallions that are separated by foliate sprigs; see Christie, no. 36, pl. XXI.

25. J. Wickham Legg and W. H. St John Hope, *Inventories of Christ Church, Canterbury* (Westminster: Archibald Constable and Co, 1902), p. 45, saw a similarity between the foliate detail on this effigy and the embroidered cloth added around the neck of the chasuble of Thomas Becket, now at Sens.

26. Christie, no. 17, proposed they were gems; in *English*

Romanesque Art, no. 493b, it was suggested that they were silver buttons; Legg and Hope, p. 47, posited that they were imitation turquoise made of stained ivory or bone.

27. Inventories with special relevance to the period under question here include the following: St Paul's, 1245, in W. Sparrow Simpson, 'Two inventories of the cathedral church of St Paul, London', *Archaeologia*, L:2 (1887), pp. 439-524 (pp. 446–500); St Paul's, 1295, in William Dugdale, *A History of St Paul's Cathedral* (London: George James, 1716; 2nd edn); Canterbury, 1315, in Legg and Hope, pp. 9-28 for overview, and inventory texts begin p. 51; Westminster, 1388, in J. Wickham Legg, 'On an Inventory of the Vestry in Westminster Abbey, taken in 1388', *Archaeologia*, LII:1 (1890), pp. 195-286; Exeter, 1277, 1327, and 1506, in George Oliver, *Lives of the Bishops of Exeter* (Exeter: William Roberts, 1861), pp. 297-366. As documents recording material wealth, inventories typically describe vestments by type (cope, chasuble, etc.), then by reference to material and to its treatment (serico, satyn, samite, baudekyn, breudata, etc.). Color, too, is usually noted, as well as any additional gems or precious objects.

28. The *c.* 1214–22 inventory at Salisbury is printed in W. H. Rich Jones, *Vetus registrum Sarisberiense, alius dictum registrum Sancti Osmundi episcopi*, 2 vols (London: Longman and Co., 1883; repr. 1965), II, pp. 127-38, and in Christopher Wordsworth, *Ceremonies and Processions of the Cathedral Church of Salisbury* (Cambridge: Cambridge University Press, 1901), pp. 169-82.

29. Legg and Hope, pp. 51-94.

30. Sparrow Simpson, pp. 446, 473.

31. Legg and Hope, p. 70. For the entry in the register, see *Registrum epistolarum fratris Johannis Peckham, archiepiscopi cantuariensis*, ed. by Charles Trice Martin, 3 vols (London: Longman and Co., 1885; repr. 1965), III, pp. 957-58. Herbert Norris, *Church Vestments, Their Origin and Development* (London: J. M. Dent and Sons, 1949), p. 106, compared the cost of Pecham's miter to the £23 6s. 8d. paid by Bishop Drokensford at Wells for two miters, and £40 for a miter that Bishop Orleton at Hereford had obtained from his predecessor. The jeweled miters were worn only by high ecclesiastics and known as *pretiosa*. Unfortunately, the miter on Pecham's tomb effigy has been removed and lost.

32. Notes taken by Scarlett, now in London, British Library, Ms Harley 1366, fol. 12v, describe the outer garment of Reynolds's effigy as 'azure powdred with gryffons passant gold', and Eastry's 'garment all red powdered with lions passant gold'.

33. For example, listed in the St Paul's inventory of 1245 are episcopal stockings with lions, and another pair with circles of eagles and dragons; see Sparrow Simpson, pp. 447, 474. Several chasubles are described with birds, flowers, lions, and trees, for example, Sparrow Simpson, pp. 449, 450. At Canterbury, a dalmatic has double-headed eagles in gold, a tunicle has stars and beasts embroidered in medallions, and another tunicle has beasts and trees in gold; see Legg and Hope, pp. 17, 57.

34. For Hubert Walter's chasuble, which has rows of medallions enclosing pairs of birds woven directly into the cloth, see Stratford, Tudor-Craig, and Muthesius, pp. 81-83; and Crowfoot, Pritchard, and Staniland, p. 112. In both, it is suggested that Hubert Walter's silk lampas was probably imported from Islamic Spain. The Pienza cope was given to the cathedral of Pienza in the fifteenth century, and is now located in the Museo Diocesano, Pienza. See Christie, no. 95, pls CXXXIX-CXLIIXXX. This cope is discussed in Christiane Elster's essay in this volume.

35. For example, the pillow in Archbishop Walter de Gray's tomb at York, and the stole and buskins found in the coffin of Archbishop Hubert Walter at Canterbury. De Gray's pillow is discussed in Ramm et al., pp. 129-31. Hubert Walter's buskins are illustrated in *English Romanesque Art*, p. 358, no. 493a; Christie, no. 15, pl. X; Stratford, Tudor-Craig, and Muthesius, p. 84. The buskins also have stylized eagles in some of the diamond-shaped matrices. Hubert's stole is in Christie, no. 18, pl. XI. An embroidered apparel for an amice at Sens Cathedral dating to the twelfth century has stylized foliate crosses within interlaced circles: see *English Romanesque Art*, pp. 356-57, no. 490, dated 1140–70.

36. See for example the will of Bishop Nicholas Longespee at Salisbury (d. 1297), printed in *English Historical Review*, 15 (July 1900), pp. 523-28, and Archbishop Winchelsey's will (d. 1313), printed in *Registrum Roberti Winchelsey*, ed. by Rose Graham (Oxford: Oxford University Press, 1952, 1956), appendix III, pp. 1340-45, which details extensive gifts of vestments to Canterbury first, and then to other churches. Winchelsey's will expressed his wish that the vestments remain in Canterbury Cathedral in perpetuity '*ad nostri memoriam ad cultus divini honorem*'. Sometimes wills could include very specific instructions, such as that of Cardinal Beaufort, who in 1446 willed to Winchester Cathedral his 'vestment embroidered [...] on condition that none should use the vestment but the Bishop of Winchester, or whoever may officiate in the presence of the King, Queen, and the King's eldest son'; Nicholas Harris Nicolas, *Testamenta Vetusta*, 2 vols (London: Nichols & Sons, 1826), I, pp. 249-50.

37. In any case, it appears that the practice was relatively rare in England at this early date. The 1245 St Paul's inventory says nothing about heraldic arms on vestments. There are a few mentions of the donor's name being worked into the cloth. The chasuble donated to St Paul's by Bishop Maurice (d. 1107), for example, had the words '*Mauritius me fecit*'. Lisa Monnas, *Merchants, Princes, and Painters: Silk Fabrics in Italian and Northern Paintings 1300–1550* (New Haven: Yale University Press, 2008), pp. 310-13, prints descriptions, extracted from St Paul's 1295 inventory, of copes associated with named benefactors. None of these entries indicate that names or heraldry formed part of the garments' design. More evidence for the decorating of vestments with arms survives from the fourteenth

century. The 1388 Westminster inventory lists heraldic arms, for example, on eighteen albs out of 325 listed. The Exeter inventory of 1506 includes a number of items donated by Bishop John Grandisson (d. 1369) that feature his arms.

38. Most of the vestments recorded in the 1245 inventory of St Paul's were associated with a donor, usually ecclesiastical; see Sparrow Simpson, pp. 448, 450, 475-90. Of the 91 copes listed in the 1295 inventory of St Paul's, 55 were identified with a bene-factor; see Monnas, pp. 310-13. On donors of goods listed in the Westminster inventory, see Legg, pp. 208-11.

39. London, Lambeth Palace Library Ms 20. Excerpts from this calendar were printed by Henry Wharton, *Anglia Sacra*, 2 vols (London: Richard Chiswell, 1691), I, pp. 52-64. See also Legg and Hope, pp. 43-44.

40. There appear to have been no gold vestments at St Paul's by 1245; see Sparrow Simpson, p. 449. Only one chasuble in the 1315 inventory at Canterbury was described specifically as 'cloth of gold', although we know that Lanfranc's richly adorned chasubles and copes, which are placed at the head of the inventory, were later burned so as to salvage the large amounts of metallic thread. See Legg and Hope, pp. 26-27, for a count of the Canterbury chasubles and copes by color. The Westminster inventory includes six items of cloth of gold by 1388, and St Paul's by 1402 had also acquired some copes of cloth of gold and matching sets of vestments. By 1411, Canterbury had acquired an astonishing 39 copes described as white copes of cloth of gold; see Legg and Hope, p. 105. Red, worn on the feast days of martyrs, is by far the most well-represented color in inventories at both Canterbury and St Paul's. Given the limited survival of full paint schemes on effigies, however, it is difficult to assess how accurately the vestments shown on effigies corresponded to those listed in inventories.

41. Monnas, pp. 181-245, considers the veracity of representations of garments in late medieval and Renaissance paintings. The complex artistic practices described in her study often led to fluidity or slippage between the real object and its representation. Monnas emphasizes the importance of conveying the wearer's status to the viewer, but notes that this was not always achieved through exact copy of existing textiles. On the accuracy of representations of textiles on twelfth-century cathedral portals, and on the legibility of these fictive garments as conveyors of meaning, see Janet E. Snyder, *Early Gothic Column-Figure Sculpture in France: Appearance, Materials, and Significance* (Surrey/Burlington: Ashgate, 2011), pp. 17-92, 164-87.

42. Medieval patrons accepted the lack of physical specificity, as the 1319 will drawn up for Dean John de Aquablanca of Hereford suggests. This document includes written instruction (a rare survival for this early date) for the making of his tomb. The Dean simply ordered a generic effigy 'of a dean in ecclesiastical vestments'; see Gardner, 'Tomb of Bishop Peter of Aquablanca', p. 105. On tomb effigies emphasizing group rather than individual identity, see Paul Binski, *Medieval Death: Ritual and Representation* (Ithaca: Cornell University Press, 1996), pp. 102-12. Medieval distinctions between episcopal office and the person who held that office only temporarily are discussed in detail by Ernst Kantorowicz, *The King's Two Bodies: A Study in Medieval Political Theology* (Princeton: Princeton University Press, 1957). Although not focused on effigies, Caroline Walker Bynum, 'Did the Twelfth Century Discover the Individual?' in *Jesus As Mother: Studies in the Spirituality of the High Middle Ages* (Berkeley: University of California, 1982), pp. 82-109; and Susan R. Kramer and Caroline Walker Bynum, 'Revisiting the Twelfth-Century Individual: The Inner Self and the Christian Community', in *Das Eigene und das Ganze: Zum Individuellen im mittelalterlichen Religiösentum*, ed. by Gert Melville and Markus Schürer (Münster: Lit, 2002), pp. 57-85, both demonstrate the importance to medieval writers of conforming to an exemplar rather than expressing individuality. Following Bynum, Dale, 'The Individual, the Resurrected Body', believes the conventionalized image of an effigy is a representation of the individual, but the individual who has been conformed to the divine exemplar. More generally on medieval portraiture, see Stephen Perkinson, *Likeness of the King: A Prehistory of Portraiture in Late Medieval France* (Chicago: University of Chicago Press, 2009), pp. 27-84, and more specifically on tomb effigies, pp. 85-134.

43. References to personal ties were avoided. On the effigial tombs from *c.* 1150–1300, heraldry was not often used. A notable exception is the Purbeck heart memorial for Bishop Aymer de Valence at the cathedral of Winchester. Family groupings of tombs were also rarer for prelates than for the laity. In some instances, family members who were canons in the cathedral did choose to be buried near their episcopal relatives, such as Peter and John of Aquablanca at Hereford, and Giles and Simon de Bridport at Salisbury, both in the 1260s, and a Burghersh family grouping at Lincoln. However, ecclesiastical members of the Bitton family at Wells were not buried near each other in the church. A third member of the family became the Bishop of Exeter and was buried there. Nor are family relationships prevalent on the inscriptions that survive. Joan Holladay, 'Portrait Elements in Tomb Sculpture: Identification and Iconography', in *Europäische Kunst um 1300*, ed. by Gerhard Schmidt (Vienna: H Böhlau, 1986), pp. 217-21, and Nigel Saul, 'Bold as Brass: Secular Display in English Medieval Effigies', in *Heraldry, Pageantry, and Social Display in Medieval England*, ed. by Peter Coss and Maurice Keen (Woodbridge: The Boydell Press, 2002), pp. 169-94 (p. 189), both note that greater specificity in costume, heraldry, and inscriptions, did occur in the later centuries of the Middle Ages. But while Holladay sees this as a step towards greater individualization, Saul interprets it as placing a person more firmly within a pre-existing group. See also, for identifying markers on secular brasses and tomb slabs, Sally Badham, 'Status and Salvation: The Design of Medieval English Brasses and Incised Slabs', *Transactions of the Monumental Brass Society*, 15:5 (1996), pp. 412-65.

44. Thanks to Warren Woodfin for this observation (personal

communication on 13 February 2010). For a priest, the alb, stole, maniple, and chasuble are the standard vesture for administering mass. Deacons and subdeacons wore the dalmatic or tunicle, respectively. Bishops wore all of the above. This was noted in the thirteenth-century work on the history, use, and symbolism of vestments written by William Durandus, *Durandus on the Sacred Vestments: An English Rendering of the Third Book of the* Rationale Divinorum Officiorum *of Durandus, Bishop of Mende*, ed. by T. H. Passmore (London: Thomas Baker, 1899), p. 84.

45. Copes were often used in representations of bishops in non-official imagery. Episcopal seals, like tomb effigies, omitted the cope. On only a very few later medieval brasses for lower-level ecclesiastics does the cope appear on a tomb, and in these cases the clothing may indicate that the person was not consecrated as a priest.

46. For example, a *c.* 1300 cope of English-work from Syon Abbey now in the Victoria and Albert museum (Christie, no. 75 and pls XCV–C), and the *c.* 1275 cope at Ascoli Piceno, probably made in England and formerly owned by Pope Nicholas IV (Christie, no. 50, pls XLII-XLV). These are entirely covered with embroidery, and the Ascoli Piceno cope also featured pearls and colored glass beads. Copes in the 1245 St Paul's inventory are described in Sparrow Simpson, pp. 475-80. At Canterbury, the copes of Archbishop Lanfranc were particularly rich, with added gems, gold, and silver-gilt bells, while two copes given by Archbishop Hubert Walter were covered with pearls; see Legg and Hope, p. 53.

47. The 970 *Concordia Regularis* stated that copes could be used at great feasts by all ranks of clergy, including monks. For this and other medieval statements regarding the use of copes, see Mayo, pp. 38-39, 53-55; Edmund Bishop, 'Origins of the Cope as a Church Vestment', *Liturgica Historica* (Oxford: Clarendon Press, 1918; repr. 1962), pp. 260-75.

48. Terence Bailey, *The Processions of Sarum and the Western Church* (Toronto: Pontifical Institute of Mediaeval Studies, 1971), p. 15.

49. Durandus, pp. 17-18.

50. The rite of episcopal ordination is found in pontificals and in sacramentaries. It usually consists of four parts: the election first, examination of the candidate, and then the conferral of episcopal authority in two parts, consecration and investiture. The collection of pontifical texts in *Les Ordines romani du haut Moyen Age*, ed. by Michel Andrieu, 5 vols (Louvain: Spicilegium Sacrum Lovaniense, 1931–61) includes *ordines* for episcopal consecration in vol. III, no. XXXIV and vol. IV, nos XXXV, XXXVA, XXXVB, XXXVI, XXXIX, XLA, XLB. These tend to date to around 1000, and are specific to Italy or northern Europe, but in their generalities they are consistent. *Le pontifical romain au Moyen Age*, ed. by Michel Andrieu, 4 vols (Vatican City: Biblioteca Apostolica Vaticana, 1938–41), I, pp. 138-52, has a pontifical from the twelfth century that combines the text from the

sacramentary as well as the directions for the ritual. For the Sarum rite in England, see William Maskell, *Monumenta ritualia ecclesiae Anglicanae*, 3 vols (Oxford: The Clarendon Press, 1882; 2nd edn), II, pp. cxxxii-cxlii, 268-90. For an overview of the process and its history, see the entry on episcopal consecration in Fernand Cabrol and Henri LeClercq, *Dictionnaire d'Archéologique Chrétienne et de Liturgie*, 15 vols (Paris: Letouzey et Ané, 1920–53), III, pt. 2, cols 2579-2604. The ritual was not always consistent. In the so-called Leofric Missal, the conferral of the staff and ring occurred at the confirmation of the bishop's election, not after his consecration as bishop; see *The Leofric Missal*, ed. by Nicholas Orchard, 2 vols (London: Harry Bradshaw Society, 2002), II, pp. 401-06. For a historical study of the legal, administrative, and jurisdictional issues involved in the conferral of insignia in the context of the investiture controversy, see Robert Benson, *The Bishop-elect: A Study in Medieval Ecclesiastical Office* (Princeton: Princeton University Press, 1968), pp. 203-372.

51. On the importance of ceremonies of investiture, see the essays in *Robes and Honor: The Medieval World of Investiture*, ed. by Stewart Gordon (New York: Palgrave, 2001), especially Michael Moore, 'The King's New Clothes: Royal and Episcopal Regalia in the Frankish Empire', pp. 95-135, and Janet Snyder, 'The Regal Significance of the Dalmatic', pp. 291-304.

52. Durandus, pp. 9-10. Dale, 'The Individual, the Resurrected Body', pp. 724-25, discusses Bruno of Segni (d. 1123), who, before Durandus, wrote of the significance of episcopal garments and their association with desirable character traits of the officeholder. Dale finds similar parallels between external markers of status and internal virtues in texts of royal consecration and coronation ceremonies. On the concept of the outer expressing the inner, in this case through gesture and comportment, see Jean-Claude Schmitt, 'The Ethics of Gesture', *Fragments for a History of the Human Body*, pt. 2, ed. by Michel Feher (New York: Zone, 1989), pp. 128-47.

53. There are few exceptions. The retrospective effigies at Wells Cathedral have their arms folded over their chests and may have closed eyes. An effigy in Llandaff Cathedral has closed eyes.

54 Margaret Aston, *England's Iconoclasts: Laws Against Images* (Oxford: Clarendon Press, 1988), pp. 98-159 (p. 110); Richard Deacon and Phillip Lindley, *Image and Idol: Medieval Sculpture* (London: Tate Gallery, 2001), pp. 25-37; Badham, '"A new feire peynted stone"', pp. 48–9; Park, 'The Polychromy of English Medieval Sculpture', p. 42; *The Color of Life: Polychromy in Sculpture from Antiquity to the Present*, ed. by Roberta Panzanelli (Los Angeles: J. Paul Getty Museum and Getty Research Institute, 2008), p. 2.

55. Cited in Badham, '"A new feire peynted stone"', p. 48.

56. *Rites of Durham*, ed. by J. T. Fowler (Durham: Surtees Society, 1903), p. 43.

57. Mechtild of Magdeburg, *The Flowing Light of the Godhead*,

trans. by Frank Tobin (New York: Paulist Press, 1998), books 2.4, 2.20, and 3. 1, the latter specifying that 'God's preachers, the holy martyrs, and the loving virgins shall stand up, for the highest honor is given to them'. In her visions, different colored robes often express different merits. Similarly, views of the elect in Herrad of Hohenbourg's *c.* 1180 compendium *Hortus Deliciarum*, ed. by Rosalie Green, 2 vols (London: Warburg Institute, 1979) showed the elect grouped and labeled according to religious merits, for example the view of the heavenly court on fol. 244r, where nine categories of saints are separated into tiers and labeled as apostles, martyrs, patriarchs, and so on. The text across the top of the image states that each will receive recompense in proportion to his merits. See also Caroline Walker Bynum, *The Resurrection of the Body in Western Christianity, 200–1336* (New York: Columbia University Press, 1995), p. 255.

58. Carolyn Marino Malone, *Facade as Spectacle: Ritual and Ideology at Wells Cathedral* (Leiden: Brill, 2004), pp. 58-69.

59. To name just a few, the north transept at Reims Cathedral; the central portal on the west façade at Notre-Dame, Paris; the central portal on the south transept at Chartres Cathedral; and the central portal on the west front at Poitiers. On the central portal of the west façade at Amiens Cathedral, the blessed are clothed, but the damned are not.

60. The effigy is currently in the north aisle of the choir. The bishop to whom the slab belonged is unknown, although Bishop Nigel (d. 1169) has been suggested. A date in the middle or the third quarter of the twelfth century is usually given for the monument. See S. Inskip Ladds, 'The Tournai Slab at Ely', *Transactions of the Cambridgeshire and Huntingdonshire Archaeological Society*, V (1937), pp. 177-80; George Zarnecki, *Early Sculpture of Ely Cathedral* (London: Alec Tiranti, 1958), p. 40; George Zarnecki, *Romanesque Lincoln: The Sculpture of the Cathedral* (Lincoln: Honywood Press, 1988), p. 96.

61. See the *oracio, secreta,* and *postcommunio* of the mass in *Manuale et Processionale ad Usum Insignis Ecclesiae Eboracensis*, ed. by W. G. Henderson (Durham: Surtees Society, 1875), p. 75*; and J. Wickham Legg, *The Sarum Missal, Edited from Three Early Manuscripts* (Oxford: Clarendon Press, 1916; repr. 1969), p. 434. See also the Office for the dead at Vespers in *Manuale et Processionale*, p. 68* (Sarum Use), and p. 64 (York Use).

62. Binski, *Becket's Crown*, pp. 81-84,123-46, discusses ideas about episcopal sanctity current in England at this time.

Notes to Chapter 9

˙ I would like to dedicate this article to Robert Suckale in memory of a highly stimulating course on 'Court Art of Emperor Charles IV', which he taught at the Technische Universität Berlin in 1992/93. Special thanks go to Andreas Puth for his help with the English translation.

1. Stephen H. Goddard, 'Brocade Patterns in the Shop of the Master of Frankfurt: An Accessory to Stylistic Analysis', *The Art Bulletin*, 67 (1985), 401-17; Hans Westhoff, *Graviert, gemalt, gepresst. Spätgotische Retabelverzierungen in Schwaben* (Stuttgart: Württembergisches Landesmuseum, 1996); Eike Oellermann, 'Die Schnitzaltäre Friedrich Herlins im Vergleich der Erkenntnisse neuerer kunsttechnologischer Untersuchungen', *Jahrbuch der Berliner Museen*, 31 (1991), pp. 213-38; Bart J. C. Devolder, 'The Representation of Brocaded Silks and Velvets in 15th and early 16th Century Netherlandish Paintings: Methods and Materials', *AIC PSG Postprints*, 21 (2009), pp. 62-75; Ingrid Geelen and Delphine Steyaert, *Imitation and Illusion: Applied Brocade in the Art of the Low Countries in the Fifteenth and Sixteenth Centuries* (Brussels: Royal Institute for Cultural Heritage, 2011). However, more recent scholarship has begun to move away from these issues; see Janet E. Snyder, *Early Gothic Column-Figure Sculpture in France* (Surrey/Burlington: Ashgate, 2011); Margaret Goehring, 'Taking Borders Seriously: the significance of cloth-of-gold textile borders in Burgundian and post-Burgundian Manuscript Illumination in the Low Countries', *Oud Holland*, 119/1 (2006), pp. 22-40; Jennifer E. Courts' essay (Chapter 10) in this volume.

2. Brigitte Klesse: *Seidenstoffe in der italienischen Malerei des 14. Jahrhunderts*, Schriften der Abegg-Stiftung Bern, 1 (Bern: Stämpfli, 1967); Anke Koch, 'Seidenstoffdarstellung auf den Altären Stefan Lochners', in *Stefan Lochner – Meister zu Köln, Herkunft – Werke – Wirkung*, ed. by Frank Günther Zehnder (Cologne: Wallraff-Richartz-Museum, 1993), pp. 149-56; Milena Bravermanová, 'Robe Fabrics on the Portraits in the Chapel of the Holy Cross at Karlštejn Castle', in *Court Chapels of the High and Late Middle Ages and their Artistic Decoration*, ed. by Jiří Fajt (Prague: National Gallery in Prague, 2003), pp. 114-23.

3. Birgitt Borkopp-Restle, *Der Aachener Kanonikus Franz Bock und seine Textilsammlungen. Ein Beitrag zur Geschichte des Kunstgewerbes im 19. Jahrhundert*, (Riggisberg: Abegg-Stiftung, 2008).

4. Walter Mannowsky, *Der Danziger Paramentenschatz. Kirchliche Gewänder und Stickereien aus der Marienkirche*, 5 vols. (Berlin/Leipzig: Seemann, 1931–38); *Liturgische Gewänder und andere Paramente im Dom zu Brandenburg*, ed. by Helmut Reihlen, Manfred Jehle, and Evelin Wetter (Regensburg: Schnell & Steiner / Riggisberg: Abegg-Stiftung, 2005); Juliane von Fircks, *Liturgische Gewänder des Mittelalters aus St Nikolai in Stralsund* (Riggisberg: Abegg-Stiftung, 2008); Evelin Wetter, 'Der Kronstädter Paramentenschatz. Altkirchliche Messgewänder in nachreformatorischer Nutzung. Mit einer Bestandserfassung in Zusammenarbeit mit Jana Knejfl-Fajt', *Acta Historiae Artium*, 45 (2004), pp. 257-315; see the catalogue raisonné on the Brașov (Kronstadt) textile treasure, Evelin Wetter, with contributions by Corinna Kienzler and Ágnes Ziegler, *Liturgische Gewänder in der Schwarzen Kirche zu Kronstadt in Siebenbürgen* (Riggisberg: Abegg-Stiftung, 2015). A publication on one of the most important medieval textile

treasures, the treasury in Halberstadt Cathedral, is currently being prepared by Barbara Pregla.

5. Jan Keupp, *Die Wahl des Gewandes. Mode, Macht und Möglichkeitssinn in Gesellschaft und Politik des Mittelalters* (Ostfildern: Thorbecke, 2010); *Fashion and Clothing in Late Medieval Europe / Mode und Kleidung im Europa des späten Mittelalters*, ed. by Rainer C. Schwinges and Regula Schorta (Riggisberg: Abegg-Stiftung / Basel: Schwabe Verlag, 2010); *Kleidung im Bild. Zur Ikonologie dargestellter Gewandung*, ed. by Philipp Zitzlsperger (Emsdetten and Berlin: Edition Immorde, 2010); Ulinka Rublack, *Dressing up: Cultural Identity in Renaissance Europe* (Oxford: Oxford University Press, 2010); Anne H. van Buren, *Illuminating Fashion: Dress in the Art of Medieval France and the Netherlands 1325–1515* (New York: The Morgan Library and Museum, 2011).

6. The former seen in Caroline Vogt, 'Episcopal self fashioning: The Thomas Becket Mitres', in *Iconography of Liturgical Textiles in the Middle Ages*, ed. by Evelin Wetter (Riggisberg: Abegg-Stiftung, 2010), pp. 117-28; Evelin Wetter, 'Von Bräuten und Vikaren Christi – Zur Konstruktion von Ähnlichkeit im sakralen Initiationsakt', in *Similitudo. Konzepte der Ähnlichkeit in Mittelalter und Früher Neuzeit*, ed. by Martin Gaier, Jeanette Kohl, and Alberto Saviello (Munich: Wilhelm Fink, 2012), pp. 129-46. The latter found in Cordelia Warr, *Dressing for Heaven: Religious Clothing in Italy 1215–1545* (Manchester/New York: Manchester University Press, 2010).

7. Lisa Monnas, *Merchants, Princes and Painters: Silk Fabrics in Italian and Northern Painting 1300–1550* (New Haven/London: Yale University Press, 2008); Rembrandt Duits, *Gold Brocade and Renaissance Painting: A Study in Material Culture* (London: Pindar Press, 2008); for a report on the current state of research on the art history of textiles, see also Anja Preiß, 'Zur neueren Erforschung der textilen Künste', *Kunstchronik*, 63 (2010), pp. 550-59.

8. Anton Podlaha and Eduard Šittler, *Chrámový poklad u sv. Víta v Praze. Jeho dějiny a popis* [*The Treasure of St Vitus in Prague: Its History and Appearance*] (Prague: Náklad dědictví sv. Prokopa, 1903); Karel Otavský, 'Der Prager Domschatz unter Karl IV. im Lichte der Quellen. Ein Sonderfall unter spätmittelalterlichen Kirchenschätzen', in *...das Heilige sichtbar machen. Domschätze in Vergangenheit, Gegenwart und Zukunft*, ed. by Ulrike Wendland (Regensburg: Schnell & Steiner, 2010), pp. 181-236; Kateřina Horníčková, 'In Heaven and on Earth: Church Treasures in Late Medieval Bohemia' (unpublished doctoral thesis, Central European University, Budapest, 2009).

9. Podlaha and Šittler, p. VI: '141. *Casula in brunetico insuto, quam dedit regina de Grecz Elyzabeth.* 142. *Casula in flaveo axamito cum liliis et litteris aureis insutis, quam dedit dna Blanca marchionissa Moraviae.* 143. *Casula in viridi axamito cum foliis magnis rotundis.* 144. *Casula de examito viridi cum piscibus cum perlis cum alba stola et humerali, quam dedit regina Romanorum et Boemiae, dna Anna. Item eadem regina donavit sollempnissi-*

mam casulam cum aquilis et leonibus in axamito flavo factis de perlis cum humerali pretioso cum alba et stola.'

10. Otto Gerhard Oexle, 'Memoria in der Gesellschaft und in der Kultur des Mittelalters', in *Modernes Mittelalter. Neue Bilder einer populären Epoche*, ed. by Joachim Heinzle (Frankfurt am Main: Insel Verlag, 1994), pp. 297-323.

11. *Privatsammlung aus Nachlaß Otto Bernheimer*, Munich, Otto Weinmüller, Auction 75, 9–10 December 1960, Catalogue, 83 (Munich: Weinmüller, 1960), lot 386, pl. 67.

12. Evelin Wetter, 'Palla mit Adler, Phönix und Pelikan' and 'Manipel', in *Zeit und Ewigkeit. 128 Tage in St Marienstern*, ed. by Judith Oexle, Markus Bauer, and Marius Winzeler (Halle an der Saale: Verlag Janos Stekovics, 1998), pp. 187-88, cat. nos 2.128-2.129; Marius Winzeler, 'Palla mit Adler, Phönix und Pelikan aus St. Marienstern', in *Krone und Schleier: Kunst aus mittelalterlichen Frauenklöstern* (Munich: Hirmer Verlag, 2005), pp. 398-90, cat. no. 285.

13. This connection has been proposed by Barbara Drake Boehm, 'Chasuble with Eagles', in *Prague, the Crown of Bohemia, 1347–1437*, ed. by Barbara Drake Boehm and Jiří Fajt (New Haven/London: Yale University Press, 2005), pp. 144-45, cat. no. 15; for a slightly extended version, see also Barbara Drake Boehm and Jiří Fajt, 'Kasel mit Adlern und Lilien', in *Karl IV. Kaiser von Gottes Gnaden. Kunst und Repräsentation des Hauses Luxemburg, 1310–1437*, ed. by Jiří Fajt in cooperation with Markus Hörsch and Andrea Langer (Berlin and Munich: Deutscher Kunstverlag, 2006), pp. 350-51, cat. no. 119.

14. This in indicated by her initials embroidered on the front orphrey of the chasuble.

15. Evelin Wetter, 'Kasel mit perlgestickten Adlern', in *Zeit und Ewigkeit*, pp. 184-85, cat. no. 2.215. For the examples mentioned, see for instance, Marie Schütte, *Gestickte Bildteppiche des Mittelalters*, 2 vols (Leipzig: Verlag Karl W. Hiersemann, 1927–30), II, pp. 13-14, pl. 7, altar cloth and super frontal with eagles from Isenhagen; pp. 48-49, pl. 43. For the chasuble cross and palla from the convent Marienborn near Helmstedt, once in the Berlin Kunstgewerbemuseum, but lost during the Second World War, see Gisela von Bock, 'Perlstickerei in Deutschland bis zur Mitte des 16. Jahrhunderts' (unpublished doctoral thesis, Rheinische Friedrich-Wilhelms-Universität Bonn, 1966), pp. 203-06, cat. nos 6-7, pls 31-32. In the palla, as well as in the stem of the chasuble cross, the eagles were combined with oak leaves and acorns, while the horizontal cross depicts the coronation of the Virgin accompanied tracery-like fields with roses, oak leaves and types of lilies; von Bock, pp. 235-36. See also the fragments of an orphrey combining eagles with the Agnus Dei in Frankfurt, Museum für Angewandte Kunst, inv. no. 16501a; and a corporal purse with an eagle and Agnus Dei; see Regula Schorta, 'Taschenbursa mit Perlstickerei', in *Der Quedlingburger Schatz wieder vereint*, ed. by Dietrich Kötzsche (Berlin: Ars Nicolai, 1992), p. 109, cat. no. 47. Regardless of how they were connected to each other before 1701,

these examples should be sufficient enough to prove that the eagles and lilies on the chasuble in Marienstern should be seen as symbols for Christ and Mary, rather than interpreted literally as the heraldic representation of a potential donor. See also Marius Winzeler, *St. Marienstern. Der Stifter, sein Kloster und die Kunst Mitteleuropas um 1300* (Dössel: Verlag Janos Stekovics, 2011), pp. 150-51.

16. Established by Charles IV himself in his autobiography and extended by contemporary chroniclers, this concept is based on an understanding of the emperor as God's representative on earth; see Hubert Herkommer, 'Kritik und Panegryrik: zum literarischen Bild Karls IV. (1346–1378)', *Rheinische Vierteljahresblätter*, 44 (1980), pp. 69-116 (pp. 87-89). Artistic patronage and faithful donations in connection with this concept have recently been intensively discussed with important results in various essays in *Prague, the Crown of Bohemia*, esp. pp. 3-21, 23-33, 59-73, and in *Karl IV. Kaiser von Gottes Gnaden*. See also *Kunst als Herrschaftsinstrument: Böhmen und das Heilige Römische Reich unter den Luxemburgern im europäischen Kontext*, ed. by Jiří Fajt and Andrea Langer (Berlin/Munich: Deutscher Kunstverlag, 2009), pp. 136-49, 300-08, also with references to the older literature.

17. Berlin, Gemäldegalerie – Staatliche Museen zu Berlin, inv. no. 1624. For a discussion of the painting's iconography, see Karel Chytil, 'Das Madonnenbild des Prager Erzbischofs Erst von Pardubitz im Kaiser Friedrich Museum', *Jahrbuch der Königlich Preußischen Kunstsammlungen*, 28 (1907), pp. 131-49; Robert Suckale, 'Die Glatzer Madonnentafel des Ernst von Padubitz als gemalter Marienhymnus. Zur Frühzeit der böhmischen Tafelmalerei, mit einem Beitrag zur Einordnung der Kaufmannschen Kreuzigung', *Wiener Jahrbuch für Kunstgeschichte*, 47 (1993/94), pp. 737-56 and pp. 889-92; reprinted with postscript in Robert Suckale, *Stil und Funktion. Ausgewählte Schriften zur Kunst des Mittelalters* (Berlin/Munich: Deutscher Kunstverlag, 2003), pp. 119-50; Jan Royt, 'Die ikonologische Interpretation der Glatzer Madonnentafel', *Umění*, 46 (1998), pp. 51-60; Stephan Kemperdick, *Deutsche und böhmische Gemälde, 1230–1430, Gemäldegalerie Berlin* (Berlin: Staatliche Museen zu Berlin – Stiftung Kulturbesitz/Petersberg: Michael Imhof Verlag, 2010), pp. 78-87, cat. no. 9.

18. See Zdenka Hledíková, *Arnošt z Pardubic. Archibiskup, zakladatel, rádce* [*Arnošt of Pardubic: Archbishop, Donor and Councillor*] Velké postavy českých dějin, 10 (Prague: Vyšehrad, 2008).

19. Bohuslaus Balbin, *Vita Venerabilis Arnesti. Primi Archiepiscopi Pragensis, Nobilitate Sanguinis, Sapientia ac Litteris [...]* (Prague: Archiepiscopali Typographia apud S. Benedictum in Collegio S. Norberti/Adamus Kastner, 1664), p. 310.

20. Liturgical robing has been analyzed in-depth by Joseph Braun, *Die liturgische Gewandung in Orient und Occident nach Ursprung und Entwicklung, Verwendung und Symbolik* (Freiburg im Breisgau: Herdersche Verlagshandlung, 1907); see also Dyan Elliott, 'Dressing and Undressing the Clergy: Rites of Ordination and Degradation', in *Medieval Fabrication: Dress, Textiles, Clothwork, and Other Cultural Imaginings*, ed. by J. E. Burns (New York: Palgrave Macmillan, 2004), pp. 55-69; Thomas Lentes, 'Die religiöse Ordnung des Gewandes', *Kunst und Kirche*, no. 4 (2010), pp. 19-22.

21. Suckale *Stil und Funktion*, p. 127 and Kemperdick, p. 83.

22. Chytil, pp. 141-44; Suckale, *Stil und Funktion*, pp. 124-26.

23. Kemperdick, p. 82.

24. Jelena Ivoš, 'Crkveno ruho riznice zagrebačke katedrale i dijecezanskog muzeja' ['Ecclesiastical Vestments in the Treasury of Zagreb Cathedral and the Diocese Museum'], in *Sveti trag. Devetsto godina umjetnosti zagrebačke nadbiskupije 1094–1994* [*The Holy Track: Nine Hundred Years Art in the Age of Zagreb*] (Zagreb: Muzejsko galerijski centar / Institut za povijest-majetnosti / Zagrebačka nadbiskupija, 1994), pp. 403-26 (p. 423, cat. no. 3); Silvia Giorgi, *La mitria di Sant'Isidoro*, Ospiti, 12 (Bologna: Museo Civico Medievale / Commune di Bologna, 1999), pp. 22-28; Heidi Blöcher, *Die Mitren des hohen Mittelalters* (Riggisberg: Abegg-Stiftung, 2012), pp. 189-81, cat. no. 2.

25. See for instance the pseudo-lampas-woven pattern of the cope of St Valerius: Mechthild Flury-Lemberg and Gisela Illek, *Spuren kostbarer Gewebe* (Riggisberg: Abegg-Stiftung, 1995), pp. 100-17, cat. no. 5c; Karel Otavsky and Muḥammad Abbās Muḥammad Salīm, *Mittelalterliche Textilien I, Ägypten, Persien und Mesopotamien, Spanien und Nordafrika* (Riggisberg: Abegg-Stiftung, 1995), pp. 190-94, cat. no. 106.

26. For instance a blue lampas in Stralsund, Kulturhistorisches Museum, inv. no. 1862: 12, see von Fircks, pp. 186-97, cat. no. 15 (pp. 188-89); see concerning the peacock-phoenix pattern (Fig. 7) von Fircks, pp. 101-25, cat. no. 4 and 4a (pp. 106-08); Otavský and Wardwell, pp. 264-73, cat. no. 102 (p. 268).

27. *Guillelmi Duranti Rationale Divinorum Officiorum I–VIII*, 3 vols, ed. by Anselme Davril and Timothy M. Thibodeau (Turnhout: Brepols, 1995–2000); Kristin Faupel-Drevs, *Vom rechten Gebrauch der Bilder im liturgischen Raum. Mittelalterliche Funktionsbestimmungen Bildender Kunst im Rationale Divinorum Officiorum des Durandus von Mende (1230/1–1296)* (Leiden/Boston/Cologne: Brill, 1995).

28. Podlaha and Šittler, p. XI, '(116) *Rudbertus de divinis officiis. Liber officiorum in mango vol.* (117) *Gemma animae* [...] (119) *Isodorus Ethimologiarum* (120) *In secundo vole. idem Isodorus Ethimologiarum melior primo*'; p. XXIV, '117. *Gemma animae.* 118 *Liber officiorum.* 119 *Speculum ecclesiae.* 120. *Rudbertus de officiis divinis.* 121 *Ysidorus ethimologiorum.*' – The first quotation concerns the inventory of 1354, the latter from the inventory of 1355. See also Andrea Denny-Brown, 'Old Habits Die Hard: Vestimentary Change in William Durandus's "Rationale Divinorum Officiorum"', *The Journal of Medieval and Early Modern Studies*, 39 (2009), pp. 545-70.

29. *Guillelmi Duranti Rationale*, I, p. 178.

30. Braun, p. 631.

31. *Guillelmi Duranti Rationale*, I, pp. 204–07.

32. *Guillelmi Duranti Rationale*, I, p. 205: '*Pontificis etiam dalmatica latiores habet manicas quam dyaconi, ad notandum quod ipse magis est expeditus, nichil habens quod ipsius manus restringat, quia pro celestibus omnia debet largiri. Caritas enim eius extendi debet etiam usque ad inimicos.*' For a summary of the various statements in liturgical writings on this topic, see also Braun, p. 725.

33. The sources to which I refer are the following: Wilhelm ab Hazmburg, 'Vita Venerabilis Arnesti primi Archiepiscopi Pragensis', in *Hagiographicus ser Bohemia Sancta: Continens Sanctos Et Beatos Bohemiæ, Moraviæ, Silesiæ, Lusatiæ [...]*, ed. by Bohuslaus Balbinus (Prague: Typis Georgij Czernoch, 1682), pp. 80–91 (pp. 85–86); Ernest in the chronicle of Beneš Krabice of Weitmil: *Scriptores rerum Bohemicarum e bibliotheca metropolitanae pragensis*, 3 vols (Prague: Náklad královské české společnosti náuk, 1783–1829), II, pp. 273-83 (pp. 379-80).

34. For the technological execution of the painting, see also Kemperdick, pp. 78-80.

35. *Guillelmi Duranti Rationale*, I, p. 178: '*Nono, anulum ut diligat sponsam sicut se.*' A more extensive explanation is to be found in the chapter 'De Anvlo. Anulus est fidei sacramentum quo Christus sponsam suam, sanctam Ecclesiam, subarauit [...]', *Guillelmi Duranti Rationale*, I, pp. 213-14.

36. *Guillelmi Duranti Rationale*, I, p. 178: '*mitram, ut si agat, quod coronam percipere mereatur eternam*'.

37. *Guillelmi Duranti Rationale*, I, pp. 209-13.

38. *Patrologiae Cursus Completus [...]. Series Latina* [PL], ed. by Jaques-Paul Migne, 221 vols. (Paris, 1844–65), CLXXII, col. 609A: '*Mitra etiam est Ecclesia, caput vero Christus, cuius figuram gerit episcopus.*'

39. Hazmburg, p. 85: '[...] *suo deinceps cum Martha solicita ministrare*'; *Scriptores rerum Bohemicarum*, II, pp. 379-80: '*Sed ipsi scientes ipsum Ecclesiae, sue sponsae, praeesse vtiliter, ab ipsius vinculo ipsum absoluere minime curauerunt.*'

40. *Scriptores rerum Bohemicarum*, II, p. 380: '*In signum namque desiderii sui praefati, coram imaginibus Dei, et beatae Virginis, quas quandoque in vitris, et aliis coloratis picturis fieri procurabat, deflexo in terram poplite pingebatur, ante cuius pedes omnia insignia Archiepiscopalia, tanquam ab eo dimissa et abiecta propter Deum, pingebantur.*'

41. See for instance Prague, Knihovna Metropolitní kapituly u Sv. Víta, sign. P7, fol. 1v: Anton Podlaha, *Die Bibliothek des Metropolitankapitels* (Prague: Verlag der Archaeologischen Commission der Böhmischen Kaiser Franz-Josef-Akademie für Wissenschaft, Litteratur und Kunst, 1904), pp. 241-45, cat. no. 119; Hana Hlaváčková, 'Arnošt z Pardubic mezi dvorem a církví. Iluminované rukopisy Arnošta z Pardubic' ['Arnošt of Pardubitz between Court and Church: Illuminated Manuscripts of Arnošt of Pardubic'], in *Arnošt z Pardubic (1297–1364). Osobnost – okruh – dědictví / Postác – środowisko – dziedzictwo* [*Arnošt z Pardubic (1297–1364): Personality, Circle, Heritage*], ed. by Lenka Bobková, Roszard Gładkievicz, and Petr Vorel (Wrocław/Prague/Pardubice: Uniwersytet Wrocławski/Univerzita karlova v Praze/ Univerzita Pardubice, 2005), pp. 207-12.

42. Michel Andrieu, *Le Pontifical Roman au Moyan-Âge*, 2 vols (Vatican City: Biblitheca Apostolica Vaticana, 1938) II, pp. 138-52; II, pp. 351-68.

43. Wardwell, pp. 108-12; for the weaving construction see Regula Schorta, 'Technische Aspekte gewebter Inschriften', in *Islamische Textilkunst des Mittelalters: Aktuelle Probleme* (Riggisberg: Abegg-Stiftung, 1997), pp. 139-43.

44. Kemperdick, p. 81.

45. For the complexity involved in understanding the names of medieval fabrics from different origins, see Wilhelm Heyd, *Geschichte des Lewantehandels im Mittelalter*, 2 vols (Stuttgart: Verlag der J. G. Cotta'schen Buchhandlung, 1879), II, pp. 688, 699. Already Ibn Baṭṭūṭa, in the second half of the fourteenth century uses the terms *panni tartarici* and *nachone* as synonyms, see *The Travels of Ibn Baṭṭūṭa, A.D. 1325–1354*, ed. by H. A. Gibb et al., 5 vols (Cambridge: Cambridge University Press, 1958–2000), II, p. 503; Thomas T. Allsen, *Commodity and Exchange on the Mongol Empire: A Cultural History of Islamic Textiles* (Cambridge: Cambridge University Press, 1997), pp. 2-4. See also Anne E. Wardwell, '"Panni tartarici": Eastern Islamic Textiles Woven with Gold and Silver (13th and 14th Centuries)', *Islamic Art*, 3 (1988–89), pp. 89-173. Concerning the discussion of oriental textiles in Prague inventories and transmission to Prague churches, see Evelin Wetter, '"De panno tartarico or de nachone?" The Perception of Oriental Silks at the Court of the Bohemian Kings during the Fourteenth Century', in *Oriental Silks in Medieval Europe,* ed. by Juliane von Fircks and Regula Schorta (Riggisberg: Abegg-Stiftung, in press).

46. *Guillelmi Duranti Rationale*, I, pp. 34-52.

47. *Guillelmi Duranti Rationale*, I, pp. 49: '*Quod autem ecclesia intus et non extra festiue ornatur, misterialiter innuit quod omnis gloria eius ab intus est.*' See also Faupel-Drevs, p. 298.

48. See on the colors of the Virgin's clothing Eva Sebald, 'Farben', in *Marienlexikon*, ed. by Remigius Bäumer and Leo Scheffczyk, 6 vols (Saint Ottilien: EOS Verlag, 1988–94), II, p. 442.

49. '*Quae autem non extra sed intus ornantur, ad moralem spon-*

sae spectant ornatum, cujus gloria est ab intus in fimbriis aureis, id est in perseverantia bonorum operum; licet enim et exterius nigra tribulationibus, est tamen intus formosa virtutibus.', PL, CCXIII, col. 44C .

50. Hans Patze, '"Salomon sedebit super solium meum" Die Konsistorialrede Clemens' VI. anläßlich der Wahl Karls IV.', *Blätter für deutsche Landesgeschichte*, 114 (1978), pp. 1-37.

51. Suckale, *Stil und Funktion*, pp. 126-27.

52. Patze, p. 7.

53. Patze, pp. 19-26.

54. Balbín, p. 310; Kemperdick, p. 82.

55. Kemperdick, p. 83.

56. New York, Morgan Library and Museum, inv. no. AZ022.1, AZ022.2. For the state of research and a concise statement on the political program of this diptych, see Jiří Fajt, 'Diptychon mit der Anbetung der Könige und dem Marientod', in *Karl IV. Kaiser von Gottes Gnaden*, p. 98, cat. no. 15a-b; for a shorter version of this entry, see Jiří Fajt, 'The Adoration of the Magi and The Dormition of the Virgin', in *Prague, the Crown of Bohemia*, pp. 153-54, cat. no. 25.

57. Evelin Wetter, 'Die Verfeinerung der Künste unter den Luxemburgern. Einführung', in *Kunst als Herrschaftsinstrument*, pp. 437-44.

58. Fajt, 'The Adoration of the Magi and The Dormition of the Virgin', p. 153.

59. Martina Giese, 'Der Adler als kaiserliches Symbol in staufischer Zeit', in *Staufisches Kaisertum im 12. Jahrhundert. Konzepte – Netzwerke – Politische Praxis*, ed. by Stefan Burkhardt, et al. (Regensburg: Schnell & Steiner, 2010), pp. 323-60.

60. Ernst Günther Grimme, 'Der Aachener Domschatz', *Aachener Kunstblätter*, 42 (1973), pp. 88-90, cat. no. 69. The later date is implied by the most recent discussion on his donations to the Aachen treasure, see Jiří Fajt, 'Reliquienmonstranz für den Gürtel Mariens', in *Karl IV. Kaiser von Gottes Gnaden*, pp. 385-86, cat. no. 123.

61. Riggisberg, Abegg-Stiftung, inv. nos 2655a-e and no. 1142; see Otavsky and Abbās, pp. 153-56, cat. no. 86; pp. 163-66, cat. no. 90.

62. Podlaha and Šittler, p. VI, no. 140.

63. Vienna, Kunsthistorisches Museum, Weltliche Schatzkammer, inv. no. XIII 15; see Rotraud Bauer et al., *Weltliche und Geistliche Schatzkammer. Bildführer* (Vienna: Residenz Verlag, 1987), pp. 147-48, cat. no. 152; Robert Suckale, *Die Hofkunst*

Kaiser Ludwigs des Bayern (Munich: Hirmer Verlag, 1993), pp. 34-36, 217-73, cat. no. 89.

64. Franz Kirchweger, 'The Coronation Robes of the Holy Roman Empire in the Middle Ages: Some Remarks on Their Form, Function and Use', in *Iconography of Liturgical Textiles in the Middle Ages*, ed. by Evelin Wetter (Riggisberg: Abegg-Stiftung, 2010), pp. 103-15 (p. 114).

65. Kirchweger, p. 115; Andreas Puth, '"Our and the Empire's Free City on the Rhine". Visualizing the Empire in the Mainz Kaufhaus Reliefs', in *Mainz and the Middle Rhine Valley: Medieval Art, Architecture and Archaeology*, ed. by Ute Engel and Alexandra Gajewski (Leeds: Maney Publishing, 2007), pp. 89-123.

66. The records of 1355 mention the eagle dalmatic and the cowl explicitly as '*phoenicea toga cum nigris aquillis, et unus globus*', or, in German, '*Braun Rok mit scwaczen Adelarn vnd eyn Gugell*'; Percy Ernst Schramm and Hermann Fillitz, *Denkmale der deutschen Könige und Kaiser, II. Ein Beitrag zur Herrschergeschichte von Rudolf I. bis Maximilian I. 1273–1519* (Munich: Prestel Verlag, 1978), p. 33. For more recent discussion, see Jürgen Petersohn, 'Über monarchische Insignien und ihre Funktion im mittelalterlichen Reich', *Historische Zeitschrift*, 266 (1998), pp. 47-96.

67. Metz, Conseil de fabrique de la cathédrale de Metz, Trésor de la Cathédrale Saint-Etienne de Metz, Cl. M. H. 20. mai 1975, see Ruth Grönwoldt, 'Kaisergewänder und Paramente', in *Die Staufer und ihre Zeit. Geschichte – Kunst – Kultur*, ed. by Reiner Haussherr, exhibition catalogue, Württembergisches Landesmuseum Stuttgart, 26 March – 5 June 1977, 5 vols (Stuttgart: Württembergisches Landesmuseum, 1977–79), I (1977), pp. 607-44 (pp. 616-17, cat. no. 775); Ruth Grönwoldt, 'Miszellen zur Textilkunst der Stauferzeit', in *Die Zeit der Staufer*, V (1979), pp. 389-418, especially pp. 393-405; see also Gilles Soubigou, 'La "Chape de Charlemagne" de la Cathédrale de Metz: étude historiographique', in *Textile Kostbarkeiten Staufischer Herrscher. Werkstätten – Bilder – Funktionen*, ed. by Irmgard Siede and Annemarie Stauffer (Petersberg: Michael Imhof Verlag, 2014), pp. 36–43; Elke Michler, 'Neue Forschungen zur sogenanten Chape de Charlemagne – Bestand Veränderungen, Schadensbilder und Konservierung', in *Textile Kostbarkeiten*, pp. 44–59.

68. Bettina Pferschy-Maleczek, 'Zu den Krönungsinsignien Kaiser Friedrichs II. Herkunft und Beduetung der nimbierten Adler auf den Krönungshandschuhen und der Metzer "Chape de Charlemagne"', *Mitteilungen des Instituts für österreichische Geschichtskunde*, 100 (1992), pp. 214-36, (pp. 232-33).

69. The later reception of the cope as connected to Charlemagne will form part of a cooperative research project to be carried out by Christoph Brachmann (University of North Carolina, Chapel Hill), Caroline Vogt and Evelin Wetter (both Abegg-Stiftung, Riggisberg), starting in 2014.

70. Schramm and Fillitz, pp. 32-33, Document C: '*Adest quoque*

*candida toga S. Caroli in manicis contexta lapidibus & unionibus,
& unum pallium s. Caroli cum duobus leonibus contextum ex auro
lapidibus unionibus; adest etiam aureaum pomum una cum aurea
cruce S. Caroli*.' Apart from the orb, these included the cope of
King Roger II and the white alb of King William II of Sicily,
both located in Vienna, Kunsthistorisches Museum, Weltliche
Schatzkammer, in. no. XIII 14 [the cope] and inv. no. XIII 7
[the alb]; for the most recent art-historical discussion and an
extensive bibliography, see Rotraud Bauer, 'Manto di Rogero
II', in *Nobiles officinae. Perle, filigrane e trame di seta dal Palazzo
Reale di Palermo*, ed. by Maria Andaloro (Catania: Giuseppe
Maimone Editore, 2003), pp. 44-49, cat. no. I.1; Rotraud Bauer,
'Alba di Giuliemo II', in *Nobiles officinae*, pp. 54-59, cat. no. I.3.

71. Podlaha and Šittler, p. LXII, no. 27.

72. Christoph Brachmann, 'Kaiser Karl IV. und der Westrand
des Imperiums. Politischer und künstlerischer Austausch mit
einer Innovations- und Transferregion', in *Kunst als Herrschafts-
instrument*, pp. 89-100 (p. 90). Concerning Charlemagne and
Charles IV, see also Zoë Opačić, 'Karolus Magnus and Karolus
Quartus: Imperial Role Models in Ingelheim, Aachen and
Prague', in *Mainz and the Middle Rhine Valley*, pp. 221-46.

Notes to Chapter 10

1. Paris, Musée du Moyen Âge; stored for the Musée du Louvre.
The panel measures 1.7 by 3.5 meters.

2. The transcribed inscription reads: '*Ce sont les representations
de nobles personnes messire Jehan Juvenal des Urssins chevalier
sauveur et baron de trainel. Conseillier du roy. Et damme mich[el]
le de Vitry. Sa fame. Et de leures enfans.
Reverend pe[re] en dieu messire Jeha[n] Juvenal des Urssins docteur
en loys et en decrect en so[n] temps evesq[ue] et co[m]te de beauvois.
Et demns ar[ch]e[v]esq[e] et duc de laon. Co[m]te d'Anisy per de
france conseillier du roy.
Ieh[ann]e Juvenal des Urssins q[ui] fu[t] [con]ioincte p[ar]
mariage aveq[ue] noble homme maistre nichole [***eschalart]
[con]se[il]l[e]r du R[oy].
Mess[ire] loys Juvenal des urssins ch[eva]l[ie]r co[n]se[il]l[e]r et
chambellan du Roy. Et bailli de troyes.
Dame J[e]h[an]ne Juven[al] des Urssins q[ui] fu[t] [con]ioi[n]cte
p[ar] mariage avecq[ue] pierre de cha[i]lli escuier. Et depui[s] a
messier guichart seign[eur] de pelvoisi[on] ch[eva]l[ie]r.
Damois[elle] eude Juv[e]n[al] des urssins q[ui] fu[t] [con]ioincte
p[ar] mariage a denis de mares esc[uier] seig[neur] de doue.
Deni[s] [J]uven[l] des Urssi(n)s. escuier eschanco[n] de mo[n]
s[ieur] loys dauphin de vienie et duc de guienne.
Seur M[arie] [Ju]ven[al] des Urssi[ns]. Relieuse a poyssy.
Mess[ire] guill[aum]e Juvenal des Urssins ch[eva]l[ie]r seign[eur]
et baron de trainel en son te[m]ps conseiller du roy. bailly de sens et
depuis chancelier de france.
Pierre iuvenal des Urssins escuier.
Michiel Juven[al] des Urssins escuier et seign[eur] de la chapelle
gaultier en brye.*

*Tres reve[re]nd pe[re] en dieu messire Jacq[ue]s Juven[al] des
urssins archevesque et duc de reims. Pr[e]mier per de fr[a]nce
co[n]se[i]ller du roy et pre[si]d[e]nt en la chamb[er] des co[m]
ptes*'. Transcribed from the original with assistance from Charles
Sterling, *La Peinture médiéval à Paris 1300–1500*, 2 vols (Paris:
Bibliothèque des Arts, 1987), I, pp. 29–30; Peter S. Lewis, Écrits
Politiques de Jean Juvénal des Ursins (Paris: Société de l'Histoire
de France, 1992), pp. 242–43.

3. Sterling, p. 30.

4. Jean Fouquet's famous portrait of Guillaume Jouvenel des
Ursins (Paris, Musée du Louvre, inv. no. 9619) is another exam-
ple of the family's use of painting to recreate the splendor of the
material world, a point I discussed in detail in an unpublished
paper given at the International Congress on Medieval Studies,
Kalamazoo in 2009 titled: 'A New Player in the Game of Art and
Legitimacy: Guillaume Jouvenel des Ursins and the Construc-
tion of Identity in Late Medieval Paris.'

5. For a complete discussion of the issues regarding the Jouvenel
des Ursins's nobility in modern scholarship, see Louis Battifol,
'Le nom de la famille Juvénal des Ursins', *Bibliothèque de l'École
des Chartes*, 50/1 (1889), pp. 537–58; Louis Battifol, 'L'origine
italienne des Juvenel des Ursins', *Bibliothèque de l'École des
Chartes* 54/1 (1893), pp. 693–717; Ch. Hirschauer and A.
de Boüard, 'Les Jouvenel des Ursins et les Orsini', *Mélanges de
l'école française de Rome* 32/1 (1912), pp. 49–67; Peter S. Lewis,
'La Noblesse des Jouvenel des Ursins', *L'État et les aristocraties:
France, Angleterre, Écosse, XIIe-XVIIe siècle*, ed. Philippe
Contamine (Paris: Presses de l'École Normale Supérieure,
1989), pp. 79–101.

6. Jean II Jouvenel des Ursins, *Histoire de Charles VI. Roy de
France, et des choses mémorable advanues durant quarante-deux
année de son règne depuis 1380 jusque en 1422*, ed. by Denys
Godefoy (Paris: l'Imprimerie royale, 1653).

7. Daisy Delogu, *Theorizing the Ideal Sovereign: The Rise of the
French Royal Biography* (Toronto: University of Toronto Press,
2008), p. 4.

8. Delogu, p. 13.

9. The full text of Jean II's first description of his family's origin
is as follows: '*Et furent aucuns chargés de trouver une personne
qui fust propre et habille à ce, et que celuy qu'ils auroient advisé,
ils le rapportassent au conseil. Lesquels enquirent en parlement,
chastelet, et autres lieux. Et entre les autres, ils rapporterent au roy
et au consiel, que en parlement y a avoit un advocat, bon clerc et
noble homme, nommé maistre Jean Juvenal des Ursins, et qu'il leur
sembloit qu'il seroit très-propre. En ce conseil plusiers y avoit, et
mesmement des nobles de Bourgongne, qui lui appartenoient, qui
pleinement dirent qu'ils respondoient pour luy, qu'il gouverneroit
bein l'office de la garde de la prevosté des marchands*.' Jouvenel des
Ursins, *Histoire de Charles VI*, pp. 364–65.

10. '*Et estoient ses predecesseurs extaits des Ursins de devers Naples, et de Rome du mont Jourdain, et furent amenés en France par un leur oncle, nommé messier Neapolin des Ursins, evesque des Mets. Et fut son pere, Pierre Juvenal des Ursins, bien vaillant homme d'arms, et l'un des principaux qui resista aux Anglois avec l'evesque de Troyes, qui estoit de ceux de Poictiers, et le comte de Vaudemont. Et quand les guerres furent faillies en France, s'en alla avec autres sur les Sarrasins, et là mourut, auquel Dieu fasse pardon.*' Jouvenel des Ursins, *Histoire de Charles VI*, p. 365.

11. Jouvenel des Ursins, *Histoire de Charles VI*, p. 365.

12. Jouvenel des Ursins, *Histoire de Charles VI*, p. 365.

13. Pierre Jouvenel's only participation in the Hundred Years' War is preserved in municipal documents from Troyes, indicating that he helped raise funds for the ransom of Jean le Bon in 1360; see Louis Battifol, 'Jean Jouvenel: Prévôt des Marchands de la Ville de Paris (1360–1431)' (unpublished doctoral thesis, University of Paris, 1894), p. 273.

14. On the use of historical prose in the construction and reinforcement of social systems in late medieval France, see Gabrielle M. Spiegel, *Romancing the Past: The Rise of Vernacular Prose Historiography in Thirteenth-Century France* (Berkeley: University of California Press, 1993).

15. Jean II's description of the festivities surrounding Berthold des Ursins in Paris read as follows: '*Le premier jour de mars, l'empereur d'Allemagne vint entre á Paris. Et furent dau dvant de luy le duc de Berry, prelates, nobles, et ceux de la ville en grand nobre. Et vint descendre au Palais où le roy estoit, lequel vint au devant de luy jesques au haut des degrees du beau roy Philippes. Et là s'entraceollerent, et firent grande chere l'un á autre. Il avoit en sa compagnée un prince qu'on appelloit le grand comte de Hongrie, le comte Bertold des Ursins, un bien sage et prudent seigneur, et autres princes et barons. Et sembloit qu'il avoit grand desir de trouver accord ou expedient entre les roys de France et d'Angleterre. Il fut grandement et honorablement recu, et souvent festoyé par le roy, et les seigneurs: et ses gens encores plus souvent. Et mesmement ledit Jean Juvenal des Ursins seigneur de Traignel, festoya ledit grand comte de Hongrie, le comte Bertold, et tous les autres, excepté l'empereur. Et fit venir les dames et damoiselles, des menestriers, jeux, farses, chantres, et autres esbatemens: et combine qu'il eust accoustumé de festoyer tous estraners, toutesfrois specialment il les voulut grandement festoyer, en faveur dudit comte Bertold des Ursins, pource qu'ils estoient d'un nom, et armes. Et du festoyement et reception furent bien contens le roy, l'empereur et les seigneurs.*' Jouvenel des Ursins, *Histoire de Charles VI*, p. 530.

16. Jouvenel des Ursins, *Histoire de Charles VI*, p. 530.

17. Jouvenel des Ursins, *Histoire de Charles VI*, p. 530. Batiffol, in discussing the validity of Jean II's account, points out that Jean I is never documented as having used the 'des Ursins' title and that the arms of the Germanic Ursins family are different than that of the French family. Battifol, 'Jean Jouvenel', p. 231.

18. The public performance and perception of noblesse, is discussed in a variety of sources including Françoise Autrand, 'L'image de la noblesse en France à la fin du Moyen Âge. Tradition et nouveauté', *Comptes-rendus des séances de l'Académie des Inscriptions et Belles-Lettres* 123/2 (1979), pp. 340–54; Marie-Thérese Caron, *Noblesse et Pouvoir en France XIIIe-XVIe siècle* (Paris: Armand Colin, 1994); Philippe Contamine, *La noblessse au royaume de France de Philippe le Bel à Louis XII: Essai de synthèse* (Paris: Presses Universitaires de France, 1997); Etienne Dravasa, *"Vivre Noblement". Recherches sur las dérogeance de noblesse du XIVe au XVIe siècles* (Bordeux: Imprimerie Biere, 1965); and Gareth Prosser, 'Later Medieval French Noblesse', in *France in the Later Middle Ages 1200–1500*, ed. David Potter (Oxford: Oxford University Press, 2002), pp. 182–209. For more on the concept of 'Living Nobly' in the larger world of Valois rule during the fifteenth century, see Jean C. Wilson, *Painting in Bruges at the Close of the Middle Ages: Studies in Society and Visual Culture* (University Park, PA: Pennsylvania State University Press, 1998); Wim De Clerq, Jan Dumolyn, and Jelle Haemers, '"Vivre Noblement": Material Culture and Elite Identity in Late Medieval Flanders', *Journal of Interdisciplinary History*, 38/1 (Summer 2007), pp. 1–31.

19. Autrand, p. 342; Wilson, p. 25.

20. Prosser, pp. 182–209.

21. On the use of a banquet to display wealth and therefore reinforce prestige, see Brigitte Buettner, 'Past Presents: New Year's Gifts at the Valois Courts, ca. 1400', *The Art Bulletin*, 83/4 (Dec. 2001), pp. 598–625 (p. 612). See also Roy Strong, *Feast: A History of Grand Eating* (Orlando: Harcourt, 2002).

22. Jean II Jouvenel des Ursins, 'Traité du Chancelier', in *Écrits Politiques de Jean Juvénal des Ursins*, ed. by P. S. Lewis, 2 vols (Paris: C. Klincksieck, 1978–1985), I, p. 477.

23. Jean II's discussion of his grandfather in the *Traité du Chancelier* is as follows: '*Son pere, Pierre Juvenal des Urssins, le laissa josne estudiant a Orleans, et s'en ala, aprez que les guerres furent falliez, a Naples vers la royne de Naples, pour savoir se il pourroit recouvrer des terres de Juvenal des Urssins, son ayeul, et en porta les lettres et tiltres qu'il avoit deça; et ou pais avoit guerre, et y fut quatre ans ou service de ladicte dame en armes, et depuis y eut accords, et fut en ung voyage dessus les Sarrasins et la morut*'; Jouvenel des Ursins, 'Traité du Chancelier', I, p. 477; Batiffol suggests that the name Juvenal was the French version of the Italian Giovenale. Louis Batiffol, 'L'origine italienne des Juvenal des Ursins', p. 696.

24. Falsifying genealogy is not unknown in fifteenth-century northern Europe. Elizabeth Brown has recently explored the de Chabannes' construction of ancestry in a paper given at the symposium at the J. Paul Getty Museum in February 2011 entitled: "Princely Pretensions and Fictive Pasts: Antoine and Jean de Chabannes and the Fabled Counts of Dammartin." Additionally, Guyont Duchamp, châtelain of Argilly (1437), visually falsified his lineage, claiming nobility. He supported this

by asserting that multiple generations of his family had faithfully lived nobly serving the Valois dukes of Burgundy. His verbal claim was supported by a series of ancestral portraits that were later proved to be fakes. Wilson, p. 48.

25. For detailed discussions on the *vidimus*, see Batiffol, 'L'Origine Italienne des Juvenel des Ursins', and 'Le nom de la famille Juvénal des Ursins'. Also see Hirschauer and De Boüard.

26. Hirschauer and De Boüard, p. 53. Batiffol gives the name as 'Latinus'; Batiffol, 'Le nom Jouvenel', p. 543.

27. Batiffol, 'Jean Jouvenel', p. 273.

28. Lewis, 'La noblesse des Jouvenel des Ursins', pp. 82–83.

29. Lewis, 'La noblesse des Jouvenel des Ursins', p. 81.

30. Lewis, 'La noblesse des Jouvenel des Ursins', p. 82.

31. Drawn from around the kingdom, the Marmousets were comprised of men primarily of merchant class backgrounds who acquired titles of nobility as the result of their prestigious governmental appointments between 1374 and 1375. Members included Bureau de la Rivière, Jean le Mercier, Enguerrand de Coucy, Jean de la Grange, Arnaud de Corbie, Pierre de Chevreuse, and Nicholas du Bosc. For a full discussion of the role of the Marmousets in the governments of Charles V and Charles VI, see John Bell Henneman, *Oliver de Clisson and Political Society in France Under Charles V and Charles VI* (Philadelphia: University of Pennsylvania Press, 1996).

32. For the most in-depth discussion of Jean Jouvenel's life, see Battifol, 'Jean Jouvenel'.

33. Battifol, 'Jean Jouvenel', pp. 36, 56–69.

34. Jean Jouvenel was a client to Bureau de la Rivière. Clientage can be described as an alternative to feudalism that developed during the later Middle Ages in France where political alliances were not based on traditional landed noble status, but instead extended to gain the political, financial, and military support from various upwardly mobile men of humble origin.

35. Battifol, 'Jean Jouvenel', pp. 60, 92.

36. Battifol, 'Jean Jouvenel', p. 132.

37. Battifol, 'Jean Jouvenel', p. 213.

38. Battifol, 'Jean Jouvenel', p. 245.

39. Battifol, 'Jean Jouvenel', pp. 171–72.

40. Jean II's writings have been most extensively discussed in: Écrits politiques de Jean Juvénal des Ursins, 3 vols, ed. by P.S. Lewis and Anne-Marie Hayez (Paris: C. Klincksiek, 1978–1992).

41. M. C. P. Gueffier, *Description historique des curiosités de l'église de Paris* (Paris: Gueffier, 1763).

42. Gueffier, pp. 162–63.

43. Michael T. Davis, 'Splendor and Peril: The Cathedral of Paris, 1290–1350', *Art Bulletin*, 80/1 (March 1998), pp. 34–66 (p 45).

44. Davis, pp. 45–46.

45. Lewis, Écrits Politiques, I, p. 246. Lewis maintains that Paul Durrieu proved conclusively that Jean II was the patron, but the late nineteenth-century transcripts no longer exist. By contrast, Charles Sterling promotes Jacques Jouvenel as the patron. Sterling, p. 35.

46. For a complete discussion of the function of the painting as part of the family's total donation to the chapel, see Jennifer E. Courts, 'The Politics of Devotion: Patronage and the Sumptuous Arts at the French Court (1374–1472)' (unpublished doctoral dissertation, Florida State University, 2011). Personal memorials are discussed fully in: Truus van Bueren, 'Care for the Here and the Hereafter: a Multitude of Possibilities', in *Care for the Here and the Hereafter: 'Memoria', Art and Ritual in the Middle Ages*, ed. by Truss van Bueren and Andrea van Leerdam (Turnhout: Brepols, 2005), pp. 13–34.

47. Bueren, p. 14.

48. See Mary Whiteley for discussion of the privatization of royal and ducal spaces; Mary Whiteley, 'Royal and Ducal Palaces in France in the Fourteenth and Fifteenth Centuries: Interior, Ceremony and Function', in *Architecture et vie sociale: l'organisation intérieure des grandes demeures à la fin du Moyen Âge et a la Renaissance,* ed. by Jean Guillaume (Paris: Picard, 1994), pp. 47–63; Mary Whiteley, 'Le Louvre de Charles V: dispositions et functions d'une résidence royal', *Revue de l'Art,* 97 (1992), pp. 60–71.

49. On the use of tapestry to construct space, see Laura Weigert, *Weaving Sacred Stories: French Choir Tapestries and the Performance of Clerical Identity* (Ithaca: Cornell University Press, 2004); Laura Weigert, 'Chambres d'amour Tapestries of Love and the Texturing of Space', *Oxford Art Journal*, 31/3 (2008), pp. 317–336 (p. 325); Kate Dimitrova, 'À la manière française: les modèles du XIVe siècle et la création des tapisseries offertes à la cathédrale de Saragosse par Dalmau de Mur', in *El Trecento en obres: Art de Catalunya i Art d'Europa al segle XIV*, ed. by Rosa Alcoy (Barcelona: Universitat de Barcelona, 2009), pp. 479–87.

50. Sterling identifies these figures, from left to right, as Saint James the Major, Saint Paul, Saint John the Evangelist, Saint Jude, Saint Thomas, and Saint Philip. Sterling, pp. 32–33. Kraus alternately identifies the third figure tentatively as John the Baptist, the fourth figure as Saint Thomas à Becket, and the fifth figure as either Saint Jude or Saint Simon. Henry Kraus, 'Notre-

Dame's Vanished Medieval Glass: The Iconography,' *Gazette des Beaux-Arts* 68 (1967), pp. 131–47 (pp. 141–42).

51. Kraus, p. 142.

52. In this, I disagree with, who argues that the space is representative of Notre-Dame de Paris; Kraus, pp. 140–42.

53. London, British Library, Add. Ms. 1885.

54. Eberhard König tentatively identifies this space as Anne's private oratory; Eberhard König, *The Bedford Hours: The Making of a Medieval Masterpiece* (Luzern: Faksimile Verlag, 2007), p. 124.
55. König, p. 124.

56. Two compelling examples of stained glass that incorporates the arms and/or pseudo-heraldic symbols in the construction of identity are: 1) the diptych by Hans Memling representing Martin van Nieuwenhove in prayer before an image of the Virgin (1487; Bruges, Hospitaalmuseum Sint-Janshospitaal); and 2) the central panel of the *Annunciation Triptych* (*Merode Altarpiece*; *c.* 1427–32, by the workshop of Robert Campin, New York, Metropolitan Museum of Art, The Cloisters Collection, inv. no. 56.70).

57. John, Duke of Bedford's arms display the quartered arms of France and England, adopted as the arms of France by Henry V, along with the silver label at the top that identifies him as the younger brother. His motto '*a vous entier*', appears on banners striped with his livery colors of blue, white, and red in the margins, and also on the livery-banded tapestries that drape his *prie-dieu* and help define his space of prayer. John's emblem—a tree stump with tendril-like roots attached, or woodstock—is additionally featured on the pseudo-heraldic tapestries and throughout the page's margins.

58. König states that the textiles serve as a device designed by the Bedford Master to negotiate spatial issues. He does not entertain the notion that tapestry could have been used to construct spaces. König additionally overlooks similar use of textiles to define space of personal prayer within larger structures as represented in other media, such as the fourteenth-century stained glass portrait of Charles VI in Evreux Cathedral. See König, *Bedford Hours*, p. 124; Weigert, *Weaving Sacred Stories*; and Weigert, 'Chambres d'amour'.

59. Brussels, Bibliothèque royale de Belgique Ms. 9092, fol. 9r.

60. Weigert, 'Tapestries of Love', p. 325.

61. To my knowledge, no publications exist concerning this set of tapestries. They are discussed in detail by Marie-Hélène de Ribou: 'Tapestry of the Bears', Louvre, accessed 16 November 2014, http://www.louvre.fr/en/oeuvre-notices/tapestry-bears, Paris, Musée du Louvre, inv. no. OA 10372. The larger of the panels measures 2.54 by 4.55 meters, and is woven in wool and silk at six to seven warps per centimeter. The exact dimensions

of the smaller panel are not published. Visual evidence suggests that the smaller panel was cut down from a larger tapestry; however, there is no estimation of the measurement of the two panels together.

62. Ribou.

63. Although this portion of the tapestry is extremely faded, it may represent another young bear.

64. The initial "J" used as an ornamental motif is found only in books owned by the Guillaume Jouvenel des Ursins, including the *Mare Historiarum* (Paris, Bibliothèque nationale de France, ms. Latin 4915), and his book of hours (Paris, Bibliothèque nationale de France, ms. n.a. Latin 3226).

65. For the etymological history of common names for *Acanthus mollis*, see William T. Stearn, 'The Tortuous Tale of "Bear's Breech", the Puzzling Bookname for "Acanthus mollis"', *Garden History Society*, 24/1 (Summer 1996), pp. 122–25.

66. Nicole Reynaud, 'Les Heures du chancelier Guillaume Jouvenel des Ursins et la peinture parisienne autour de 1440', *Revue de l'art*, 126 (1999), pp. 23–35 (p. 27).

67. The escutcheon hanging in the center of the larger panel is more difficult to interpret. Ribou suggests that this shield represents the arms of the English Sydenhall family—sable, three dexter hands or, apaumé, and couped. In contrast, the dismembered hands represented against the sable background in the Jouvenel des Ursins tapestry panel are depicted dorsed—with the back of the hand, not the palm, facing forward. Distinctive stitching visible around the unusual device indicates that it may have been a later addition to the panel and perhaps included by subsequent owners. The smaller panel, rather than bearing the arms of the Orsini family, displays an escutcheon argent, three lions azure rampant. The heraldry present is consistent with a design instituted for Walter Mildmay (*c.* 1520–89), the Chancellor of the Exchequer of England under Elizabeth I. The inclusion of sixteenth-century English heraldry on a fifteenth-century French tapestry once again indicates that the Mildmay arms were a later addition to the series originally woven for Guillaume Jouvenel des Ursins. The addition of two, later heraldic shields of English origin prompts many questions about the long journey from the *Tapestries of the Bears* original owner, Guillaume Jouvenel des Ursins, to their current repository in the Louvre. For more on the sixteenth-century heraldry present, see John Burke and John Bernard Burke, *A Genealogical and Heraldic History of the Extinct and Dormant Baronetcies of England*, 2nd edn (London: John Russell Smith, 1844), p. 355.

68. Another potential location for display of the heraldic tapestry was the Hôtel de la Chancellerie in Tours.

69. Although documentary evidence does not record a suite of textiles that can be identified with the *Tapestry of the Bears*, the presence of armorial images suggest they were used in a secular

location. My thanks to Laura Weigert who confirmed my speculations in email correspondence (11 November 2009).

70. Paris, Bibliothèque nationale de France ms. lat. 4915.

71. P. S. Lewis, 'The Chancellor's Two Bodies: Note on a Miniature in BNP lat. 4915', *Journal of the Warburg and Courtauld Institutes*, 55 (1992), pp. 263–65; Nicole Reynaud and Peter Lewis, 'Sur la Double Representation de Guillaume Jouvenel des Ursins et sur ses Emblèmes', *Revue de la Bibliothèque nationale*, 44 (1992), pp. 50–57. This is in opposition to Sterling who argues that this is Guillaume's brother, Louis Jouvenel des Ursins. Sterling, p. 35. Identification of both figures as Guillaume is confirmed by a drawing of the now-lost bronze tomb of the chancellor from the Roger de Gaignières collection. The drawing reproduces the complete original inscription around the tomb that celebrates the military and administrative achievements of the Guillaume Jouvenel des Ursins. A more frequently reproduced image (Paris, Bibliothèque nationale de France, Ms. Estampes, Pe 9, fol. 94r), which is more refined in its technical execution, contains only a partial reproduction of the tomb. Because it is missing a large portion of the text, this may have been the source of Sterling's incorrect identification of the second figure as Louis Jouvenel des Ursins.

72. David Potter, 'King and Government Under the Valois', in *France in the Later Middle Ages 1200–1400*, ed. by David Potter (Oxford: Oxford University Press, 2002), pp. 155–81 (p. 158).

73. For a detailed discussion of the use and value of 'pomegranate' cloth of gold in the fifteenth and sixteenth centuries, see Lisa Monnas, *Merchants, Princes and Painters: Silk Fabrics in Italian and Northern Paintings 1300–1550* (New Haven: Yale University Press, 2008), pp. 258–65.

74. The two widows retired to convents after the deaths of their husbands, and the youngest sister, Marie, was never married, but instead was a nun at the prestigious royal abbey at Poissy.

Notes to Chapter 11

* This article updates a paper given at the 3rd *Shahnama* Conference, 'Illustrating the Narrative', University of Edinburgh, 8–9 March 2003. The author wishes to acknowledge the editors of the present volume, Kate Dimitrova and Margaret Goehring, for their kind concern, patience, and encouragement.

1 The Great Mongol *Shahnama* does not survive in its entirety, and its illustrations and text pages are currently scattered among several private and public collections. Grabar and Blair suggest that the manuscript originally had approximately 280 folios with some 120 illustrations; see Oleg Grabar and Sheila Blair, *Epic Images and Contemporary History: The Illustrations of the Great Mongol Shahnama* (Chicago: University of Chicago Press, 1980), p. 12, Appendix 2. Blair, however, corrects the estimate

of the number of illustrations in her article published in 2004, from 120 to some 180 to 200; Sheila S. Blair, 'Rewriting the History of the Great Mongol Shahnama', in *Shahnama: The Visual Language of the Persian Book of Kings*, ed. by Robert Hillenbrand (Aldershot: Ashgate, 2004), p. 37.

2. A number of exhibitions and conferences took place in 2010 to celebrate the millennium of the production of the Book of Kings. Among the recent publications on *Shahnama* studies, see Barbara Brend and Charles Melville, *Epic of the Persian Kings: The Art of Ferdowsi's Shahnama* (London: I. B. Tauris, 2010).

3. See *The Legacy of Genghis Khan: Courtly Art and Culture in Western Asia, 1256–1353*, ed. by Linda Komaroff and Stefano Carboni (New York: Metropolitan Museum of Art/Yale University Press, 2002), pp. 99-102, 153-55.

4. Although no colophon of the Great Mongol *Shahnama* survives, this manuscript has been connected to the patronage of Ghiyath al-Din; see Grabar and Blair, pp. 46-55.

5. The text panels measure 410 x 290 mm, according to Grabar and Blair, p. 5. For further discussion on the paper size of Ilkhanid painting, see Jonathan M. Bloom, *Paper before Print: The History and Impact of Paper in the Islamic World* (Hew Haven: Yale University Press, 2001), pp. 62-65. It remains difficult to trace the exact provenance of the manuscript, although some scholars suggest it was rediscovered at several stages in history; see Jonathan M. Bloom, 'The Great Mongol Shahnama in the Qajar Period', in *Shahnama*, p. 25.

6. For the ideological aspect of the manuscript, see Grabar and Blair, pp. 13-27; for the interpretation of the manuscript as a chronicle of the Mongol rulers, see Abolala Soudavar, 'The Saga of Abu-Saʿid Bahādor Khān. The Abu-Saʿidnāmé', in *The Court of the Il-Khans 1290–1340*, ed. by Julian Raby and Teresa Fitzherbert (Oxford: Oxford University Press, 1996), pp. 95-217.

7. The most complete study of the extant fifty-seven illustrations of the Demotte *Shahnama* remains by Grabar and Blair. Twenty-five illustrations of the manuscript have been displayed at the Ilkhanid art exhibition; see Komaroff and Carboni, cat. nos 36-61. The extent of later restorations is beyond the scope of this paper. Although some alterations may have been necessary to repair damage, it is likely that, except for some heavily repainted pages, most illustrations have kept their original features; see Sarah Bertalan's technical study of the Demotte leaves in Komaroff and Carboni, p. 228.

8. This idea is clearly manifested in the *Jamiʿ al-Tawarikh* ('Compendium of Chronicles') of Rashid al-Din; see Thomas T. Allsen, *Culture and Conquest in Mongol Eurasia* (Cambridge: Cambridge University Press, 2001), p. 197; Ilkhanid copies of the Rashid al-Din manuscript will be referred to in the following discussion.

9. *The Sháhnáma of Firdausí*, trans. by Arthur George Warner and Edmond Warner, 9 vols (London: Kegan Paul, 1905-25; rep. London: Routledge, 2000), V, p. 251.

10. See James C. Y. Watt and Anne E. Wardwell, *When Silk Was Gold: Central Asian and Chinese Textiles* (New York: Metropolitan Museum of Art, 1997), pp. 107-25, especially p. 110, fig. 44.

11. See Anne E. Wardwell, 'Flight of the Phoenix: Crosscurrents in Late Thirteenth-to Fourteenth-century Silk Patterns and Motifs', *Bulletin of the Cleveland Museum of Art*, 74, no. 1 (1987), pp. 2-35; Anne E. Wardwell, 'Two Silk and Gold Textiles of the Early Mongol Period', *Bulletin of the Cleveland Museum of Art*, 79, no. 10 (1992), pp. 354-79.

12. For further discussion, see Yuka Kadoi, *Islamic Chinoiserie: The Art of Mongol Iran* (Edinburgh: Edinburgh University Press, 2009), p. 56. Although no Ilkhanid pattern books are known to survive, a stucco plate showing the architectural plan for a *muqarnas* vault was discovered at the Mongol palace at Takht-i Sulayman in north-west Iran. For a recent study of the plate, see Yvonne Dold-Samplonius and Silvia L. Harmsen, 'The Muqarnas Plate Found at Takht-i Sulayman: A New Interpretation', *Muqarnas*, 22 (2005), pp. 85-94.

13. Boston, Museum of Fine Arts, inv. no. 22.393; see Grabar and Blair, cat. no. 24.

14. See Warner and Warner, V, pp. 273-76.

15. See Julia Bailey, 'Set Forth as a Feast', *Hali*, 119 (2001), pp. 103-05 (pp. 103-04). For Tartar velvets, see Milton Sonday, 'A Group of Possibly Thirteenth-century Velvets with Gold Disks in Offset Rows', *Textile Museum Journal*, 38-39 (1999–2000), pp. 101-51.

16. For a list of 'Tartar cloth with gold disks (or coins)' found in church inventories, see Anne E. Wardwell, 'Panni Tartarici: Eastern Islamic Silks Woven with Gold and Silver (13th and 14th Centuries)', *Islamic Art*, 3 (1988–89), pp. 95-173 (p. 139); see also Lisa Monnas, 'Dress and Textiles in the St Louis Altarpiece: New Light on Simone Martini's Working Practice', *Apollo*, 137, no. 373 (March, 1993), pp. 170-01.

17. Chicago, Art Institute of Chicago, inv. no. 1911.202.

18. For a recent study of medieval Islamic textiles in Europe, see David Jacoby, 'Oriental Silks Go West: A Declining Trade in the Later Middle Ages', in *Islamic Artefacts in the Mediterranean World: Trade, Gift Exchange and Artistic Transfer*, ed. by Catarina Schmidt Arcangeli and Gerhard Wolf (Venice: Marsilio, 2010), pp. 71-88. In particular, the Ilkhanid or broadly Mongol textiles found in the tomb of Cangrande della Scala (d. 1329) in Verona are of utmost importance; see *Cangrande della Scala: La morte e il corredo di un principe nel medioevo europeo*, ed. by Paola Marini, Ettore Napione, and Gian Maria Varanini (Venice: Marsilio,

2004); I am most grateful to Ettore Napione for the information on the exhibition and its catalogue.

19. 'Of gold-woven brocade / They made his winding-sheet, while all bewailed him, / And, having shrouded thus that noble form / Beneath brocade of Chín, they covered it / With honey to the feet and then sealed down / The lid of that strait coffin.'; Warner and Warner, VI, p. 184.

20. It remains unclear whether this type of textile was produced in Ilkhanid Iran or in Mamluk Egypt or Syria. Wardwell notes that Mamluk weavers, who migrated to Iran in the thirteenth and early fourteenth centuries, may have been involved in the production of this type of textile; see Wardwell, 'Panni Tartarici', p. 115. For further information, see Komaroff and Carboni, p. 260, cat. no. 70.

21. For further discussion of Mongol dress during the thirteenth and fourteenth centuries, see Thomas T. Allsen, 'Robing in the Mongol Empire', in *Robes and Honor: The Medieval World of Investiture*, ed. by Stewart Gordon (New York: Palgrave, 2001), pp. 305-13; Baohai Dang, 'The Plait-line Robe: A Costume of Ancient Mongolia', *Central Asiatic Journal*, 47, no. 2 (2003), pp. 198-216.

22. In relation to this point, it is interesting to compare the pictorial conventions of textiles in medieval Persian manuscript painting and Renaissance painting. The latter, which depicts a number of Tartar silks, is discussed in detail by Lisa Monnas, *Merchants, Princes and Painters: Silk Fabrics in Italian and Northern Paintings 1300–1550* (Hew Haven: Yale University Press, 2008), pp. 217-45.

23. The standard study of this type of textile is by Wardwell, 'Panni Tartarici'; see also Karel Otavský and Anne E. Wardwell, *Mittelalterliche Textilien II: Zwischen Europa und China* (Riggsberg: Abegg-Stiftung, 2011).

24. For the color in the Great Mongol *Shahnama* manuscript, see Bertalan's essay in Komaroff and Carboni, pp. 227-29.

25. For the significance of gold in Mongol society, see Thomas T. Allsen, *Commodity and Exchange in the Mongol Empire: A Cultural History of Islamic Textiles* (Cambridge: Cambridge University Press, 1997), pp. 60-70.

26. Allsen, *Commodity and Exchange in the Mongol Empire*, p. 67.

27. In addition, blue is also used in the dress of the main character in the following illustrations (as numbered in Grabar and Blair): Zahhak enthroned (1); Faridun asking about his lineage (2); Faridun greeting Iraj and seeing his coffin (7); Zal climbing to Rudaba (9); Isfandiyar approaching Gushtasp (17; Fig. 7); Iskandar fights the Habash monster (33); Iskandar building the iron rampart (37); Ardavan captured by Ardashir (42); Bahram Gur killing a dragon (49); Bahram Gur in a peasant house

(50; Fig. 12); Picture of Nushirvan the Just (54); Nushirvan rewarding the young Buzurgmihr (55); Nushirvan eating the food brought by the sons of Mahbud (?) (56).

28. See Yuka Kadoi, 'Blue in Medieval Iranian Textiles: The Cycle of *Chinoiserie*', a paper given at the Historians of Islamic Art Association Symposium, 'Spaces and Visions', Philadelphia, 16–18 October 2008; For a survey of the use of the color blue in the art and architecture of West Asia throughout the ages, see Yuka Kadoi, 'Persian Blue: Arts of West Asia', *Orientations*, 42, no. 3 (2011), pp. 39-42.

29. For the blue wolf, see *The Secret History of the Mongols*, tran. and ed. by Francis W. Cleaves (Cambridge, MA: Harvard University Press, 1982), p. 1.

30. Kadoi, 'Blue in Medieval Iranian Textiles'. It is reported that some Mongol shamans dressed in animal skins during their performance; see Julian Baldick, *Animal and Shaman: Ancient Religions of Central Asia* (New York: New York University Press, 2000), p. 111.

31. The *tiraz* is a textile with woven or embroidered Arabic or Persian inscriptions, often carrying messages associated power and authority; see Yedida K. Stillman, Paul Sanders and Nasser Rabbat, 'Tirāz', in the *Encyclopaedia of Islam*, 2nd edn, 12 vols (Leiden: Brill, 2000), X, pp. 534-38.

32. Equally related to this is a striped textile at Regensburg; see Wardwell 'Panni Tartarici', pp. 99-100, fig. 5.

33. For a recent study of this textile, see Markus Ritter, 'Kunst mit Botschaft: der Gold-seide-stoff für den Ilchan Abū Saʿīd von Iran (Grabgewand Rudolfs IV. In Wien) – Rekonstruktion, Typus, Repräsentationsmedium', *Beiträge zur islamischen Kunst und Archäologie*, 2 (2010), pp. 105-35.

34. For a Tibetan example comparable to the image of Isfandiyar, see, for example, *Dahan de shiji: mengyuan shidai de duoyuan wenhua yu yishu* ('Age of the Great Khan: Pluralism in Chinese Art and Culture under the Mongols') (Taipei: National Palace Museum, 2001), pl. III-3. Tibetan sources must have been widely available in Ilkhanid territory thanks to the involvement of Tibetan Buddhists in the Mongol court, especially during the reign of Arghun (r. 1284–91). For Mongol-Tibetan relations, see Luciano Petech, 'Tibetan Relations with Sung China and with the Mongols', in *China among Equals: The Middle Kingdom and its Neighbors 10th–14th Centuries*, ed. by Morris Rossabi (Berkeley: University of California Press, 1983), pp. 173-203. Related to the Tibetan connections in the context of Mongol textiles, many surviving examples of cloths of gold are said to have come from Tibet, indicating that such textiles were woven as part of the imperial donations from the Mongol Khans to Tibetan monasteries (for example, see Watt and Wardwell, no. 35 and p. 129).

35. For Buddhist elements found in the art of Mongol Iran, see Yuka Kadoi, 'Buddhism in Iran under the Mongols: An Art-historical Analysis', in *Proceedings of the Ninth Conference of the European Society for Central Asian Studies*, ed. by Tomasz Gacek and Jadwiga Pstrusińska (Newcastle-upon-Tyne: Cambridge Scholars Publishing, 2009), pp. 171-80.

36. For example, see Wardwell, 'Panni Tartarici', fig. 59.

37. For this portrait, see Anning Jing, 'The Portraits of Khubilai Khan and Chabi by Anige (1245–1306), a Nepali Artist at the Yuan Court', *Artibus Asiae*, 54, no. 1/2 (1994), pp. 40-86.

38. For flower motifs in thirteenth- and fourteenth-century Chinese or Central Asian textiles, see Watt and Wardwell, nos 37, 40; Feng Zhao, *Treasures in Silk: An Illustrated History of Chinese Textiles* (Hong Kong: ISAT, 1999), pls 07.04, 07.06-07.07, and 07.09.

39. The earliest known occurrence of this type of floral motif in textile design can be found in the Small *Shahnamas* (probably north-west Iran or Baghdad, *c.* 1300); see Marianna Shreve Simpson, *The Illustration of an Epic: The Earliest Shahnama Manuscripts* (New York: Garland, 1979), figs 3, 5, 8, 12, 15, 18, 20, 22, 30, 32, 34, 41, 43, 51, 63-64, 66, 70, 77-78 and, 82-83. See also the use of floral patterns in the garments depicted in the Gutman *Shahnama* (probably Isfahan, *c.* 1335; New York, Metropolitan Museum of Art, inv. no. 1974.290, reproduced in Marie Lukens Swietochowski and Stefano Carboni, *Illustrated Poetry and Epic Images: Persian Painting of the 1330s and 1340s* (New York: Metropolitan Museum of Art, 1994), pls 15, 28, 38 and, 44-45.

40. See Norman A. Stillman, 'Khilʿa', in the *Encyclopeadia of Islam*, 2nd edn, 12 vols (Leiden: Brill, 1986), V, pp. 6-7.

41. Allsen, *Culture and Conquest in Mongol Eurasia*, p. 25.

42. The standard study of Mongol hats in Ilkhanid painting remains Eric Schroeder, 'Ahmad Musa and S̲h̲ames al-Dīn: A Review of Fourteenth Century Painting', *Ars Islamica*, 6 (1939), pp. 113-42 (pp. 122-23, figs 1-2).

43. See *Dahan de shiji*, pp. 288-89, pl. I-5.

44. Paris, Musée du Louvre, inv. no. AO 7096; see Grabar and Blair, no. 28.

45. For further discussion of the cloud collar, see Schuyler Cammann, 'The Symbolism of the Cloud Collar Motif', *Art Bulletin*, 33 (1951), pp. 3-10.

46. For Mongol dress depicted in Yuan murals, see Nancy S. Steinhardt, 'Yuan Period Tombs and their Decoration: Cases at Chifeng', *Oriental Art*, n.s., 36, no. 4 (1990–91), pp. 198-221; Yunyan Shen, 'Yuanmu bihua zhong de Yuandai fushi [Dress in Yuan Murals]', *Gugong wenwu*, 90, no. 8 (2001), pp. 32-41. See Kadoi, *Islamic Chinoiserie*, fig. 1.15, for one of the surviving examples of the cloud collar datable to the Yuan period.

47. For the Copenhagen example (40/1997), see Kjeld von Folsach, *Art from the World of Islam in the David Collection* (Copenhagen: The David Collection, 2001), no. 641. For a group of the Mongol hangings in the Museum of Islamic Art in Doha (inv. no. TE.40.2002); see Jon Thompson, *Silk: 13th to 18th Centuries, Treasures from the Museum of Islamic Art, Qatar* (Doha: National Council for Culture, Arts and Heritage, 2004), cat. no. 19. This device is also widely used in several media of Ilkhanid art (e.g., Qur'an illumination, stucco decoration); see Kadoi, *Islamic Chinoiserie*, pp. 32, 98, 224, and 226, fig. 6.15.

48. See also an illustration depicting a ruler enthroned in the Istanbul Saray Album (probably Iran, *c.* 1300); Istanbul, Topkapı Saray Museum, inv. no. H. 2152, fol. 60v, which contains a cloud collar in the ruler's robe; see Mazhar Ş. Ipşiroğlu, *Painting and Culture of the Mongols* (London: Thames and Hudson, 1967), pl. 11.

49. For example, see the Baysunquri *Shahnama* (Herat, 1430; Golestan Palace, Tehran, no. 6), reproduced in *Golestan Palace Library: A Portfolio of Miniature Paintings and Calligraphy* (Tehran: Golestan Palace Museum, 2000), pp. 93, 98, 102, and 104-08. Judging by surviving examples, little pictorial attention has been given to this device in post-Timurid painting.

50. See Schuyler Cammann, 'The Development of the Mandarin Square', *Harvard Journal of Asiatic Studies*, 8 (1944), pp. 71-130; Valery M. Garrett, *Mandarin Squares: Mandarins and their Insignia* (Hong Kong: Oxford University Press, 1990). For further discussion of the square badge in Persian painting and its Chinese connections, see Yuka Kadoi, 'Beyond the Mandarin Square: Garment Badges in Ilkhanid Painting', *Hali*, 138 (2005), pp. 42-47.

51. See Warner and Warner, VI, p. 383.

52. For surviving examples of the Mandarin square datable to the Yuan period, see Zhao, p. 290, pl. 09.09. See Cammann, 'The Development of the Mandarin Square', and Garrett, for the square badge of the Ming and Qing periods.

53. See Simpson, figs 7, 11, 18, 22, 31-32, 34, 48-49, 51, 58, 63-64, 66, 73, 76, 84, 86, 89-90, 93-94, and 113.

54. For instance, the fourteenth-century English poet Chaucer refers to 'cloth of Tars' embroidered with pearls; quoted in Paget Toynbee, 'Tartar Cloths', *Romania*, 29 (1900), pp. 559-64 (p. 563).

55. For this device, see Basil W. Robinson, 'The Vicissitudes of Rustam', in *The Iconography of Islamic Art: Studies in Honour of Robert Hillenbrand*, ed. by Bernard O'Kane (Edinburgh: Edinburgh University Press, 2005), pp. 253-68; Yuka Kadoi, 'Rustam's Tiger-skin Coat', paper given to the 6th Biennial Conference of Iranian Studies, SOAS, University of London, 3–5 August 2006.

56. Edinburgh, Edinburgh University Library, MS Arab 20; see David Talbot Rice, *The Illustrations to the 'World History' of Rashīd al-Dīn* (Edinburgh: Edinburgh University Press, 1976), pp. 76-77.

57. This has been widely pointed out; see, for example, Basil Gray, 'Iranian Painting of the 14th Century', *Proceedings of the Iran Society*, 1 (1936), pp. 50-58 (p. 56). For the relationship between the two manuscripts, see Shelia S. Blair, *A Compendium of Chronicles: Rashid al-Din's Illustrated History of the World* (Oxford: Oxford University Press, 1995), pp. 92-93.

58. For the image of Iskandar in the Great Mongol *Shahnama*, see Robert Hillenbrand, 'The Iskandar Cycle in the Great Mongol Šāhnāma', in *The Problematics of Power: Eastern and Western Representations of Alexander the Great*, ed. by Margaret Bridges and J. Christoph Bürgel (Bern: Peter Lang, 1996), pp. 203-29.

59. The enthronement scene is in Paris at the Musée du Louvre, Paris, inv. no. AO 7096; see Grabar and Blair, no. 28. 'Iskandar Building the Iron Rampart' is in Washington DC at the Arthur M. Sackler Gallery, inv. no. S1986.104; see Grabar and Blair, no. 37.

60. Kadoi, 'Beyond the Mandarin Square', p. 43.

61. For a study of the economic relationship, including gift exchanges, between Yuan China and Ilkhanid Iran, see Allsen, *Culture and Conquest in Mongol Eurasia*, pp. 41-50.